DANCE

Edited by **Jane Dini**

DANCE
American Art
1830–1960

With essays by

Thomas F. DeFrantz, Lynn Garafola, Dakin Hart, Constance Valis Hill, Analisa Leppanen-Guerra, Valerie J. Mercer, Jacqueline Shea Murphy, Kenneth John Myers, Bruce Robertson, and Sharyn R. Udall

DETROIT INSTITUTE OF ARTS
DISTRIBUTED BY YALE UNIVERSITY PRESS | NEW HAVEN AND LONDON

This catalogue was published in conjunction with the exhibition *Dance: American Art, 1830–1960*

Detroit Institute of Arts, March 20–June 12, 2016
Denver Art Museum, July 10–October 2, 2016
Crystal Bridges Museum of American Art, Bentonville, AK, October 22, 2016–January 16, 2017

The exhibition has been organized by the Detroit Institute of Arts. Support has been provided by the National Endowment for the Humanities and the National Endowment for the Arts. Additional support has been provided by an ADAA Foundation Curatorial Award and the Association of Art Museum Curators. Support for the catalogue has been provided by the Ida and Conrad Smith Fund.

© 2016 Detroit Institute of Arts
All rights reserved. This book may not be reproduced, in whole or in part, including illustrations, in any form (beyond that copying permitted by Sections 107 and 108 of the U.S. Copyright Law and except by reviewers for the public press), without written permission from the publishers.

Director of Publishing and Collections Information:
 Susan Higman Larsen
Manager, Photography: Eric Wheeler
Image research and permissions: Kimberly Long

Designed by Patricia Inglis | Inglis Design
Index by David Luljak
Separations by Professional Graphics, Inc.
Printed and bound in Italy

Library of Congress Cataloging-in-Publication Data

Dance : American art, 1830–1960 / edited by Jane Dini ; with essays by Thomas F. DeFrantz, Lynn Garafola, Dakin Hart, Constance Valis Hill, Analisa Leppanen-Guerra, Valerie J. Mercer, Jacqueline Shea Murphy, Kenneth John Myers, Bruce Robertson, and Sharyn R. Udall.
 pages cm
"This catalogue was published in conjunction with the exhibition *Dance : American art, 1830–1960*, Detroit Institute of Arts, March 20–June 12, 2016, Denver Art Museum, July 10–October 2, 2016, and Crystal Bridges Museum of American Art, Bentonville, AK, October 22, 2016–January 16, 2017."
Includes bibliographical references and index.
ISBN 978-0-89558-173-0 (Detroit Institute of Arts)
ISBN 978-0-300-21161-0 (Yale University Press)
 1. Dance in art—Exhibitions. 2. Dance—United States—Exhibitions. 3. Art, American—19th century—Exhibitions. 4. Art, American—20th century—Exhibitions. I. Dini, Jane, 1963–
II. Detroit Institute of Arts. III. Denver Art Museum.
IV. Crystal Bridges Museum of American Art.
N8217.D3A78 2016
704.9'4979280973—DC23

2015021782

Published by the Detroit Institute of Arts
www.dia.org

Distributed by Yale University Press, New Haven and London
www.yalebooks.com/art

cover: Arthur F. Mathews, *Youth* (detail), ca. 1917 (cat. 35)

Contents

8 *List of Lenders*

9 *Director's Foreword*

11 Invitation to the Dance
 JANE DINI

29 In the Eye of the Beholder: The Black Presence in the Art of American Dance
 CONSTANCE VALIS HILL

51 Dance and the Performance of Self in America: 1810 to 1850
 KENNETH JOHN MYERS

65 The Art of Native American Dance
 JACQUELINE SHEA MURPHY

87 The Art of Dancing Out-of-Doors
 JANE DINI

115 American Modernism and Dance: Arthur B. Davies's *Dances,* 1915
 BRUCE ROBERTSON

135 Anna Pavlova in America: Performance, Popular Culture, and the Commodification of Desire
 SHARYN R. UDALL

153 The Dancer as Muse
 JANE DINI

177 Visualizing Dance of the Harlem
 Renaissance
 THOMAS F. DEFRANTZ

197 The Vicissitudes of African American
 Artists' Depictions of Dance between
 1800 and 1960
 VALERIE J. MERCER

221 *H. P.:* A Lost Dance of the Americas
 LYNN GARAFOLA

249 Modern Shenanigans at a Filling Station
 Designed by Paul Cadmus
 JANE DINI

265 Immortal Dancers: Joseph Cornell's
 Pacifism During the Second World War
 ANALISA LEPPANEN-GUERRA

281 Isamu Noguchi and Ruth Page in an
 Expanding Universe
 DAKIN HART

292 *Checklist*

299 *Selected Bibliography*

300 *Index*

303 *Acknowledgments*

304 *Photo Credits*

List of Lenders

Addison Gallery of American Art, Andover, MA
Amistad Research Center, Tulane University, New Orleans
The Art Institute of Chicago
Brooklyn Museum
The Butler Institute of American Art, Youngstown, OH
Cincinnati Art Museum
Crystal Bridges Museum of American Art, Bentonville, AK
Denver Art Museum
Detroit Institute of Arts
Evansville Museum of Art, History and Science, Evansville, IN
Hall Art Foundation, New York, NY
Harvard Art Museums, Cambridge, MA
Heard Museum Collection, Phoenix, AZ
The Irvine Museum, Irvine, CA
The Jewish Museum, New York
Kansas Historical Society, Topeka
Dr. and Mrs. John E. Larkin
The Long Island Museum of American Art, History, and Carriages, Stony Brook, NY
Los Angeles County Museum of Art
Mead Art Museum, Amherst College, Amherst, MA
The Melvin Holmes Collection of African American Art, San Francisco
The Menil Collection, Houston
The Metropolitan Museum of Art, New York
Milwaukee Art Museum
Missouri History Museum, St. Louis
Moorland-Spingarn Research Center, Howard University, Washington, DC
Munson–Williams–Proctor Arts Institute, Utica, NY
Musée d'Orsay, Paris
Museum of Fine Arts, Boston
The Museum of Modern Art, New York
National Gallery of Art, Washington, DC
National Portrait Gallery, Smithsonian Institution, Washington, DC
The Newark Museum
New-York Historical Society, New York
New York Public Library
The Isamu Noguchi Foundation and Garden Museum, Long Island, NY
North Carolina Museum of Art, Raleigh
The Oakland Museum of California
Pennsylvania Academy of the Fine Arts, Philadelphia
The Phillips Collection, Washington, DC
Manoogian Collection, Taylor, MI
Richard L. Feigen and Co., New York, NY
The Rose Art Museum of Brandeis University, Waltham, MA
Santa Barbara Museum of Art
Smithsonian American Art Museum, Washington, DC
Spelman College, Atlanta
Spencer Museum of Art, Lawrence, KS
Toledo Museum of Art
Collection of Jan T. and Marica Vilcek, New York
Wadsworth Atheneum Museum of Art, Hartford, CT
Walker Art Center, Minneapolis
The Andy Warhol Museum, Pittsburgh, PA
The Westmoreland Museum of American Art, Greensburg, PA
Whitney Museum of American Art, New York
Yale University Art Gallery, New Haven, CT
Private collections

Director's Foreword

Throughout history, dance has provided a visual language to express such themes as the bonds of community, the allure of the exotic, and the pleasures of the body. *Dance: American Art, 1830–1960* accompanies the first major traveling exhibition to explore visual art related to American dance. From Arthur Davies's cubist interpretations of Isadora Duncan to Reginald Marsh's jitterbugging crowds at the Savoy to Paul Cadmus's lone dancer practicing arabesques in a New York ballet studio, dance has touched all segments of American society. These artists did not merely represent dance, they were inspired to think about how Americans move, present themselves to one another, and experience time.

 First and foremost, we would like to thank Jane Dini for organizing the exhibition and the essays that appear in this volume. The contributions by both dance and art historians offer us new and intriguing perspectives on American artists both well know and less familiar. The stunning variety of work—paintings and sculpture; prints and photographs; set designs and costume—appears courtesy of the many lenders, without whom there would be no exhibition. To those institutions and individuals, we extend most heartfelt thanks. In addition, we would like to thank Christoph Heinrich, Frederick and Jan Mayer Director of the Denver Art Museum, and Rod Bigelow, executive director of Crystal Bridges Museum of American Art, whose institutions will host the exhibition after its Detroit debut. Finally, we are grateful for the generous support we have received from the National Endowment for the Humanities and the National Endowment for the Arts, and the additional funding from the Association of Art Museum Curators and an ADAA Foundation Curatorial Award. The Ida and Conrad Smith Fund also gave support for this catalogue. And now, please join us in the dance.

<div style="text-align: right;">

SALVADOR SALORT-PONS
Director, Detroit Institute of Arts

</div>

Invitation to the Dance | *Jane Dini*

Throughout American history, dance has engaged every segment of society and every artistic medium, creating arenas for social interactions, spiritual exaltation, popular entertainment, and artistic experimentation. In the United States, in particular, images of dance have addressed class divisions, racial tensions, and the shifting role of women. Artists did not merely represent dance, they were inspired by dance to think about how Americans interact with one another, share culture, and express themselves through movement. For some artists, the way they put paint on canvas, carve a sculpture, or frame a photograph is imbued with the rhythms of the body in motion.

Dance: American Art, 1830–1960 explores the fundamental connections of dance and its representation as it crosses from the nineteenth into the twentieth century. While dance was at the nexus of early twentieth-century modern art, many of the themes were a continuation of nineteenth-century American concerns: a celebration of the vernacular, social mobility, and racial relationships. The essays in this catalogue are written by art and dance historians, each with different perspectives and emphasis, in what I hope produces a true collaborative study between the fine and performing arts that will shine a spotlight on those artists who played an integral role in celebrating the most ephemeral of the performing arts.[1]

Almost two hundred years ago in Philadelphia, the German-born American artist John Lewis Krimmel painted *Country Frolic and Dance* (1819), an image of a young couple dancing to the music of an African American fiddler in a country tavern. In the related watercolor (fig. 1), the dancers display their fine form and physique in a jaunty jig derived from English folk traditions. Hopping in the air, the dapper male, his right arm akimbo, shows off his handsome profile to a young woman, opposite, who holds the skirts of her empire-waist dress to show off her delicate footwork. In much the same way the English jig derived from continental sources, so,

Cat. 1. George Luks, *The Spielers*, 1905

fig. 1. John Lewis Krimmel, *Country Frolic and Dance*, ca. 1820, watercolor. Library of Congress Prints and Photographs Division Washington, DC

fig. 2. Titian, *The Andrians*, 1523–24, oil on canvas. Museo del Prado, Madrid

too, does the image itself. Krimmel's debt to the traditions of Dutch and Flemish genre painting vis-à-vis British painters (i.e., Scotland's David Wilkie and England's William Hogarth) is well documented. Krimmel scholar Anneliese Harding reinforces this visual history, observing that "Although the subject of country dances had a long history in European art (earlier examples are in the works of Brueghel, Rubens, Teniers), it had not existed in American art. Krimmel introduced it and used it as an opportunity to present a slice of American life."[2]

In Krimmel's slice of American life, the artist demonstrates a still wider knowledge of European sources, including several figures that playfully mirror those in Venetian painter Titian's *The Andrians* (1523–24; fig. 2). In *Country Frolic and Dance,* as in the Italian Renaissance prototype, revelers surround a dancing couple in various states of drunkenness. Krimmel's American tavern keeper, who reaches across his body for a glass with one hand while popping a champagne cork with the other, is a direct quotation of Titian's naked male Andrian, who arches over to dispense wine from a golden pitcher into the saucer of a young maiden. There are other similarities, too, but the striking artistic device shared by Krimmel and Titian was to use dance to organize the composition and activate the flowing gestures and movements. Krimmel's dancers are the nexus of the action and from them spiral the secondary movements that make up the tavern party. That dance was the centerpiece of public life, let alone in an American painting, was novel.

Presiding over the American bacchanal is an image of George Washington. His presence above the fireplace mantle contends with a smattering of advertisements on the chimney breast. Portraits of such worthies as Washington were to be emulated and revered, especially in Philadelphia. The remembrance of heroic sacrifice now vies with more earthly pleasures. That Krimmel humorously declares dance part of American life is significant.

Just as the country was in its nascent stages politically, so, too, was American dance, and most artists like Krimmel depicted European forms. The tapping of the fiddler's mule slipper, however, alerts us to the new rhythms afoot in the United States.[3] Small observations and details such as these would become more pronounced in the years ahead as American artists would come to recognize that American dance was no longer only a European-based form. Over the next two hundred years, American dance images would depict a myriad of styles based on a polyglot of cultures, including those of Indigenous traditions that had already been in motion for centuries.

Constance Valis Hill's observations set the perfect stage for the discussion. In "In the Eye of the Beholder: The Black Presence in the Art of American Dance," she discusses the depiction of African American communities by primarily white artists, and examines stereotyping and exclusions within the visual culture. She reveals the intercultural roots of early American vernacular dance forms, the hierarchies of which were firmly in place by the time of the Civil War. Successful Anglo-American genre painters such as William Sidney Mount (1807–68) and George Caleb Bingham (1811–79) depicted performances that were transformed, as Valis Hill describes, into a "kinesthetic aliveness." These dancing bodies, she argues, inspired artists to experiment with new modes of expressivity that were fundamental to the American cultural and social experience, creating, for instance, a cross-racial kinship between Irish and African American social dance, both of which have deep roots in North America.

How these images found their way to the professional arena, particularly the stages of New York City, is of keen interest to Kenneth Myers, who observes in "Dance and the Performance of Self in America: 1810 to 1850" that the origin story resides in popular prints that emphasized class. From this vantage point we can see the formation of American audiences and taste. Until the 1850s, Myers argues, images of dance by and large celebrated the ability of dancers to discipline the dexterity, refinement, and finesse of the body, and satirized the movements of dancers who failed to do so. As new class identities were consolidated in mid-century, Myers observes, painters adopted an aesthetically distanced point of view that enabled them to celebrate the exuberance of the nongenteel dance while marginalizing it as expressive of an inferior way of being in the world.

Seen together, Valis Hills and Myers set forth important ways of relating race and class to American dance images later in the century. We can better read, therefore, how artists represented class distinctions through the physical gestures of dancers. For instance, George Luks's *The Spielers* (1905; cat. 1), an image of two working-class Irish girls dancing together with great gusto on a New York City sidewalk, is a striking contrast to Cecilia Beaux's *Dorothea and Francesca* (1898; cat. 2), an image of two sisters from Philadelphia's upper class, the older of whom is delicately instructing the younger on the finer points of a dance. The images emphasize distinctions in the girls' comportment, revealing how seemingly charming and anodyne dance paintings could be an indicator of ethnicity and social class at the end of the nineteenth century. Early twentieth-century artists often portrayed the dances of immigrant children as a sign of a continuing and thriving cultural heritage, as seen in the realist sculptor Abastenia St. Leger Eberle's *Girls Dancing* (1907; cat. 3).

Cat. 2. Cecilia Beaux, *Dorothea and Francesca*, 1898

Cat. 3. Abastenia St. Leger Eberle, *Girls Dancing,* 1907

However, visual markers of ethnic difference helped preserve social boundaries between middle-class audiences and the immigrant subjects depicted in the works of art. Rarely did the social realist painter Raphael Soyer depict work that referred to his Russian Jewish heritage, nonetheless, *Dancing Lesson* (1926; cat. 4) celebrates his roots. In the image, he depicts his brother and sister learning to dance to the tunes of a younger brother's harmonica in front of an at-home family audience in the Bronx, while his mother reads a Yiddish newspaper and a picture of relatives from the old country hangs on the wall.

Immigrant dances changed as the dancers came to identify as Americans. Others were excluded. Nowhere was the body of the dancer more contested than in the depiction of Native and African Americans. In the nineteenth century, their bodies were satirized, made into humorous grotesques, or exoticized. In the twentieth century, these communities championed their own representations, repudiating entrenched stereotypes in favor of image-making that celebrates and honors their dance communities.

Dance, the sacred ritual of Native American culture, became a popular theme for Western tourist art early in the twentieth century, but later Native American artists reclaimed their culture and once again became a thematic subject of great spiritual resonance for Indigenous artists. Jacqueline Shea Murphy's essay, "The Art of Native American Dance," chronicles images of sacred dances by both Native and non-Native artists, explaining political contingencies for both communities and how dance shaped their perceptions. Her essay charts the anthropological documentation of dances by non-Native explorers; the effect of the tourist trade in the Southwest on paintings by non-Native and Native American artists alike; and the controversial question that began to be asked of artists like Native American artist Oscar Howe: what makes a twentieth-century Native American work "authentic"? Howe paved the way for future generations of artists, such as Harry Fonseca, who humorously challenged stereotypes in paintings such as *Shuffle Off to Buffalo #V* (1983; cat. 5), an image of Coyote, a trickster from Maidu folklore, in the guise of Uncle Sam performing in a Hollywood musical.

Nineteenth-century New York painter William Holbrook Beard also found delight in the animal kingdom by satirizing human behavior with his personifications of drunken bears and lascivious monkeys. In *The Bear Dance* (1870; cat. 6), the animals dance in celebration of their good fortune. Also known as *The Bears of Wall Street Celebrating a Drop in the Stock Market* and *The Wall Street Jubilee,* Beard's painting is an allegory of greed and hubris that is just as poignant today as it was then.

Images of social dances appear throughout the essays, including dances performed during courtship, dancers practicing their footwork, club scenes, and intimate dances performed by women in small groups. The subject of modern, dancing women without male partners was new in American art and coincided with their appearance in graphic media and mass-circulated journals. This visual flood of dancing women, shedding their restrictive clothing in favor of attire that let the body move freely, was a subset of the New Woman, a late nineteenth-century feminist ideal that helped shape the suffrage movement.

Cat. 4. Raphael Soyer, *Dancing Lesson*, 1926

Cat. 5. Harry Fonseca, *Shuffle Off to Buffalo #V*, 1983

Cat. 6. William Holbrook Beard, *The Bear Dance,* ca. 1870

Cat. 7. Robert Henri, *Ruth St. Denis in the Peacock Dance*, 1919

In "The Art of Dancing Out-of-Doors," I look to artists who represented the earliest nineteenth-century forms of dancing in nature; most depicted robust lower-class folk dance. But in the later part of the century, Americans were inspired by Greek classical dress and naturalism, and artists depicted the countryside as Edenic and celebrated the dancing body as a graceful form. Dancers such as Isadora Duncan turned away from traditional ballet and began to appear uncorseted, dancing out-of-doors, shedding the trappings of city life. Bound up in these representations are questions of a women's place in the social order. As women's suffrage began to build steam in the United States, this new, natural dance provoked a wide array of visual responses.

Bruce Robertson, in "American Modernism and Dance: Arthur B. Davies's *Dances, 1915*," also looks back to the era of Grecian-inspired dance in the United States, but in this case to propel his argument forward into the history of modern dance and its representation. The focal point for his study is the painter Arthur B. Davies, whose brief foray into a cubist, abstracted visual language helps us understand the contingencies of modernism and the emerging sensibilities of modern dance and its representation in paintings. By focusing on modernist choreography such as that of Isadora Duncan and her antecedents in the world of dramatic expression, Robertson challenges our assumption of the conventional histories of art. He describes how the modern dancing body was a vital interest for a range of artists not normally brought together in the traditional canon of art history. His story is about dance and modern art, rather than style and modern art.

Today, Isadora Duncan may be the most recognizable female dancer of the early twentieth century, but she was part of a new age of female dancers, which I discuss in "The Dancer as Muse." These women were celebrated by such fine artists such as Robert Henri, whose *Ruth St. Denis in the Peacock Dance* (1919; cat. 7) is an image of the daring pioneer of modern dance. In the full-length portrait, through the dramatic sway of St. Denis's whole body, Henri conveys the dancer's novel choreography deriving from her appropriation of non-Western dance forms. She performed her sensuous rhythms in a shimmering, iridescent costume of violet and green evocative of the coloring and movements of the male bird. Henri enthused:

> I am painting a portrait of Ruth St. Denis, the great dancer. Have had three sittings and am to have 3 more next week—it's a big piece of work getting on very well so far. She is in her dance of the "Peacock." The story is Egyptian princess very proud, etc. whose spirit is confined in a peacock. It is a very wonderful dance and she is very beautiful in it. Costume is naturally in the character and colors of peacock.[4]

Sharyn Udall, in "Anna Pavlova in America: Performance, Popular Culture, and the Commodification of Desire," makes clear that America was the perfect place for a dance star—of any nationality—to market herself and fashion an identity that could be famous and profitable. Udall traces the U.S. career of the Russian prima ballerina whose marriage of "high art" ballet and popular culture, including commercial advertising, propelled her into an unprecedented level of celebrity. She explains, however, that it was Pavlova's carefully cultivated accessibility to visual

Cat. 8. Jenne Magafan, *Cowboy Dance (mural study, Anson, Texas Post Office)*, 1941

artists (many of whom were sculptors who captured her extraordinary poses) that ultimately ensured her legacy as a legendary dancer.

While some dancers benefited from their popular persona in the commercial media, others struggled to be free of the stranglehold of damning satire. During the 1920s and 1930s, African American artists challenged entrenched racist images. Harlem Renaissance painter and muralist Aaron Douglas (1899–1979), for instance, challenged negative stereotypes established by the minstrel show and its related visual culture, and sought to create and sustain a vibrant cultural identity by exploring dance legacies from Africa. Douglas, however, was a rare exception.

Thomas DeFrantz discusses why this was the case in "Visualizing Dance of the Harlem Renaissance," explaining that the physical creativity demonstrated in African American dance escaped careful consideration by the intellectual architects of the Harlem Renaissance. He points out, as does Valerie Mercer in "The Vicissitudes of African American Artists' Depictions of Dance between 1800 and 1960," that dance was not a suitable agent of change to be deployed in the articulation of the New Negro. The reason, DeFrantz explains, is that for many artists and critics, dance represented a lower form of artistic expression, one that mattered less than music, drama, poetry, or fiction writing. Because Africanist dance forms in the United States had never been considered classical in any sense of that word, he states, there was no classical tradition available for black artists of dance to engage in during the early decades of the twentieth century. And while African American social dances enlivened mainstream publics throughout the 1920s and 1930s, in dances like the Charleston and the Lindy Hop, these dances were generally dismissed as unable to express the profundity and diversity of black life. The paucity of African American dance images persisted well into the twentieth century, says Mercer, who underscores this absence with the example of 1940s and 1950s bebop, a form of jazz whose proponents encouraged careful listening rather than as an accompaniment for dancing.

Nevertheless, the important visual strategies of Harlem Renaissance artists like Douglas and William Johnson (1901–70) who championed their histories help us better understand artists who used dance to celebrate regional histories across the country during the Depression. In a time of economic uncertainty, Jenne Magafan's U.S. Post Office mural *Cowboy Dance* (1941; cat. 8) gave Texans a visible sign of a vibrant and resilient culture. As American vernacular dance struggled for an inclusive American identity, so, too, did the professional performers, including those in established forms such as ballet.

In the 1930s, U.S. artists worked within the European Romantic tradition to create original, modern American myths and fantasies. Diego Rivera's fanciful costume designs of pineapples and banana plants for *H.P. (Horsepower)* (1927) reveal the socio-economic interests and tensions between South and North America. In "*H.P.*: A Lost Dance of the Americas," Lynn Garafola focuses on Diego Rivera's little known ballet with music by Carlos Chávez, designs by Diego Rivera, and choreography by Catherine Littlefield, which opened in Philadelphia in 1932. As with so much American ballet, its history, ballet stars, and performance, *H.P.* was indebted to Serge Diaghilev's Ballets Russes, which, Garafola explains, treated ballet not as a display of the

Cat. 9. Isamu Noguchi, *Cave of the Heart: Serpent and Spider Dress*, 1946

danse d'école but as an art of expressive movement. For artists, musicians, and writers, Ballets Russes' works offered a model for transforming populist traditions into high modernist art. She argues that *H.P.* complicated this formula with its dual imagined communities, Americas of the industrialized North and the agricultural South. At the height of the Depression, Garafola points out, it was a ballet in which workers triumphed that looked and sounded both modern and expansively American. Sadly, for such an original theme, *H.P.* had only one performance.

During this period, ballet companies struggled and sought populist strategies to attract audiences. In "Modern Shenanigans at a Filling Station Designed by Paul Cadmus," I explore Paul Cadmus's collaboration with Lincoln Kirstein and Lew Christensen for the 1938 ballet *Filling Station*. Cadmus's bold and vibrant scenic design created a cartoonish background for Christensen's eclectic choreography, which interspersed vaudevillian pratfalls with the soaring leaps of classical movement. It was Cadmus's framing of the body, however, that was most significant. His costumes for the middle-class customers of the gas station reflected his vision of Depression-era class and culture, and the see-through overalls of the protagonist, Mac, the gas-station attendant, were of singular importance. Together, Cadmus and Christensen (who danced the role of Mac) displayed delight in the presentation of the athletic male body. Alternatively, Cornell's *Untitled (Celestial Fantasy with Tamara Toumanova)* (1940) reveals an intimate meditation on the ballerina and her European legacy. Artists' responses to a performance could be deeply personal, as well as political.

In "Immortal Dancers: Joseph Cornell's Pacifism During the Second World War," Analisa Leppanen-Guerra explains how the artist explored the ephemeral and spiritual qualities of ballet in his collages and assemblages to develop a pacifist, anti-war message. As she describes, Cornell created several works in the early 1940s that celebrate the nostalgic aura of the Romantic ballet, and yet, beneath the pink gauze and sequined tulle, as Lappanen-Guerra so charmingly describes, lies a sharp critique of the war raging around him. Cornell associated the Romantic ballet with the ephemeral, spiritual, and immortal, and so in Cornell's mind, this subject becomes evocative of key concepts from Christian Science. Set against the backdrop of World War II, these works become Cornell's own version of a pacifist protest.

In considering sculptor and set designer Isamu Noguchi's contribution to dance and his collaboration with dancers,

fig. 3. Philippe Halsman, *Martha Graham wielding Isamu Noguchi's Spider Dress in Cave of the Heart*, 1946, photograph. Archives of the Noguchi Museum, New York

JANE DINI

Dakin Hart, in "Isamu Noguchi and Ruth Page in an Expanding Universe," focuses not on the artist's more famous collaborations with Martha Graham but those with Ruth Page, who was equally experimental and novel in her approach to dance and the choreographic appropriation of fine art. Noguchi and Page shared a deep creative empathy, and it was this shared passion for experiment, invention, and success, and their belief that like-minded artists, constituting something of a world apart, should support each other. This resulted in what Hart describes as a constellation of collaboration, including Page's modern dance *Expanding Universe* and the sculpture that it inspired, Noguchi's *Miss Expanding Universe* (1932; cat. 89).

This essay propels us into the conclusion of the exhibition, which ends with a series of extraordinary collaborations between dancers and artists from the mid-century to the 1960s, including one of the most trusting collaborations in the history of American art between Martha Graham and Isamu Noguchi. Noguchi created more than thirty designs for Graham's modern dances, matching his abstracted forms to her stylized body movements. Noguchi's *Serpent and Spider Dress* (1946; cat. 9), the strikingly gorgeous and barbaric costume for Medea in the dance *Cave of the Heart* (1946), demonstrates Noguchi's desire to sculpt the spaces in which the dancers dance and modify their bodies on stage. Even though Noguchi's sets presented often severe physical challenges to the dancers, moving through the art played an important role in shaping their performances. Indeed, the photograph of Martha Graham wearing the Spider Dress is a bold declaration that the dancer is literally at the center of cultural life in the United States (fig. 3). She and her costume radiate energy, just as Bingham's dancer in the *Jolly Flatboatmen* (cat. 11) did one hundred years before. The dancer ignites our senses and our passions.

Dance as a conveyer of meaning was equally powerful for artists in the nineteenth century as it was to their twentieth-century counterparts. To make these connections clear, *Dance: American Art, 1830–1960* embraces nineteenth-century artists' representational depictions of dance alongside twentieth-century artists' abstractions of dance and argues that they deeply inform one another, proving that American modernism is not a break from the past but deeply connected to it.

Notes

1. Several recent museum exhibitions have explored how dance was central to the evolution of European and American modernism. In *Diaghilev and the Golden Age of the Ballets Russes, 1909–1929,* at the Victoria and Albert Museum, London, in 2010, Jane Pritchard and Geoffrey Marsh revealed the extraordinary contribution that scenic and costume designs made to the evolution of modern dance. In *On Line: Drawing Through the 20th Century,* at the Museum of Modern Art, New York, in 2011, Cornelia Butler argued that modern dance choreography was central to artists' exploration of new gestures and forms. And, most recently, in *Danser sa vie* (Dance Your Life) at the Pomidou Center in Paris, in 2011, Christine Marcel and Emma Lavigne showcased twentieth-century art and dance's common interest in the moving body.

2. Anneliese Harding, *John Lewis Krimmel: Genre Artist of the Early Republic* (Wilmington, DE, 1994), 158.

3. In his study of the instrumentation in early minstrel shows, Robert B. Winans reports that "particularly before the 1850's, the guitar was rarely present on the minstrel stage." See "Early Minstrel Show Music, 1843–1852," in *Musical Theatre in America,* ed. Glenn Loney (Westport, CT, 1984), 71–97.

4. Henri to his mother, Theresa Gatewood Lee, February 15, 1919, Henri Papers, Beinecke Rare Book and Manuscript Library, Yale University.

In the Eye of the Beholder: The Black Presence in the Art of American Dance | *Constance Valis Hill*

John McLenan's *The Dance / The Breakdown,* a wood-engraved illustration, was published on April 13, 1861, in the "American Home Scenes" section of *Harper's Weekly* (fig. 1), a New York–based periodical that prided itself on being the most valuable source for lively images of domestic and social life. *Harper's Weekly* literally informed modern audiences about the "arrangement" of people in places in the late nineteenth century. This edition of "Home Scenes" presented six vignettes of domestic life in rural America: two featured African American groups and four, as counterparts, featured Caucasian groups. Two central vignettes, "The Dance," with white participants, and "The Breakdown," with black participants, depicted lively social gatherings with music and dance. The scenes were racially segregated, but the style of dance—both the upright, on-the-balls-of-the-feet jig that whites performed in "The Dance" and the flat-footed, buck-and-wing danced by blacks in "The Breakdown"—derived from an early form of percussive stepping (later called tap dance) that had evolved from a three-hundred-year musical and social exchange that began with the interaction of Irish indentured servants and enslaved West Africans in the Caribbean in the 1600s. "The Dance" and "The Breakdown," then, shared biracial roots.

The publication of McLenan's "American Home Scenes" illustration is also auspicious: April 13, 1861, commenced the bloodiest four years in American history, when, on the previous day, Confederate shore batteries under General P. G. T. Beauregard opened fire on Union-held Fort Sumter in South Carolina's Charleston Bay. During the next thirty-four hours, fifty Confederate guns and mortars launched more than 4,000 rounds at the poorly supplied fort. On April 13, U.S. Major Robert Anderson surrendered the fort. Two days later, U.S. President Abraham Lincoln issued a proclamation calling for 75,000 volunteer soldiers to quell the Southern "insurrection," thus pronouncing the beginning of the American Civil War.

Cat. 10. James Goodwyn Clonney, *Study for "Militia Training": Boy Dancing,* ca. 1839

fig. 1. John McLenan, *The Dance / The Breakdown*, "American Home Scenes," *Harper's Weekly,* April 13, 1861

fig. 2. William Sidney Mount, *Dancing on the Barn Floor,* 1831, oil on canvas. The Long Island Museum of Art, gift of Mr. and Mrs. Ward Melville

The Dance / The Breakdown, as published on the eve of the Civil War, made literal the racial polarities of the day. The formal composition of the double-fold page, with "Dance" placed top center and "Breakdown" bottom center, referenced the Southern plantation's "Big House," where whites enjoyed the musical frivolities of their country dances, and "Slave Quarters," where blacks danced their Ring Shouts. Embedded within these dancing images, however, are racial slippages that countered strict segregation and substantiated the interracial dance practices long embedded in the culture.

This essay examines the intercultural roots of early American vernacular dance forms as imaged by the artists of *Dance: American Art, 1830–1960.* I am interested in how such percussive dance forms as jigging, patting juba, buck and wing, clog, and hornpipe, were drawn in a multiplicity of images as to become iconographic of the dance form itself. How quickly, for instance, viewers recognized the angularities of the buck-and-wing dancer with an upright torso, arms outspread, one leg bent at the knee with a flexed foot (cat. 10). As a performance studies scholar, I view these art works as "performative," as they place the dancing subjects within a "proscenium frame," where they perform for the pleasure of those in their surrounds and for the artist who "records" the performance. In William Sidney Mount's *Dancing on the Barn Floor* of 1831 (fig. 2), for instance, the artist frames four figures—two dancers, a fiddler, and a woman—in the opening of a barn, the front edge of which is parallel to the picture frame. The sliding doors frame the couple dancing an allemande. The formal composition of the painting allows for multiple viewing positions: the woman peering through the open door at the back of the hay barn; the seated fiddler facing away from the dancers; the dancers facing each other but directing their focus to a subject beyond the frame. The sideways direction of their focus suggests they are performing for a friendly observer, or for the artist himself, who paints the scene *en plein air.*

What is unique about this genre painting is that long after the performance, the artist must transform the kinesthetic aliveness of the dancing bodies onto the canvas. It is the dance, then, that inspired American artists to experiment with new modes of expressivity. Their resultant art works produced a nuanced understanding of how dance played a significant part in American culture and was fundamental to the social experience, creating a cross-racial kinship.

Afro-Irish Fusions in American Dance

In the 1650s, during the thirteen-year war between England and Spain (1641–54), Oliver Cromwell sent an estimated 40,000 Celtic Irish soldiers to Spain, France, Poland, and Italy. After deporting the men, Cromwell succeeded in deporting their wives and children. Thereafter, thousands more Irish men, women, and children were deported, exiled, or sold into newly colonized English tobacco islands of the Caribbean.[1] Within a few years, in a development independent of what was going on in England, substantial numbers of Africans along the Atlantic coast were chained into so-called coffin ships and transported as slaves to the Caribbean. The cultural exchange between first-generation enslaved Africans and indentured Irish continued in the British colonies of the Americas through the late 1600s, on plantations and in the surrounding villages and towns, as white indentured servitude was replaced by African slave labor.

As Africans were transported to the Americas, African religious circle-dance rituals were adapted and transformed. The African American *juba*, derived from the African *djouba* or *gioube*, was danced in a counterclockwise circle and was distinguished by the rhythmic shuffling of feet, clapping of hands, and "patting" the body as if it were a large drum. With the passage of the Slave Laws in the 1740s prohibiting the beating of drums, for fear of slave uprisings, creative substitutes were developed for drumming, such as bone-clapping, jawboning, hand-clapping, and percussive footwork. The oral traditions and expressive cultures of the West Africans and the Irish that converged in America is best heard in the lilting 6/8 meter of the Irish Jig, played on the fiddle. The fusion produced black and white fiddlers who "ragged," or syncopated, jig tunes. Similarly, the African American style of dance that angled and relaxed the torso, centered movement in the hips, and favored flat-footed gliding, dragging, and shuffling steps, melded with the Irish American style of step dancing, which featured an upright torso that minimized hip motion and dexterous footwork, and that favored bounding, hopping, and shuffling.

Jigging

By 1800, "jigging" became the general term for this new American percussive hybrid and was recognized as a "black" style of dancing, in which the body was bent at the waist and movement

CONSTANCE VALIS HILL

was restricted from the waist down. Jumping, springing, and side-winging air steps made it possible for the airborne dancer, upon take off or landing, to produce a rapid, rhythmic shuffling of the feet. Jigging competitions featuring buck-and-wing dances, shuffling ring dances, and breakdowns abounded on plantations, where dancing was encouraged and often enforced. As James W. Smith, an ex-slave born in Texas around 1850, remembered:

> Master...had a little platform built for the jigging contests. Colored folk comes from all around to see who could jig the best...on our place was the jigginist fellow ever was. Everyone round tries to git somebody to best him. He could... make his feet go like trip-hammers and sound like the snare drum. He could whirl round and such, all the movement from his hips down.[2]

Breakdown

Any dance in the so-called Negro style was called a *"breakdown,"* as depicted in William Sidney Mount's *The Breakdown, Bar-Room Scene,* 1835 (fig. 3), which depicts a white male dancing before his peers. Only the back of the dancer is visible, but his flat-footed style of stepping is iconic of this rambunctious style of jigging, which is appreciated by one man looking at the dancer's feet, another clapping hands, a third enjoying the chatter of feet while smoking a pipe, and a boy gazing on in admiration.

Breakdowns were a favorite with the white riverboat men who turned the raised wooden platform of the flat boat into a performance space. In *Life on the Mississippi* (1883), Mark Twain wrote that "keelboatmen got out an old fiddle and one played and another patted juba and the rest turned themselves loose on a regular old-fashioned keelboat breakdown." George Caleb Bingham, in his riverboat paintings, captured the camaraderie of male musical gatherings on the flatboat, where men performed for each other in a moment of relaxation and isolated pleasure. In *The Jolly Flatboatmen* (cat. 11), one man dances, another fiddles, and a "tambourine" player sets the rhythm by beating on a cooking pan. Bingham inscribed a scene of utter tranquility by framing the musicians and dancer between two seated men: one looks straight out at the viewer and the other stretches out on his back, clasping his hands behind his raised head, to catch the high-stepping footwork.

Women were conspicuously absent from Bingham's river dance paintings. "Males, in the prevailing gender stereotype of the day, could break into spontaneous dance with a kind of thumping sturdiness that was off limits to women, who were still defined largely by their domestic and maternal qualities," writes Sharyn Udall. Ladies might dance in sedate indoor settings or watch males dancing outdoors, but in the mid-nineteenth century, "respectable women were excluded from anything remotely akin to public dance performance. Those mores and manners persisted late into the century, especially among those who equated the outdoors with masculinity."[3]

Clog and Hornpipe

In the early 1700s, great numbers of Scotch Irish or Ulster Scots (descendants of British families planted by Protestant Britain in Roman Catholic Ireland to create a Protestant bastion) began to arrive in North America. Of the one-quarter to one-third of a million Irish that emigrated to North America between 1700 and the American Revolution, most were Ulster Presbyterians, and almost half eventually settled in the southern colonies. A minority of those arriving directly from Ireland aboard ships disembarked at southern ports, but the majority first landed in Philadelphia, moved west, and then south, often over several generations, down the Great Wagon Road into the backcountries of Maryland, Virginia, the Carolinas, and Georgia. The Scotch Irish influence on American percussive dance is evident in the vertical alignment of the jig dancer, whose arms are raised gracefully above the head—so lovingly depicted in William Sidney Mount's *Dance of the Haymakers,* in which the placement of the arms is similar to that of the Scottish Highland dancer (cat. 12).

fig. 3. William Sidney Mount, *The Breakdown, Bar-Room Scene,* 1835, oil on canvas. The Art Institute of Chicago, William Owen and Erna Sawyer Goodman Collection

Jump Jim Crow

By the 1800s, "Ethiopian delineators," many of them English and Irish actors, arrived in America, and by the end of the 1820s they had established the singing-dancing "Negro Boy" as a dance-hall character. These minstrel performers were copying the latest new song and dance, "Jim Crow," which achieved phenomenal success with the white actor and hornpipe dancer Thomas Dartmouth "Daddy" Rice.

Born in New York City in 1808 in the Seventh Ward (an Afro-Irish ghetto in downtown Manhattan), Rice's father was a ship's rigger who lived at 60 Catherine Street, near the docks and just blocks from Catherine Market, where the boy first saw black dancers. His interests in African American folklore, music, and gesture were furthered while touring the South as a young actor. There are a number of conflicting stories about how Rice first saw a black livery stable boy, who was crippled, do a little song and dance that the actor quickly copied and transformed into one

CONSTANCE VALIS HILL

Cat. 11. George Caleb Bingham, *The Jolly Flatboatmen*, 1846

Cat. 12. William Sidney Mount, *Dance of the Haymakers*, 1845

that consisted of limping, shuffling, and jigging movements, with a little jump at the end of each refrain. The lyric, set to an old English Morris dance tune, was as follows:

First on de heel,
Den on de toe,
Ebery time I wheel about
I jump Jim Crow.

The dance combined the hops of the Irish jig with a jump and a shuffle. The jump came from the custom of the jumping the broom, which took place when black slave couples were about to get married on the plantation; the shuffle was the plantation slave's creative substitute for dancing without crossing the legs, which was forbidden. After "Daddy" Rice, Irishmen George Churty and Dan Emmett organized the Virginia Minstrels, a troupe of blackface performers, thus consolidating Irish American and Afro-American song and dance styles on the minstrel stage.

By 1840, the minstrel show—a blackface act of songs, fast-talking repartee in Negro dialects, and shuffle-and-wing tap dancing—became the most popular form of entertainment on the American stage.

The iconic image of "Daddy" Rice dancing "Jump Jim Crow" was ubiquitous in American popular culture, as artists paired any style of jigging with Rice's dance. We see this in a lithograph produced in 1848 by James Brown, titled "Jack, A Negro and Dancer for Eels" or simply, "Dancing for Eels," which was used to advertise Frank Chan Frau's popular play, *New York As It Is* (fig. 4).

The lithograph, based on an earlier folk drawing titled "Dancing for Eels, 1820 Catherine Market," shows two black men dancing before a mixed-race crowd of onlookers. Located at the Catherine Street boardwalk by New York Harbor in a working-class area of New York City, Catherine Market was a crossroads and meeting place for African Americans, at a time when slavery was slowly being abolished across the northern states. New Jersey had enacted a law in 1804 freeing all African Americans born subsequent to passage, though as late as 1860, the state was still home to a number of slaves. New York, on the other hand, had abolished slavery entirely in 1827. Slaves from New Jersey were sent to Manhattan to sell their masters' produce; they were joined at Catherine Market by free blacks from the city. If they were unable to win money at gambling, the black men would literally dance for the eels, or fish, sold at Catherine Market.

fig. 4. James Brown, *Dancing for Eels: A Scene from the Play "New York As It Is," as Played at the Chatham Theatre, New York,* 1848, hand-colored lithograph. Library of Congress Prints and Photographs Division Washington, DC

Dancing for Eels shows three communities of slaves, freemen, and whites coming into contact and keeping alive a culture of movement and dance that would survive slavery, adaptation, and cooptation by minstrels in blackface during the Jim Crow era.

fig. 5. Anonymous, *William Henry Lane, Master Juba*, ca. 1850, wood engraving. Schomburg Center for Research in Black Culture/ Photograph and Prints Division

Juba

It is largely because of William Henry Lane (ca. 1825–52) that black jigging in the minstrel period was able to retain its African American integrity (fig. 5). Born a free man, Lane grew up in the Five Points district of lower Manhattan, near Catherine Market, its thoroughfares lined with brothels and saloons largely occupied by free blacks and indigent Irish immigrants. Learning to dance from an "Uncle" Jim Lowe, an African American jig-and-reel dancer of exceptional skill, Lane was unsurpassed in grace and technique. He was popular for imitating the steps of famous minstrel dancers of the day and then executing his own specialty steps that no one could copy. In 1844, after beating the reigning Irish American minstrel John Diamond (1823–57) in a series of challenge dances, Lane was hailed "King of All Dancers" and proclaimed "Master Juba." He was the first African American dancer to tour with the all-white minstrel troupe, Pell's Ethiopian Serenaders, and to perform without blackface makeup for the queen of England. Lane's grafting of African rhythms and a loose body styling onto the exacting techniques of jig and clog forged a new rhythmic blend of percussive dance that was considered the earliest form of American tap dance.

Orality and Aurality

Unlike ballet with its codification of technique, early American percussive dance forms developed from people listening to and watching each other dance in the street or in social spaces where steps were copied, shared, and reinvented. "Technique" is transmitted visually, aurally, and corporeally, in a rhythmic exchange between dancers and musicians. This oral tradition of learning music and dance is captured in Thomas Eakins's *Negro Boy Dancing (The Dancing Lesson)*, 1878 (fig. 6), which shows three generations of African Americans—a boy practicing his jig (cat. 13); a young man accompanying on banjo (cat. 14); and an elder man, his top hat and cane placed on a chair, intently watching his young protégé.

CONSTANCE VALIS HILL

fig. 6. Thomas Eakins, *Negro Boy Dancing (The Dancing Lesson),* 1878. Watercolor on off-white wove paper. The Metropolitan Museum of Art, Fletcher Fund, 1925

A small oval-framed photograph of President Abraham Lincoln and his son Tad hangs on the upper-left wall and points to the difference in learning modes between these two groups. President Lincoln is seated with a large book in his lap and young Tad, standing at his side, is reading along with his father, while the African American group is engaged in looking, listening, and responding to each other. *The Dancing Lesson* "depicted a traditional oral form of learning that evoked the 'plantation,'" writes Alan Braddock. "The painting thereby equivocated on the issue of black education…it did not decisively challenge entrenched perceptions of black intellectual development or racial competence."[4]

The oralities depicted in *The Dancing Lesson* may have been judged to be of a "lesser" form of education, a preliminary step in the evolutionary ladder leading up to Western European culture (deemed to be the pinnacle of civilization, at least to Western Europeans and their descendants), but all practitioners, white and black, of the jig, breakdown, hornpipe, clog, and reel engaged in these oral modes. The sociality of music- and dance-making, then, which allowed for racial inclusivity, moved Americans toward the cusp of a new concept of culture, one that was becoming increasing accepting and absorptive of cultural difference.

The Power of Music

The interracial exchanges that countered strict segregation on the eve and in the wake of the Civil War were surely advanced by the itinerant black musician and dancer who created a site for a somewhat fluid social exchange that eased racial fears and tensions. Eastman Johnson's *Fiddling His Way* of 1866 focuses on the visit of an itinerant black musician to a white family's farm and continues the theme of the music-making African American while avoiding the worst stereotypes of either character or physical appearance (fig. 7). Johnson paints this fire-lit scene in the farmhouse with homey intimacy, binding his ensemble together, compositionally and emotionally, through the skillful use of overlapping forms and interconnecting glances and gestures. He portrays the black fiddler sympathetically, encircled by members of the household who are in serene ease with their musical guest. The scene thus relaxes the interracial tensions of such a social situation while avoiding the unsettled status of African Americans at the close of the Civil War.

The inclusion of the black musician in an all-white social gathering is further rendered in William Sidney Mount's *Rustic Dance After a Sleigh Ride* (cat. 15). Mount packs several revelers

Cat. 13. Thomas Eakins, *Study for "Negro Boy Dancing": The Boy*, 1877

Cat. 14. Thomas Eakins, *Study for "Negro Boy Dancing": The Banjo Player*, 1877

Cat. 15. William Sidney Mount, *Rustic Dance After a Sleigh Ride,* 1830

fig. 7. Eastman Johnson, *Fiddling His Way,* 1866, oil on canvas. Chrysler Museum of Art, bequest of Walter P. Chrysler, Jr.

into a plain, candlelit interior festooned with garlands. In the center of the room are two couples stepping to the tune of an African American fiddler and banjo player, and surrounded by nearly two dozen onlookers. One couple is dressed in formal finery and in close embrace, while the other couple, dancing apart, is more expressive in their response to the music. Both couples enjoy the playing of the black fiddler, who was a slave belonging to the Hawkins and Mount families. Mount must have had affection for this musician, as the painting is based on his fond childhood memories of his life on Long Island and his love of music-making. Still, the racist image of the black fiddler—his grinning face, dark skin, and enlarged red lips—shows the influence on the artist of blackface minstrels "Daddy" Rice and Dan Emmett.

Christian Friedrich Mayr, in *Kitchen Ball at White Sulphur Springs, Virginia,* presents a view of social life among an African American serving class that bridges the interracial conventions of rural and urban and black and white entertainments (cat. 16). The German-born and trained artist arrived in the United States in 1831 at the age of twenty-eight and traveled in the South as an itinerant painter, sometimes staying at the resort of White Sulphur Springs in Virginia. There he witnessed a kitchen ball for slaves that inspired him to set his scene under the beams of an expansive candlelit kitchen where servants, most likely slaves who accompanied their masters to the resort, were gathered. Young and old, light and dark skinned, they make merry with music and dancing, perhaps to celebrate the wedding of the central dancing couple, dressed in white. The musicians (on fiddle, bass fiddle, and flute) and the couples dressed in finery are elegantly presented. Despite their status as servants, Mayr envisions a relatively comfortable lifestyle, one that emulates the social conventions of the whites they serve.

Eastman Johnson's *Negro Life at the South* eschews the subtlety of interracial exchange in the pre-Civil War era to depict the reality of miscegenation (cat. 17). Set in the backyard of the artist's father's house on F Street, between 13th and 14th Streets in Washington, D.C., the nation's capital, the painting depicts African Americans in an urban, outdoor space. A woman holding an infant looks out her back window into the yard, where a young man woos a shy woman attending to her stitchery; a mother seated on a blanket holds a young boy's hand and teaches him to dance; a young boy leaning against a wall holds the rope to his wagon; and two girls play. The scene is united by the central figure of a man, plaintively strumming his banjo. Intruding into this enclave is a young white woman—clearly an outsider—in a brocaded gown who enters the yard through a small wooden door. Her whiteness and social class contrast with and bring an awareness to the varying skin tones of the figures in the scene. The skin color variations, with nearly each individual shown as a different "person of color," reflects African American society, but may also have been intended to invite the viewer to contemplate the

Cat. 16. Christian Friedrich Mayr, *Kitchen Ball at White Sulpher Springs, Virginia*, 1838

Cat. 17. Eastman Johnson, *Negro Life at the South,* 1859

mixed racial ancestry of those portrayed.[5] The contradictory elements of *Negro Life at the South* have been interpreted by both proponents and detractors of slavery. Southerners associated it with plantation life, noting that the Negroes seemed cheerful in their leisure time, while Northerners concentrated on the top half of the painting with the dilapidated roof, representing the degradation of slavery, and the light-skinned woman and child suggesting a theme of miscegenation.[6] "Johnson's canvas demonstrates superbly the ability of genre painting to both depict and inspire a community, to address the tensions of contemporary life and, simultaneously, to paper over them," writes Bruce Robertson, adding that the truths about slave life in the nation's capital were too difficult for most viewers to witness.[7]

Conclusion

Surely, the "American home scenes" rendered in these works of art, produced on the eve and in the wake of the American Civil War, confirm the ubiquitous black presence in social gatherings necessitating musical entertainments. These socials became subversive sites for the interplay of black and white cultures, albeit through the protocol of the performance that maintained a safe distance between performer and spectator. While the black artist was drawn into the all-white scene, his participation constituted a socially coercive performance, his artistry deemed a commodity in which "payment" for services might solely be the privilege of performing before an all-white group.

The central figures in James Goodwyn Clonney's *Militia Training,* 1841, are two young black jig dancers who are performing during a Fourth of July celebration for an all-white throng of militia (cats. 10, 18–19). Accompanied by two fiddlers, one dancer claps hands while performing a heel-and-toe breakdown; the other, balancing on the ball of one foot with the raised leg bent at the knee, performs a jig. Based on a story by John Frost, the painting offered a comic representation of the muster of the village militia. Critics found fault with the subject's overall lack of decorum, especially with the drunken behavior of the white militia, but not with the African-American dancers who were rendered as graceful and skilled. When exhibited in 1841, the painting was praised for its "decided merit" by a reviewer in *The Knickerbocker,* but it was also criticized for having "something too much of the vulgar," as portrayed by the drunken white militia men. Clonney's depiction of the black dancers was praised by the same reviewer who observed, "The Negroes are painted with great truth."[8]

The presence of African Americans in Union camps during the Civil War was not unusual, as many had joined the ranks, some fighting on the battlefields and others assigned mostly menial tasks, such as cooking and mule driving. Winslow Homer's wood-engraved illustration "A Bivouac Fire on the Potomac," published in *Harper's Weekly* in 1861, presents an unusually lively evening campfire where soldiers gather to watch the performance of a black jig dancer accompanied by a fiddler (fig. 8). During the Civil War, Homer worked as an artist-

fig. 8. Winslow Homer, *A Bivouac Fire on the Potomac,* from *Harper's Weekly,* December 1861, wood engraving on paper. Smithsonian American Art Museum, The Ray Austrian Collection, gift of Beatrice L. Austrian Collection, Caryl A. Austrian and James A. Austrian

fig. 9. William Sidney Mount, *The Power of Music,* 1847, oil on canvas. The Cleveland Museum of Art, Leonard C. Hanna, Jr. Fund

reporter embedded within the Union army. He empathically captures the animated fire-lit faces of the men in this scene who are caught in a rare moment of respite from the war's grisly daytime reality.

Even when the singular image of the African American dancer is not dominant, the black figure is represented in the scenography of the work. Mount's *Dance of the Haymakers, or, Music is Contagious,* 1845, pays tribute to the power of music that is racially inclusive (cat. 12). Painted on a farm near present-day Stony Brook, Long Island, where the artist's ancestors had been farmers for five generations, the painting shows two men with shirts undone and arms raised overhead, in an open barn door, dancing a jig to a fiddler's tune. The soft afternoon light floods the barn, revealing two men, clapping and looking intently at the stepping, and a young boy looking up into the hayloft where two women—one white and one black—look on. Just outside the barn opening, a black youth taps out the rhythm directly onto the door with drumsticks and his foot. He may not be the central figure in this social scene, but he, too, released by the tune of the fiddler's music, inserts himself into the music-making, which is contagious. Mount's subjects, both black and white, are thus freed to respond physically to the music with an energy that defies the propriety of the relations between the races.

Mount suggests a more conventionally structured set of race relations in *The Power of Music,* 1847 (fig. 9), which shows two white men in a barn, in calm reflection as they listen to a young white man playing a touching, sentimental melody on his fiddle. The white men are ensconced in meditative reflection of the music, while it has also captured the attention of a passing black man who has put down his axe and jug to lean against the open barn door and listen. Mount's genre subjects of music and dance came from his personal experience as an amateur fiddler player. After successive evenings of music at the home of his good friend the artist Thomas Cole, Mount wrote, "My violin has been the source of a great deal of amuse-

DANCE: AMERICAN ART, 1830–1960

Cat. 18. James Goodwyn Clonney, *Militia Training*, 1841

Cat. 19. James Goodwyn Clonney, *Study for "Militia Training": Boy Singing and Dancing*, ca. 1839

ment."[9] More than an amusement, Mount posits the therapeutic power of music's harmonies. All the models in the painting were well known to, and held in esteem by, the artist. The young man playing the violin was Mount's nephew, Thomas Nelson Mount; the standing white man was his brother-in-law, Charles Seabury; the older white man seated in shadow at the back of the barn was an English-born laborer named Reuben Merrill who worked for Seabury; and the black man standing peacefully by the barn was Robin Mills, one of the few African American landowners in Stony Brook. Mills, a literate man who was respected in the community, was an elder of the local African Methodist Episcopal Zion Church. Mount thus conjures a scene of racial harmony that is made possible through the unifying experience of music.

When *The Power of Music* was exhibited in New York City in 1847, viewers who admired the work were unsure of how to place it. Did it depict a black man as lazy and easily seduced by the charms of music, or did it dignify him? "Mount deliberately renders the issue ambiguous," Bruce Robertson writes. "The black man is represented fully in the foreground and, while the standing white man may have some advantage of height, he and his seated companions are set farther back and are partly obscured. The meaning of the painting is provided by the black man and not the white three who, for once, are peripheral."[10]

As Mount wrote about his paintings: "I must paint such pictures that speak at once to the spectator, scenes that are most popular—that will be understood on the instant."[11] Indeed, the "American scenes" that Mount and artists of his generation inscribed with paint and pencil were instantly absorbed into the American conscience and contributed to the understanding of a modern American identity, confirming that one could not tell a story about American sociability without telling the story of black musicality.

Notes

1. Sean O'Callaghan, *To Hell or Barbados: The Ethnic Cleansing of Ireland* (County Kerry, Ireland, 2000).

2. Marshall Stearns and Jean Stearns, *Jazz Dance: The Story of American Vernacular Dance* (New York, 1968), 37.

3. Sharyn R. Udall, *Dance and American Art: A Long Embrace* (Madison, WI, 2012), 39.

4. Alan C. Braddock, *Thomas Eakins and the Cultures of Modernity* (Berkeley, 2009), 15–16.

5. John Davis, "Eastman Johnson's *Negro Life at the South* and Urban Slavery in Washington, D.C.," *Art Bulletin* 80 (March, 1998): 67–92.

6. Eleanor Jones Harvey, *The Civil War in American Art* (New Haven, 2012), 186–92.

7. Bruce Robertson, "Stories for the Public, 1830–1860," in *American Stories: Paintings of Everyday Life 1765–1915*, ed. H. Barbara Weinberg and Carrie Rebora Barrat (New York, 2009), 69–70.

8. Guy C. McElroy, *Facing History: The Black Image in American Art, 1710–1940* (Washington, DC, 1990), 39.

9. William Sidney Mount, "Letter to brother Melson from Catskill, October 1, 1843," quoted in Udall 2012, 33.

10. Robertson 2009, 68.

11. William Sidney Mount, "Diary, July 11, 1890," in Alfred Frankenstein, *William Sidney Mount* (New York, 1975), 241.

Dance and the Performance of Self in America: 1810 to 1850 | *Kenneth John Myers*

The love of the body of man or woman balks account, the

body itself balks account,

That of the male is perfect, and that of the female is perfect.

— WALT WHITMAN, *"I Sing the Body Electric"* [1]

One could make a strong case that William Sidney Mount's *Dance of the Haymakers* (1845; cat. 12), the same artist's *The Power of Music* (1847; The Cleveland Museum of Art), George Caleb Bingham's *The Jolly Flatboatmen* (1846; cat. 11), Richard Caton Woodville's *War News from Mexico* (1848; Crystal Bridges Museum of Art, Bentonville, AK), and Eastman Johnson's *Negro Life at the South* (1859; cat. 17) were, and still are, the best known and most iconic painted representations of everyday life produced in the United States before the Civil War. Three of these paintings include representations of dance, as do a surprisingly high percentage of all genre paintings by leading artists produced in the United States during the middle third of the nineteenth century.[2] Like most painted representations of dance from these years, *Dance of the Haymakers*, *The Jolly Flatboatmen*, and *Negro Life at the South* all feature nongenteel people dancing for their own amusement. The representation of dance in contemporary prints is very different. Although some mid-nineteenth-century prints of dance feature nongenteel people, the vast majority show either genteel social dance or commercial dance that people paid money to see. In this essay I use period prints to draw attention to the kinds of dance that influential artists like Mount, Bingham, and Johnson chose not to paint in order to clarify some of the social meanings embedded in the subjects they did paint. Comparison of painted with printed representations of dance suggests that in both subject matter and structure, mid-nineteenth-century genre paintings like *Dance of the Haymakers*, *The Jolly Flatboatmen*, and *Negro Life at the South* simultaneously expressed and contributed to the consolidation of an emergent middle-class way of being founded on the internalization of self-discipline and the control of a wide range of bodily desires and activities that earlier generations of Americans had either approved of or accepted as inevitable.

Cat. 11. George Caleb Bingham, *The Jolly Flatboatmen* (detail), 1846

Visual Content

The earliest visual representations of dance produced by professional artists in what is now the United States date from about 1810. The earliest I know of is *La Walse: Le Bon Genre* (The Waltz: The Good Kind), a satiric etching based on a French original, published as a sheet-music cover in New York in 1807.[3] The first original representation of dance by a professional American artist seems to have been *"Come, and trip it as you go; On the light fantastic toe,"* an unsigned engraving published as the frontispiece to Francis Nichols's dance manual *A Guide to Politeness* (1810; fig. 1). The earliest known drawing or painting by a professional artist to represent dance is John Lewis Krimmel's watercolor *Dance in a Wayside Inn* from about 1812 (fig. 2). Krimmel returned to the subject of dance in 1819–20, when he completed the oil painting *Country Frolic and Dance* (private collection) and a closely related watercolor (Library of Congress, Washington, DC).[4]

Krimmel died in 1821, just as the U.S. economy began a dramatic economic expansion that continued, with some pauses, for the rest of the century. In the period 1825–50, economic development was driven by numerous interconnected factors, including increasing European demand for cotton and other U.S. agricultural products; rapidly growing trade within the United States made possible by the development of reliable systems of steam-powered transportation and the construction of an extensive network of canals; a dramatic increase in the production of affordable manufactured goods made possible by the introduction of water-powered machinery and new ways of organizing labor; the enactment of laws permitting limited liability corporations, which encouraged the emergence of larger businesses; and the establishment of banks and other new financial institutions, which facilitated the expansion of both trade and production by reducing the cost of capital. One effect of this fundamental transformation of the national economy was the dramatic growth of cities, which expanded exponentially, attracting hundreds of thousands of new residents, most from rural parts of the United States, but many from abroad.[5]

fig. 1. Artist Unknown, *Come, and trip it as you go; On the light fantastic toe,* 1810, etching. Courtesy, American Antiquarian Society

fig. 2. Attributed to John Lewis Krimmel, *Dance in a Wayside Inn,* 1811–ca. 1813, watercolor and graphite on white laid paper. The Metropolitan Museum of Art, Rogers Fund, 1942

The expansion and transformation of the U.S. economy created new opportunities for the domestic production of many kinds of luxury goods, including paintings. But except for the previously mentioned paintings by Krimmel, William Sidney Mount's *Rustic Dance after a Sleigh Ride* of 1830 (cat. 15), and Thomas Bang Thorpe's *Ichabod Crane* of 1833 (Palmer Museum of Art, Pennsylvania State University), professional American artists produced few if any paintings of dance until the end of the 1830s, and the subject did not become prominent until the 1840s. Beginning in the mid-1820s, however, the improvement of the transportation system, the development of more efficient printing presses, and the introduction of lithography reduced the cost of making and distributing printed images, spurring production of thousands of comparatively inexpensive prints, including hundreds of images of dance. Images of dance were published as stand-alone images suitable for display, illustrations in books and magazines, and, most often, on sheet-music covers. Some images featured rustic, ethnic, or racial types, or (more often) professional performers who played those roles, but the vast majority of images of dance produced in the period 1825–50 featured well-dressed couples dancing in the privacy of their homes or at fancy balls, or genteel professional dancers like the Austrian ballerina Fanny Elssler, who toured the United States in the early 1840s (figs. 3–4).[6]

Dance can express many meanings, but in the context of the United States in the early national period, the most important meaning expressed by genteel social dance was probably self-control and self-discipline. The transformation of the U.S. economy changed the nature

fig. 3. Napoleon Sarony, *The Cally Polka Arranged by Allen Dodworth,* 1846, lithograph. Jerome Robbins Dance Division, The New York Public Library for the Performing Arts, Astor, Lenox and Tilden Foundations

fig. 4. E. Brown Jr., *Fanny Elssler in the Character of La Cachucha,* early 1840s, lithographed sheet music cover. Frances G. Spencer Collection of American Popular Sheet Music, Crouch Fine Arts Library and Baylor University Digital Collections, Baylor University, Waco, Texas

and structure of work for many Americans. The explosive expansion of production and trade required the rapid creation of many new kinds of jobs as employers discovered an urgent need for managers, salespeople, bookkeepers, scribes, teachers, and other kinds of work that later Americans learned to think of as "white collar" or middle class. At the same time, the shift from shop production to larger-scale manufactories meant that employers became more insistent upon the maintenance of regular hours and a consistent pace of production. In the 1820s and 1830s, the ability of management to enforce higher standards of workplace discipline was especially evident in industries like textiles and furniture, where manufacturers were able to divide complex tasks previously performed by highly trained and comparatively well-paid workers into a series of simpler tasks performed by less skilled workers who were paid substantially lower wages. By the end of the 1830s, social and economic changes that required greater workplace discipline for increasing numbers of both middling and poorer Americans had led to the emergence of urban police forces and numerous social reform movements that sought to encourage or impose more rigorous standards of self-discipline and self-restraint. Among the most influential of the reform movements was Temperance, which sought to discourage or prohibit the consumption of alcohol.[7]

Beginning in the mid-eighteenth and continuing through the end of the nineteenth century, instruction in dance was a primary means by which potentially respectable Americans were taught to think and act with the internalized self-discipline expected of well-to-do and wealthy people. Dancing masters like Francis Nichols not only taught dance, they also provided instruction in deportment and manners. The goal of this instruction was the production of genteel people who would use good judgment to control their actions and, more fundamentally, their feelings and desires:

> In a well ordered dancing school, the mere movements of the feet is not all that demand the attention of the master. The pupil is taught correct and easy address; proper attention to his superiors; good treatment to his equals; a becoming and manly civility to his inferiors, and not only the proprieties and graces of a ball room, or on public occasions, but a pleasing appearance to his nearest connections, and a becoming and highly important regard to his parents. In short, the teacher must endeavour to impress his young pupils with an idea of correct address and good breeding in general; that they may at the age of manhood be calculated in all situations to act with good judgment, and have a proper knowledge of men and things, and of whatever constitutes the gentleman and good citizen.[8]

The frontispiece to Nichols's book, *"Come, and trip it as you go,"* shows a violin-playing dancing master with four well-dressed young women. At the end of the book, Nichols included directions for thirty-five cotillions, a fashionable form of dance recently imported from France, in which four mixed pairs of dancers moved through a prescribed series of steps. All four dancers in the print are women, suggesting that the viewer was expected to interpret the image as showing a scene of instruction. Similarly, when *The Cally Polka* was first published, in the early

1840s, the polka was still a "new" dance, recently imported from central Europe, which the genteel people pictured on the cover would have learned in a formal or semi-formal setting. And the image and title of *Fanny Elssler in the Character of La Cachucha* emphasized the fact that Elssler was a trained professional who was performing a learned role. Like hundreds of other images of genteel social dance and genteel professional dancers that flooded the American marketplace in these years, all three of these images visually suggest that the dancers they represent had internalized the mental self-discipline that was a crucial key to success in an increasingly individualistic and competitive economy.

Apart from Krimmel's watercolors and painting, the most ambitious treatment of dance produced in the United States before 1830 was a portfolio of hand-colored etchings drawn by Edward William Clay and published by Richard H. Hobson in Philadelphia in 1828. Titled *Lessons in Dancing: Exemplified by Sketches from Real Life in the City of Philadelphia,* the portfolio consisted of a title page and eight prints, each of which represented a mixed pair of dancers (figs. 5–6). The portfolio was arranged hierarchically with each image using costume, pose, body type, and a descriptive title to identify the social standing of each pair of dancers, the type of dance they performed, and the location with which that dance was associated. The more socially prestigious the couple and the more genteel the place with which they were identified, the more refined the movement they were shown performing. The scale ranged from the stately movement of courtly dances and waltzes in *Fancy Ball* and *Bonnafon's Cotillion Parties* at the top, to the more exuberant motions of shuffles, jigs, and the African American percussive dance known as "patting juba" at the lower middle and bottom. Although the title of Clay's portfolio seemed to promise instruction in dance, *Lessons in Dancing* instead provided instruction in the use of dance as a marker of respectability and social class.[9]

Where most prints representing dance focused on social dance in genteel urban settings or respectable theatrical dance, almost all painted representations of dance

fig. 5. Edward William Clay, *Fancy Ball: Turn Partner,* 1828, hand-colored etching. Courtesy, American Antiquarian Society

fig. 6. Edward William Clay, *Taylor's Alley: Jig,* 1828, hand-colored etching. Courtesy, American Antiquarian Society

KENNETH JOHN MYERS

produced before the Civil War focused on social dance in rural settings and included an emphasis on nongenteel dance. From Krimmel's work in the 1810s until the end of the 1830s, almost all painted images of dance poked gentle fun at the exuberance of rural folk who tried but failed to control their movements and actions as the better sort of people were able to do. In addition to Krimmel's *Country Frolic and Dance* (1819), paintings that do this include Mount's *Rustic Dance After a Sleigh Ride* (1830), Thorpe's *Ichabod Crane* (1833), and Christian Mayr's *Kitchen Ball at White Sulphur Springs, Virginia* (1838; cat. 16). One of the few paintings from this period that represents a different kind of dance is James Goodwyn Clonney's *Militia Training* (1841; cat. 18), but it, too, turns on the juxtaposition of nongenteel with genteel rural dance. In the center foreground of the painting are two exuberant African American men who dance not for fun but for tips. Instead of contrasting them with genteel dancers, Clonney surrounds them with drunken revelers but counts on his viewers to supply the implied comparison to how respectable people ought to behave and move.[10]

In all these paintings, humor comes from the explicit or implicit juxtaposition of the graceful movements of genteel people who exhibit a high degree of self-control with the more vigorous, often jerky, motions of their social inferiors. Like Clay's *Lessons in Dancing,* each of these paintings uses exuberance to represent a lack of internalized self-control. In all, exuberance both expresses and symbolizes potentially disruptive energies that these images associate with the laboring classes, African Americans, and, most fundamentally, the human body. All presume that nature—both the natural world and human nature—is inherently corrupt or sinful. The body needs to be disciplined so that potentially disruptive feelings and desires are channeled toward socially and spiritually productive ends.

The attitude toward nature expressed by these prints and paintings was still culturally dominant in the United States in the 1830s but was being superceded by an emergent attitude that conceived of nature, including human nature, as pure or innocent. Historians of American literature date this shift to the middle third of the nineteenth century and identify it with the writings of William Cullen Bryant, Ralph Waldo Emerson, Henry David Thoreau, Emily Dickinson, and Walt Whitman. Historians of American art also date the shift to the middle third of the century, often associating it with the popularization of landscape painting. Paintings of dance evidence the same change. Like earlier paintings of dance, both *Dance of the Haymakers* (1845; cat. 12) and *The Jolly Flatboatmen* (1846; cat. 11) focus on the dance of nongenteel rural people, but instead of finding humor in the exuberant movement of rural folk, these paintings seem to celebrate it.

According to the dance historian Christopher J. Smith, the way the dancer in Bingham's painting holds his body suggests that he is performing an Anglo-Celtic fling, while the manner in which the dancers in Mount's painting hold theirs suggest either an Anglo-Celtic fling or a hornpipe. In contrast to the genteel social dance represented in *"Come, and trip it as you go"* or *The Cally Polka,* springy percussive dances like these allowed greater opportunities for improvisation and self-expression. This was especially true in the case of solo dances like the one repre-

sented in *The Jolly Flatboatmen*. Moreover, by the 1840s, flings and hornpipes were old, familiar dances, knowledge of which had been commonplace in the English-speaking world since the 1600s. Unlike "new" dances, cotillions and waltzes in the 1810s or polkas in the 1840s, knowledge of flings and hornpipes could be, and generally was, passed from one generation of dancers to the next informally, one member of a community teaching another, as the young African American woman in the right foreground of Eastman Johnson's *Negro Life at the South* (cat. 17) appears to be doing. And because knowledge of vernacular dance movements was generally transmitted informally, the content of that knowledge could and did come to seem intuitive. The erasure of the history of jigs, flings, and other kinds of vernacular dance meant that both genteel and nongenteel Americans drew a sharp distinction between genteel dances that were "learned" and vernacular dances that were presumed to be "natural."[11]

In one of the most famous and influential passages in English literature, William Wordsworth defined the source of poetry as "the spontaneous overflow of powerful feelings," which is a pretty good definition of what I think Mount and Bingham were trying to represent in *Dance of the Haymakers* and *The Jolly Flatboatmen*. Both paintings are set in rural America—Mount's in eastern Long Island, Bingham's on the Missouri River. All the adults in the paintings are hard-bodied working men who live by the sweat of their brow. Both illustrate an interlude of leisure in lives defined by physical labor. Both paintings suggest that although these men need to work, they dance because they can. They dance not to live but to express the joy of living, of having a body and being alive. Like Gene Kelly's character in *Singin' in the Rain,* they dance because they have been moved by a strong feeling they are unable to express in any other way: "Gotta dance. Gotta dance. Gott-taa daaance." Like Walt Whitman, the central figures in these paintings sing the body electric.[12]

Visual Form

In paintings that juxtapose genteel with nongenteel dance, both kinds of dancers share a common space and humor marks the presence of a narrative point of view that privileges gentility as normative. Paintings like *Dance of the Haymakers* and *The Jolly Flatboatmen* are less overtly condescending than earlier nineteenth-century paintings of dance because they erase the explicit juxtaposition of working-class exuberance with genteel decorum. But although they conceal all visible signs of that juxtaposition, it is still present in the point of view of the implied viewer who has distanced him- or herself from the exuberance of the dancers by sentimentalizing it. In the earlier visual structure, the implied genteel viewer of the painting had surrogates who shared a common space with their social inferiors. Although the new visual structure seems to have eliminated the genteel, it would be more accurate to say that it has displaced the laboring classes, whom it visually relegates to separate but unequal spaces far from the cities where middle class and wealthier Americans earned their living and occasionally enjoyed looking at or owning

sentimental representations of the kinds of rural places from which they or their ancestors had come and the kind of rural people their ancestors may have been.[13]

The innovative visual structure organizing the representation of rural dance in paintings like *Dance of the Haymakers* and *The Jolly Flatboatmen* emerged in the same years as a parallel shift in the relationship between professional performers and their audience. Indeed, changes in the content and form of commercial theatre in New York and other U.S. cities in the 1830s and 1840s almost certainly influenced the shift to the sentimentalized and aesthetically distanced kind of viewing implied by the visual structure of mid-century genre paintings.

Until the early 1820s, even the largest American cities were too small to support more than a few commercial theaters, and the economic reality that every theater needed to attract a socio-economically mixed audience shaped the selection of materials to be performed, the style of performance, and the layout of the auditorium. Following older European patterns, seating was divided into three sections: boxes, the pit, and the gallery. Well-to-do men and women generally sat in the boxes, which were the most expensive seats in the house and were often outfitted with chairs. The pit was equipped with benches and was populated by artisans and other members of the working classes, including some women, although it also attracted some respectable people, especially young single men. The cheapest seats were in the gallery, which drew the poorest and rowdiest patrons. Managers often reserved the top tier of boxes for prostitutes. In most theaters African Americans were denied entrance or restricted to the gallery. Because the audience was so mixed, so was the entertainment offered, generally combining a longer play with a variety of shorter offerings that typically included musical interludes or dances and a one-act burlesque or travesty. During this early period all theaters were rowdy places. As theater historian Bruce McConachie has put it, they were filled with "cigar smoke, bad language, and drunkenness.... The rowdiest part of the playhouse was the gallery. Sailors, apprentices, servants, and other 'gallery gods' shouted out tunes to the orchestra, demanded encores from the actors, and bombarded the pittites [people in the pit] with fruits and nuts."[14]

fig. 7. *American Theatre Bowery New York,* photograph of an unlocated print, ca. 1833. Collection of the New-York Historical Society

Economic expansion and urban growth led to increased attendance at the theater, which became one of the most popular forms of urban leisure. But as the market for commercial entertainment grew, it segmented, with more expensive theaters catering to the wants of the genteel while cheaper houses offered more exuberant entertainments for poorer patrons or respectable people in search of a rowdier good time (fig. 7). By the mid-1840s, popular theaters were featuring spectacular melodramas, blackface minstrel shows, and other entertainments that appealed to a largely male working-class audience, while the "better" theaters offered more

refined fare, including Shakespeare plays, Italian operas, ballets, and music by Handel, Haydn, and Beethoven. Unlike popular theaters, the more refined theaters depended on and encouraged attendance by genteel women who became an increasingly prominent part of the audience at "respectable" venues.[15]

While audiences in the popular theaters continued to act exuberantly, audiences in more genteel theaters became quieter and more passive. In elite theaters, the shift from active participation to primarily passive observation was accompanied by physical changes in the design of the stage and auditorium. Where earlier theaters had brought audiences and performers close together by extending the stage beyond the proscenium, newer elite theaters reduced the size of the stage apron and eliminated proscenium boxes or doors, or made them vestigial, largely confining the performers to the main stage behind the proscenium. At the same time, where older theaters had relied on drop scenery, so that performers appeared in front of the scenery, the introduction of moveable side flats meant that performers began to appear within the scenery. The development of better systems of gas lighting further separated the audience from the stage by enabling the management to dim the lights in the auditorium. The cumulative effect of these changes was to isolate the genteel audience from the performers, transforming the proscenium into a frame through which a pacified audience enjoyed a distanced and aestheticized performance—as Mount and Bingham expected their viewers to apprehend *Dance of the Haymakers* and *The Jolly Flatboatmen*.[16]

The kind of distanced and aestheticized viewing encouraged by the emergent "legitimate" theater and solicited by the new style of sentimentalized genre painting became culturally powerful because although it expressed the class interests of the genteel, genteel people did not experience it that way. As well-to-do people became practiced in this kind of viewing, they began to take it for granted and eventually came to accept it as an intuitive or natural way of being in the world. Like internalized self-discipline, it became normative within genteel culture. Of course, working-class people responded to the normalization of this kind of viewing differently, as is suggested by the comic lithograph *Lola has Come!,* which directly interrogates the class affiliations of distanced and aestheticized viewing (fig. 8).

The famously scandalous Irish dancer Eliza Oliver, better known as the Spanish dancer Lola Montez, arrived in New York in early December 1851. She arrived to great fanfare, much of it drummed up by the New York *Herald,* a copy of which is held by the comically wide-eyed gentleman in the box at the upper right of the lithograph. Montez gave her first American performance at

fig. 8. John L. Magee, *Lola Has Come! Enthusiastic Reception of Lola by an American Audience,* 1852. Courtesy, American Antiquarian Society

the genteel Broadway Theatre on the evening of December 29, 1851. For her premier, she danced the lead in a new ballet *Betly the Tyrolean,* choreographed for her by George Washington Smith, who had danced with Fanny Elssler when she toured America in the early 1840s. Montez had recently ended a long public affair with King Ludwig I of Bavaria. Because of her notoriety, genteel women stayed away from her opening night, but the house was packed with more than three thousand generally well-to-do men. Although some newspaper critics complained about the quality of Montez's dancing, the performance was a success and Montez's initial contract for a one-week run was extended to three. The effeminate figure at the left probably represents her manager, Edward Payson Willis. In his pocket, he carries a sheet noting that Montez is to be paid "half the house." In the center middle ground, the sole person in the pit is a plainly dressed Quaker gentleman who carries a book titled *Sober Thoughts*. He forks his fingers in front of his face in shame but, like the man in the box, cannot take his eyes off the scantily dressed dancer.[17]

Although Montez drew packed houses, *Lola Has Come!* represents the theater as empty except for the man behind the *Herald* and the Quaker in the pit. This is implausible as a representation of an actual performance but is a visually compelling representation of the kind of distanced, aestheticized viewing promoted by a host of mid-century genteel activities, including the "legitimate" theater and sentimental genre painting. In the print, the physical isolation of the man behind the *Herald* and the Quaker in the pit marks the presence of a psychic distance that was supposed to enable genteel people to appreciate performances like Lola Montez's as art rather than being aroused by them as sexually provocative displays. But the artist who drew *Lola Has Come!* isn't buying it. He rejects both the genteel project of desexualizing the body by aestheticizing it and bourgeois claims for the disinterestedness of the kind of distanced viewing encouraged by highbrow culture. From his working-class perspective, genteel people like those represented by the man behind the *Herald* and the Quaker in the pit are hypocrites who hide behind the claims of propriety and culture but lust in their hearts.[18]

Genteel people insisted upon the necessity of internalized self-discipline and decried the excesses of a rowdy working class. But they could, and needed to, find sexualized if sublimated satisfactions somewhere. *Lola Has Come!* represents the partial escape of repressed erotic desire. As such, it helps us to visualize something of the social and psychological complexity of the putatively impersonal and disinterested viewing of exuberant working-class male bodies solicited by *Dance of the Haymakers* and *The Jolly Flatboatmen*.

Notes

1. *Walt Whitman: The Complete Poetry and Collected Prose,* ed. Justin Kaplan (New York, 1982), 251. I want to thank Garrett Swanson, an intern in the Department of American Art at the Detroit Institute of Arts, who helped me locate and research many of the images I discuss in this essay.

2. On the history of genre painting in the United States up to the Civil War, see Hermann Warner Williams, Jr., *Mirror to the American Past* (Greenwich, CT, 1973); Patricia Hills, *The Painters' America: Rural and Urban Life, 1810–1910* (New York, 1974); Elizabeth Johns, *American Genre Painting: The Politics of Everyday Life* (New Haven, 1991); and *American Stories: Paintings of Everyday Life, 1765–1915,* ed. H. Barbara Weinberg and Carrie Rebora Barratt [exh. cat., Metropolitan Museum of Art] (New Haven, 2009).

3. The image was engraved by William Charles and published in New York by John & M. Paff. Unlike the example at the American Antiquarian Society, the example at the Winterthur Museum, Garden and Library (1971.0280) is complete with accompanying sheet music. The ultimate source for the image was a print that showed two dancing couples. Titled *La Walse,* it was originally published in Paris in 1801 in a collection of satiric images titled *Le Bon Genre,* but William Charles's immediate source seems to have been a later version, titled *La Walse: Le Bon Genre,* drawn by the English caricaturist James Gillray. When these prints were drawn, the waltz was still a new dance, recently imported from central Europe. Many genteel people considered it scandalous, both because it was a partner dance, rather than a group dance, and because it required that the gentleman grasp his partner around her waist. I want to thank Georgia B. Barnhill of the American Antiquarian Society for drawing my attention to this rare print.

4. Milo M. Naeve, *John Lewis Krimmel: An Artist in Federal America* (Newark, DE, 1987), 79–80, 103, 122, and Anneliese Harding, *John Lewis Krimmel: Genre Artist of the Early Republic* (Winterthur, DE, 1994), 47–49, 156–61, 177–79, 199, 223.

5. Of the many relevant sources, see especially Daniel Walker Howe, *What Hath God Wrought: The Transformation of America, 1815–1848* (Oxford, 2007); Sean Wilentz, *The Rise of American Democracy: Jefferson to Lincoln* (New York, 2005); Douglass North, *The Economic Growth of the United States: 1790–1860* (Englewood Cliffs, NJ, 1966); and George R. Taylor *The Transportation Revolution, 1815–1860* (New York, 1951).

6. The earliest prints produced in the United States date from the mid-1600s. But the number of subjects drawn, the physical size of the images, and the size of editions all remained small until the introduction of commercial lithography in the 1820s. For the early history of lithography in the United States, see *Philadelphia on Stone: Commercial Lithography in Philadelphia, 1828–1878,* ed. Erika Piola (University Park, PA, 2012); Sally Pierce and Catharina Slautterback, *Boston Lithography, 1825–1880: The Boston Athenaeum Collection* (Boston, 1991); *Prints and Printmakers of New York State 1825–1940,* ed. David Tatham (Syracuse, 1986); and Peter C. Marzio, *The Democratic Art: Pictures for a 19th-Century America: Chromolithography, 1840–1900* (Boston, 1979). On sheet-music covers in particular, see Nancy R. Davison, "The Grand Triumphal Quick-Step; or, Sheet Music Covers in America," in *Prints in and of America to 1850,* ed. John D. Morse (Winterthur, DE, 1970), 256–89.

7. The first scholar to raise these issues in an influential way was the British historian E. P. Thompson in his classic essay "Time, Work-Discipline, and Industrial Capitalism," *Past & Present* 38 (December 1967), 56–97. The transformation of the American economy hastened the decay of a colonial social structure built on the distinction of those who were genteel from those who were not. In the United States, the modern three-tiered structure (upper, middle, lower) emerged after 1820, and included a middling social group that eventually, in the second half of the nineteenth century, came to think of itself as middle class, and a numerically larger group that during the middle decades of the nineteenth century came to think of itself as working class. The emergence and consolidation of this new class structure in the United States in the nineteenth century has been the subject of intensive scholarly investigation since the 1980s. For two seminal studies see, Sean Wilentz, *Chants Democratic: New York City & the Rise of the*

American Working Class, 1788–1850 (New York, 1984); and Stuart M. Blumin, *The Emergence of the Middle Class: Social Experience in the American City, 1760–1900* (New York, 1989). For a dated but classic overview, see Herbert F. Gutman, "Work, Culture, and Society in Industrializing America, 1815–1919," *American Historical Review* 78 (1973), 531–88. On Temperance, see W. J. Rorabaugh, *The Alcoholic Republic: An American Tradition* (Oxford, 1979).

8. From Francis D. Nichols, *A Guide to Politeness* (Boston, 1810), 24, but see also 7–8. On American dancing masters, including some discussion of Nichols, see Joseph E. Marks III, *America Learns to Dance: A Historical Study of Dance Education in America before 1900* (New York, 1957), 13–65, and Ann Wagner, *Adversaries of Dance: From the Puritans to the Present* (Urbana and Chicago, 1997), 82–90, 108–10, 124–27, and 218–20. For Fanny Elssler's American tour, see Ivor Guest, *Fanny Elssler* (London, 1970), 104–85. Of the extensive scholarship on manners in eighteenth- and nineteenth-century America, see especially Karen Halttunen, *Confidence Men and Painted Women: A Study of Middle-Class Culture in America, 1830–1870* (New Haven, 1982); John F. Kasson, *Rudeness and Civility: Manners in Nineteenth-Century Urban America* (New York, 1990); Richard L. Bushman, *The Refinement of America: Persons, Houses, Cities* (New York, 1992); and C. Dallett Hemphill, *Bowing to Necessities: A History of Manners in America, 1620–1860* (Oxford, 1999).

9. *Lessons in Dancing* (Philadelphia, 1828). So far as I know, the only scholarly discussion of *Lessons in Dancing* is Nancy Reynolds Davison, "E. W. Clay: American Political Caricaturist of the Jacksonian Era," Ph.D. diss., University of Michigan, 1980, 60–62, 351. Davison reports that she located copies of this rare publication at the Rosenbach Foundation and the Historical Society of Pennsylvania (this copy lacks its title page). I worked from a scan of a complete copy that the American Antiquarian Society acquired in 2012. Five of the prints in the American Antiquarian Society copy are inscribed in pencil with names identifying the dancers. *Fancy Ball* is inscribed "Arthur Middleton" (one of the wealthiest men in America) and "Miss Marcoe" (?). *Bonaffon's Cotillion Parties* is inscribed "Spanish Minister Tacon's Son & Daughter" (Don Francisco Tacon was Spanish Ambassador to the United States). *City Assembly* is inscribed "Tom Willing" (?) and "Miss Roberts." *Chestnut Street Theatre* is inscribed "Monsieur & Madame Hutin" (French dancers who performed at the Chestnut Street Theatre in Philadelphia in 1827). As befits their place in both the series and Philadelphia society, the plainly dressed dancers in *Union Hall, Jersey* are described not by name but by type, as "Friends, or Quakers." None of the dancers in the remaining prints is named or described. According to Davison (p. 22), after spending several years in Europe, Clay returned to Philadelphia in early 1828. The last of the eight prints, *African Fancy Ball,* seems to reference a social event held at "Mr. August's Rooms, in Fourth Street near Chesnut," (sic) on February 28, 1828. For an extended account of this apparently unusual event, see Undae [pseud.], "The African Fancy Ball," *Philadelphia Monthly Magazine* 2 (April 15, 1828), 53–57.

10. The visual organization of the earliest of these images (especially the ones by Krimmel, Mount, Thorp, and Mahr) echo, probably intentionally, the visual organization of the second plate in William Hogarth's influential book *The Analysis of Beauty* (London, 1753). Like the American painters, Hogarth satirically juxtaposed the studied elegance of a genteel pair of dancers with the boorish exuberance of their social inferiors.

11. Christopher J. Smith, *The Creolization of American Culture: William Sidney Mount and the Roots of Blackface Minstrelsy* (Urbana, Chicago, and Springfield, 2013), 58 and 193. For Bingham, see also John Francis McDermott, *George Caleb Bingham: River Portraitist* (Norman, OK, 1959), and Nancy Rash, "George Caleb Bingham's *Lighter Relieving a Steamboat Aground,*" *Smithsonian Studies in American Art* 2 (Spring 1988), 16–31. For Mount, see also Frederick C. Moffatt, "Barnburning and Hunkerism: William Sidney Mount's *Power of Music,*" *Winterthur Portfolio* 29 (Spring 1994), 19–42; and Bruce Robertson, "*The Power of Music*: A Painting by William Sidney Mount," *Bulletin of the Cleveland Museum of Art* 79 (1992), 38–62. For *Negro Life at the South,* see John Davis, "Eastman Johnson's *Negro Life at the South* and Urban Slavery in Washington, D.C.," *The Art Bulletin* 80 (March 1998), 67–92. On the class associations of jigs, hornpipes, and reels, see Kate Van Winkle Keller, *"If the Company can do it!": Technique in Eighteenth-Century American Social Dance* (Sandy Hook, CT, 1991), 8–15. For

the process by which learned ideas and patterns of feeling come to seem intuitive and natural, see the classic discussion in Raymond Williams, *Marxism and Literature* (Oxford, 1977).

12. The quotation from William Wordsworth is from the "Preface" to the second edition of *Lyrical Ballads* (1801), reprinted in *Wordsworth: Poetical Works,* ed. Ernest de Selincourt (Oxford, 1969), 740.

13. For sentimentalism as a key component of the genteel way of being in the world, see Thomas Haskell's influential essay "Capitalism and the Origins of the Humanitarian Sensibility," *American Historical Review* 90 (April and June 1985), 339–61, 547–66. For the early history of sentimentalism in the United States, see Bruce A. McConachie, *Melodramatic Formations: American Theatre and Society, 1820–1870* (Iowa City, 1992); Cathy N. Davidson, *Revolution and the Word: The Rise of the Novel in America* (New York, 1986); and Ann Douglas, *The Feminization of American Culture* (New York, 1977). See also Asher B. Durand's painting *The Morning Ride* (1851; Manoogian Collection), which combines the two visual structures I am discussing. As in the earlier formation, it juxtaposes the dignity of the genteel figures on horseback in the left foreground with the exuberance of the nongenteel dancers at the right. But instead of satirizing the exuberance of the nongenteel figures, *The Morning Ride* sentimentalizes it, treating exuberance as a sign for the authenticity of a way of being in the world that is too remote (in space or time) to be threatening.

14. Bruce McConachie, "American Theatre in Context, from the Beginnings to 1870," in *The Cambridge History of American Theater,* Vol. 1, *Beginnings to 1870,* ed. Don B. Wilmeth and Christopher Bigsby (Cambridge, 1998), 132.

15. For the differentiation of respectable and non-respectable theatrical culture in the period 1825–50, see Dale Cockrell, *Demons of Disorder: Early Blackface Minstrels and Their World* (Cambridge, 1997); Eric Lott, *Love and Theft: Blackface Minstrelsy and the American Working Class* (Oxford, 1993); Vera Brodsky Lawrence, *Strong on Music: The New York Music Scene in the Days of George Templeton Strong,* 3 vols. (Chicago, 1988–99); and Lawrence W. Levine, *Highbrow / Lowbrow: The Emergence of Cultural Hierarchy in America* (Cambridge, MA, 1988). For the timing of this shift, see especially McConachie 1998, 155–64, and Peter G. Buckley, "Paratheatricals and Popular Stage Entertainment," in *Cambridge History of American Theatre,* 456–57.

16. For changes in the physical structure of genteel theaters, see Mary C. Henderson, "Scenography, Stagecraft, and Architecture in the American Theatre, Beginnings to 1870," in *Cambridge History of American Theatre,* 414–15. Henderson's essay summarizes evidence first developed in Mary C. Henderson, *The City and the Theatre: New York Playhouses from Bowling Green to Times Square* (Clifton, NJ, 1973).

17. For Montez's first performances in New York, and for her relationship with the New York *Herald* and with Willis, see Bruce Seymour, *Lola Montez: A Life* (New Haven, 1996), 276–86. For the Broadway Theatre, which opened in the fall of 1847, see William C. Young, *Documents of American Theater History,* Vol.1, *Famous American Playhouses, 1716–1899* (Chicago, 1973), 109–10; and *American Theatre Companies, 1749–1887,* ed. Weldon B. Durham (Westport, CT, 1986), 121–23. *Lola Has Come!* was published in *The Old Soldier,* a short-lived satiric monthly published in New York from January 1852 until the following June. Each issue of *The Old Soldier* consisted of four to eight lithographed cartoons on political and social themes. The satire was generally aimed at Whig politicians and the pretensions of the well-to-do. *The Old Soldier* published six cartoons featuring Lola Montez, two in January, one in February, one in April, and two in May, all probably drawn and printed by John L. Magee. Born in New York around 1820, Magee worked as a lithographer in New York from the 1840s until sometime in 1852. For Magee, see Erika Piola, "Drawn on the Spot: Philadelphia Sensational News-Event Lithographs," in *Philadelphia on Stone,* 185–86; and the biographical entry in the online database *Philadelphia on Stone* maintained by the Library Company of Philadelphia.

18. For the concept of aesthetic distance, the classic studies are Edward Bullough, "'Psychical Distance' as a Factor in Art and as an Aesthetic Principle," *British Journal of Psychology* 5 (1912), 87–117; and Jerome Stolnitz, "On the Origins of 'Aesthetic Disinterestedness,'" *Journal of Aesthetics and Art Criticism* 20 (winter 1961), 131–43. For an overview of the history of the concept, see David E. W. Fenner, *The Aesthetic Attitude* (Atlantic Highlands, NJ, 1996).

RECORD OF PAROLED PERSONS,

DATE PAROLED	NAME OF PRISONER	CONDITIONS OF PAROLE	AMOUNT OF BOND	SURETIES FOR BOND	Where Prisoner Employed	RECOR Date

Caddo Women
Ghost Dance

The Art of Native American Dance
Jacqueline Shea Murphy

What is the art of Native American dance? Dancing has always been a central part of Native social and ceremonial life. Yet who has engaged with Native dance *in* art? In what medium? For whom? And why? What gets included in a discussion of Native American dance in American art—and what does not—directs any discussion of it, including in this essay.

 Native artists have been depicting Native American dance, for Native viewers, to recount Native history, perspectives, and understandings, since well before 1820. One commentator describes pictographs showing figures "clasping hands in a dance or ritual" at a site in what is now Texas, which was used as early as 1300 CE (fig. 1).[1] Another includes a depiction of Apache dancers at Hueco Tanks, in western Texas, noting that Mescalero Apaches moved into the area in the 1700s.[2] Scholars discuss petroglyphs of Native dance in California that span centuries.[3] In writing about pre-contact practices via nineteenth-century Plains pictographic work, literary scholar Hertha Dawn Wong notes that male Native Americans painted on tipis, shields, cloth, or skins as forms of autobiographical narrative, often as records of heroic actions, warrior feats, or visions.[4] These examples suggest that depicting and recording dance, in diverse media and forms, has long been integral to Indigenous cultural practices.

fig. 1. Forrest Kirkland, *Kirkland-Plate 1,* watercolor. Courtesy of Texas Beyond History.net, Texas Archeological Research Laboratory, The University of Texas-Austin

fig. 14. Dolores Purdy Corcoran, *Caddo Women Taking Repatriation of Ghost Dance Pole Into Their Own Hands* (detail), 2007, color pencils and india ink on antique paper. Kansas Historical Society

Cat. 20. George Catlin, *Bull Dance, Mandan O-kee-pa Ceremony*, 1832

By the 1830s, Native art was increasingly produced not only by and for Native peoples and their communities, but also in relation to cross-cultural exchange with non-Native political leaders and artists. Barbara A. Hail, curator at Brown University's Haffenreffer Museum of Anthropology, describes how, in the 1830s, the German prince Maximilian and the Swiss artist traveling with him shared drawing styles and materials with Native artists, as did, later, the American artist George Catlin. She also notes how Maximilian published pictographic artwork by Mandan chief Mato-Tape so that the personal story it depicts became "cross-cultural property."[5]

The relations, and perhaps tensions, that emerged from these exchanges and understandings can be seen in Catlin's 1832 work *Bull Dance, Mandan O-kee-pa Ceremony* (cat. 20), which depicts part of a four-day event with and for Mandan participants who encircle and witness the ceremony. The perspective of the artist and viewer is from a distance, as if looking down from a nearby hill. From the position of the outsider, the figures appear grotesque and frenzied, and the image is rendered with a quasi-ethnographic attention to detail. Early descriptions of the painting were steeped in the language of Western religion: "The disrupting figure at left is the evil spirit, soon to be neutralized by a magic medicine pipe," writes American novelist and anthropologist Oliver LaFarge, using terms that both situate the ceremony in a Christian context ("evil spirit") and suggest distance from it and its "magic."[6] Catlin's description of the participants as "actors" who "imitate the actions of the buffalo, whilst they were looking out of its eyes as through a mask," is given from the Western perspective of theater rather than from an understanding of ceremonial transformation—one in which participants become the buffalo, rather than acting as and imitating one.[7] Nevertheless, Catlin depicts the dancers as purposefully involved in a specific ceremony, signals his interest in its importance, and shows his proximity to it. The painting, one of the earliest of the subject seen by non-Native viewers, brought awareness of Native culture to a widespread non-Native public and helped create a record of the ceremony for future generations.

The perspective of non-Native viewers looking from the periphery at Native American dancing informed U.S. policy on Native dance for more than a century following Catlin's depiction. In the United States, a directive listing dance as a federal "Indian Offense," punishable by fines and imprisonment, was on the books from the early 1880s until 1934. Aspects of the restrictions, including the ban on "torture" as part of the Sun Dance, continued as de facto restrictions until around 1952. The earlier restrictions focused on the military threat the dancing was perceived to pose, as in so-called War and Ghost dances. These and other Native American dance practices were seen as a threat of one sort or another to American political stability, and to the Protestant moral and work ethics upholding it. The outsider perspectives both reflected a limited understanding of what the dancing was about, even as it also showed an awareness of its potency.

These anti-dance regulations curtailed many practices by and for Native people, yet many Native Americans also refused or circumvented the attempts to ban and restrict dancing. The anti-dance regulations also contributed, paradoxically, to an increase in Native dance seen by non-Native audiences. In 1883, when "war, scalp, sun, &c" dances were officially outlawed,

fig. 2. Sioux, Native American, *Sun Dance*, ca. 1890, pen and ink, graphite pencil, and color pencil on wove paper. Detroit Institute of Arts, Founders Society Purchase, 81.233.16

fig. 3. Walter Bone Shirt, *Plate 08 Omaha Dancer*, pen, pencil, and colored pencil. Mandeville Special Collections, UCSD Libraries, UC San Diego

Colonel William Cody, an enthusiastic proponent of American expansionism, an Indian scout for the U.S. Cavalry, and an Indian killer who participated in more than a dozen campaigns, began promoting Native performance as spectacle for non-Native audiences. For his Buffalo Bill's Wild West show, which toured the United States and Europe through 1917, Cody hired hundreds of Plains people to stage various "Winning of the West" scenarios. A number of paradoxes lie at the core of these staged presentations. Although "Indian war dances" were a staple of the show, just five weeks before Cody began touring his Wild West prototype, the commissioner of Indian Affairs had outlawed Indian war dances. Fears of so-called Ghost dancing, however, actually garnered Cody additional performers: at the commissioner's suggestion, Cody hired men who had been imprisoned for Ghost dancing for his spectacle. This tension between Native dance within and for the Native community, which outsiders feared as dangerous, and Native dance performed as spectacle for non-Native viewers, which outsiders saw as colorful and theatrical, informs art work of the era, as well as art work since then.

The restrictions on Native ceremonial dance were a central part of larger nineteenth-century federal policies that attempted to police Native bodies and erase Native culture, part of the drive to "win the west" and take Native land and resources. Ralph Albert Blakelock's *The Vision of Life / The Ghost Dance* (1895–97; cat. 21) depicts the dancers as shadowy figures who are almost imperceptible in the landscape. The tonalist style of the painting emphasizes shades of green and yellow, with the dancers in shades of a lighter yellow that is also the color of the earth. Thus, the painting fuels understandings that connect Native peoples and Native dance with a romance of nature, ghostliness—and inevitable (if tragic) disappearance.

Some Native art work, including depictions of Native dance, also emerged in relation to colonizing drives and the policing of Native bodies that accompanied them, and the presentation of Native dance as spectacle. Several years before Native Ghost Dance leaders were freed from prison to perform in the Buffalo Bill show, seventy-two Southern Plains warriors were incarcerated at Fort Marion in Florida, and while there, given paper and drawing materials. The resulting "ledger art"—so called because the works were sometimes drawn in cast-off account books—is viewed as a continuation of Plains Indian pictorial art, which moved from animal hides to paper, muslin, and canvas following mid-nineteenth-century destruction of the buffalo herds and other game animals of the Great Plains.[8] A number of these

Cat. 21. Ralph Albert Blakelock, *The Vision of Life / The Ghost Dance*, 1895–97

fig. 4. Milton Oleaga, *Primitive Mysteries, No. 2/ Martha Graham*, n.d., photograph. Library of Congress Prints and Photographs Division Washington, DC

fig. 5. Robertson, *Ted Shawn's Invocation to the Thunderbird*, 1931, photograph. Courtesy of Jacob's Pillow Dance Festival Archives, Beckett, MA, 001.00.00

ledger drawings, generally dated from 1860 to 1890, illustrate dance, including depictions of Buffalo dances, Sun dances (fig. 2), and Medicine dances.[9] An awareness of spectators infuses several, including one image by Lakota artist Walter Bone Shirt that shows an "Omaha dancer" (performing what U.S. officials and Buffalo Bill labeled a "war dance") bent forward, with feathers in his hair roach and around his ankles, standing on a green mound before what looks to be an arena, with colored squiggles to indicate a festive crowd (fig. 3). This art was created in the context of tourists and show-goers,[10] and at times commented on these viewing relationships.

Before the late 1900s, representations of much Native American art, including those of dancing bodies, would have been produced by men.[11] Wong differentiates between pictographic records of individual men's achievements (such as those depicted on animal hides and ledgers) and the symbolic geometric designs that women used in porcupine quill or bead work. The beading or quill work on dance regalia is related to dance, yet ingrained and gendered attitudes about what constitutes "art," as opposed to craft, as well as the idea that the presentation of dance is more important that the preparation for it, put the focus on pictorial art and the male artist.

In the early twentieth century, however, women artists, both Native and non-Native, enter the scene in the Southwest. Martha Graham, for example, traveled to the region in the 1930s and created such dances as *Primitive Mysteries* (1931; fig. 4), *Ceremonials* (1932), and *El Penitente* (1940), which were inspired by those of the Southwest Indians that she had seen. Georgia O'Keeffe, who

DANCE: AMERICAN ART, 1830–1960

Cat. 22. Joseph Henry Sharp, *The Harvest Dance,* 1893–94

fig. 6. Quah Ah (Tonita Peña), *Corn Dancer,* 20th century, watercolor. Detroit Institute of Arts Gift of Miss Amelia Elizabeth White, 37.229

fig. 7. Quah Ah (Tonita Peña), *Buffalo Dancers,* 20th century, watercolor. Detroit Institute of Arts, Gift of Miss Amelia Elizabeth White, 37.211

began traveling to Santa Fe in 1929, and Cochiti Pueblo painter Quah Ah (Tonita Peña) both painted dance-related works. Graham and O'Keeffe were part of a movement that had started in the 1920s, in which non-Native artists flocked to a newly invented American "Southwest," entranced by Indian arts and culture made increasingly accessible after the opening of the Santa Fe railway in 1863. Along with these artists came hordes of tourists, likewise drawn by the proximity and accessibility of Indians, Indian arts, and Native American culture. These tourists and artists invoked pervasive rhetoric of a disappearing Southwest Indian culture that fueled the need to know about Indian dances before they were lost to the world. They included visual artists such as Joseph Henry Sharp, who painted *Harvest Dance* from his first trip to Taos in 1883 (cat. 22); in 1912 he founded the Taos artists colony, and in 1915, along with E. Irving Couse and four others, he also founded the Taos Society of Artists. Writers, including Mary Austin and D. H. Lawrence, and other dance artists, such as Ted Shawn, were also active in the area. Shawn traveled in the region and staged himself and later his "Men Dancers" in pieces such as *Invocation to the Thunderbird* (1917; fig. 5); *The Feather of the Dawn* (1923); *Hopi Indian Eagle Dance* (1923); *Zuni Ghost Dance* (1931); *Osage-Pawnee Dance of Greeting* (1931); *Ponca Indian Dance* (1923); and others.

While non-Native artists and tourists flocked to Southwest Indian dances in pursuit of their own enrichment, federal officials focused on the harm they believed the dances caused Native peoples. In 1909, participation in ceremonials considered "offensive" to Christian standards was illegal.[12] In restrictions newly reissued in the 1920s, government officials stressed the waste of time, energy, and resources of, and the immorality enabled by, the dances. The Hopi Snake Dance was singled out as being "filthy," "weird," "hideous," and "barbaric." Officials were attentive, if not sympathetic, to the artistic and touristic interest in Southwest Indian art—and the rich and influential artists and writers supporting it. They were careful to provide clauses in law that recognized the value of Indian dance as "art," which they saw as elevating and refined,

as well as the health benefits of exercise that dance provided. Yet even that rhetoric presumed Protestant values about health, worth, and productivity.

Quah Ah (Tonita Peña; figs. 6–7), like Oqwa Pi (Abel Sanchez; fig. 8) and Awa Tsireh (Alfonso Roybal; fig. 9), was part of the San Ildefonso Self-Taught Group.[13] She was the only woman member, and through her painting, she challenged the gendered expectations of her community. Her finely detailed paintings depict Cochiti and San Ildefonso dances at a time when Pueblo ceremonials were under siege, and when the Indian Bureau forbade the teaching or practice of American Indian arts in its schools. Scholars suggest there has been debate about her work within her community—perhaps because she divulged details or because she showed an authority about dance practices that a woman was not supposed to have[14]—and within the art world, her work has been dismissed, as it was produced for white patrons and therefore was seen to be tainted by commodification. Others, though, argue for the importance of her work both politically and artistically. "Peña articulated, through her paintings, an overt public reaffirmation of Pueblo practices," writes scholar Marilee Jantzer-White, noting the political import of depicting these dances in a positive light at a time when officials were trying to eradicate Pueblo ceremony. "Each of these ceremonial dances constituted an essential aspect of the ongoing traditions that produced balance and assured success for the Pueblo," Jantzer-White writes. She notes further how the flatness and lack of perspective in the paintings reinforce Pueblo understanding of balance and reciprocity, in contrast to Renaissance ideals that create a single, correct perspective. "Peña seeks neither to dominate the social or natural world which she paints, nor to privilege her perspective on that world."

The figures in Quah Ah (Tonita Peña)'s paintings can be seen as commenting on the dance-viewing economies in which they were created, as well. The dancers do not engage with the viewer but rather are focused on their dancing and on one another. They suggest a continuity of dance practiced in awareness of, yet with some disregard for, the role and place of the audience, even while the context of non-Native viewers is intrinsic to them (the paintings were, largely,

fig. 8. Oqwa Pi (Abel Sanchez), *Eagle Dancer and Drummer,* 20th century, watercolor. Detroit Institute of Arts, Gift of Lillian Henkel Haass and Constance Haass McMath, 58.325

fig. 9. Awa Tsireh (Alfonso Roybal), *Corn Dance #2,* 20th century, watercolor. Detroit Institute of Arts, Gift of Miss Amelia Elizabeth White, 37.202

made to be sold).[15] The paintings thus capture some of the ambivalence surrounding non-Native viewers of Native dance in the Southwest in this era. On the one hand, tourists and artists were avid fans of Native dance. At the same time, tourist activity, and touristic, artistic, and ethnographic practices of intrusive looking, recording, and questioning, led to increasing restrictions on non-Indian activities. The Hopi, for example, banned photography at the Hopi Snake Dance—which had become hugely popular with tourists—at Walpi Village starting in 1913, and by the early 1920s had forbidden sketching of it. Eventually the Snake Dance was closed to outsiders altogether. These restrictions served to protect and control the transformative power of dancing and of watching the dances, at a time when more and more non-Native American people were seeking out chances to experience them.

Tensions between insider and outsider perspectives emerge when comparing artistic depictions of other Native dances, particularly those that most captured the visceral and sensationalized fascination of non-Native audiences, like the Hopi Snake Dance and the so-called Ghost Dance. Considering Oqwa Pi (Abel Sanchez)'s *Hopi Snake Dancer* alongside Eanger Irving Couse's 1903 *Moki Snake Dance—A Prayer for Rain* brings these issues and various perspectives into sharp focus.

Oqwa Pi (Abel Sanchez) began painting in the early 1920s, part of the same group of artists as Quah Ah (Tonita Peña). He was successful, supporting his family through his painting and as a leader at San Ildefonzo Pueblo, serving as its governor six times.[16] His watercolor *Hopi Snake Dancer* (fig. 10) depicts the ceremony in a way that emphasizes and invites understanding of its symbolism and purpose. His image is strikingly different from the many photographs, drawings, and paintings of the dance that circulated in the press, on postcards, and as stereographs. Those images invariably represented the end of the last day of this multi-day ceremony to ensure abundant rainfall for corn crops, during which Hopi spiritual leaders carried live snakes in their mouths. Pi's depiction, however, shows one dancer centered in a geometrically balanced space, holding a snake—not coiling but calm and straight—in one hand and standing between two side frames showing snakes shaped as lightning bolts and looking in at the dancer. These bright green snakes, their bodies made of zigzag lines, lean against a bright yellow and black step invoking the angles of ladders and adobe houses, also drawn with straight-edged lines. The piece conveys a sense of brightness, balance, and intention. The snakes, in color, placement, and form, are supportive both of the structures and the dancer, who wears an armband and a zigzag lighting-bolt design on his skirt in the same bright green color as the snake. The work suggests the importance not of one climactic, sensational moment in a multi-day ritual, but the meaning and symbolism of the entire ritual. The dancer's straightforward gaze invites not

fig. 10. Oqwa Pi (Abel Sanchez), *Hopi Snake Dancer,* ca. 1920–25, watercolor, ink, and pencil on paperboard. Smithsonian American Art Museum, Corbin-Henderson Collection, gift of Alice H. Rossin

DANCE: AMERICAN ART, 1830–1960

intrusion, but recognition and understanding. His attire encodes the snake's supportive purpose, and the fringes signal the sound of rain. It makes reference to sacred colors (yellow, green, red and white, with black lines), echoing the elaborate Hopi sand paintings made in Kivas before the Snake Dance begins, where these colors represent the directions of north, south, east, and west.[17] It presents an image of how this dance enacts an intact, balanced, and sophisticated worldview.

Couse's *Moki Snake Dance—A Prayer for Rain* (fig. 11) paints a very different picture, from a perspective that reflects his position as one of the foremost Anglo painters of the region. Couse was a founder of the Taos Society of Artists and one of the Santa Fe Railway's favorite artists. He was known for painting peaceful and idyllic paintings of Indian life that, for his day, were seen as sympathetic to Native peoples. Couse first visited the Southwest in 1902, and *Moki Snake Dance* is based on a dance he saw at Walpi in 1903. It depicts, in muted brown, yellow, and reddish earthy tones, one moment in the multi-day Snake Dance ceremony. The perspective is one of an outsider close to the dancers, most of whom are indifferent to those watching, save one, who seems to look at and register the viewer's presence. The painting's lines, both those of the snakes curling on the ground and of the dancers in pairs and procession, are curved and squirmy. Literary scholar Leah Dilworth suggests how the work occupies a position somewhere between exoticism and ethnography, placing it in the realm of nineteenth-century European painting:

fig. 11. Eanger Irving Couse, *Moki Snake Dance — A Prayer for Rain,* 1903. Anschutz Collection

> Couse's painting depicts the moment in the dance when the priests circle the dance plaza carrying the snakes in their mouths.... It is realistic in the sense of being an illusionistic rendering, but the ritual is highly romanticized and somewhat sensationalized in the way the painting pushes the viewer into the action. And yet the dance is not presented as threatening or grotesque. There is a serenity and intimacy to the scene, and rather than feeling repelled, the viewer is encouraged to contemplate the various activities depicted. There are relatively few observers, and they appear to be Hopis, not outsiders. With the omission of Anglo observers, the viewer has a sense of primal discovery, similar to the ethnographer's point of view.... There is a stately, dreamlike quality to the painting, an excessive calmness that completely tames the snakes and Indians and

JACQUELINE SHEA MURPHY

evokes not only the tradition of orientalism in nineteenth-century European painting but also a kind of painterly pastoralism. These Indians resemble not savages so much as European peasants in paintings by Courbet.[18]

Both artists present the Hopi Snake Dance in ways that register and depict their worldview and their understanding of the significance of the dance. These works of art also register ways of viewing—romanticizing, supporting, intruding, explaining—in the early twentieth-century Southwest.

The depictions of what is commonly referred to as the Ghost Dance similarly enact different ways of seeing and understanding both dance and world views. The Ghost Dance was a spiritual movement that included a variation of a centuries-old rejuvenation dance that spread from Paiutes in Nevada through the Dakotas during the late 1880s. Its practice, particularly among Lakota, raised the fears of the U.S. government, whose resistance to it led to the Wounded Knee massacre at Pine Ridge in 1890.[19] While a primary issue circulating around the Snake Dance in the early twentieth-century Southwest had to do with invasive and over-eager artistic and touristic viewing, coupled with lack of cultural awareness of what was being seen, a primary issue hovering around the Ghost Dance involved Native spiritual and physical survival. The physical eradication of Indian peoples was what the Ghost Dance intended to prevent: dancers danced to save themselves in the face of warfare, territorial encroachment, illness, and starvation, and to enact a vision of peace, renewal of Native peoples and ways of life, and decline of whites. This Ghost Dance version of the rejuvenation dance also emerged in response to the killing of Native peoples and the eradication of Native ways of life, furthered still by the massacre at Wounded Knee associated with the Ghost Dance's repression. These were all part of federal policy attempting to eradicate Native Americans and were entwined with accompanying rhetoric about the "vanishing Indian" that repeatedly predicted and/or bemoaned this vanishing, and attempted to situate the "Indian" as an absent figure from the American past.

Blakelock's *The Vision of Life / The Ghost Dance* of 1895–97 and Oscar Howe's *The Ghost Dance* of 1960 (cat. 23) both address these issues. Scholar Elizabeth Tebow notes how the painting grew out of Blakelock's "long interest in and sympathy with native American culture" but also how it is "possessed of a vague title and indistinct figures," described further as "vaporous figures caught up in a frenzied swirl."[20] In one sense, this could be related to how, as Tebow writes, Blakelock "was more concerned with the spirit underlying the dancing and its mystical implications" than on ethnographic particulars (though this also, she notes, is related to the fact that his knowledge of the Ghost Dance came from press accounts and his imagination). In another sense, its murky feel, ambiguous composition, and ghostliness reinforce ideas of fading memory and disappearance that the Ghost Dance signaled for many viewers like Blakelock.

Yanktonai Dakota painter Oscar Howe's *The Ghost Dance* disrupts these assumptions. For one, it exists, and as such shows that Howe himself exists not only as a very much alive descendant of Yankton Sioux leaders in the twentieth century but also as a vibrant contemporary artist.

Cat. 23. Oscar Howe, *Ghost Dance,* 1960

The modernist style and form of the work challenges the idea that Indians are in and of the past, and that Lakota art has to exude identifiable traditional and cultural specific forms to be considered Native American. Howe's work, particularly his paintings of Native dance, posed challenges to dominant perceptions of Native art and peoples. His 1958 painting *Umine Wacipi — War and Peace Dance* (now lost) was rejected by the Philbrook Art Center's Indian Art Annual because its abstract style was thought to be similar to European modernism. It's "a fine painting—but not Indian," the jury wrote in explaining their rejection of the work.[21] Howe, however, insisted that his work and its innovations in form—which looked modernist and cubist to non-Native audiences—were actually developed from Dakota visual traditions of symbolic abstraction rather than from non-Native sources. Howe also rooted his artistic process in Dakota ceremony, particularly the collective practice of "the painting of the truth," in which abstract art, including the symmetrical, abstract motifs of Plains hide paintings and quill work, would be completed during a verbal account of history and in the presence of witnesses who confirmed its validity and legibility. "Whoever said that my paintings are not in the traditional Indian style has poor knowledge of Indian art indeed," Howe wrote to the Philbrook curator in protest.[22] Howe's *Ghost Dance* depicts the dance as a contained mass that appears like bright red flames, burning full, dappled with darker oval shapes constituting what at first glance seems like an abstract design. Then, under the shades of red, the small dark shapes clarify as feet. Splashes of white on top materialize as faces, uplifted; the black around them seems filled with dark hair. Within the work's abstraction, in other words, dancers do not disappear into inevitable death but emerge in increasing clarity, burning bright, and associated with the red of blood, fire, and war of Dakota symbolism (where blue, from sky, symbolizes peace; red, from fire and blood, symbolizes war; yellow, from light, symbolizes religion and spirituality; and green, from plants, symbolizes growth).[23] Nor does the painting depict the Ghost Dance ethnographically, with attention to specific detail. Rather, as the viewers' eyes start to see more within what first appeared to be abstraction, the dancers emerge, and the symbolism around them flickers into continuing force. It shows the Ghost Dance not as a desperate attempt in the face of inevitable destruction but an effective act of survival and resistance. As Laguna writer Leslie Marmon Silko writes about the Ghost Dance (through her character Wilson Weasel Tail):

> The truth is the Ghost Dance did not end with the murder of Big Foot and one hundred and forty-four Ghost Dance worshippers at Wounded Knee. The Ghost Dance has never ended, it has continued, and the people have never stopped dancing; they may call it by other names, but when they dance, their hearts are reunited with the spirits of beloved ancestors and the loved ones recently lost in the struggle.[24]

Howe's contemporary painting of *The Ghost Dance* tells a similar story, not of ghostly disappearance but physical and spiritual continuity and strength.

This narrative echoes through numerous depictions of Native American dance by other

Cat. 24. Dolores Purdy Corcoran, *Caddo-lac Dancers*, 2014

fig. 12. Dolores Purdy Corcoran, *Turkey Dancers / Noon'-cah'-a-shun-nah,* 2006, color pencils and india ink on antique paper. Courtesy of Dolores Purdy Corcoran

fig. 13. Dolores Purdy Corcoran, *Cad-do-Lacs,* 2009, color pencils and india ink on antique paper. Courtesy of Dolores Purdy Corcoran

Native artists in American art in the decades since 1960, perhaps none more incisively than Dolores Purdy Corcoran's playful colored-pencil ledger drawings depicting Caddo dancers. Corcoran's depictions of Caddo social dances layer histories of continuity, embedded through ongoing Caddo dance practices, on top of antique documents from the archives of Native American history (cat. 24). Her 2006 *Turkey Dancers / Noon'-cah'-a-shun-nah* (fig. 12), for example, depicts two Turkey dancers from the back, their dush-tos (women's headpieces), dresses, and other regalia elaborate and brightly colorful, on top of an 1895 tax ledger from an Oklahoma Treasurer's office. Corcoran's drawing of this victory dance, which continues today as one of the most important of the Caddo dances, is, according to scholar Richard Pearce, "a proud record of heroic resilience and vitality imposed upon a ledger page recording the taxes financing the settlement on what had been their homeland six years earlier."

Corcoran's 2009 *Cad-do-Lacs* (fig. 13) plays further with this depiction of Caddo dance as part of a vibrant, victorious, contemporary continuity, overriding outdated, largely useless, archival documentation. Drawn over an 1890 record of merchandise bought and sold, it shows three Turkey dancers racing on their way to a dance, driving bright Cadillacs, their dush-tos streaming out behind them. Its humor resides in its juxtapositions as well as in the way one of the drivers turns her faceless head to look at the viewer, as if to ask, "Yes? What are YOU looking at?" Corcoran has suggested, in discussing her paintings' signature empty faces, that their blankness

80 DANCE: AMERICAN ART, 1830–1960

is part of a work's humor, both questioning "why the viewer is there," and perhaps "asking the viewer to join in and hop on one of the horses and come along."[25]

Corcoran's 2007 *Caddo Women Taking Repatriation of Ghost Dance Pole Into Their Own Hands* (fig. 14), showing eight Turkey dancers in their regalia galloping across an Osage county record of paroled persons, comments on crime by referencing the taking of highly prized "artifacts" by collectors and the "warrior women" who fight this practice:

> In this ledger the women, in their traditional Turkey Dance regalia, are racing away from the black marketers to keep the Ghost Dance pole from becoming an item to be sold and end up in a personal collection. The women have taken repatriation into their own hands by taking over possession of the Ghost Dance pole. For a touch of humor, I included a faceless rider looking out at the viewer. She is inviting those who view the ledger to join her in this battle.[26]

Corcoran's art depicting contemporary Native women dancers provokes viewers to join her in rethinking historical assumptions about Native dance as fading and in the past, and see it as a vibrant and alive contemporary practice of artistic-warrior resistance.

Indigenous dance practitioners today are similarly bringing vibrant, creative, Indigenous dance, deeply based in Indigenous worldviews, to contemporary stages and gatherings—and in ways that, like art depicting Native dance, may also provoke new understanding about what constitutes "traditional" and "Indigenous" art. Choreographer DAYSTAR/Rosalie Jones began making dance work in the 1970s that used the modern dance stage as a tool for engaging with Indigenous stories, understandings, and approaches. Now in her seventies, she continues to choreograph new work. In 2014, DANCING EARTH Indigenous Contemporary Dance Creations celebrated its tenth anniversary of making professional dance work, using culturally appropriate creation practices, and with a commitment to both emerging and established Indigenous choreographers. Like with Howe's work, this company's Indigenous core resides in its process of making work, not in adhering to what audiences see as a "traditional" look.[27] Other contemporary Indigenous choreographers in the United States—such as the Minneapolis-based artists Emily Johnson/Catalyst and Rosy Simas Danse—have produced decades of work in which their Native worldviews infuse their chore-

fig. 14. Dolores Purdy Corcoran, *Caddo Women Taking Repatriation of Ghost Dance Pole Into Their Own Hands,* 2007, color pencils and india ink on antique paper. Kansas Historical Society, 2007.28

JACQUELINE SHEA MURPHY

ography in ways that sometimes are, and sometimes are not, signaled clearly to audience members.[28] Contemporary dance artists working with tribally specific dance groups also challenge expectations that Native dance is "traditional" only if it looks the same as what existed in the past or matches decades-old ethnographic depictions. Native dancer and group leaders, using appropriate protocol, continue to create songs and dances that respond to present-day issues, much as Native art, and Native dance, has always done.[29] This dance work, like the artwork depicting Native dance, provokes viewers, as well as funding and presenting agencies, to recognize that "Indigenous" art and dance continue to be vibrantly alive and responsive to Indigenous peoples and worldviews.

Notes

Special thanks to Christine Sahin for research assistance and to Mique'l Dangeli for comments on previous drafts.

1. "In tones of red, orange, yellow, white, and black, native artists painted animals, such as buffalo and deer, human figures, some appearing to be clasping hands in a dance or ritual, and a kaleidoscope of geometric designs on the high bluff.... artifacts indicate that the site was used at least as early as the Toyah period (ca. AD 1300–1650), and are reflected in drawings of hunters carrying bows and arrows. Paintings of horses and a church demonstrate that use of the site by native groups continued after contact with the Spanish." http://www.texasbeyondhistory.net/plateaus/images/he4.html (accessed July 10, 2014).

2. The website at http://www.desertusa.com/mag07/jan/imagesinstone.html (accessed July 10, 2014) notes that "On stony surfaces across our arid land, you may find, for instance, strangely abstracted and haunting graphic expressions of a mind apparently untethered from reality, presumably the work of a hallucinating shaman reaching for the spirit world. You may find figures, awash in symbolism, of prehistoric deities, rituals, masks, dance, ceremonies and pilgrimages." The site includes a depiction of Apache dancers at Hueco Tanks, western Texas.

3. See http://www.petroglyphs.us/article_culture_crisis_and_rock_art_intensification.htm (accessed July 10, 2014).

4. Hertha Dawn Wong, *Sending My Heart Back Across the Years: Tradition and Innovation in Native American Autobiography* (New York, 1992), 28–37.

5. This treatment of Native culture and topics as available to all, rather than only to be seen or used by those individuals or communities that produced them, when proper protocol for sharing is followed, continues to inform depictions of Native dance today. Hail writes, "In the 1830s, Mandan chief Mato-Tope drew pictographs of his personal battles on his hide shirt, as a form of expressing his individual identity and achievements to fellow warriors within his own tribe. But because German Prince Maximilian was visiting and asked for a copy of the drawings, which he subsequently published, Mato-Tope's personal story became cross-cultural property. Further, Swiss artist Karl Bodmer was accompanying Maximilian's expedition and provided some of the subjects of his paintings with art materials and an opportunity to observe his own detailed and ethnographically accurate portraits of them. American artist George Catlin and Swiss artist Rudolf Kurz continued the policy of sharing drawing styles and materials. The interplay of artistic ideas had begun. Barbara A. Hail, "Foreword," in Richard Pearce, *Women and Ledger Art* (Tuscon, 2013), xiv.

6. Oliver LaFarge, *A Pictorial History of the American Indian* (New York,1956), 176.

7. See http://www.americanart.si.edu/collections/search/artwork/?id=4204 (accessed July 8, 2014).

8. See http://www.ethnicstudies.ucsd.edu/faculty/frank.html (accessed July 8, 2014).

9. See the online archive at https://plainsledgerart.org/ (accessed July 8, 2014).

10. Hail writes how "The intended audiences for these [Fort Marion] drawings were fellow prisoners of differing tribes, and residents and tourists from nearby St. Augustine who came to view dance performances." In Pearce 2013, xiv.

11. Hertha Dawn Wong, in writing about pre-contact practices via nineteenth-century Plains pictographic work, describes the "artistic representations" that male Native Americans painted on tipis, shields, cloth, or skins as forms of autobiographical narrative, often as records of heroic actions, warrior feats, or visions. She differentiates these pictographic records of individual men's achievements from the "symbolic geometric designs" that women used in porcupine quillwork or beadwork, and sees these as "akin to the abstract designs of Navajo women's woven blankets" (Wong 1992, 36). In her foreword to Pearce 2013, Barbara A. Hail also writes how "until recently, Plains figurative art on paper, or ledger art, has been considered a male domain." She notes that "Women had actually begun moving from abstract to figurative art in the late nineteenth century, depicting men, women, children, and animals with quill and bead embroidery on clothing and

household objects." Both scholars, however, suggest that before the (late?) nineteenth century in many Native contexts, figurative representation would have been done primarily by men.

12. Leah Dilworth, *Imagining Indians in the Southwest: Persistent Visions of a Primitive Past* (Washington, DC, 1996), 62. She writes, "The code was withdrawn in 1923, but in the intervening years, although the Snake dance was not forbidden, it was not encouraged. It was not outlawed in part because it was such a big tourist attraction; the railroads promoted it and tourists demanded it."

13. Marilee Jantzer-White writes how "Beginning in the 1960s, fragmentary descriptives such as 'self-taught,' 'non-traditional,' and 'influenced by white patronage' dominated the discourse about American Indian painters of the 1920s. Ultimately this labeling prevented in-depth analyses of these artists' works, including those of Tonita Peña. Considered tainted by Anglo contact, these artists' paintings slid into limbo, neither 'traditional' nor 'modern.'" Marilee Jantzer-White, "Tonita Peña (Quah Ah), Pueblo Painter: Asserting Identity Through Continuity and Change," *American Indian Quarterly* 18, no. 3 (Summer 1994): 369.

14. Janzter-White (ibid.) quotes Peña's son, Sam Arquero, hinting at the controversy her knowledge of dance provoked among tribal members: "Because even at that time the folks who were around at that time were not fully aware of certain things, certain details, certain dances. She was concerned and that was one way of preserving those things. Unfortunately, the tribal members didn't see it that way, at that time. And the other thing too was that especially the male folks take exception to a woman knowing all these things, all the details that go into certain things." Jantzer-White writes as well of how many of the paintings, through a focus on women's roles and agency, "Peña deconstructs fixed Pueblo and western notions about Pueblo female identity."

15. Jantzer-White (ibid.) quotes letters Peña wrote indicating both. "The pictures that I have just done are real nice, the new dance which they danced this winter, one is the war dance, (also) the dog dance and the eagle dance, and two Indian ladies baking bread in the oven. Each picture costs $4.00," she wrote to an official at the Museum of New Mexico in 1922. Peña was clearly adept at advertising her own work, which was key to surviving in the newly introduced cash economy.

16. Oqwa Pi writes, "I, Oqwa Pi, have been painting since the early 1920s. As I found that painting was the best among my talents, I decided to do my best to win me fame as an Indian artist.... as an artist, I have raised a big, healthy family for my painting brought in good income...." (artist letter to Philbrook Art Center). See http://www.adobegallery.com/art/san-ildefonso-painting-of-a-black-doe (accessed July 8, 2014).

17. See http://encyclopedia2.thefreedictionary.com/Hopi+Snake+Dance (accessed July 9, 2014).

18. Dilworth 1996, 60. E. Irving Couse made paintings for twenty-two of the famous Santa Fe calendars (p. 449).

19. Numerous scholars have addressed at length the history of the so-called Ghost Dance Religion at Pine Ridge, and the ensuing massacre at Wounded Knee in December 1890. Some have argued persuasively that ethnologist James Mooney, whose writing on what he called the "Ghost Dance Religion" or "outbreak" forms the basis for almost all published discussions of it, effectively invented the practice; see James Mooney, *The Ghost-Dance Religion and the Sioux Outbreak of 1890* (Lincoln, 1991; orig. pub. 1892–93 as Part 2 of the *Fourteenth Annual Report of the Bureau of Ethnology*). Tharon Weighill, in "The 2-Step Tales of Hahashka and Pullack'ak: Expressions of Corporeality in Aboriginal California," PhD diss., Univeristy of California, Riverside, 2004, argues that by isolating and naming one version of widespread and common aboriginal rejuvenation practices the "Ghost" Dance (translated from the Lakota for "Spirit Dance," and called "Dance in a Circle" among the Paiute), Mooney played on whites' fears of ghosts as dangerous and demonic, creating an atmosphere in which to rationalize the use of force against, and thereby further deterritorialize, aboriginal peoples. According to Mooney's widely circulated discussion, the "Ghost Dance Religion" began when a number of Lakota from Pine Ridge became interested in the message of a sacred Paiute man, Wovoka, living in Mason Valley, Nevada, around 1889, during a period of increasing famine on the reservation. Word of Wovoka had spread to the

Dakotas, and messengers from Pine Ridge had traveled to see him and returned. One of those receiving these messages, Black Elk, reports that Wovoka told them to "put this paint on and have a ghost dance, and in doing this they would save themselves, that there is another world coming—a world just for the Indians, that in time the world would come and crush out all the whites." As famine spread across Pine Ridge, Black Elk and others' dancing became increasingly frequent—Black Elk writes "we were dancing nearly every day"—and caused increasing fears of "wild and crazy" dancing Indians among the soldiers and agents; Raymon J. DeMallie, ed., *The Sixth Grandfather: Black Elk's Teachings Given to John G. Neihardt* (Lincoln, 1984), 257. These fears lead to the identification of sixty perceived leaders of the Ghost Dance, Sitting Bull, a Hunkpapa Lakota Holy Man who had performed in *Buffalo Bill's Wild West*, among them. On December 15, the Indian police attempted to arrest Sitting Bull at Standing Rock. When they did, a shooting match erupted and Sitting Bull, seven of his supporters, and six police were killed in what some Hunkpapas believed then, and since, to be Sitting Bull's assassination. What followed in the next two weeks is what has become known as the "Wounded Knee Massacre": refugees among Sitting Bull's and other bands joined Big Foot's band, and fled to the Bad Lands. On December 28, 1890, this group surrendered to soldiers of the Seventh Cavalry (Custer's regiment), and moved with the troops to Wounded Knee creek. The next morning, December 29, during preparations to disarm the people, one man refused to give up his gun and in the ensuing struggle over it shooting started. In the fighting that followed, the Lakotas killed forty-three soldiers, and the 470 soldiers killed 300 Lakota people, most of them women, children, and elders. Some had been shot in the back as they ran, their bodies found scattered and frozen to death for up to two miles from the site, though a few were found still alive three days later, after a blizzard had cleared. Journalists arrived at the scene and their descriptions of the frozen contorted bodies of dead Indian women—some holding babies that had been wrapped in shawls and were still barely alive—led to a national outcry, as well as to increased fears of Indian "outbreaks."

20. Elizabeth Tebow, "Ralph Blakelock's *The Vision of Life / The Ghost Dance*: A Hidden Chronicle," *Art Institute of Chicago Museum Studies* 16, no. 2 (1990), 182–83.

21. Mark Andrew White, "Oscar Howe and the Transformation of Native American Art," *American Indian Art Magazine* 23 (1997): 37.

22. Ibid.

23. Bill Anthes, *Native Moderns: American Indian Painting, 1940–1960* (Durham, NC, 2006), 163.

24. Leslie Marmon Silko, *Almanac of the Dead* (New York, 1991), 723.

25. Ibid., 59.

26. Corcoran, as quoted in Pearce 2013, 62.

27. DANCING EARTH INDIGENOUS CONTEMPORARY DANCE CREATIONS, for example, has had grant proposals rejected on the grounds their work sample did not look "native" enough. According to DANCING EARTH Artistic Director Rulan Tangen, some presenters have suggested to them that Native dance does not belong on fully equipped theatrical stages but (only) in Native community settings; or required that publicity reflect particular visual markers (requesting only photos of the more "Native" looking cast members—i.e., the long-haired men—for publicity; or asked for guarantees that original cast members, wearing "traditional" regalia, be available for special appearances). Other venues have tried to police the ways the company acts or appears so they adhere to limited, stereotypical, ideas about how Native people should look and where they should be allowed. Email correspondance with Tangen, July 30, 2011. For more information, see www.dancingearth.org.

28. These include, among those that more clearly signal their grounding in Native history and worldview, Johnson's *Niicugni* (2013) and Simas's *We Wait in the Darkness* (2014).

29. See Mique'l Askren, "Dancing Our Stone Mask Out of Confinement: A Twenty-First-Century Tsimshian Epistemology," in *Objects of Exchange: Social and Material Transformation on the Late Nineteenth-Century Northwest Coast*, ed. Aaron Glass (New York, 2011), 37–47.

The Art of Dancing Out-of-Doors | *Jane Dini*

In 1911 John Sloan painted *Isadora Duncan* (cat. 25), an image of the pioneer of modern dance captured in the floodlights of a New York theater stage. Dressed in a translucent, Greek-inspired chiton, Duncan strikes a dramatic pose with her head thrown back and one arm thrust forward in her signature free-style choreography. Sloan said of the performance that inspired his painting and several prints (fig. 1), "She dances away civilization's tainted brain vapors, wholly human and holy—part of God." In the early twentieth century, dancers such as Isadora Duncan turned away from traditional ballet and began to appear uncorseted, dancing out-of-doors, shedding the trappings of city life. In Sloan's painting, however, the only sign of nature are three roses that her male admirers have thrown at her feet.[1]

Long before Isadora Duncan and her cohorts graced international stages with their outdoor dancing routines, late nineteenth-century American artists were depicting dancers in a variety of natural settings to achieve arresting compositions. Many of these American artists went beyond the purely lyrical and touched upon the socio-political concerns of their day. Of course, the subject of outdoor dance laced with social commentary was not new. Flemish painter Pieter Bruegel's (1525–69) *The Wedding Dance* of 1566 (fig. 2), for instance, depicts frolicking couples dancing on the edges of the forest, much in the same way as they dance around the edges of decorum.

The philosophical underpinnings of Duncan's classical revival dance performed out-of-doors cannot be understated; nonetheless, it should not eclipse the strategies that many artists had used previously to link dance to its surrounding environments. How Duncan built upon this visual trope for a stage show is just one of the many ways dancers were able to tap into fantasies that American artists had established in the previous decades. These Arcadian fictions parallel some of the greatest cultural and demographic shifts in America, including migration, immigration, and the struggle for equality between men and women.[2]

Cat. 29. Winslow Homer, *A Summer Night* (detail), 1890

Cat. 25. John Sloan, *Isadora Duncan*, 1911

Dancing West

Artists such as George Caleb Bingham explored westward expansion through the civilizing rituals of dance along Midwestern river ways in paintings such as *The Jolly Flatboatman* (1846; cat. 11). In the picture, the dancer throws his arms skyward as he jigs atop a flatboat enclosed by a symmetrical and balanced arrangement of musicians and admirers as they glide down the river at sunrise. The flatboat men of the Missouri and Mississippi Rivers represented the rowdy, disreputable edge of the frontier. Bingham's decision to portray his dancer as the apex of a stable pyramidal composition, a structure based on Renaissance prototypes, gave viewers a framework in which to view the dancer's body. Bruce Robertson suggests that Bingham's boatmen are updated Arcadians. "Like the shepherds in that mythical region of ancient Greece, these boatmen do not work in the same way that farmers, artisans, and factory workers do; rather, they spend their days drifting lazily on the river, waiting for the few moments when they are needed."[3]

In the meantime, they dance. How they dance, explains Constance Valis Hill in her catalogue essay, further suggests that Bingham's image depicts the hybridity found only in America, where, in the course of westward movement, the footwork of a Scots Irish jig has become modified by the dancer's joyously raised arms. This American dancer, clad in blue striped pants

fig. 1. John Sloan, *Isadora Duncan,* 1915, etching printed on black wove paper. Detroit Institute of Arts, City of Detroit purchase, 29.205

fig. 2. Pieter Bruegel, *The Wedding Dance,* 1566, oil on panel. The Detroit Institute of Arts, City of Detroit purchase, 30.374

JANE DINI

fig. 3. Asher B. Durand, *A Morning Ride / Dance of the Haymakers,* 1846, oil on canvas. Manoogian Collection

fig. 4. Charles Christian Nahl, *The Fandango,* 1873, oil on canvas. Crocker Art Museum, E.B. Crocker Collection

and a red and white striped shirt, embodies the American flag waving aloft (as it would on the stern of the ship), proclaiming westward expansion.

U.S. society could not advance without a stable "home front." In Asher B. Durand's *A Morning Ride / Dance of the Haymakers* (1846; fig. 3), a folk dance serves as a demarcation of class in a tranquil yet fixed hierarchal community. On the right, country peasants join hands in a roundel or ring dance. They are observed, on the left, by an upper-class couple, finely dressed astride Arabian horses, a rare and expensive breed imported into the United States in the mid-nineteenth century. In juxtaposition, a farm hand sits on a sturdy workhorse whose ears are pinned back, a sign of submission, further alerting the viewers to the class distinctions afoot in this work of art.[4]

Durand's *A Morning Ride* provides a clear and delineated structure for viewing mid-nineteenth-century American society. Its social stratifications were as distinct as the dances. Country outdoor dances were occasions of local celebrations corresponding to the Church calendar or the change of seasons, usually accompanied by musical instruments that were easily transported outdoors and for travel. In contrast, upper-class dance was established at court (imported to the United States) or by the local gentry, held indoors, not viewed by the masses, and accompanied by more sophisticated instruments and music.

In a circle dance, all participants are treated equally, moving in the same direction and linked together rhythmically. Durand uses the dance, a metaphor for the circle of life, to activate the other social interactions in his picture and direct the viewer to vignettes that underscore the passage of time. Children play (one nicking food out of an unguarded basket), young teens flirt and cavort, and an old farm worker rests his hand on the trunk of a massive elm tree, its branches forming a shaded canopy for the dancers. The tree is as stable and enduring as he. Indeed, the farmer's large rake becomes a kind of a cane in a visual reminder of the physical limitations that make dance so precious. Durand portrays different scenes of idyllic country life under the watchful and appraising eye of the upper class. As long as the social order is maintained it will endure.

In contrast, all hell breaks loose in Charles Christian Nahl's *The Fandango* (1873; fig. 4), an image of *ranchero* life in California. Nahl's work is equal parts

DANCE: AMERICAN ART, 1830–1960

myth and verisimilitude in a historic recreation of *Californios* (Mexicans living in California) enjoying a fiesta. Commissioned by Edwin Bryant Crocker, a California supreme court justice, for his grand house in Sacramento, the painting's theme of lust and lawlessness in days gone by was constructed for a man whose role was to uphold law and order, underscoring his important position in both maintaining the exuberant spirit of the Wild West and its subsequent civilization.[5]

In the image, one couple dances the fandango, a Spanish courtship dance in triple time, between couples who gesture enticingly to one another as they closely circle and weave in and out of each other's grasp. Horace Bell writes in *Reminiscences of a Ranger* (1881), a memoir that celebrates Los Angeles's Spanish past, "Nothing but an adobe house could have stood an old-fashioned fandango. A modern earthquake is no comparison to an old-fashioned California fandango, especially such as we had in those good old times in this angelic city."[6]

In common practice, the dance begins slowly. The seduction escalates with the speed of the dance. As the tempo increases there are certain measures in the music when the couple stops and dramatically strikes a pose, taunting each other and rousing the crowd. Nahl captures this moment: the man twists his body to face his partner, broadly stretching his arms and elegantly cupping his hands; the woman arches back, head inclined to the man's, lifting her dress to show off her beautifully pointed foot in a *tendu*. Nahl's female dancer looks more like a European ballerina dancing in the Spanish style, such as superstar Fanny Elssler (fig. 5), than a woman on the frontier. Much in the same way that late nineteenth-century visual artists such as Nahl appealed to a more diversified audience by incorporating popular culture, period choreographers included crowd-pleasing scenes in their Romantic ballets by placing dancers "outdoors" where formal, codified steps were replaced by the more spirited moves of folk or rustic peasant dances.[7]

Similar to the ring dance in Durand's *A Morning Ride,* the central dancers of Nahl's fandango echo and make dynamic the scenes of courtship that surround them. The dancing couple is flanked on the right by another fandango couple (she wears ballet slippers and he has a red sash tied around his waist, mirroring the central dancers). Finished with their dance, they are being carried off by a rearing steed to the delight of their adoring fans. To the left, under the veranda, a more fraught encounter is taking place. A woman struggles to break free of her suitor. Still more violent is the vignette to their left, where two men fighting over a woman have brandished knives, ready for a fight.

fig. 5. *Dancer Fanny Elssler (1810–1884) Performing Fandango Dance Step,* 19th century, engraving. De Agostini Picture Library/ A. Dagli Orti/Bridgeman Images

JANE DINI

Cat. 26. John Singer Sargent, *Capri Girl on a Rooftop*, 1878

While Nahl was creating Western archetypes in California, the American expatriate John Singer Sargent looked to Italian folk traditions during Italy's greatest population migration to the United States. In 1878 Sargent painted *Capri Girl on a Rooftop* (cat. 26), an image of Rosina Ferrara dancing the tarantella by the light of the rising moon. A musician sits on the edge of the roof, one foot hooked over the other, singing to the beat of a large tambourine gaily decorated with red and green pom-poms, rendered so precisely that their fuzzy texture is apparent.

The dancer's arms are silhouetted by the dusky pink glow of the evening sky creating sharp and indelible contrasts with the physical world. Ferrara's raised arms bend at the elbow, her attenuated wrists show off the articulation of her fingers delicately snapping to the music, her pink skirt is tucked up into her white slip to allow for more physical freedom. Sargent renders a pose that is so elegantly balanced—the dancer's left arm raised as her right hip juts out—and so nuanced—the tilt of her head tucked into the curve of her right shoulder— that one forgets how frenetic and fast paced this folk dance can be. The depiction of dancer and dance, so keenly observed by the artist, was the result of much detailed study, including a series of striking profile portraits of Ferrara's head.[8] Nature, however, was the direct inspiration for this extraordinary study of form and line.

In more earth-bound representations, Sargent depicted Rosina Ferrara in striking attitudes, such as resting in the crook of a tree branch. In *A Capriote* (1878; fig. 6), Sargent poses Ferrara in a wild olive tree, positioning her arms to echo its twisting limbs. A root sprout catches her pink skirt and further envelopes Ferrara into the folds of Capri's natural world.

Sargent's dancer is reminiscent of classically inspired nymphs, such as Daphne, who is transformed into a Laurel tree to escape the advances of Apollo. Further still, the twisting lines linking tree and dancer bring to mind the spirited dance of a Bacchante, a dancing devotee of Bacchus. Mary Cassatt captured this dancer of Dionysian rituals in her painting *Bacchante* (1872; cat. 27), also painted in Italy early in her career. The frenzied dance of a Bacchante was a world away from the domestic scenes of motherhood for which Cassatt became best known. Clad in an Italian folk costume with ivy vines woven throughout her hair, the golden discs of her necklaces shake as she clashes the cymbals together in her dance. Her transfixed gaze is arresting. The popularity of classical themes for ambitious nineteenth-century painters such as Sargent and Cassatt was as appealing as it was for Duncan who, a generation later, strove to develop modern themes from the classical past.

fig. 6. John Singer Sargent, *A Capriote,* 1878, oil on canvas. Museum of Fine Arts, Boston, Bequest of Helen Swift Neilson, 46.10

JANE DINI

Cat. 27. Mary Cassatt, *Bacchante*, 1872

Dancing on a Sidewalk

During the last decades of the nineteenth-century in America, a taste for genre paintings depicting sentimental scenes of Italian peasants appeared and, as the influx of Italian immigrants increased, so did a fear that this new immigrant population would contribute to the contamination and degradation of a native culture and the mongrelization of its people. For the first time, both Italian images and Italians were present in large numbers in America. This historical coexistence offers an exemplary opportunity to understand how American audiences were able to negotiate between a well-established romanticized ideal and a newly perceived social threat. How did the painted image of the romanticized Italian in works such as Sargent's *Capri Girl on a Rooftop* coexist with the perceived threat of the "dirty" Italian? What were the cultural paradoxes and contradictions that this aestheticizing project provoked and sought to contain?[9]

In the United States, American artists translated scenes of immigrant dances celebrating folk traditions from the countryside of Italy and performing them on the city streets of New York, Chicago, and Boston. In *The Sidewalk Dance* (1894; cat. 28), John George Brown depicts New York immigrant children (or children of immigrants) dancing to the music of an Italian musician's hurdy-gurdy. Ironically, he doffs his cap for any tips that might come his way from this rag-tag crowd. The children, perhaps mostly of Irish descent, try a variety of dance steps.[10] The dancing boy to the left strikes a pose that mirrors that of Rosina Ferrara in Sargent's *Capri Girl on a Rooftop*. This comparison shows how European culture was transmitted by immigrants, then adopted and altered into a changing American culture.

Nineteenth-century immigrant communities also held great appeal to American artists, who portrayed the dances of children of foreign-born parents as a sign of a continuing and thriving cultural heritage. This trend continued well into the twentieth century in such paintings as George Luks's *The Spielers* (1905; cat. 1), an image of two working-class Irish girls dancing with great gusto on a New York City sidewalk. However, visual markers of ethnic difference helped preserve social boundaries between middle-class audiences and the immigrant subjects in the works of art.

Of course, what was captivating to artists were the hybrid forms and movements seen in the new dances in America. This was especially evident in the large immigrant populations that arrived during the latter half of the nineteenth century. Artists captured modified Irish jigs and urbanized Italian tarantellas as evidence that recent immigrants were grappling with their cultural identity in new and unfamiliar surroundings; in other words, through dance, performed out of doors for the world to see, the bodies of immigrants were becoming American.

American artists seldom recorded or imagined scenes in the grand ballrooms of the nineteenth century, but the theme pervades the popular prints and cartoons circulated through numerous popular magazines and newspapers during the golden age of illustration (ca. 1870–1900). Winslow Homer, for example, documented the changes afoot in nineteenth-century dance throughout his career. On November 27, 1858, *Harper's Weekly* published Homer's four-panel

JANE DINI

Cat. 28. John George Brown, *The Sidewalk Dance*, 1894

wood engraving *Thanksgiving Day,* including *The Dance* (1858; figs. 7–8). In the charming domestic scene that follows the feast, furniture is pushed back against the wall to provide ample room for the multi-generational dance. In the center, a grandfather takes a turn with a much younger woman, presumably his daughter or granddaughter, while his wife, his partner from yore, watches approvingly. Grandfather is dancing in the older style, jigging a country folk dance with the aid of a cane, his spritely footwork causing his coattails to flap up behind him. With good nature, his younger partner matches his footwork. Her generation is in the background taking a spin in the close partner dance of the waltz. This newer dance was considered more refined and cosmopolitan. The two dances in juxtaposition show the passage of time and the changing patterns of American life.

The waltz picks up speed in Homer's *The Great Russian Ball at the Academy of Music, November 5, 1863,* published in *Harper's Weekly* during the height of the Civil War (fig. 9). On the left, a seated woman accepts a man's dance proposal, as she delicately places her hand in the crook of his arm, in a social ritual prescribed for such occasions. To their right, Homer depicts the speed and elegance of the dance by placing three couples in the foreground at different angles, anticipating Eadweard Muybridge's experimental stop-motion photography by two decades (fig. 10). Twirling before our eyes like a kaleidoscope, the hooped skirts of the women's dresses are festooned with swags; decorated like Christmas trees, they sweep and swoop across the floor and further animate the scene of the festive ball.

From African American breakdowns around a campfire to French high kicks in a Parisian nightclub, Homer produced wood-engraved images of social dancers and their watchful admirers for the commercial press. Yet, in his most evocative image of dance, Homer removes the waltz from the confines of the ballroom, away from the scrutiny of the dancing instructor and discerning eyes of the older generation; a place with no gossip hounds, no lurid party-goers.

fig. 7. Winslow Homer, *Thanksgiving Day Way and Means / Arrival at the Old Home / The Dinner / The Dance,* from *Harper's Weekly,* November 27, 1858, wood engraving on paper. Smithsonian American Art Museum, The Ray Austrian Collection, gift of Beatrice L. Austrian, Caryl A. Austrian and Jame A. Austrian, 1996.63.105

fig. 8. Detail of fig 7 showing *The Dance*

JANE DINI

fig. 9. Winslow Homer, *The Great Russian Ball at the Academy of Music, November 5, 1863,* from *Harper's Weekly,* November 21, 1863, wood engraving. Smithsonian American Art Museum, The Ray Austrian Collection, gift of Beatrice L. Austrian, Caryl A. Austrian and James A. Austrian

fig. 10. Eadweard Muybridge, *Animal Locomotion, Plate 197,* 1887, gelatin silver print. Victoria and Albert Museum, London

In 1890 Homer painted *Summer Night* (cat. 29), an image of two women waltzing to the rhythms of the sea. Behind them, a wave crashes to shore creating a spray of water lifting into the air that echoes the shape and embodies the freedom of the dancing couple. In the highly finished oil sketch for the painting, *A Summer Night—Dancing by Moonlight* (1890; cat. 30), the spume of water rises just to the horizon where sea meets sky. In the finished painting, however, the spume extends beyond the sea reaching to the heavens, linking all three registers of the painting: the women moving on the ground; the frothy, churning sea; and the moonlit sky. On the rocks below, five figures in silhouette turn their attention to the dance of light on the waves, reinforcing the private dance of the women along the shore.

Summer Night depicts a rare, if not singular, theme in Homer's paintings that he produced in Prout's Neck, Maine, where he lived and worked for the last thirty years of his life. Homer used this sparsely populated stretch of northeastern coastline as inspiration for some of his most dramatic seascapes and shipwrecks; powerful images that confront the conflict between man and nature. *Summer Night* is a recitation on humankind in accordance with nature. The sea spray frames the women with a halo or mandala, but Homer is not sentimental; these women are not blessed by religion but affirmed by nature, its power and its rhythms. The sea foam becomes an extension of the dance.

Not far from Homer's studio on Prout's Neck was a seaside hotel for summer guests, The Checkley, where dancing took place. The women may be outside the hotel, listening to the music from within, their platform illuminated by the new electric lights of the resort. But both artificial light and music give way to the moonlight and the sounds of waves breaking. They dance toward nature away from civilization.[11]

Cradled by the sea, the women glide and twirl across a platform deck. Their outstretched arms perfectly balanced, their hands resting lightly on each others, their feet almost *en pointe* as they grace the floor boards. They dance closely, exhibiting the intimacy of familiarity. In the nineteenth century, women commonly danced together, particularly at home, in school, or in casual settings. Homer's image signals a shift in the representation of the modern women—out at night, without male partners, without chaperones, free to enjoy each other's company, have fun, and be swept up in the beauty of the sea.

Inland, in the art colony of Cornish, New Hampshire, not far from Maine but far removed from Homer's sensibilities, were visions of outdoor dance constructed by the artist Thomas Dewing. In the same year Homer painted *Summer Night,* Dewing painted *Summer* (1890; see Robertson's essay, fig. 1) depicting four women dancing a Virginia reel, a country dance imported from Scotland and popular in America in the nineteenth century. In the painting, the finely dressed women form a line weaving and changing partners from hand to hand to the accompaniment of a fifth woman playing a harp. Dewing's composition is an ode to another dance tableau with the same title, Sandro Botticelli's *La Primavera* (1482). Dewing transforms the goddess of Spring and three graces in the Italian Renaissance prototype into fashionable modern women in the countryside of New Hampshire.

In Dewing's image, the verdant landscape becomes a lush backdrop to the dance performance, much in the same way that Homer's crashing sea dramatically offsets his dancers. But there is a mannered, theatricality to those of Dewing, unlike those of Homer who are vibrant and robust. To the left of the composition, the first dancer has her back to the viewer, delicately reaching with her right hand for the women next in line. Together, the dancers form a series of V shapes, elegantly mirroring one another. Dewing's assiduous attention to broken and unbroken lines is further accentuated by the corseted dresses shaping their slim silhouettes. In one sense, their gestures and movements seem staged, as if they were performing in a theatrical masque, a pastime of the Cornish artistic community.[12] But their attire is in keeping with high society ball gowns from the period and their coiffures reflect the latest fashions.

In the late nineteenth century, the ball was a cornerstone of high society and demarcated important dates throughout a social season. The ball was a nexus of social codes and mores to be followed and upheld, and for many young women shaped their physical identity and set the course of their publicly scrutinized courtship, marriage, and sexual life. Rife with irony and contradictions, the image of the ball and its social types—young and old, boorish and vain—was fodder for popular illustrations and cartoons. On May 1, 1890, *Life Magazine* ran Charles Dana Gibson's *Social Nuisances: The Hostess Who Pays Off Too Many Social Debts at Once* (fig. 11), an image of a ballroom jam-packed with well-dressed couples, cheek by jowl; a cautionary tale for the discerning host and hostess.

In *Spring* and later works, Dewing plucked the high society hot-house flower from the dance floors of New York and the pages of *Life Magazine,* separated her from her male counterpart, and planted her in a fictional garden, a fairyland of make believe. In a nature setting the

Cat. 29. Winslow Homer, *A Summer Night,* 1890

Cat. 30. Winslow Homer, *A Summer Night—Dancing By Moonlight*, 1890

fig. 11. Charles Dana Gibson, *Social Nuisances: The Hostess Who Pays Off Too Many Social Debts at Once,* from *Life,* May 1, 1890. Reprinted with permission from digital images produced by ProQuest LLC. www.proquest.com

dancer is more sensuous; connected to the atmosphere of the environment; and outside the confines of established social rituals, societal mores, and gender restrictions. But Dewing also removes his women from signs of power and real social engagement. Bound up in these representations are questions of a women's place in the social order.

The 1890s were a turning point for the women's suffrage movement. During this period, a woman's role and position in society was debated and artists such as socially conservative Dewing were wary of her full participation in advanced education and the increasingly industrialized work force.[13] "Women are so active nowadays in advancing the cause," stated "Topics of the Time" in the February 1891 issue of *The Century*.[14] Dewing's women, on the other hand, dance in a kind of eternal enchantment.

From this wellspring of American culture sprang the young Isadora Duncan, igniting the popular imagination. Her career breakthroughs in Chicago and New York coincided with one of the greatest cultural shifts in the lives of American middle- and upper-class women. Although there were plenty of cultural antecedents, Duncan and her admirers laid claim to the Greek revival. Early biographer Mary Desti proclaimed, "From far antiquity came Isadora bringing to moderns all the grace of movement, suppleness of body, charm and lightness of raiment, long sealed in the secret archives of sculptural Greece."[15]

During this period, American dancers and visual artists purportedly looked to ancient Greek statuary to uncover classical movements and create what they considered a more authentic dance than those of the professional ballerina, vaudeville skirt dancer, or the social dances prescribed in a ballroom. As women's suffrage began to build steam in the United States, this new, natural dance provoked a wide array of visual responses.

Most notably, and notably forgotten, was Robert Frederick Blum's *Moods to Music* (1893–95), one of a pair of grand-scale murals commissioned for the concert hall proscenium in New York's Mendelssohn Hall.[16] At the time, *Moods* and its complement, *The Feast of Bacchus,* was considered Blum's finest work, decorating one of New York's premier cultural venues. When the club was demolished in 1912, Blum's work was rolled up and put in storage at The Brooklyn Museum, where it has received little recognition for imaging the nexus of the fine and the performing arts at a time of emerging new dance traditions. In the mural study for *Moods to Music* (cat. 31), approximately eleven dancers strike poses that evoke moods in music from the plaintive to the ecstatic. Draped in brilliantly colored pastel chitons, the dancers join hands in a circle; those toward the rear are more restrained and frolic with flowered garlands in a kind of maypole dance, while those in the foreground pull and strain the arms of their companions as they throw

Cat. 31. Robert Frederick Blum, *Study for "Moods to Music,"* 1893–95

fig. 12. Jacob Schloss, *Isadora Duncan*. Courtesy of the Dance Collection of the New York Public Library for the Performing Arts, Astor, Lenox, and the Tilden Foundations

fig. 13. Arnold Genthe, *Isadora Duncan,* 1915/18, gelatin silver print. Detroit Institute of Arts, Gift of Frederick P. Currier, F1985.201

fig. 14. Abraham Walkowitz, *Isadora Duncan,* 1916, brush and ink over graphite pencil on off-white wove paper. Detroit Institute of Arts, gift of the Archives of American Art, 59.270

their heads back in expressive movement. Clearly, Blum is inspired by cultural shifts that focused on expressive human body that included the aesthetic philosophy of Arthur Schopenhauer, the universality of human emotions by biologist Charles Darwin, and the emotional expression of performance by composer François Delsarte, whose American disciple Genevieve Stebbins had an enormous influence on early modern dancers such as Duncan and Ruth St. Denis.[17]

Jacob Schloss's photograph of a twenty-two-year-old Duncan appears to be a living embodiment of one of Blum's moods (fig. 12). Like a modern Galatea, her sinuous back bending seems more a response to the contemporary art world of Blum than a Greek statue. As she matured as a dancer and her fame grew, Duncan understood how important it was to work with photographers and together compose the right shot. Talented and shrewd, Duncan achieved worldwide acclaim despite the fact that her dances were never filmed. Duncan forbade recording of her performances, insisting that the medium would distort the subtlety and power of her dances. What grew up around her instead was an artistic cult, including artists as diverse as the realist John Sloan, photographer Arnold Genthe (fig. 13), and the modernist Abraham Walkowitz, whose watercolors capture the dancer's vivacity and musicality. Images such as *Isadora Duncan* (1916; fig. 14) were sketched quickly to suggest the same improvisational vitality that Duncan possessed on stage.[18]

The subject of modern dancing women without male partners was new in American art and coincided with their appearance in graphic media and mass-circulated journals. This visual flood of dancing women, shedding their restrictive clothing in favor of attire that let the body move freely, was a subset of the New Woman, a late nineteenth-century feminist ideal that

DANCE: AMERICAN ART, 1830–1960

helped shape the woman's suffrage movement. In 1917 a playful commentary in verse appeared in *Vanity Fair* entitled "Modern Outdoor Dancing."

> It's really upsetting,
> The way we're getting
> Our dancers, lately,—
> Not draped,—sedately,
> Nor gowned, nor hosed,
> Nor bound, nor enclosed,—
> But—just like the photos in which they're disclosed,
> Often underdeveloped and overexposed.[19]

The "photos" that the verse mentions refer to the enormously popular rotogravures in period newspapers and magazines.

For more than thirty years, from 1890 to 1920, the outdoor dancer *à l'antique* persisted in American art from the fairly conventional to the avant-garde. Bessie Potter Vonnoh's small-scale figures *The Scarf* (1908; cat. 32) and *The Dance* (1897; cat. 33), and Paul Manship's *Dancer with Gazelles* (1916; cat. 34), are examples of the kind of sculpture that reflected costumes, nature-based settings, and graceful movement during this artistic period. Manship's work evokes the natural world of South Asia. Flanked by two gazelles, the dancer's sinuous movements are inspired by *ragamala*, a genre in Indian painting depicting melodies that often portrays human and beast in rhythmic harmony.[20]

Back out west, in the early twentieth century, outdoor dance again became a popular theme. Gone are Nahl's Wild West Spanish fandangos, images of the energetic social dances of diverse communities. Gone, too, are visual signs of the legacy of Indigenous dance seen through the eyes of artist-explorers, such as in a work attributed to German Georg Heinrich von Langsdorff, *Dance of Indians at Mission in San Jose, New California* (ca. 1803–7; fig. 15), a rare document of the ritual dance from the Ohlone Nation. In the image, six dancers with elaborately painted bodies and feather headdresses are presented in a baroque-inspired landscape that leads the viewer's gaze from the dancers in the foreground to the topographical interests of the California hills in the background.

Artists such as Arthur Mathews reimagined California as a

fig. 15. Wilhelm Gottlief Tilesius von Tilenau, (attributed to) Georg Heinrich von Langsdorff, *Dance of Indians at Mission in San Jose, New California*, 1803–7, ink, wash, and gouache. The Bancroft Library, University of California Berkeley

JANE DINI

Cat. 32. Bessie Potter Vonnoh, *The Scarf*, 1908

Cat. 33. Bessie Potter Vonnoh, *The Dance,* 1897

Cat. 34. Paul Manship, *Dancer and Gazelles,* 1916

Cat. 35. Arthur F. Mathews, *Youth,* ca. 1917

fig. 16. John Singer Sargent, *Apollo and the Muses,* 1921, oil on canvas. Museum of Fine Arts, Boston, Francis Bartlett Donation of 1912 and Picture Fund

fig. 17. Robert Altman, *Dance! Hippie Hill, Golden Gate Park, San Francisco,* 1967

new Eden, an Arcadian landscape filled with modern, Anglo-Saxon Bacchantes clad in Grecian chitons and coiffed with flower-adorned chignons. In these pastoral, utopian visions of rural California, dance appears as a kind of historical theater with classical archetypes rather than an exuberant expression of a community's culture. Mathews and his wife / collaborator artist Lucinda were exponents of the Arts and Crafts Movement, which included politically progressive artists who believed that art and design could shape the public good.[21]

Mathews's *Youth* (ca. 1917; cat. 35) depicts the Nine Muses of Greek mythology led by Urania, the muse of astronomy, clanging her symbols in a golden skirt charmingly decorated with the signs of the zodiac, her attribute. In the background, oak trees dot the green recumbent hills, so typical of springtime in Northern California before the region turns a golden brown in summer. In the right foreground, a large multi-colored, purple, red, and white, rhododendron branch sprouts magically like a natural offering to the dancers, bringing to mind Isadora's roses on her New York stage.[22]

The muses gambol across the composition like a vibrant, animated classical freeze come to life, not unlike John Singer Sargent's classically inspired images from the same period. In Sargent's *Apollo and the Muses* (1921; fig. 16), a mural for the Museum of Fine Arts, Boston, the dancing acolytes of Apollo form a circle to honor the god of music. In Sargent's Boston studio, Thomas McKeller, an African American model, dancer, and hotel employee, posed for the heroic male figure. Seen in numerous studies and a photograph, Sargent adopted McKeller's muscular physic for the Greek god but not the color of his skin. The classical past represented in Boston museums and California landscapes remained white, scantily clad, and barefoot.[23]

In a slightly later work, Mathews painted *Dancing Figures on the Beach, Carmel* (private collection), an image of two full-length women, one brunette, one red head dancing on the beach in Carmel-By-the-Sea where outdoor dance played an important role.[24] The seaside community of Carmel had become an artist's colony in the early twentieth century with summer workshops, theater productions, and a dance school headed by Portia Mansfield of the famed Perry-Mansfield

DANCE: AMERICAN ART, 1830–1960

Performing Arts School in Colorado. "Their aim was for a natural and harmonious development of the body. Classes were often conducted on the beach and in the woods, and Carmel figured frequently in San Francisco papers as a result of the scantily clad nymphs tripping sportively about at the edge of the sea or floating like wraiths through the pines."[25]

As the century progressed, this Greek-inspired dance, rousing florid descriptions, would cease to provide pictorial inspiration for American artists. It wasn't until the 1960s that artists captured a revival of sorts. In Robert Altman's photograph *Dance! Hippie Hill, Golden Gate Park, San Francisco* (1967; fig. 17) the male and female dancers exhibit a free, spontaneous dance expressing the spirit of the age, of new beginnings. The natural and harmonious development of these bodies was meant to convey nonaggression and inclusive behavior. In nearly two hundred years, the representation of outdoor dance had progressed from a conformist, community-based pursuit, to a Greek-inspired ideal, to an activity that threatened the status quo. American artists understood that the political underpinnings of dancing out-of-doors should not be dismissed.

Notes

1. *John Sloan's New York Scene, from the Diaries, Notes and Correspondence 1906–1913,* ed. Bruce St. John (New York, 1965), 352.

2. Deborah Jowitt, *Time and the Dancing Image* (Berkeley, 1988). Isadora Duncan and Joan Acocella, *My Life,* rev. ed. (New York, 2013). Dorée Duncan et al., *Life into Art: Isadora Duncan and Her World* (New York, 1993). Ann Daly, *Done into Dance: Isadora Duncan in America* (repr. ed., Middletown, CT, 2010).

3. Bruce Robertson, "Stories for the Public, 1830–1860," in H. Barbara Weinberg and Carrie Rebora Barratt, eds., *American Stories: Paintings of Everyday Life 1765–1915* [exh. cat., The Metropolitan Museum of Art] (New York and New Haven, 2009), 52–53.

4. For more on early social dance, see Joy Van Cleef, *Rural Felicity: Social Dance in 18th-century Connecticut* (New York, 1976). On Durand, see Linda S. Ferber, *Kindred Spirits: Asher B. Durand and the American Landscape* [exh. cat., Brooklyn Museum] (New York and London, 2007).

5. Janice Tolhurst Driesbach, Harvey Jones, and Katherine Church Holland, *Art of the Gold Rush* (Berkeley, 1998), and Alex Nemerov, review of *Art of the Gold Rush,* in *California History* 77, no. 3 (fall 1998): 186–89.

6. Horace Bell, *Reminiscences of a Ranger or Early Times in Southern California* (Santa Barbara, 1927), 199.

7. Lynn Garafola, *Rethinking the Sylph: New Perspectives on the Romantic Ballet* (Hanover, NH, 1997).

8. See Richard Ormond and Elaine Kilmurray, *John Singer Sargent, Figures and Landscapes, 1874–1882* (New Haven, 2006), 168–69.

9. Jerre Mangione and Ben Morreale, *La Storia: Five Centuries of the Italian American Experience* (New York, 1992).

10. See Martha Hoppin, *The World of J.G. Brown* (Chesterfield, MA, 2010), 198–205.

11. David Tatham, "Winslow Homer and the Sea," in Philip C. Beam et al., *Winslow Homer in the 1890s: Prout's Neck Observed* (New York, 1990), 68. Bruce Robertson, *Reckoning with Winslow Homer: His Late Paintings and Their Influence* [exh. cat., Cleveland Museum of Art] (Cleveland, 1990), 33.

12. For more on the Cornish community, see Alma Gilbert-Smith and Judith B. Tankard, *The Artists and Gardens of the Cornish Colony* (Berkeley, 2000).

13. For more on Dewing's politics, philosophical outlook, and aesthetics, see Kathleen Pyne, *Art and the Higher Life: Painting and Evolutionary Thought in Late Nineteenth-Century America* (Austin, 1996), and Susan A. Hobbs, *The Art of Thomas Wilmer Dewing: Beauty Reconfigured* (Brooklyn, 1996).

14. "Topics of the Time," *The Century Magazine* 41, no. 4 (1891): 631.

15. Mary Desti, *The Untold Story: The Life of Isadora Duncan, 1921–1927* (New York, 1929), 17.

16. For more on Robert Frederick Blum's *Moods to Music,* see Royal Cortissoz, "The Making of a Mural Decoration: Mr Robert Blum's Paintings for the Mendelssohn Glee Club," *The Century Magazine* (November 1899): 58–63, and Bruce Weber, "Robert Frederick Blum (1857–903) and His Milieu," PhD diss., City University of New York, 1985, esp. pp. 377–419.

17. I think there is also evidence that this theme was influenced by the theories in *The World as Will and Representation* (1818); see Arthur Schopenhauer, *The World As Will and Idea,* R. B. Haldane and J. Kemp, trans., 3 vols. (London, 1883–86). For Duncan and Schopenhauer, see Daly 2010, 32. Charles Darwin, *The Expression of the Emotions in Man and Animals* (1872), and Nancy Lee Chalfa Ruyter, *The Cultivation of Body and Mind in Nineteenth-century American Delsartism* (Westport, CT, 1999).

18. Ann Cooper Albright, *Modern Gestures: Abraham Walkowitz Draws Isadora Duncan Dancing* (Middleton, CT, 2010).

19. George S. Chappell, "Modern Outdoor Dancing," *Vanity Fair* 7 (January 1917): 55.

20. On Paul Manship and Indian art, see Susan Rather, *Archaism, Modernism, and the Art of Paul Manship* (Austin, 1993).

21. Scott A. Shields, *Artists at Continent's End: The Monterey Peninsula Art Colony, 1875–1907* (Berkeley, 2006).

22. Harvey L. Jones, *The Art of Arthur and Lucia Mathews* (Petaluma, 2006).

23. Isadora Duncan and others, such as the Morgan dancers, were touted for reviving a taste for the antique Greek which was reflected in their movements, costumes, and insistence on performing out of doors, preferably among classical ruins. As such ruins were hard to come by in the United States, dancers performed in architectural settings that approximated the feel of the ancient world. Such sites in the early teens and twenties could be found in and around art museums that had facades built in the style of Greek and Roman temples. Performances were held at the Wadsworth Athenaeum, The San Francisco Legion of Honor, and The Cleveland Museum of Art.

24. Daisy F. Bostick and Dorothea Castelhun, *Carmel at Work and Play* (San Jose, 1925), 65.

25. Ibid.

American Modernism and Dance: Arthur B. Davies's *Dances*, 1915 | *Bruce Robertson*

Arthur B. Davies's *Dances* is a colorful mural that represents two nude dancers, rendered abstractly with prismatic and vivid colors laid over their bodies and draperies (with a third dancer in the background; cat. 36). It is a striking painting and a problem for art historians.

In conventional histories of art, there is almost always a straightforward trajectory from the old to the new, a drive toward modernism, with some lagging behind those who ride the wave of the future or even lead it. In these histories, Davies is a cautionary tale: the artist who organized the Armory Show in 1913, the radical exhibition that brought avant-garde art to the United States and made American art modern, was himself ultimately a reactionary, a painter of confusing, wrong-headed talent whose work is whimsical or even trivial. He tried to "modernize" himself and failed: *Dances,* painted two years after the Armory Show, is emblematic of this failure and, indeed, the failure of so many American artists to "modernize." But seen through the lens of its subject—contemporary, modern dance—a more interesting story emerges, one in which it is not at all clear who wins or loses, who falls behind, or who becomes modern. This is the story I want to tell: the involvement of American visual artists with contemporary dance in the first part of the twentieth century, and how the modern dancing body interested a wide range of artists—a story about dance and modern art rather than style and modern art.

To begin, we must go back well before the Armory Show and consider such artists as Thomas Dewing, one of many who produced idyllic images of women in graceful robes parading across the canvas with slow, rhythmic gestures. Paintings such as Dewing's *Summer* (1890; fig. 1), or Louise Howland King's *A Rondel* (1892; fig. 2), are usually thought of as anti-modern, resisting or turning against the forces that characterize modernity: industrial technology, the rise of wage labor, the tentacles of imperialist power and capital. In fact, however, the image of the beautiful

Cat. 38. Max Weber, *Russian Ballet* (detail), 1916

Cat. 36. Arthur Bowen Davies, *Dances*, 1914/15

woman in a Greek chiton, turning gracefully and naturally with arms falling or rising in rhythm with her movement, rests at the foundation of modern understandings of the body. This vision of ancient Greek dance—for that is what it is—was the most radical image of all.

Richard Wagner, the great totemic figure of modern music and art, proclaimed the ideal of the complete work of art, the *Gesamtkunstwerk,* which revolutionized the ambitions of not just composers but all artists. His ideal art work united music, poetry, and dance in a resurrection of the fundamental unity of Greek tragedy, so that dance was explicitly elevated to the center of artistic endeavor—even if in Wagner's lifetime it fell far short of that.[1] The adoration of Wagner in American circles from the 1880s continued unabated well into the next century: Davies never missed a production.[2] The philosopher Nietzsche, also turning to the study of Greek tragedy, galvanized many artists at the turn of the century by arguing that the Dionysian forces of irrationality and disorder are as fundamental to the nature of art as Apollonian ideals of rationality and order. In Nietzsche's words, the greatest expression of the Dionysian in art is dance: "I would only believe in a god who could dance." And: "I would consider a day lost in which we have not danced at least once."[3] Isadora Duncan, the first great modern dancer, wrote: "I had three great Masters, the three great precursors of the Dance of our century: Beethoven, Nietzsche and Wagner. Beethoven created the Dance in mighty rhythm, Wagner in sculptural form, Nietzsche in Spirit. Nietzsche created the dancing philosopher."[4]

The common thread for all three figures—Wagner, Nietzsche, and Duncan—was ancient Greece. Duncan herself studied Greek vases and sculpture to adapt the poses and gestures she found there to her choreography. In this she was not alone; rather, her work she was simply the latest manifestation of an overwhelming flood of interest in all things Greek. It is impossible to overestimate the importance of this allegiance to ancient Greece in the culture of the day: one could fairly call the nineteenth century the Greek century, from Greek revival architecture at its beginning to Greek dance and theaters at the end and, of course, the founding of the modern Olympic Games in 1894. And one could extend this revival well into the twentieth century, from Art Deco sculpture in the 1920s to Jungian-influenced mythological titles of abstract expressionist paintings in the 1940s. The nature of this interest unfolded over the course of the century, and

fig. 1. Thomas Dewing, *Summer,* 1890, oil on canvas in an original plaster and pine frame. Yale University Art Gallery, Gift of the Estate of Miss Frances L. Howland

fig. 2. Louise Howland King, *A Rondel,* 1892, oil on canvas. High Museum of Art, Atlanta, purchase with funds from the Phoenix Society, 1986.2

BRUCE ROBERTSON

many different evocations of ancient Greece appeared before the public, from Keats's *Ode on a Grecian Urn* to the archaeological and sentimental paintings of Lawrence Alma-Tadema in the last part of the century, to Mark Rothko's abstractions three-quarters of a century later. Each succeeding generation used Greece as a way to inspire a new return to authenticity—a way of revitalizing inspiration and sensibility, clearing the mind and spirit to face the stressful conditions of modernity.[5]

Between the paintings of Dewing and Davies there would appear to be a significant gulf: the one entirely bound up in Aesthetic ideals of beauty and grace, and the other in a jarring attempt to break up the human body into rhythmic fragments. But both are grounded in the same continuously evolving appreciation of the ways in which ancient Greece could be called upon to return us to a natural condition. Both artists are engaged in the same enterprise: to understand the new American body through contemporary dance movement.

By the 1890s, the American body was understood to be in perilous condition, a victim of the "American disease" of nervousness. George Beard, the doctor who was the major promoter of this idea, claimed that the body had a fixed and limited amount of nervous energy, and that the stress of U.S. civilization caused modern Americans to expend their nervous force more than any other nation. The causes were manifold and expanding: "The invention of printing, the extension of steam power into manufacturing interests and into means of conveyance, the telegraph, the periodical press, the political machinery of free countries, the religious excitements that are the sequels of Protestantism...and perhaps more than all, the heightening and extending complexity of modern education...."[6]

For men the solution to this problem was obvious: manly, mostly outdoor, exercise, as we can see in the work of Winslow Homer and Thomas Eakins, or in the actions of Theodore Roosevelt. For women there was another answer, expressed in new regimens of physical culture especially designed for the ladies, for the most part derived from the work of the French musician and educator François Delsarte. Delsarte's theories of the relationship of body and gesture were transformed and popularized in the United States by a number of American followers. Genevieve Stebbins became perhaps the most influential, by marrying Delsarte's ideas about gesture to a system of gentle exercise and edifying culture. Stebbins and others like her had a tremendous influence on the general understanding and public presentation of American women in elite, high culture, and health-conscious circles (while realizing that on the commercial dance stage pirouettes, backbends, high kicks, and skirt dances were still the staple diet).

Two Delsartian principles and activities, pioneered by Stebbins, laid the groundwork for Duncan. The first was an emphasis on the natural body, healthy dress, and movement: women needed to ditch the corset and regain their health. The second was the odd phenomenon of statue-posing, whereby young women displayed their success in liberating their bodies from social convention through the ennobling imitation of ancient Greek sculpture. Swathed in white draperies, slippered or in bare feet, and hair loosely bound up, women would assume the poses of famous statues, a living tableau of ancient Greece, moving in slow, graceful rhythms.[7] Ruth

St. Denis, Duncan's greatest American dance contemporary, recalled seeing Stebbins: "There stood an exquisite woman in a costume made of soft ivory-white material that fell in gracious lines to her feet.... She moved in a series of plastiques which were based upon her understanding of the laws of motion discovered by Delsarte [with] a lovely childlike movement,... a light rhythmic step."[8] As late as 1954, Ted Shawn, St. Denis's dancing partner and half of Denishawn, the first successful modern dance company in the United States, would publish a book about his devotion to the ideas of Delsarte.[9]

The key to all these efforts was the iron-clad linkage of the "natural" body with the ancient Greeks. Perhaps the most often repeated was the claim of learning to dance naturally by studying Greek sculpture and vases, especially in the Louvre, a claim that virtually every artist or performer interested in the modern body seems to have made: on the one hand, there are serious books like Maurice Emmanuel's much copied volume *The Antique Greek Dance after Sculptured and Painted Figures* (first published in French in 1895, and translated into English in 1916), and on the other the anecdotes of Léon Bakst taking Vaslav Nijinsky to the Louvre to prepare him for *L'Après-midi d'un faune* in 1912. The reciprocal relationship between the visual arts as the foundation for natural dancing and dancing for reinvigorating the visual arts was hardwired from the beginning. As the dancer Maud Allan declared to her public in London in 1908, the role of the dancer is to translate the composer's thoughts into visibility: that is, the same role that modern painting had undertaken. Allan wanted the audience to forget that it is a body they were seeing, but rather "the finely shaded vibration of a soul,"[10] terms not so distant from those used by Kandinsky and others.

A return to Greek dance contributed both a means to escape the stress and to repair it: "It would be a most gratifying result if our young women who are so intent on their careering that they are becoming pale, nervous, and awkward could be persuaded to enroll in an intelligent course of aesthetic exercises—or, if you will, of dancing," declared Dudley Sargent, the Harvard-based leader of the physical culture movement in America, in the *New York Times* in 1909. "In our everyday habits of living and in our methods of educating children we are going back slowly but surely to the simple practices of the Greeks." His article is subcaptioned: "Aesthetic dancing, by girls in good condition, is equivalent to a walk of ten miles."[11]

Thomas Dewing began his successful career as an artist painting women in Greek dress reclining on marble benches, very much in the mode of the British artist Alma-Tadema. During the 1880s and sometimes later, he was pegged as a follower and neo-Greek.[12] The flowing draperies of the costumes that his pensive seated women wear were based on Greek models, as he wrote to a friend.[13] For Dewing, the Greekness of his models was part of a larger aesthetic project, one that marked nearly every aspect of his domestic life (and the basis for his subjects).[14] Especially in the summer colony of Cornish, New Hampshire, of which Dewing was the principal figure, every aspect of the experience seems to have been subjected to aesthetic considerations; the women, in particular, actively representing themselves as art objects, as they organized dinner parties, musical soirees, masques, and picnics.[15] Maria Oakey Dewing, noted as the regal and

elegantly imperturbable head of the enterprise, could even demonstrate how to ride a bicycle successfully in an evening gown. The Dewings, as was true for all of aesthetic Boston, it seemed, were devoted to Wagner; indeed, the Dewings used him therapeutically, losing themselves in the oceanic depths of his music by visiting Bayreuth after the death of one of their babies.[16] Cornish represented their *Gesamtkuntswerk*.

Dewing's *Summer,* set in this aesthetic idyll, shows four women gracefully dancing to the harp played by another; all are in softly flowing evening gowns in a verdant green field and woods. The movements are perhaps derived specifically from a Virginia reel, with hints of Botticelli's *Primavera* or a Watteau *fête galante* in both the pictorial idea and motifs, as Susan Hobbs suggests, and the women are probably corseted. But these figures are set firmly in the matrix of American Delsartism: Greek-like dress, natural movement, aesthetic poses.[17] Howland King's *A Rondel* (1892) represents another phase of the Aesthetic Movement's assimilation of Greek dance but now heavily medievalized: distinctions between ancient Greece and the Middle Ages were seldom made in such fantasy pictures; both served to represent equally well the desire to depict unfettered, natural movement. However, as Kathleen Pyne has emphatically pointed out, Dewing's women are ultimately valorized as highly evolved but nonetheless aesthetic objects.[18]

Arthur Mathews's *Youth* (1917) represents a particular West Coast version of Dewing's vision, a region where Greece itself seemed to come alive again. Not only was California's climate Mediterranean and its culture open to health movements, it seemed to produce the most devoted followers of Greek ideals in America. A leading venue for this revival was the Greek Theater at Berkeley, which featured presentations of Greek tragedy with chorus and dance. Perhaps the most famous of these was Denishawn's production of *The Pageant of Egypt, Greece, and India* in July 1916, with a cast of 170 performers; Mathews's painting may well have been inspired by it.[19] By this time as well, a California girl, as she was generally called by the American press, had become the epitome of good, healthy American looks and the new avatar of Greek or natural dancing: Isadora Duncan.[20]

Duncan's contribution was certainly not limited to her presentation of her choreography as a revival of Greek dance. While her major influence may well have been in Europe, where she was painted by any number of artists, and arguably influenced Mikhail Fokine's choreography for the Ballets Russes, her innovations touched on a wide range of concerns in the United States.[21] At the heart of her power was certainly her choreographic influence: an entirely new way of moving the dancing body, the radical move of dancing to the music of major composers (Shubert, Beethoven, Chopin, Wagner). But the sight of her, the first significant barefoot dancer, clad in a light tunic, running and skipping with fluid ease across an empty stage, presented for the first time a liberated, natural woman's body as a public object to scrutinize and emulate. As Dudley Sargent commented: "She has taken the simple acts of tossing, throwing, bending, stooping, walking, running, hopping, skipping, leaping and whirling with which we are all so familiar, and infused them with new life and meaning. She has idealized motion and made motion music." This body was specifically an American body. As Duncan herself argued: "The real American

type can never be a ballet dancer. The legs are too long, the body too supple...A tall finely made woman could never dance the ballet."[22]

Duncan first came to public attention in Europe with recitals in London in 1900. Her first New York performances were in 1908, with subsequent appearances in 1909, 1911, 1915, and several times later, her choreographic vision evolving and becoming more ambitious with each return. Her first dances were to short pieces by Chopin and Schubert, but by 1910 she was performing to Beethoven's *Seventh Symphony* and excerpts from Wagner's *Tristan and Isolde* and *Die Meistersinger von Nürnberg,* and to settings of Greek tragedy, moving from Gluck's *Orfeo* and *Iphigenia in Tauris* to a production of Sophocles's *Oedipus Rex* by 1915. Artists flocked to see and meet her when she first returned to New York. The most infatuated was probably Abraham Walkowitz, who seems to have recorded every movement Duncan made on stage in thousands of drawings (fig. 3), but everyone from Robert Henri to John Sloan raved about her, Davies along with the rest (he sketched her and also produced a painting of her dancers onstage in 1917).[23]

fig. 3. Abraham Walkowitz, *Study of Isadora Duncan,* early 20th century, pen and black ink on cream wove paper. Detroit Institute of Arts, F1988.16

Duncan was by no means the only such Greek dancer on the New York stage: Maud Allan, another Californian, was her greatest competition, but there were many other rivals and imitators.[24] By 1916 a reviewer in the *New York Times* could comment with ennui: "Almost every variety program has its corps of more or less draped dancing maidens, disciples of these pioneers [Duncan and Allan], and there are schools to promote the bare-foot dances at every side." Even the first performances of the Ballets Russes early that year were viewed through the same lens: *L'Après-midi d'un faune* was treated rather dismissively, although the reviewer noted that "the figures move deliberately and always in the poses of antique Greek vases. The face turned profile and the peculiar angle of arms and legs were very characteristic and effective."[25] And it might be noted that Arthur Davies's mistress, who had trained professionally as a dancer before modeling for him, clearly placed herself in the Greek camp: Edna Potter published a treatise on Greek dancing in the 1920s.[26]

Dance, as exemplified by Duncan and others, contributed more than a renewed visual language of poses and gestures in a thrilling enactment of the modern natural and American body in action; it also affirmed a new fundamental modality of modern perception: rhythm. The concept and the term "rhythm" dominated cultural discourse from this period.[27] The sociologist

BRUCE ROBERTSON

fig. 4. Morgan Russell, Study for *"Synchromy in Blue-Violet,"* 1912/13, oil on paper. The Jan T. and Marica Vilcek Collection, 2010.04.04

fig. 5. Stanton MacDonald-Wright, *Arm Organization*, 1914, oil on canvas. Museum of Fine Arts, Houston, Museum Purchase

Herbert Spencer, for example, argued that evolutionary forces were always in motion, that the equilibrium was never a stable state, but that the balance of antagonistic forces was achieved rhythmically, just as the seasons turned through the year.[28] A reaction to the great speed and perceived chaos of modern existence, rhythm imposed order and direction, giving coherence to chaotic energy. Artists, both European and American, used the term frequently to describe their goals. The painter Morgan Russell, for example, declared that he was looking for "rhythm in color" in order to reflect "intensely *le rhythm* of our time."[29] Understandably, dance provided a common and fundamental organizing principle to the propulsive energy of modern life, the spiral. Hillel Schwarz has written on torque and spiral as the quintessential modern movements.[30] American artists played a pivotal role in this development, especially in dance, from Loïe Fuller's Serpentine Dance of 1890 to Katherine Dreier's claim in 1933, writing about Ted Shawn, that "the American continent's great contribution [is] the spiral form of rhythm."[31] This spiral rhythm was fundamental to the first self-conscious American modern art movement, synchromism, as promoted by its founders Russell and Stanton MacDonald-Wright. They, too, came to understand the primary nature of the spiral through dance. A revealing sketch by Russell for his first major statement of synchromism, *Synchromy in Blue-Violet,* 1913—a mural-sized painting larger than 10 by 7 feet—represents Isadora Duncan in motion, reduced to a few curving lines (fig. 4). Russell found the same forms in Michelangelo: for him, as for Duncan, Michelangelo represented a bridge between natural movement and the validation of high culture. MacDonald-Wright's *Arm Organization* (1914; fig. 5) similarly focuses on the spiral movement of an arm reaching out.

DANCE: AMERICAN ART, 1830–1960

Paris was much more of a hotbed for modern dance than New York, with the first Ballets Russes performances there in 1909; the United States had to wait to see them until 1916. Small avant-garde art journals devoted issues and published articles on modern dance frequently; Loïe Fuller had a theater built for her, and the new Théâtre des Champs-Élysées was decorated by Antoine Bourdelle with images of Nijinsky and Duncan.[32] Anne Estelle Rice, a young American expatriate like Russell and MacDonald-Wright, explored this new world of sensation through the liberating color of fauvism. Her figure paintings feature heavy-lidded sensual and exotic women, and she found in the Ballets Russes a vivid expression of her interest in rhythms that were embodied rather than mechanical, as the real core of the modern experience. She wrote in 1913 of her desire "to express a greater force, a harmony of sex of an object for an object." During these same years she contributed essays and drawings (including one on the Ballets Russes) to *Rhythm,* a journal devoted to "rhythm as a universal principle."[33]

Featured in the first performances of the Ballets Russes was the heady confection *Cleopatre,* a rich mélange of exoticism and sex, with Ida Rubinstein at its center enticing a young man to a night of wild love and then killing him (a real femme fatale!). The ballet inspired Rice's large painting *Egyptian Dancers* of the following year, a fauvist homage to the orgiastic splendor of the ballet (cat. 37). The well-known American illustrator Troy Kinney, writing in 1914, paid homage to the revolutionary quality of just this connection between dance and Orientalism, a major component of Ruth St. Denis's choreography, as well. After acknowledging the emotional truth brought by Duncan, he argues that we are living in an age of a new Renaissance, in which dance will be the force that inspires culture to new heights. He enumerates the elements of the scene: the "classic dancers, dancers interpreting certain musical compositions, dancers showing the characteristic dances of foreign lands, especially of the East, dancers of every variety and shade of proficiency." The "two great factors [are] Russian ballet and the influence of the Orient," which overlap when the Russians do oriental ballets.

> This is what makes the dance the thing of the hour, for the dance is of its very nature subtle, reaching its emotional effect by the channels of the imagination; by its ability to suggest and to stimulate the aesthetic sense.... We shall have cause for rejoicing if we let the dance play its full share in the period of artistic renaissance in which we are fortunate enough to be living.[34]

Max Weber got to see the Ballets Russes when they finally performed in New York in 1916.[35] Like so many others, he was utterly captivated, but he saw the Ballets Russes largely as part of the whole extraordinary efflorescence of dance in New York City in these years, along with Duncan and St. Denis, vaudeville, and dance clubs. His painting *Russian Ballet* (cat. 38), full of cubist pyrotechnics, focuses on the dancing figures at the center of the scene, perhaps a memory of *Daphnis and Chloe* or *Petrouchka* (two of the ballets on the program he saw with Davies);[36] the knot of forms at the center of Weber's painting are not so different from Russell or Macdonald-Wright's abstractions. For Weber, the Ballets Russes is part of the panorama of New York, wit-

Cat. 37. Anne Estelle Rice, *The Egyptian Dancers (Two Egyptian Dancers)*, 1910

Cat. 38. Max Weber, *Russian Ballet*, 1916

nessing the deep mark that modern dance had made on the city in the space of the few years since Duncan's first performances a decade earlier. His Ballets Russes painting is part of a program of paintings that capture the things that delighted this New Yorker and spelled modernity to him: Chinese Restaurants, the subway, skyscrapers, vaudeville—part of the patterns and rhythms of movement in the modern metropolis.

The years immediately after the Armory Show were a competitive period for New York avant-garde artists, much like the lively and quickly changing dance scene: how were they going to negotiate at such a distance the radical and radically different styles that were occurring in Europe? Would fauvism and Matisse (whose dancing figures had appeared in the Armory Show) win the day? Or cubism, especially as exemplified by Marcel Duchamp and Francis Picabia, both actually in New York? (Picabia's *Dances at the Spring,* 1912, had been exhibited as well.) Kandinsky and expressionism? The futurists? Or synchromism, first seen in New York in March 1914, in an exhibition organized by Davies.[37]

Davies's paintings before the Armory Show had for the most part depicted softly painted and idealized studies of nude young women, drifting in stylized poses across the canvas. To our eyes they look as unembodied as Dewing's women. But to contemporary audiences they were insistently modern. According to a reviewer of Davies's work in 1914:

> Nude in soul as well as in body, the figures are made to respond to complex modern emotions in a simple, primitive way. No Greek and no artist of the Renaissance would have illustrated the pretty myth of Hylas and the Nymphs quite as Davies has done.... It is a splendid evocation of the modern spirit. It is easy to read into it the woe and the unrest and the inarticulate desire of Twentieth Century women.

He then goes on to compare figures to Ibsen's Hedda Gabler and the Russian actress Alla Nazimova, as well as Euripides's Trojan women.[38]

Davies had been at the center of avant-garde activities in New York since the Armory Show, so that when *Dances* was exhibited in March 1915, it was a prominent public proposition on a monumental scale, one centered on a new vision of the American body. Beginning soon after the Armory Show ended, Davies began exhibiting his new works to largely sympathetic, even flattering, reviews.[39] Building a synthesis of cubism, synchromism, and the color and proportional theories of Hardesty Maratta (who, in turn, claimed to have recovered ancient Greek ideals), Davies forged a distinctive style.[40]

In the summer of 1914, Davies had been commissioned by one of his major patrons, Lillie P. Bliss, later a founder of the Museum of Modern Art in New York, to paint murals for her music room, "the first murals by any American modern," according to Walt Kuhn. This first set of murals inspired a second, uncommissioned group. Along with Maurice Prendergast and Kuhn, Davies exhibited these in the spring of 1915, entitling his contribution "New Numbers, Decoration, Dances." The painting remained on display for another month, included with other works

of "modern art applied to decoration" by more conservative artists (like William Glackens) and more advanced (like Charles Sheeler, Morton Schamberg, and Man Ray). The murals were then bought by John Quinn, the leading collector of contemporary art in New York and the lawyer behind the Armory Show.[41]

Dances includes three figures moving aggressively within the space. One rushes in from the right, her left leg raised and her torso spiraling back, draperies fluttering from her hands; another occupies the center left: she is stepping and leaning forward, her drapery held in her right hand as she winds it around her left arm. Behind these two, a third figure strides off the canvas to the left. These are Maenads or Bacchantes from the mold of Duncan (although the pose of the front-most figure is not closely based on her choreography), as much Greek figures as contemporary bodies, yet long-limbed and American.

Davies clothes the figures in prismatic colors rather than dismantling them cubistically. The critic Frank Jewett Mather describes this exactly: "a reinforcing of the old strong rhythm of contours by a new interior rhythm…[carrying] the incoming curves of the figures across the forms, the intersections of these refluent curves forming a vigorous network, certain meshes of which could be enlivened by abstract tone or color." Adjectives such as "unrestrained" and "exuberant" are used by other critics.[42] But even his most ardent supporters were hesitant to go as far as Davies had: as Mather later declared, "the most audacious realization of the endeavor was in

fig. 6. Man Ray, *The Rope Dancer Accompanies Herself with Her Shadows*, 1916, oil on canvas. Museum of Modern Art, gift of G. David Thompson

BRUCE ROBERTSON

two large panels of madly dancing figures shown about nine years ago at Montross. Here the veil was as garish as a tartan, and as stimulating, [but] less satisfactory than those that preceded and followed."[43] Tartan is never something one wants to see in serious painting. Davies's decision to turn away from his radical synthesis of cubism and synchromism might possibly be seen as a prophetic one: returning to neo-classicism a full two years before Picasso and other cubist leaders. But it is hard not to see his decision as a largely commercial-driven response instead. Simply put, Davies's earlier style remained more popular, and it was unclear that his work had gained anything relevant to its goals when pressed through an avant-garde sieve.

With Man Ray's *The Rope Dancer Accompanies Herself with Her Shadows* (fig. 6), painted only a year later than Davies's *Dances,* we enter a different world. Ray's painting may be read as a wholehearted rejection of the path that Davies was attempting to forge, the attitude of an advanced, younger generation as brutal and witty as Duchamp's *Fountain* exhibited the following year. Ray's painting was inspired by a rope dancer in a vaudeville act, a working-class exhibition as far from the high-minded dances of Duncan as possible. Instead of a natural woman grounded by her bare feet in nature, uncorseted and free, with a dramatically heaving torso, the rope dancer is dainty and precise in her movement, entirely artificial, with a torso kept as rigidly balanced as possible, and outfitted in a tutu and tights—essentially, a ballerina on a rope.[44]

Ray made the decision to depict a rope dancer as a self-conscious rejection of the high-toned dancing found on the Metropolitan Opera stage, but as he drew the dancer and attempted to start the canvas, he found himself frustrated. His working method was also self-consciously a rejection of a normal painting process: he was cutting out silhouettes of the dancer instead of drawing them. But the results were boring and trivial. Glancing at the scattering of paper fragments on the floor—the backgrounds rather than the figures themselves—he found them to be much more interesting. In the final canvas, the rope dancer is a twinkly, tiny form at the top, tied to her colorful shadows that surround her. The colors themselves are deliberately unlovely in their choice and arrangement, as Ray stated later.

Ray's position in the art world at the time was that of a junior insider. He was supported by the dealers, included by Davies in exhibitions, and his work even appeared alongside Davies's *Dances*. He was frequently favorably praised by the critic Willard Wright, Stanton MacDonald-Wright's brother and the leading apologist for synchromy.[45] Discussing the creation of *The Rope Dancer* in his memoirs, Ray implicitly acknowledged that his starting point had been synchromist: "each [sketch was] on a different sheet of spectrum-colored paper, with the idea of suggesting movement not only in the drawing but by a transition from one color to another."[46] Synchromy and the place of color in contemporary painting was still in his mind nearly fifty years later.

But there's more to the painting than simply the radical stance of a younger generation. Sharyn Udall has advanced the most interesting interpretation, that Ray uses the rope dancer and her shadows as a metaphor for the goal of the modern artist not to reproduce nature but to produce a new reality: instead of imitating the rope dancer and her actions, Ray produces new forms, rising to the quintessential challenge of modernism, much like Duchamp would with *The*

fig. 7. Marcel Duchamp, *The Bride Stripped Bare by Her Bachelors, Even (The Large Glass)*, 1915–23, oil, varnish, lead foil, lead wire, and dust on two glass panels. The Philadelphia Museum of Art, Bequest of Katherine S. Dreier

fig. 8. Charles Demuth, *In Vaudeville: Acrobatic Male Dancer with Top Hat*, 1920, watercolor, graphite, and charcoal on wove paper. The Barnes Foundation, BF1199

fig. 9. Elie Nadelman, *Tango*, ca. 1920–24, painted and gessoed cherry wood. Whitney Museum of American Art, New York; purchase, with funds from the Mr. and Mrs. Arthur G. Altschul Purchase Fund, the Joan and Lester Avnet Purchase Fund, the Edgar William and Bernice Chrysler Garbisch Purchase Fund, the Mrs. Robert C. Graham Purchase Fund in honor of John I. H. Baur, the Mrs. Percy Uris Purchase Fund, and the Henry Schnakenberg Purchase Fund in honor of Juliana Force, 88.1a c

Bride Stripped Bare by Her Bachelors, Even (The Large Glass) (fig. 7). Udall also detects possible references to Duncan.[47]

Man Ray's deeply ironic attitude toward the American body, for all the power of the painting and the ones that followed it in the next few years, was not one commonly followed by American artists. Instead, the postwar generation reveled in the freedom from convention and the rebelliousness embodied in jazz and vaudeville. Charles Demuth's watercolors of the cabaret and circus scene are representative of this new interest (fig. 8), as is Elie Nadelman's *Tango* (fig. 9). In contrast, Duncan's revulsion and fear of jazz are vividly conveyed by her remarks in her essay "I see America Dancing":

> [It is] monstrous for anyone to believe that the Jazz rhythm expresses America. Jazz rhythm expresses the South African savage.... Long-legged strong boys and girls will dance to this American music — not the tottering, ape-like convulsions of the Charleston [cat. 39]... and this dance will have nothing in it either of the servile coquetry of the ballet or the sensual convulsion of the South African negro. It will be clean.[48]

But by 1920 her radical gestures were ripe for dethronement. The effects of World War I had made the notion of the whole body, pure, natural, and uncorrupted, an almost laughable notion. Now what was wanted was the jazz body.

However, Katherine Dreier, the great patroness of radical art in America, may have the last word. In discussing Ted Shawn, she makes a distinction between those who experience the highest beauty of music and nature as a clear note — Pavlova — and those who experience it as rhythm — Shawn. Rhythm is more fundamental than melody and Shawn, through his birth in the American West, has been able to express the "rhythm of various nations," but most particularly

BRUCE ROBERTSON

Cat. 39. Frank Myers, *The Charleston*, 1926

his own. While Duncan expressed Greece and St. Denis expressed the Orient, Shawn expresses America: "American dance has reawakened the world." And this is best expressed in male dancing: "It is this upward swing of sustained joy, the spiral movement, which is essentially the gift of the American continent to the world, which finds such a full rich expression in Shawn."[49]

To accompany her words, Dreier painted an "abstract psychological portrait" of Ted Shawn in 1929 (fig. 10). Circling forms dominate the picture, representing in two-dimensions the space-filling rhythms of Shawn's form moving out from the center to control the space. The arrow cuts up across the canvas diagonally from left to right, indicating the direction Shawn's rhythm will take us, while cast in the background on the lower right are the squares and boxes left behind.

Dreier's emphasis on the psychological, rather than the natural, prepares us for the work of Martha Graham and the surrealists, the next generation of artists and choreographers. The references to ancient Greece survive, especially in the work of Graham (another California girl and trained by Ted Shawn), but the claims are no longer made to make a case for the natural, for a vision of dance growing like a tree out of the chorus of Greek tragedy, but for tragedy itself, a fact only too well known in Europe and America by mid-century.

fig. 10. Katherine Dreier, *The Psychological Abstract Portrait of Ted Shawn,* 1929, oil on canvas. Munson-Williams-Proctor Arts Institute, Utica, Purchased in honor of the Museum's current and former docents 96.29

BRUCE ROBERTSON

Notes

1. See, for example, Juliet Koss, *Modernism after Wagner* (Minneapolis, 2010), xiii.

2. Bennard B. Perlman, *The Lives, Loves, and Art of Arthur B. Davies* (Albany, 1998), 288.

3. Nietzsche, *The Birth of Tragedy*. For a passionate account of dancing's importance for Nietzsche's philosophy, see Horst Hutter, *Shaping the Future: Nietzsche's New Regime of the Soul and Its Ascetic Practices* (Lanham, MD, 2006), 180ff.

4. Isadora Duncan, "I see America dancing," in *The Art of the Dance,* ed. Sheldon Cheney (New York, 1928), 48.

5. See, for example, Helene P. Foley, *Reimagining Greek Tragedy on the American Stage* (Berkeley, 2012). Foley lists major productions of Greek tragedies in the New York area in the mid-teens, pp. 34, 40, 48. She discusses Duncan, pp. 81–83, and dance generally, pp. 80–96.

6. George M. Beard, *American Nervousness* (New York, 1972; 1881 ed.), 99–100.

7. Genevieve Stebbins, *Delsarte System of Expression* (New York, 1977; reprint of 6th ed., 1902), 459, 464. Stebbins taught "esthetic gymnastics," derived from Delsarte, the Swedish or Ling system of physical exercise, and the "communal form of Oriental prayer" (p. 400).

8. Quoted in Nancy Lee Chalfa Ruyter, *Reformers and Visionaries* (New York, 1979), 23–34. For an extended discussion of Stebbins' influence, see Suzanne Shelton, *Divine Dancer: A Biography of Ruth St. Denis* (New York, 1981), 13ff.

9. Ted Shawn, *Every Little Movement…* (Pittsfield, MA, 1954).

10. "Miss Maud Allan on London and Dancing," *New York Times,* May 3, 1908, SM4.

11. Dudley A. Sargent, "Modern Dances as Athletic Exercise," *New York Times,* Jan 3, 1909, SM7.

12. William Howe Downes and Frank Torrey Robinson, "Later American Masters," *The New England Magazine* 14 (1894): 134. See also Clarence Cook, *Art and Artists of our Time,* vol. 6 (New York, 1886), 288.

13. Susan A. Hobbs, *The Art of Thomas Wilmer Dewing: Beauty Reconfigured* [exh. cat., Brooklyn Museum of Art] (New York 1996), 138.

14. As Frances Grimes commented, everything was pictorial, and seen as artistic. Frances Grimes, "Reminiscences," in *A Circle of Friends: Art Colonies of Cornish and Dublin* [exh. cat., University Art Gallery, University of New Hampshire] (Durham, NH, 1985), 63.

15. See Frances Mary Steele and Elizabeth Livingston Steele Adams, *Beauty of Form and Grace of Vesture* (New York, 1892), 200ff. They stress the importance of Greek costume as a standard for beautiful dress.

16. Kathleen Pyne, *Art and the Higher Life: Painting and Evolutionary Thought in Late Nineteenth-Century America* (Austin, TX, 1996),155.

17. The Steeles recognize that Greek dress is an ideal and value any slim-profiled dress as good enough.

18. Pyne 1996, 188ff.

19. Suzanne Shelton, *Divine Dancer: A Biography of Ruth St. Denis* (Garden City, NY, 1981), 134–36.

20. See Ann Daly, *Done into Dance: Isadora Duncan in America* (Bloomington, IN, 1995), and Doree Duncan et al., *Life into Art: Isadora Duncan and Her World* (New York, 1993).

21. "Modern Dances Held to Mean A Modern Renaissance," *New York Times,* May 3 1914, SM5. Interestingly, the Kinneys treat Duncan and the Ballets Russes under the same heading, "The Romantic Revolution," in their book. They acknowledge Fokine's profound debt to Duncan, who danced in Saint Petersburg in 1904, and reproduce a photograph of Duncan and Pavlova in Greek dress in sequence. See Troy and Margaret West Kinney, *Dance: Its Place in Art and Life* (New York, 1914), 246. For an account of Duncan's influence on visual artists, see Duncan et al. 1993.

22. Duncan 1928, 49.

23. Elizabeth Sussman, "Rhythm and Music in the Frieze Paintings of Arthur B. Davies," in *Dream Vision: The Work of Arthur B. Davies* [exh. cat., Institute of Contemporary Art] (Boston, 1981). Robin Veder's

work on Davies is fundamental: see "Arthur B. Davies' Inhalation Theory of Art," *American Art Journal* 23, no. 1 (2009): 56–77; and " Modern Motives: Arthur B. Davies, 'Continuous composition,' and Efficient Aesthetics," in *Modern Movement* [exh. cat., Maier Museum of Art, Randolph College] (Lynchburg, VA, 2013).

24. The reviewer notes that Allan is not appearing in Salome, her famous dance, but in Greek dances, with which New York audiences are familiar through Duncan, Loïe Fuller's dancers, and the ballet in Gluck's *Orfeo* then at the Metropolitan Opera. He adds that her poses, which are described fully, are "presumably inspired by a study of Greek vases." "Maud Allan in Greek Dances," *New York Times,* January 10, 1910, p. 11.

25. "Russian Ballet in a Pastoral Work," *New York Times,* January 19, 1916, p. 12.

26. Edna Potter Owen, *The Quality of Greek Movement, or the Truth of Rhythm in Human Expression* (Carrara, 1929).

27. See Hillel Schwarz, "Torque: The New Kinaesthetic of the Twentieth Century," in Jonathan Crary and Sanford Kwinter, eds., *Incorporations* (Cambridge, MA, 1992), 81.

28. Herbert Spencer, *The Principles of Sociology* (London, 1896).

29. Gail Levin, *Synchromism and American Color Abstraction 1910–1925* [exh. cat., Whitney Museum of Art] (New York, 1978), 12, 16 (1909 and 1913, respectively).

30. Schwarz 1992, 71–125.

31. Katherine S. Dreier, *Shawn The Dancer* (London, 1933), 13.

32. See the journal *Montjoie!,* with illustrations by Russell in 1914. Levin 1978, 45.

33. Quoted in Carol A. Nathanson, *The Expressive Fauvism of Anne Estelle Rice* (New York, 1997), 18, 20–21.

34. Kinney, in *New York Times,* May 3, 1914, SM5.

35. For Max Weber in this decade, see Percy North, *Max Weber: The Cubist Decade 1910–1926* [exh. cat., The High Museum of Art] (Atlanta, 1992), 27, 45, n. 11.

36. North 1992, 39.

37. Perlman 1998, 241.

38. John Cournos, "Arthur B. Davies," *Forum* (May 1914): 770. See Robin Veder's illuminating analyses of movement and rhythm in Davies art, cited above, note 23.

39. Perlman 1998, 238–49.

40. Ibid., 240.

41. Ibid., 261, 263.

42. Ibid., 263.

43. Frank Jewett Mather, *Estimates in Art* (New York, 1931; orig. pub. 1916), 327–38.

44. But also see Jacques Villon's *L'Equilibriste,* 1913 (both oil painting and drypoint) for another cubist image of a tightrope walker. Reproduced in R. Stanley Johnson, *Cubism and La Section d'Or* (Seattle, 1991), 144.

45. See, for example, reviews by Wright in *Forum* (January 1916): 29.

46. Man Ray, *Self Portrait* (New York, 1963), 60.

47. Sharyn R. Udall, *Dance and American Art: A Long Embrace* (Madison, WI, 2012), 214–15.

48. Duncan 1928, 49.

49. Dreier 1933, 5, 11–12.

Anna Pavlova in America: Performance, Popular Culture, and the Commodification of Desire | *Sharyn R. Udall*

On the wintry afternoon of February 12, 1910, dozens of New York reporters and photographers waited in an overheated room for a press conference with a pair of newly arrived Russian dancers. Expected any moment was the ballerina Anna Pavlova, appearing with her new partner Mikhail Mordkin, at the start of a two-month trip to America. While waiting for Pavlova, reporters mused on what they knew about her, gleaned largely from a raft of advance publicity: here was the *prima ballerina assoluta* who, in the company of the legendary impresario Serge Diaghilev, had led the Imperial Russian Ballet's diaspora from Saint Petersburg to Western Europe. In Paris, Diaghilev had paired her with Vaslav Nijinsky for the first Ballets Russes season of 1909 (fig. 1).

That explosive debut had brought the Russian stars international notice and glowing reviews as they toured other European capitals. One London critic spared no superlatives: "Nothing like [Pavlova's dancing] has been seen before in the London of our time.... Pavlova and the Russian dancers of the present moment... have given us Londoners something really new: an extraordinary technical accomplishment, an unfailing sense of rhythm, an unerring feeling for the elegant in fantasy.... The dancing of Anna Pavlova is a thing of perfect beauty."[1]

fig. 1. Anna Pavlova and Vaslav Nijinsky in *Le Pavillon d'Armide, Russia*, ca. 1907, published in *Comoedia Illustré,* May 1909. New York Public Library

fig. 7. Malvina Hoffman, *Pavlova Dancing the Gavotte,* 1915, bronze. Detroit Institute of Arts, gift of George G. Booth, 19.54

Fortified with such plaudits, the twenty-nine-year-old Pavlova, after only a single season with Diaghilev, seized the moment to strike out on her own.[2] Fresh from her stunning successes in Paris and London, she decided to risk her reputation in a high-stakes gamble: bringing Russian ballet, a largely unknown quantity, to America. Thus, with her new partner Mordkin, a corps of young dancers, and several tons of stage sets and costumes, Pavlova braved a rough February North Atlantic crossing, during much of which she was confined to her cabin from seasickness.

In 1910, ballet was still poorly understood in a land where few had been exposed to its arcane terminology and technique.[3] Americans had a long way to go before they could comfortably distinguish a *plié* from a *pirouette,* a *grand jeté* from a *glissade.* Even the dancer's names were challenging: how, for example, did one spell or pronounce a name that was variously recorded as Pavlova, Pavlowa, Pavlouva, or Pavlov? Could her partner's first name be simplified from Mikhail into Mike? (No! came the resounding answer from Mordkin).

Clearly, Americans, before they could fully appreciate ballet's finer points, had to be shown how to describe, judge, and appreciate it. Pavlova prepared herself for a campaign that would educate this untapped new public about ballet's standard repertoire, its disciplined system of movement, and its enduring viability as an art form superior to its rivals, chiefly the exploding modern dance movement. Thus, Pavlova appointed herself as a kind of roving ambassador for ballet, working to integrate it into American culture. What she could not then imagine was the depth to which she would immerse herself into the nation's cultural life—both high and popular—and the extent to which she would endear herself to its people.

On the fall 1910 tour, Pavlova and company, after initial October performances in New York, would zig-zag by private train to cities large and small throughout North America. They would play the largest auditorium in each city, usually staying only one night. In the course of ten weeks, the train would take them to Boston, Chicago, Saint Louis, and many more cities. By January 1911, the troupe had reached Detroit, where the audience responded warmly to Pavlova's *Giselle,* and local critics declared her a supreme artist.

Over the next five years, with a changing cast of partners, Pavlova's passionate leaps and graceful poses thrilled thousands from coast to coast. Her American tours became a substantial component of a career that would span three decades, during which she logged more than 400,000 miles by train and steamer. Over time, audiences were becoming educated about ballet and about Anna Pavlova, on whom they bestowed unreserved applause and frequent adoration. A certain "fantasy" element, so often cited by reviewers, was seen most vividly in the dance that became her signature "expressive solo," *The Dying Swan*. Danced to the familiar music by Camille Saint-Saëns, the *Swan* had been part of Pavlova's repertoire since Mikhail Fokine choreographed it for her in 1905 back in Russia. Her costume then, and in many later roles, was designed by Léon Bakst (1866–1924), who embellished her swan tutu with sequins and goose feather "wings," to be worn with a diamanté headdress of blue glass gems and feathers (fig. 2). When Pavlova danced her dying swan in her first New York performances at the Met, American critics and audiences proclaimed it exotic, fantastic, ethereal, and tragic. Pavlova's *Swan* was all

these things, and audiences clamored for it everywhere she went, to the point that she and the swan became inseparable.

Trying to capture the delicate, ephemeral swan proved a challenge for critics as well as visual artists. New York's Mishkin Studios, experienced in celebrity portraits, set up a 1910 photo shoot with Pavlova as the swan, garbed dutifully in white tutu and feathers. But the era's slow film, so effective for bringing out detail in a face, proved impossible for the pose, *en pointe,* that Pavlova assumed. Even she, with her superb body control, could not maintain the perfect stillness required for the necessary long exposure. So American ingenuity had to be invoked: the photographer strung a clothesline across the studio, at shoulder level, to provide extra support for Pavlova in holding the pose. Later, in the darkroom, the line was airbrushed out.

In further anticipation of her latest American tour, Pavlova entered another sphere of national life, its burgeoning culture of mass consumption. Americans chasing youth, beauty, and comfort were increasingly being subjected to the power of advertising images, and the cachet of the Russian ballerina, her promoters rightly guessed, could add appeal and enhance the sales of almost any product. She was even featured in an ad campaign touting Pond's Vanishing and Cold Creams, some of the era's most famous skin-care products (fig. 3). Here was another way in which ordinary Americans could identify with the legendary dancer, who (so she said) cared for her complexion in the same affordable manner they did: "I find it very good for softening and

fig. 2. Léon Bakst, Tutu worn by Anna Pavlova in *Le Mort du Cygne (The Dying Swan),* early 20th century, net, satin, goose feathers, and stone. Fine Arts Museums of San Francisco, Joseph Rous Paget-Fredericks Dance Collection, Long term loan from the Bancroft Library, University of California, Berkeley, L78.87.4a

fig. 3. Pond's Facial Cream advertisement

SHARYN R. UDALL

fig. 4. Pavlova wearing Fortuny gown, 1908–14, photograph. The Royal Ballet School Collections, White Lodge Museum

whitening my skin," she attested, urging readers to apply for a free sample. With very little effort, Pavlova could reap financial gains from her product endorsements, using advertising revenues to help finance her dance company.

In an era of stupendous hats, Pavlova's millinery was nearly unparalleled. From the frothy black hat—the much-discussed confection she wore at her first New York press conference in 1910—it was clear that high fashion played a role in her public persona. Not conventionally pretty, Pavlova's splendid bone structure and dancer's carriage made her unusually photogenic. More, her queenly bearing showed off any gown to perfection, and she glided with an ease that made each draped panel, each ostrich feather, move with airy grace.

Whenever she appeared in street clothes, reporters remarked on Pavlova's unerring chic, her ability to appear poised, fashionable, and polished on any occasion. Perhaps she had initially acquired that polish from Diaghilev and burnished it further during her residence in Paris. She looked wonderful in designer clothes, and couturiers such as Fortuny, whose garments featured thousands of tiny clinging pleats (fig. 4) clamored to have Pavlova wear (and be photographed) in their clothes. She complied happily, simultaneously indulging her own interest in fashion and knowing that the widely circulated photographs would enhance her appeal as a glamorous celebrity.

In an age when street clothes reached almost to the floor, women's bodies were kept mostly under wraps. A flash of trim ankle or baring the neck and shoulders in a modest *décolletage* were the extent of bodily display. Not so on stage, of course, where Pavlova's filmy costumes often revealed midriff, bosom, arms, and legs. When she appeared on stage, her initial delicacy soon gave way to a display of seemingly effortless energy. But far from being effortless, her legendary stamina resulted from superb physical conditioning combined with old-fashioned devotion to a work ethic. As a student, Pavlova had worked at building her endurance, confounding teachers and critics by her ability to practice many hours daily and perform the most difficult roles with apparent ease. From the beginning of her career she performed even when ill, and in America she struggled to overcome exhaustion brought on by nearly incessant travel, teaching, public appearances, and constant interviews. In one, the *Chicago Herald* lauded Pavlova as "The Hardest Working Person in Chicago," possessed of "mental and spiritual vivacity, a pagan joy in physical perfection and a wonderful 'creative' ability."[4]

The period of Pavlova's U.S. tours coincided with a rise of interest in health and physical fitness. Social historian Frederick Lewis Allen, writing in *Vanity Fair* in 1915, noted a national proliferation of "schools of rhythm, hygiene, physical culture and correlated arts...." Health reform was on the minds of many Americans, and dance was seen as fitting closely into this vision of an active life, part of an evolving blueprint for a more liberated and enlightened society. Writes one dance historian, "By 1916 dance meant something very substantial to Americans.... physical culture enthusiasts—the women who made their families take the fresh air, the men

who did exercises—connected artistic dance to an ideal state of the body and therefore the soul."[5] The body's need for moving air and light played neatly into the hands of health reformers, who advocated that Americans get up from their meat-and-potato laden tables to exercise outdoors.

Pavlova and her canny publicists devised many stratagems to situate dance as an aesthetic centerpiece of the physical self-consciousness of the age. She continued her entry into the popular culture and imagination of America by her willingness to try almost anything, and she gamely partook of the nation's newest entertainments, sports, and diversions. If they boosted publicity for her performances on tour, so much the better, and if they were health-enhancing, that could be a second benefit.[6] With those possibilities in mind, during her first U.S. tour Pavlova came down from her famous "million dollar toes" to try her hand at the social dances sweeping the country. By the 1910s ragtime was all the rage, and Pavlova was curious about the new dances that were propelling Americans onto the dance floor. Could classical dance compete for ticket sales with the likes of the Bunny Hug? She determined to try out the new dances that were bringing Americans to their feet, and photographer Arnold Genthe was on hand to watch. During her 1910 visit to San Francisco, reported Genthe, "Pavlova wanted to see the new dances she had heard so much about—the Turkey Trot, the Texas Tommy and the Grizzly Bear."[7] At one of the crowded honky-tonks on the city's "Barbary Coast," Pavlova and Mordkin first watched, then made their way to the dance floor, where, incognito, they

> began to feel out the barbaric rhythm with hesitant feet. Gradually they were carried away by it and, oblivious to their sordid surroundings, they evolved, then and there, a dance of alluring beauty. Gradually, one couple after another stepped aside to watch, forming an astonished circle at the edge of the floor. When Pavlova and Mordkin had finished, there was a moment of silence, followed by wild bursts of applause.... This incident has always seemed to me a thrilling example of the power of great art.[8]

By stepping blithely from the concert hall to the dance hall, fusing her own "great art" with the brassy entertainments of the country's youth, Pavlova caught a wave that swept her into the mainstream of America's popular culture. She endeared herself to all potential Turkey Trotters by demonstrating that social dance, even the uninhibited "animal dances," could enhance ordinary Americans' pure fun, promote healthy physical activity and thus, so the argument went, improve their health.

Preparing for her 1913 American tour, Pavlova decided to promote her upcoming performances by capitalizing on the continuing vogue for social dancing, as popularized by the elegant Irene and Vernon Castle. In the weeks preceding her arrival in New York, the *Evening Sun* ran a series featuring Pavlova and her then-partner Laurent Novikov demonstrating "The New Social Dances." Unlike the Castles—and more than her rivals Loïe Fuller, Isadora Duncan, or Ruth St. Denis (who were always trying to elevate their dancing into the high art realm, and whom she gently disparaged)—Pavlova was already there: in the minds of Americans she already stood

at the zenith of high art. From there she could continue to engage with popular culture without undermining her lofty status. And engage she did. Besides performing folk dances and interpretive dances from Russia, Italy, Spain, and Greece, she incorporated the waltzes and mazurkas of Frédéric Chopin and other celebrated composers into her repertoire. So successfully, in fact, did she blur the boundaries between ballet and social dance that vestiges of elitism clinging to the former and any whiff of honky-tonk scent emanating from the latter melded into a new Pavlovian message of vivacity, youthful grace, and refinement. In succeeding years, Pavlova continued to elevate ballroom dancing by inventing and popularizing new steps such as the Pavlowana, the New Pavlowa Gavotte, and The Czarina Waltz, all of which were published to great fanfare during 1915 in successive issues of the *Ladies' Home Journal* (fig. 5).

fig. 5. Pavlova and Clustine demonstrating the new social dances, *Ladies Home Journal*, 1915. Courtesy of University of Michigan Library

Pavlova's already famous face would soon become even more widely known to Americans. Further embracing the technology of the brand-new twentieth century, Pavlova took another bold step in her career: she decided to participate in Hollywood films. America's fledgling motion-picture industry was booming, and as early as 1914 she was offered a large sum of cash plus a quarter interest in a film that would document her performing one complete ballet and two *divertissements*. Schedule conflicts forced her to decline that offer, but many more followed. In 1915, primarily as a means of generating capital for her company, she said yes to a proposal to star in a new film dramatization of Daniel Auber's opera *La muette de Portici* (*The Dumb Girl of Portici*), in which she would play Fenella, the mute heroine of the silent film. Always cooperative with the press, Pavlova gave an interview to *Motion Picture* magazine in which she told of her visit to Hollywood's new Universal Film Manufacturing Company, being impressed by their facilities, and agreeing to join the project. With a budget of $250,000, *The Dumb Girl of Portici* promised to be an epic on a par with the kind of film spectacles produced by D. W. Griffith. But unlike the usual Hollywood fare, Pavlova's film project was spearheaded by a woman, Lois Weber, who wrote the screenplay and directed it. Filmed in Chicago and California, *The Dumb Girl* originally called for Pavlova to take a purely dramatic role, but Weber wisely decided that the public would expect the ballerina to dance, so they added some gypsy dances and visionary sequences in which Pavlova drifted about *en pointe*. In one, Pavlova danced with a male partner dressed entirely in black, rendering him invisible to the camera as he lifted her aloft in a seemingly magical ascent.

Upon seeing the film's initial rushes, the dancer disliked her own acting, but she willingly accepted coaching from her co-stars and was soon turning out performances quite as compelling—that is, in the overblown melodramatic style of the silent era—as those of her fellow actors. When the film opened in San Francisco and New York early in 1916, critics hailed

it as a smashing success and its star as "incomparable on the screen." Gushed one New York theater writer, "To the many who have seen her as a dancer in the flesh and to the many more who have not because of the prohibitive prices, Anna Pavlowa, the inimitable, proved a revelation because of her wonderful power as an actress."[9] Once again, she had bridged the gap between America's vernacular and high art audiences, this time through the powerful new medium of film. Everybody went to the movies, and America's middle class felt both edified and entertained by *The Dumb Girl*. Happiest of all were American women, especially its feminists, who delighted in the female star and female director; women's clubs from coast to coast bought blocks of tickets and attended en masse.

After *The Dumb Girl* was released, Pavlova returned to her great love and her great compulsions: touring and performing around the world. One of her few misgivings about her chosen career was that each evening, as the applause died down, she was reminded of the haunting ephemerality of live dance, recognizing that it exists mainly in the moment of its performance. Pavlova knew that dance—like painting, sculpture, prints, and photographs—is communicated by visual means. But dance differs significantly from visual art, which exists in space, and music and poetry, which exist in time. Dance lives at once in time and space, its rhythmic patterns of movement and active use of space created by the dancer's body. The dance and the dancer cannot be separated. Said another way, dance—unlike the visual arts (with traditional products in objects), and unlike carefully notated (and therefore repeatable) forms of music—has traditionally been preserved by a kind of "oral" transmission, passed from person to person in formal or informal settings. To facilitate that kind of preservation, Pavlova founded schools of dance and nurtured dozens of young performers on both sides of the Atlantic.

But passing on her artistry to young dancers still did not solve the problem of ephemerality in Pavlova's own performances. She remarked to a photographer, "My art will die with me. Yours will live on when you are gone."[10] For that reason, and because she believed that the arts could mutually enhance each other, she began to encourage visual artists to help preserve her work by creating dance images that would find their way into galleries, private collections, and museums. The efforts were protean and uneven. Today, looking at the results, one instantly sees that capturing Pavlova in the act of dancing proved a task that engaged many artists but eluded more than a few. All faced the challenge of creating convincing images of her grace, her gestural expressiveness, and those legendary, weightless flights across the grand stage. Even more tricky was the question of how a painter, photographer, or sculptor could convey, besides the *look* of her performance, the *feel* it generated, its expressive component.

Among the first American painters to try was George Luks (1866–1933), the realist painter, member of Robert Henri's circle of Ashcan painters, and a devotee of theater of all kinds. Rapid-fire action, often on urban streets, delighted Luks, and his well-known paintings of vernacular dance are a natural outgrowth of that kind of direct observation. But when he queued up for a ticket to see Anna Pavlova, Luks took on an entirely different kind of dance performance, one at the opposite end of the popular/classical continuum. No doubt Luks sketched Pavlova from the

Cat. 40. George Luks, *Pavlova's First Appearance in New York*, ca. 1910

audience, as Henri urged all his colleagues to do while watching dance. The artist's quick sketches could later be worked up into a more finished composition, in this instance, Luks's oil *Pavlova's First Appearance in New York,* 1910 (cat. 40).

At this stage of his career Luks was clearly less comfortable in the opera-house setting than with more popular entertainments. Despite his efforts to render the drama of the stage lighting and capture Pavlova's onstage grace, Luks's Pavlova is ultimately less penetrating and less sympathetic than his home-grown American dancers. Missing from *Pavlova's First Appearance* is the nuanced dramatic expression Pavlova always projected beyond the footlights.

More successful in capturing the ethereality of Pavlova's movements was the gifted photographer Arnold Genthe (1869–1942), already encountered as observer of her 1910 visit to a San Francisco honky-tonk. A few years later, during another of her American tours, Genthe had a chance to photograph Pavlova in his New York studio. By then, Genthe was becoming one of the most accomplished of dance photographers, famous for his soft focus Pictorialist images infused with textures and subtle tones. He had already photographed Isadora Duncan, and Pavlova admired those pictures. "I love the pictures you made of her," Pavlova told Genthe, "and I want you to make some of me that Isadora will like.... You will have no difficulty, I am sure, as I can hold any dance pose for several seconds." This, despite, what they both knew about the camera's impossible demands for stillness. Nonetheless, Genthe agreed to try, and as the dancer warmed up, dancing freely about his studio, Genthe began to click the shutter of a small camera. "I made a number of exposures," recalled the photographer. "Only one was successful [fig. 6]. It is one of the best photographs of the dance I have ever made and the only one in existence showing Pavlowa in the free movement of the dance. Upon seeing the proof a few days later, she threw her arms around me and actually cried. 'This is not a photograph,' she exclaimed, 'it is a miracle.'"

The gifted sculptor Malvina Hoffman (1887–1966) would produce the most celebrated images of Pavlova in American art. A student of Rodin, Hoffman found, like her teacher, much sculptural potential in the forms of the dance (cat. 41), and she took seriously his advice to focus closely on the study of anatomy. Hoffman's first important sculptural group was based on Pavlova and Mordkin dancing the *Bacchanale,* a London performance which electrified the sculptor (cat. 42). "Fireworks were set off in my mind," recalled Hoffman. "Here were impressions of

fig. 6. Arnold Genthe, *Anna Pavlova,* 1913, photograph. Private collection, courtesy Joan Myers

SHARYN R. UDALL

Cat. 41. Malvina Hoffman, *Russian Dancers,* 1911

Cat. 42a. Malvina Hoffman, *Bacchanalia* (front view), 1914

Cat. 42b. Malvina Hoffman, *Bacchanalia* (side view), 1914

Cat. 42c. Malvina Hoffman, *Bacchanalia* (back view), 1914

motion of a new kind, of dazzling vivacity and spontaneity and yet with a control that could come only from long discipline and dedication.... I went to further performances, standing up when necessary, and made sketches. These precious sketches I took back to Paris."[11] There, under the guidance of her mentor Rodin, Hoffman worked up a maquette for a bronze piece. Looking at her first study, Rodin advised her, "When you carry joy to its full intensity like this, you are already on the borderline of exquisite pain. Don't forget that these dancers could be drunk with joy or mad with despair. It is all so closely interwoven in human life!"[12]

The Russian ballerina and the American sculptor were personally introduced in New York when Pavlova was performing at the Metropolitan Opera. Noticing Hoffman observing and sketching her performances from afar, Pavlova responded warmly to the young American and arranged a permanent observation spot for her in the theater wings. From that post Hoffman made many studies of the ballerina. Eventually, when Pavlova agreed to pose in the sculptor's studio, their friendship achieved an informality that broke down the natural reserve of both.

One of their collaborations was of Pavlova dancing the *Gavotte,* which she performed in concert and, as described earlier, introduced as a social dance. Posing, Pavlova wore a diaphanous yellow dress, high-heeled golden slippers, and a yellow bonnet with long streamers. Cast in bronze, the *Gavotte* was much appreciated for its airy, seemingly effortless grace, a pose the sculptor achieved in reality only after many preliminary drawings and test armatures of hands, arms and feet (fig. 7).

fig. 7. Malvina Hoffman, *Pavlova Dancing the Gavotte,* 1915, bronze. Detroit Institute of Arts, gift of George G. Booth, 19.54

For seven years Pavlova and Hoffman collaborated in what became a joint project to preserve the dynamics of dance in sculptural form. More personal were Hoffman's individual sculptures of Pavlova, using plaster, wax, marble or bronze (cat. 43). She made some exquisite photographs of the dancer, resulting in sensitive portraits in marble and in wax.

Many other visual artists clamored to interpret Pavlova's career in America, using mediums as wide-ranging as her own repertoire.[13] Besides achieving iconic status in nearly every form of dance, Pavlova proved a durable example of the modern woman—independent, adventurous, traveling the world to advance acceptance of her art, finding partners for herself, and creating repertory. More than any other performer, she created a worldwide ballet audience and, not incidentally, achieved global celebrity in the process.[14] Pouring her energies and frustrations

SHARYN R. UDALL

Cat. 43. Malvina Hoffman, *Anna Pavlova*, 1924

into a career that developed amidst bewildering social flux, Pavlova fearlessly embraced change, willingly adapting her own nineteenth-century training and sensibility to the *Zeitgeist* of the twentieth.

Pavlova achieved enormous financial success, becoming one of the highest-paid artists of her day. Yet if her promoters were dollar-driven, Pavlova never seemed to be. Despite her periodic involvement with commercial enterprises such as product advertising and Hollywood films, she never sacrificed her artistry to any other consideration, always demanding perfection of herself and those around her. Pavlova's unremitting *need* to dance meant that she drove herself impossibly hard. With only a few breaks, she traced a dense web of journeys over the globe. Few American towns and cities missed her tours, and she was still performing well into her forties, long after most ballerinas ceased to dance. A photograph of Pavlova, made in the 1920s when cameras were fast enough to catch mid-air leaps, captures her still-extraordinary elevation. Such feats she sustained until—almost willing herself to die dancing—she succumbed at age fifty, while on tour, to a bout of pleurisy.

Pavlova's art did not, as she feared, die with her. She remained, in the memories of Americans, the epitome of grace; they learned to love dance through loving her. It was Pavlova, more than any other Russian dancer, who raised expectations and appreciation for Russian ballet among American audiences. As such, she did more for its acceptance in the United States than any other individual. What made Pavlova a superstar in America was the marriage of art and promotion that propelled her into an unprecedented level of celebrity: she became America's first pop-star ballerina. What endeared her to her legions of fans in this country was her willing embrace of American culture and her seeming accessibility to audiences. Especially before Diaghilev and his Ballets Russes reached American shores in 1916, she introduced the glamor, the technical brilliance, and the high-art cachet that subsequently attached to her profession. On the stages where she performed, America's adopted *prima ballerina assoluta* laid a groundwork for generations of great Russian dancers who followed: Baryshnikov and Nureyev built their own legacies upon her earlier fame, becoming, like her, both beneficiaries and prisoners of their superstar status.[15]

Notes

Some material in this essay has been adapted from my book *Dance and American Art: A Long Embrace* (Madison, WI, 2012).

1. A. B. Walkley, *The London Times,* mid-July 1910.

2. The reasons for Pavlova's defection from Diaghilev may be more complex: he and Nijinsky had become lovers, and Pavlova sensed the impresario's distinct favoritism directed to male over female dancers.

3. If Americans had troubled themselves to look back through their relatively short cultural history, they would have seen precedents: in the nineteenth century some of Europe's great Romantic ballerinas—French, Italian, and Austrian—had visited the United States, laying the groundwork for legitimate "art" dance to emerge as a symbol of cultural internationalism. The Viennese Fanny Elssler, for example, made an extended tour of the New World from 1840 to 1842, and several American ballerinas, such as Mary Ann Lee, Julia Turnbull, and Augusta Maywood, achieved success at home and abroad. But by the middle of the nineteenth century, Romantic ballet had begun to decline in America and was incorporated into popular stage extravaganzas such as *The Black Crook,* which opened in New York in 1866 to wild acclaim and continued, in various incarnations, for decades. For the most part, however, from the mid-nineteenth century until 1910, there was, as Helen Thomas has written, "little evidence of ballet as a high art on the American stage." Helen Thomas, *Dance, Modernity and Culture* (London and New York, 1995), 38.

4. *Chicago Herald* (13 July 1915).

5. Elizabeth Kendall, *Where She Danced* (New York, 1979), 123.

6. Each time she prepared for an American tour, carefully placed advance publicity engaged audiences in the United States. One year, she was photographed playing a new sport: "Noted Dancer to Bring New Sport to America; Mlle. Pavlova playing hoop-la," read the caption to the photograph. She was quoted as saying that the new game was the "best exercise for gracefulness."

7. Arnold Genthe, *As I Remember: The Autobiography of Arnold Genthe* (New York, 1936), 176. The so-called animal dances became enormously popular in the United States and Europe.

8. Everywhere they went, Pavlova and Mordkin became dancing demigods in the minds of Americans, arresting in physical appearance as well as in performance. A unnamed critic in San Francisco wrote, for example, that "[Mordkin] is physically fit to be a sculptor's model, and thought and emotion as well as manly beauty mark his face." Winthrop Palmer, *Theatrical Dancing in America,* 2nd ed. (New Brunswick, NJ), 175.

9. Keith Money, *Anna Pavlova: Her Life and Art* (New York, 1982), 229.

10. Mikka Gee, Judith Keller, and Anne Lyden, *Dance in Photography* [exh. cat., J. Paul Getty Museum] (Los Angeles, 1999), n.p.

11. Malvina Hoffman, *Yesterday is Tomorrow: A Personal History* (New York, 1965), 108.

12. Rodin, quoted in Hoffman 1965, 118. Hoffmann won first prize at the 1911 Paris Salon for this piece. Another version, over-life size, of *Bacchanale Russe (*aka *Bacchanale),* 1917, was cast as an outdoor sculpture and installed at the Luxembourg Gardens, Paris; another cast remains in the Fine Arts Garden of the Cleveland Museum of Art.

13. Early examples include Carl Sprinchorn (1887–1971), who exhibited a watercolor of Pavlova (1912; present whereabouts unknown) in the landmark Armory Show of 1913. Alfred David Lenz (1872–1926) made several bronze sculptures of Pavlova in her celebrated persona as the Dragonfly (*The Dragonfly,* 1916, Metropolitan Museum of Art, New York, 1920.17). In that same role the dancer was even interpreted in the pale delicacy of Dresden porcelain (*The Dragonfly,* ca. 1920, Museum of Modern Art, New York, Department of Theatre Design). From both the visual arts and literature, Pavlova's talents attracted some of the most creative collaborators of her era: for her ballet *Xochimilco,* the Mexican painter Adolfo Best-Maugard provided decor, while Katherine Anne Porter wrote the libretto.

14. Yet as well as the world came to know Pavlova, there was an element of her modern independence that would remain an enigma: she maintained a long relationship with her personal manager, Victor Dandré, but it is not clear that they ever married. He encouraged her professional career, urging her to renounce conventional domesticity to remain at the pinnacle of her abilities. Like some other women artists of her day, she chose to devote all her energies to her career, writing that "...A true female artist must be consumed in her art, just like a nun. She does not have the right to lead such a life as would seem desirable to most women." In an interview she was quoted as saying, "You know what I would like—I would like to have a baby. But it does not go wiz my art...."

15. Like these successors, Pavlova could scarcely elude the tentacles of international politics: despite receiving the German Order of Merit from the kaiser, she was arrested in 1914 as a spy and held for several days in Berlin shortly after the outbreak of World War I. All her baggage was searched, and she was released only on condition that she leave Germany at once.

The Dancer as Muse | *Jane Dini*

In 1890 dancer Carmen Dauset Moreno posed in New York City for John Singer Sargent in a painting that bears her stage name, *La Carmencita* (cat. 44). In the portrait, she strikes a dramatic stance with one foot thrust forward, arms akimbo, and a slight twist to her torso. It is a pose with a purpose, bold and audacious, daring the viewer to look and commanding appreciation and respect. Her hauteur belies her delight in the playful antics Sargent performed to make her keep still. New York Times journalist H.J. Brock reported, "Sargent used to paint his nose red to rivet her childish interest upon himself, and when the red nose failed he would fascinate her by eating his cigar."[1] However embellished this newspaper account may be, it signals the new relationships between artists and celebrity dancers and how they shared the creative process.

These were not commissioned portraits or straightforward portrayals; each artist, fine art or performing, worked in concert to inspire each another and offer exchanges that took them in new directions in their respective forms. For the next fifty years and beyond, from the Ballets Russes to burlesque strippers, American visual artists would be indebted to dancers and choreographers for helping shape new visual languages. And yet, the artistic legacy of dance has been less prized than that of visual art because of economics. As dance historian Lynn Garafola concisely put it, "You can't sell dance in an auction house."[2] The resulting artworks proclaim dance as vital to modern thought and aesthetics.

In Sargent's painting, the ballet dancer from Almeria, Spain, is grounded by the weight of a yellow satin and lace costume. When in motion, the large skirt accentuates the dance's twists and turns, which were captured in an early film by Thomas Edison's company.[3] Carmencita's performances in New York City music halls elicited rave reviews by many artists, including the American writer John Jay Chapman, who claimed it was "the most wonderful dancing I shall

Cat. 52. Walt Kuhn, *Plumes* (detail), 1931

Cat. 44. John Singer Sargent, *La Carmencita*, 1890

Cat. 45. Robert Henri, *Salome Dancer*, 1909

ever see. She was like the daughter of Herodias...She sang at the same time that she danced. She is about twenty and like a young panther."[4] The daughter of Herodias, or Salome, would become a stock character for women on the New York vaudeville stage. By 1909 when the realist painter Robert Henri painted *Salome Dancer* (cat. 45), there were at least a dozen "Salome Dancers" in New York City, from the highly erotic to the repentant, including Edith Lambelle Langerfeld, known as La Sylphe, who danced "The Remorse of Salome."[5] For many female dancers, a life in musical theater meant a certain kind of financial and creative freedom. Nonetheless, their sex appeal was an integral part of their performance and identity.

In order to study her extraordinary moves, Sargent arranged for Carmencita to perform in the Tenth Street studio of William Merritt Chase. Evan Charteris, Sargent's friend and biographer, described the evening concert: "Carmencita, a light thrown on her from below, now writhing like a serpent, now with an arrogant elegance, strutted the stage with a shadowy row of guitarists in the background strumming their heady Spanish music."[6] Chase was inspired to paint his own exhilarating portrait, *Carmencita* (cat. 46), perhaps basing the pose on Edouard Manet's *Spanish Ballet* (1862; fig. 1). In Chase's image, a gold bracelet and flowers have been tossed at her feet to suggest the audience's enthusiasm for her dancing. Sargent, on the other hand, packed all of her energy into a pose. His invitation to Isabella Stewart Gardner was ecstatic: "You must come to the studio on Tuesday at any time and see the figure I am doing of the bewildering superb creature."[7] The artistry of female dancers was often described as animalistic, likened to creatures, even when dancers such as Carmencita worked with artists to shape and solidify their reputations. Of the 1954 premiere of Balanchine's *Nutcracker,* the critic Walter Terry wrote, "Maria Tallchief, as the Sugar Plum Fairy, is herself a creature of magic, dancing the seemingly impossible with effortless beauty of movement, electrifying us with her brilliance, enchanting us with her radiance of being."[8]

fig. 1. Edouard Manet, *Spanish Ballet,* 1862, oil on canvas. The Phillips Collection, Washington, DC, acquired 1928

One woman who needed no help with her reputation was Gertrude Vanderbilt Whitney. The noted amateur dancer, in addition to being a respected sculptor, magnanimous art patron, and museum founder, commissioned Sargent in 1913 to draw her in a stylish fancy dress costume designed by Léon Bakst, the brilliant costume and stage designer for Serge Diaghilev's Ballets Russes (cat. 47). Whitney's fashionable ensemble of "harem" pantaloons matched with a "lamp shape" tunic was a sartorial reference to Bakst's costumes for the Ballets Russes' enormously popular 1910 production of *Scheherazade* (Rimsky-Korsakov), an exotic, erotic, Arabian fantasy based on the prologue to *The Thousand and One Nights.* Whitney's grand gesture, arms wide and expressive, is Sargent's nod to the ballet's sensuous choreography by the groundbreaking Russian choreographer Michel Fokine, who transformed classical ballet into a modern experimental form.

Cat. 46. William Merritt Chase, *Carmencita*, 1890

Cat. 47. John Singer Sargent, *Gertrude Vanderbilt Whitney*, ca. 1913

Cat. 48. Florine Stettheimer, *Music*, ca. 1920

Fokine's choreography can also be seen in Florine Stettheimer's *Music* (ca. 1920; cat. 48), a memory painting inspired by her enchantment with the Ballets Russes and its principal dancer and superstar, Vaslav Nijinsky. In 1912 she saw him perform in Paris and recorded in her diary, "He danced the Dieu Bleu and the Rose in which he was as graceful as a woman and Scheherazade. He is the most wonderful male dancer I have seen."[9] In the painting, Stettheimer placed an image of herself asleep on a canopied bed. She dreams of her favorite moments from the Ballets Russes, including Adolph Bolm as the Moor in Igor Stravinsky's ballet *Petrouchka* (1911). He is shown in the left foreground playing with a ball on a fanciful, tasseled magic carpet with a large orange and yellow striped pouf under his head. In the center of the composition, Nijinsky appears in a white aureole as the Spirit of the Rose from the ballet *Le Spectre de la Rose* (1911). The theme of the ballet is the awakening of a young girl's sexual desire. Upon falling asleep after her first ball, she dreams that her souvenir rose awakens her to dance. In a period publicity photograph (fig. 2), Nijinsky's athleticism is complemented by his languid arms, limp wrists, and delicate fingers that emphasize gesture, a signature of Fokine's expressive style. In Stettheimer's painting, Nijinsky poses *en pointe,* further emphasizing his femininity and grace.

Ballerinas typically wore pointe shoes, as do the lithe and ethereal dancers in Everett Shinn's *The Green Ballet* (1943; cat. 49). The title derives not from the ballet but rather the stage lighting, which reflects the deep green and blues of the richly painted sets and bathes the scene, including the ballerinas' white tutus, in a green glow. It is an image of a classical ballet that includes a large female *corps de ballet* featured in such nineteenth-century post-Romantic productions as *Swan Lake* or *La Bayadère*. Shinn's work is a fiction, much like Stettheimer's enchanted fantasy, and evidence of the continuation in America of traditional dance forms alongside the development of modern dance.[10]

In Shinn's earlier work, he had featured the female dancer of the variety stage framed by the orchestra and her audience in such paintings as *A French Music Hall* (1906; cat. 50) and *Dancer in White Before the Footlights* (1910; cat. 51). The connection between the theatergoers, the music, and the dance was an integral part of his thematic and compositional structure.[11] Inspired by Edgar Degas's ballet scenes and spectators in the French Opéra, Shinn carries Degas's relationships further as both dancer and spectator look out into the viewer's space. This heightens the sensory experience; the sheet music signals sounds from the orchestra, the eye delights in the elaborately painted sets and well-coiffed audience members, the tactile is suggested by the dancers who in *A French Music Hall* demurely raise their skirts to show off their footwork and well-turned ankles. The whole shapely leg is revealed four years later in *Dancer in White before the Footlights,* in which the dancer's energetic twirls lift her skirt well over her knees. Shinn never identified the individual dancers in his works but he gave his thoughts about the women he painted to art collector R. H. Norton, who purchased a similar scene: "The picture you have is one of our

fig. 2. Vaslav Nijinsky, Russian ballet dancer, in *Le Spectre de la Rose,* Paris, 1911, from *La Revue Musicale,* December 1, 1930, photograph

Cat. 49. Everett Shinn, *The Green Ballet*, 1943

Cat. 50. Everett Shinn, *A French Music Hall*, 1906

Cat. 51. Everett Shinn, *Dancer in White Before the Footlights,* 1910

Vaudeville theaters in those days of smothering skirts. She has no particular identity. However, without fixing her on a known personality, she is, or the picture in its entirety is, my personality plus the forgotten vaudeville performer which inspired it."[12] These dancers need not have been forgotten if Shinn had recorded their names and performances.

The anonymous showgirl remained a popular subject between the wars for such realist painters as Walt Kuhn. In his *Plumes* (1931; cat. 52), magnificent black and white ostrich feathers crown the head of a weary showgirl who appears to rest between acts. When the art patron and museum founder Duncan Phillips bought the work he wrote, "The girl under the Plumes is thoroughly disillusioned and tired of it all. She seems to sag under her magnificent head-dress and to wonder perhaps why she ever left home."[13] Nameless, exhibiting a dolled up, deadpan expression, the showgirl's attractive invisibility underscores her desirability. She is as strong as the feathers are delicate and displays a fortitude and resolve that clearly keeps her employed during The Great Depression. In the 1920s and 1930s, in large stage productions such as the Ziegfeld Follies, "flocks" of such chorus girls would back up the male dancing lead. Edward Steichen's celebrity photography for *Vanity Fair* and *Vogue* turned dancers into household names, such as *Fred Astaire* (1927; cat. 53). In the photograph, the tap dancer wears his costume from the Broadway musical *Funny Face*. The show was Astaire's first hit. Steichen posed the dancer in his evening clothes from the production and signaled out his top hat and its rhythmic shadow as the dancer's motif, securing Astaire's reputation as the most debonair tap dancer of the twentieth century. While Astaire was able to secure the identity of the urban high-class gent, many females were featured in decidedly lowbrow affairs.

In Thomas Hart Benton's *Burlesque* (ca. 1930; cat. 54) the dancer is at the end of the stage wagging her feathered tush to the delight of the "hoochie-coochie" men in the audience. Benton reminisced about the days of these New York burlesque shows, "where the art of 'stripping,' just begun, used to make the old boys drool at the mouth and keep their hands in their pockets."[14] The theater swirls around the dancer; the arching forms of the stage and balcony undulate like the rhythms of her dance, pleasing the guffawing, cigar-chomping, all-male audience. She looks like a cockatiel that is about to be consumed by a bunch of fat cats.

One has the sense that Benton's bird will fly away in the nick of time. However, the stripper in Hopper's *Girlie Show* (1941; cat. 55) looks firmly trapped in her gilded theater cage and reminds us of the desolation dancers felt who could find no other work but to strip. Jo Hopper, the artist's wife, modeled for the burlesque dancer. She, too, was a painter and had acting experience. She would role play a character while Edward would direct the scene. "Ed beginning a new canvas—a burlesque queen doing a strip tease—and I posing with out a stitch on in front of the stove—nothing but high heels in a lottery dance pose."[15] In the painting, the dancer is at once heroic and pathetic, striding along the stage with a blue scarf she has stripped off to reveal a statuesque figure and taught conical breasts. Her flaming red hair creates a strong contrast to her porcelain flesh, and she looks determined not to make eye contact with the men in her audience.[16]

While Hopper was exploring the isolation of creative performers in the early 1940s, the

Cat. 52. Walt Kuhn, *Plumes*, 1931

Cat. 53. Edward Steichen, *Fred Astaire*, 1927

Cat. 54. Thomas Hart Benton, *Burlesque,* ca. 1930

Cat. 55. Edward Hopper, *Girlie Show*, 1941

fig. 3. David Smith, *Study for Terpsichore and Euterpe*, 1947, black ink and purple fiber-tip ink on cream wove paper, darkened. Harvard Art Museums/Fogg Museum, Gift of Lois Orswell, 1974.154

sculptors and, for a time, married partners, Dorothy Dehner and David Smith found inspiration in New York's modern dance community. They mined new choreography, including that of Martha Graham and her company (with whom Dehner had studied), for forms and shapes that made their sculpture dynamic.[17] Dance and Graham historian Deborah Jowitt convincingly posits that Smith was attracted to Graham's work because of her forceful lines and the "counter tensions that her body imprinted on space."[18] Smith's drawing *Study for Terpsichore and Euterpe* (1947; fig. 3) is an attempt to understand the spacial relationships of the physical form. In the image, two ancient Greek muses, highly abstracted—the dancing figure of Terpsichore and the seated figure of Euterpe playing the piano—are repeated numerous times in slight variations as Smith experiments with contrapposto, balance, and the intersection of planes in space. It is as if music in the form of a prismatic piano activates the dancer by piercing her torso. In the resulting bronze sculpture, *Terpsichore and Euterpe* (1947; cat. 56), Smith achieves a balance between the two elements—an interplay of dance and music that appears at once grounded and lyrical.[19]

There is a sense of whimsical, playful rhythms in Smith's formal language that harkens back to his teacher Jan Matulka (1890–1972). The Czech-born cubist painter was an influential teacher at the Art Students League in the 1920s. In the decade before, he had made his name as a young artist traveling the Southwest on a Joseph Pulitzer Traveling Scholarship, studying the customs and artwork of the Pueblo Nation. In *Indian Dancers* (ca. 1917–18; cat. 57), Matulka's stylized and geometric renderings capture the liveliness and colorful regalia of Pueblo dances. In the image, three dancers—one with a headdress and the other two with animal masks—are seen in profile moving to the left. According to W. Jackson Rushing, this dance has been identified as a Hopi hunting ceremonial called the Mixed Animal Dance.[20] The dynamic spaces between the dancers are just as integral to the sense of movement, music, and rhythm as the dance itself.

In the twentieth century, dancers brought attention to the spaces that surround us, and others carried this further to explore the vast spaces of our mind. Martha Graham believed that her new dances were a deep dive into the psyche, and it was there that she could explore her intense emotional responses through gesture and movement. Graham explained, "Ballet...did not say enough, especially when it came to intense drama, to passion."[21] One can only admire Graham for wrestling with the dominance or, in her case, the stranglehold of classical ballet. But for other artists, such as abstract expressionist Franz Kline, exploring the passion of ballet led to his artistic maturation.

JANE DINI

Cat. 56. David Smith, *Terpsichore and Euterpe,* 1947

Cat. 57. Jan Matulka, *Indian Dancers*, ca. 1917–18

Cat. 58. Franz Kline, *Large Clown (Nijinsky as Petrouchka)*, ca. 1948

In Kline's *Large Clown (Nijinsky as Petrouchka)* (ca. 1948; cat. 58), he rendered ballet's most brilliant and tortured dancer, Nijinsky, in the role of the forlorn, rag doll Petrouchka as a meditation on insanity. Caked with white pancake make-up, the clown's slight smile, furrowed brow, and distracted glance suggests a mind disconnected from the external world. The colorful accents of his costume—the hat's gold and green tassel, the pink ruffle of the collar—are reminiscent of Stettheimer's enchanted fantasies. But the red in his eyes serve to emphasis his pain. For more than a decade the subject of Nijinsky took Kline on a profound journey from realism to abstraction. Kline's *Nijinsky* (1950) is one of the grand black and white gestural paintings for which he is best known. The image is not a literal abstraction of the dancer but the distillation of the emotional power and courageous talent of the Russian superstar (fig. 4).[22]

fig. 4. Franz Kline, *Nijinsky*, 1950, enamel on canvas. The Metropolitan Museum of Art, The Muriel Kallis Steinberg Newman Collection, Gift of Muriel Kallis Newman, 2006, 2006.32.28

Toward the end of the nineteenth century, visual artists began to respect dancers and regard them with admiration. Women on the popular stage were valued for being inventive and independent; Native American dancers, once thought arcane, were recognized for their skill and talent; both ballet and modern dancers plumbed emotional depths and sought new choreographic forms. Their artistry had profound effects on the visual arts of the twentieth century and helped shape a partnership between the fine and performing arts whose legacy continues to this day.

Notes

1. W.H. Downes, "John Sargent," p. 31, citing H.J. Brock, "John Sargent, Man and Painter: Death of Modern 'Old Master' Releases Flood of Anecdote Regarding One of the Most Debated Figures in the Art World," *New York Times,* 19 April 1925, 5.

2. Conversation with Lynn Garafola. Saturday, April 18, 2015.

3. M. Elizabeth Boone, *Vistas de España: American Views of Art and Life in Spain, 1860–1914* (New Haven, 2007), 139; to see Carmencita dance in front of an Edison camera, see *Carmencita* (Edison Manufacturing Co., 1894), in the Library of Congress Motion Picture, Broadcasting, and Recorded Sound Division, http://www.loc.gov/item/00694116/ (accessed June 10, 2015).

4. M.A. De Wolfe Howe, *John Jay Chapman and His Letters* (Boston, 1937), 83.

5. Rebecca Zurier and Robert W. Snyder, *Metropolitan Lives: The Ashcan Artists and Their New York* (Washington, DC, 1995), 19.

6. Evan Charteris, *John Sargent* (New York, 1927), 111.

7. Undated letter (1890), Archives of the Isabella Stewart Gardner Museum, Boston.

8. Walter Terry, "The Nutcracker: Magic," *New York Herald Tribune,* February 3, 1954.

9. "Nijinsky the faun was marvelous. He seemed to be truly half beast if not two-thirds. He was not a Greek faun for he had not the insouciant smile of a follower of Dionysos. He knew not civilization—he was archaic—so were the nymphs. He danced the Dieu Bleu and the Rose in which he was as graceful as a woman and Scheherazade. He is the most wonderful male dancer I have seen." Parker Tyler, *Florine Stettheimer: A Life in Art* (New York, 1963), 128, citing Florine Stettheimer's diary, June 7, 1912.

10. Barbara L. Jones with Judith Hansen O'Toole and Harley N. Trice, *Picturing America: Signature Works from the Westmoreland Museum of American Art* (Greensburg, PA, 2010), 239–41.

11. Sylvia Yount, "Everett Shinn and the Intimate Spectacle of Vaudeville," in *On the Edge of Your Seat: Popular Theater and Film in Early Twentieth-Century American Art,* ed. Patricia McDonnell and Robert Clyde Allen (New Haven, 2002), 161.

12. Everett Shinn, New York, to Ralph H. Norton, Chicago, 14 February 1940, curatorial file, Norton Museum of Art, Palm Beach. Published in Janay Wong, *Everett Shinn: The Spectacle of Life* (New York, 2000), 81–82; see also Louis A. Zona, *Masterworks from the Butler Institute of American Art* (Youngstown, OH, 2010), 327.

13. Philip Rhys Adams, *Walt Kuhn, Painter: His Life and Work* (Columbus, OH, 1978)

14. Thomas Hart Benton, *An Artist in America* (Columbia, MO, 1968), 268.

15. Jo Hopper to Marion Hopper, letter of February 21, 1941, cited in Gail Levin, *Edward Hopper: An intimate Biography* (New York, 2007), 335; and see Vivien Green Fryd, *Art and the Crisis of Marriage: Edward Hopper and Georgia O'Keeffe* (Chicago, 2003).

16. For more on this rich topic and related bibliography, see Judith Lynne Hanna, "Dance and Sexuality: Many Moves," *Journal of Sex Research* 47 (March 2010): 212–41; for the history of American striptease, see Rachel Shteir, *Striptease: The Untold History of the Girlie Show* (Oxford, 2005).

17. Mark Franko, *Martha Graham in Love and War: The Life in the Work* (Oxford, 2012).

18. Deborah Jowitt, "Dances with Sculpture," *Tate Etc.,* September 1, 2006: http://www.tate.org.uk/context-comment/articles/dances-sculpture (accessed June 10, 2015).

19. Marjorie B. Cohn and Sarah Kianovsky, *Lois Orswell, David Smith, and Modern Art* (Cambridge, MA, 2002), 349; E.A. Carmean, *Lois Orswell, David Smith, and Friends: Works from the Lois Orswell Collection, Harvard University* (New York, 2003).

20. W. Jackson Rushing, *Native American Art and the New York Avant-Garde: A History of Cultural Primitivism* (Austin, 1995), 71.

21. Russell Freedman, *Martha Graham: A Dancer's Life* (New York, 1998), 56.

22. Gary Tinterow, Lisa Mintz Messinger, and Nan Rosenthal, *Abstract Expressionism and Other Modern Works: The Muriel Kallis Steinberg Newman Collection in the Metropolitan Museum of Art* (New York, 2007). Harry F. Gaugh, *The Vital Gesture: Franz Kline* (New York, 1985), 67.

Visualizing Dance of the Harlem Renaissance | *Thomas F. DeFrantz*

Critics and historians generally describe the Harlem Renaissance as the period from 1918 to 1937 that delivered a large cache of creative work by young African American poets, visual artists, musicians, cultural critics, playwrights, and novelists to audiences eager to revise their understandings of black life.[1] Many of these artists had moved to New York from other regions of the country as part of the Great Migration from the rural South and Midwest of the United States. They searched for relief from the brutal racism of institutionalized Jim Crow that encouraged social disenfranchisement and dis-ease for black Americans. The Harlem Renaissance, and its articulation of a New Negro, confirmed vibrant intellectual capacities fomenting among black artists and their cultural practices, realized in outstanding cultural products hungrily received by whites and others.

During the Harlem Renaissance, artists hoped that their youthful exuberance might offer some antidote to potent, everyday denigrations that continually surrounded black life. Positioned at the palpable cusp of generational change in the United States, these younger, New Negro artists pushed toward creative expression that reflected their individuality while also forwarding a group ethos of uplift for the race. Taken as a group, these artists worked to consciously make manifest a constructed black subjectivity that honored the rich diversity of black experience; told of the painful histories of African American enslavement and white disavowal; demonstrated creative excellence and originality of form, function, and aesthetic engagement; and imagined a liberated black expressivity full of everyday joy, wit, and communal celebration. As Langston Hughes offered in 1925,

Cat. 62. James VanDerZee, *Untitled (Dancing Girls)* (detail), 1928

> We younger Negro artists who create now intend to express our individual dark-skinned selves without fear or shame. If white people are pleased we are glad. If they are not, it doesn't matter. We know we are beautiful. And ugly too. The tom-tom cries and the tom-tom laughs. If colored people are pleased we are glad. If they are not, their displeasure doesn't matter either. We build our temples for tomorrow, strong as we know how, and we stand on top of the mountain, free within ourselves.[2]

Dance, as practiced by African Americans, actually answered each of these calls to creativity in its embodied telling of black history, its patently fresh physical outlooks, its witty demonstrations of individuality within a group dynamic, and, most importantly, its wide diversity of form. African American theatrical dances, sacred dances, and social dances share historical genealogies but diverged in some key ways by the time of the Harlem Renaissance into separable, yet still intertwined, strands of practice. Sacred dances, possibly the oldest forms of group physical practice by people of an African diaspora, allowed ritualized expressions of faith. These dances were rarely seen by outsiders who were not involved in the spiritual practices at hand. Theatrical dances emerged in response to the difficult legacies of nineteenth-century blackface minstrelsy, which usually mocked African American artistry by rendering it as buffoonery suitable for ridicule. The theatricality of spirited cakewalks, flamboyant tap dancing, and jazz-era stage dancing were generally received as culturally significant, thrilling examples of black American virtuosity, available for audiences willing to be titillated by the presentation of boundless physical effort. Social dances developed by African Americans offered profound nodules of individual expression and social flexibility created to allow for both physical improvisation and group communion. In other words, black dance, which always arose in affiliation with black music, provided essential strands of human relationship that would seem to fit well with the ambitions of younger New Negro artists.[3]

 We might be surprised, then, that while the Harlem Renaissance produced a dizzying array of musical, literary, and visual artistry, the actual archive of achievement devoted to visualizing dance is fairly small. Notwithstanding a few wondrous paintings, sculptures, and photographs, dance occupied a contested and diffuse space in the construction of New Negro rhetoric. For many artists and critics, dance represented a lower form of artistic expression, one that mattered less than music, drama, poetry, or fiction writing. Because Africanist dance forms in the United States had never been considered classical in any sense of that word, there was no classical tradition available for black dancers to engage with in the early decades of the twentieth century. And while African American social dances enlivened mainstream publics throughout the 1920s and 1930s in dances like the Charleston and the Lindy Hop, these dances were generally dismissed as unable to express the profundity and diversity of black life. In effect, the physical creativity demonstrated in dance escaped careful consideration by the intellectual architects of the Harlem Renaissance as a suitable agent of change to be deployed in the articulation of the New Negro.

Author Zora Neale Hurston helps us understand how black dance might have been perceived by outsider audiences of whites and others:

> Negro dancing is dynamic suggestion. No matter how violent it may appear to the beholder, every posture gives the impression that the dancer will do much more. For example, the performer flexes one knee sharply, assumes a ferocious face mask, thrusts the upper part of the body forward with clenched fists, elbows taut as in hard running or grasping a thrusting blade. That is all. But the spectator himself adds the picture of ferocious assault, hears the drums and finds himself keeping time with the music and tensing himself for the struggle. It is compelling insinuation. That is the very reason the spectator is held so rapt. He is participating in the performance himself—carrying out the suggestions of the performer.[4]

For African Americans, though, dance answered calls to social communion that were always particpatory, but seldom threatening or violent. There may be two strands of logic that matter here. Dance within African American communities tends to be ubiquitous and urgent, but also fairly ordinary. In many black circumstances, *everyone* dances, whether well, poorly, or not at all; and dance as a practice escapes scrutiny as any sort of remarkable act. Outside of black communities, though, black dancing is often viewed as astonishing, grotesque, unusual, virtuosic, flamboyant, complex, and compelling. This odd duality of dance conceived as everyday within black communities and entirely specialized when viewed by outsiders led to a difficult circumstance that simultaneously discarded and exoticized black dancing. Nevertheless, artists of the Harlem Renaissance who visualized dance engaged this difficult double-bind of representation with dynamic creative invention, replete with an outstanding diversity of approach and execution.

The earliest codified and documented dances of slaves combined ritual, play, and communal rebirth within the provisional safety of the Christian church. The Ring Shout—a circle dance of praise that allowed for bits of individual expression—emerged in Georgia, Virginia, and the Carolinas (fig. 1). Although the Protestant church frowned upon rhythmic fiddle music and

fig. 1. Maxfield Parrish, Jr., *Ring Shout in the Cabin*, 1935, photograph. From *Slave Songs of the Georgia Sea Islands* (Athens, GA, 1992), 128

THOMAS F. DEFRANTZ

fig. 2. George Luks, *Cake Walk,* 1907, monotype. Delaware Art Museum, Gift of Helen Farr Sloan, 1978

dance, "marching praise services" were allowed for some congregations in the nineteenth century. As these marching services developed complex rhythmic structures, worshipers developed rules to satisfy the stringent church restrictions: the feet must not leave the floor or cross each other. Technically, this made the Ring Shout "not a dance." Like later group dances of the twentieth century popularized during the Harlem Renaissance, including the Big Apple—a circle-based dance that calls for the group to move in concert, counterclockwise as they perform occasional solo and duo variations—the Ring Shout encouraged individual expression, as dancers innovated with body patting, clapping, and stomping within the repeated slide-together-slide circular movement of the group. The Ring Shout continued as a central feature of many black churches and probably led to the rise in liturgical praise dancing of many later twentieth-century denominations.

The Cakewalk (fig. 2), the most famous dance created by African Americans before the twentieth century, derived from activities at corn-husking festivals in the earliest part of the nineteenth century. This partnered dance emerged as a sly parody of the quadrille, a French-derived "set dance" popular among slaveholders in the South. African American dancers made fun of the "genteel manners" of the quadrille and adapted its erect posture and precision patterns to include syncopated rhythmic walking steps, sequences of bowing low, waving canes, tipping hats, and a fast-paced, high-kicking grand promenade. Although it began as a sort of "showing-off" social dance, it transformed quickly into a competitive form that involved acrobatic stunts performed by duos who strove to maintain an upright stance even as they kicked, higher and higher, in tandem. Those determined to possess the most precision, grace, ease—and the highest kicks—won a highly decorated cake prepared for the occasion.

Surprisingly, whites who witnessed the Cakewalk failed to notice its derisive origins and clamored to learn it. The form transferred easily into blackface minstrel shows and early Broadway offerings, as it spread as a popular pastime. The highly successful African American minstrel team of Williams and Walker (Egbert Austin Williams and George Walker) became the most famous practitioners of the dance. Walker and his wife Aida Reed Overton, a noteworthy dancer and choreographer in her own right, brought the Cakewalk to the height of its international popularity when they danced in a Command Performance at Buckingham Palace in 1897. Thus, the Cakewalk, which began as a racialized parody of white manners, offered social mobility to its African American performers who became professional entertainers to the very people mocked by their dance.

Black social dances proliferated during the years of the Harlem Renaissance, some of them imported to New York from the South and Midwest, while others were local. Typically,

dances would find their way to New York by way of house parties and night clubs; they would be further refined and transmitted to cabarets and Broadway stages, and eventually performed abroad by professional artists to international audiences. Josephine Baker's celebrity built upon this circulation of black social dance, and her comic agility in Southern-derived social dances contributed mightily to her appeal among the devoted audiences she enjoyed in France (cat. 59). The Savoy Ballroom in Harlem allowed interracial groups of dancers the space to codify a great many social dances that gained international currency during the era, including the Lindy Hop, the Harlem Stomp, the Big Apple, Peckin', and versions of dances from down South, including the Turkey Trot and the Bunny Hug. Sculptor Richmond Barthé created a vibrant illustration of the dynamic work involved in social dancing with his exquisite *Rugcutters* of 1930 (See cat. 66).

Classical forms of dance during the era of the Harlem Renaissance included ballet and nascent, but generally respected, modern dance. Black Americans participated in both of these idioms in small numbers. The study of ballet remained out of reach for most hopeful dancers, as the few teachers who would take on black students inevitably ran into the difficulty of finding suitable partners for them.[5] In 1937, just at the end of the Renaissance, German choreographer Eugene Von Grona brought forth the American Negro Ballet, a short-lived company that offered a few concerts with balletic intentions at the Lafayette Theater in Harlem. In the 1950s, the First Negro Classic Ballet, led by German emigre Joseph Rickhard, enjoyed some success on international tour. By glimmers, these small efforts predicted the triumphant founding of the Dance Theatre of Harlem by Arthur Mitchell and Karel Shook in 1969.

The slim history of African diaspora dancers in ballet makes Alice Neel's 1950 *Ballet Dancer* all the more luscious to consider (cat. 60). The relaxed, thoughtful position of the leotard-and-tights-clad young man posing for the artist conveys the slight disdain that many dancers express when asked not to move. Neel's painting, with its variety of blockish sculptural forms encasing formidable musculature offset by the soft, sweeping lines of repose, suggests communities of dancers engaged in serious study, albeit at the margins of mainstream understandings of concert dance. *Ballet Dancer* arrives long after the Harlem Renaissance had done its important labor as a provocation for American arts and letters, and yet it stands as one of the only representations of concert dance practice depicting an artist of color during the first half of the twentieth century. Like his contemporary classical and modern artists, the young dancer seems to wonder, "What Shall the Negro Dance About?"[6]

Two African American women gained unequivocal celebrity status as "pioneers" of African American modes of modern dance performance. Katherine Dunham (1909–2006; cat. 61) and Pearl Primus (1919–1994) each surrounded her artistic innovations with graduate work in anthropology, a strategy that ensured attention respectful of the effort to catalogue deep structures of African American performance. Dunham achieved her greatest performing success within the commercial arenas of Broadway and Hollywood. She based much of her stage choreography on her research in the Afro-Caribbean, and developed a dance technique from aesthetic features of African movement retentions visible in the Americas. In 1931, Dunham founded the

Cat. 59. Stanislaus Julian Walery, *Josephine Baker*, 1926

Cat. 60. Alice Neel, *Ballet Dancer*, 1950

Cat. 61. Werner Philipp, *Portrait of Katherine Dunham*, 1943

Negro Dance Group in Chicago, and after traveling extensively in the West Indies, she choreographed one of her most famous works, *L'Ag'Ya* (1938), based on a fighting dance of Martinique. She made Haiti a principal site of her research before moving to East Saint Louis in 1967, where she created a museum and center for dance and culture. Dunham's importance to intellectual and artistic strands of dance is demonstrated by the moody Werner Philipp portrait of the artist (cat. 61), which casts her in powerful presence, presumably backstage and in costume at one of her many performances of theatricalized African diaspora social dance.

> By shedding the old chrysalis of the Negro problem we are achieving something like a spiritual emancipation.... With this renewed self-respect and self-dependency, the life of the Negro community is bound to enter a new dynamic phase, the buoyancy from within compensating for whatever pressure there may be of conditions from without.[7]

Dance exemplifies the "buoyancy from within" that philosopher Alain L. Locke proclaimed in his statement of New Negro emancipation. Participation in music and dance can begin early in black social life, and includes songs and rhyming games affiliated with jump rope and hopscotch, such as "Miss Mary Mack" and "Old Grey Goose."[8] Dance instruction songs, prevalent in African American communities across most historical eras, provide casual directions for new dance moves to match newly minted musical accompaniments. But the most proficient dancers usually enjoy coaching and teaching by seasoned performers. Methods of teaching surely vary. The off-camera tap dance teacher of James VanDerZee's *Untitled (Dancing Girls)* (1928; cat. 62) seems to encourage an expressive, playful enthusiasm among the young girls that might allow each of them to realize a bubbling, animated individuality by way of dance. This sort of individual subjectivity encourages the dancer to determine at least some of the ways that she is seen by a viewing audience. Here, young black American dancers are allowed a reflective, interior imagination enlivened by motion. These dancers will not be flattened into stereotype. In photography of the Harlem Renaissance, then, we see the flickering emergence of subjectivity attendant to black presence as dancers.

Aaron Douglas numbers among the most famous visual artists whose works define Harlem Renaissance aesthetics (cat. 63). Douglas turned to dance several times as he fulfilled commissions to illustrate black history. In general, his work explored a geometric massing of volume to create modernist scenes with the impact of multidimensional woodcuts. In at least two early offerings, Douglas depicted dance as a couple practice that brought together a man and woman. In *Party Invitation* (1927; fig. 3), created in honor of a celebration for Grace and James Weldon Johnson, the dance referenced is buoyant, light on its feet, and egalitarian in terms of effort for each partner. Note the lifted carriage of the torsos and the prominent sway of the backs, as well as the pointed toes and nimble feet scarcely touching the ground. The figures suggest a cosmopolitan turn away from group dancing and toward the couple as a standard for black sociability.

Cat. 62. James VanDerZee, *Untitled (Dancing Girls)*, 1928

Cat. 63. Aaron Douglas, *Dance*, ca. 1930

fig. 3. Aaron Douglas, *Party for Grace and James Weldon Johnson (Invitation),* 1927. Yale University, Beinecke Rare Book and Manuscript Library

fig. 4. Aaron Douglas, *Congo,* ca. 1928, gouache and pencil on paper board. North Carolina Museum of Art, gift of Susie R. Powell and Franklin R. Anderson

The razor-sharp feet at the bottoms of these Douglas figures are echoed in the precise lines employed by Palmer Hayden in his 1927 depiction of a classy social dance, *Jeunesse* (private collection). Here, slender legs lead to tiny, pointed feet that trip lightly across the floor. Hayden crafted this watercolor the same year he moved to Paris for an extended stay of study. The youthful couple in the foreground demonstrates a propulsive lightness, unfettered by social pressures of the outside world; on a mural in the background of the scene, black nymphs cavort in silhouette. The young couple can surely be seen to stand in for the New Negro ambitions to take up more space, to dance vigorously in unexpected patterns, and to break the mold of simple closed-position partnering exemplified by the smartly dressed older dancers in the background.

While Hayden rarely returned to dance as a subject, Douglas mined its importance in several grand murals depicting black history. Douglas agreed with Locke, who assumed unassailable cultural connections from African homelands to New Negro modernity, and his drawings consistently aligned mythic ritual practices to the contemporary dance and music-making of the twentieth century.[9] Attendant to blues and jazz as essential siblings to dance, his important paintings, gouaches, and drawings consistently suggest transgeographic and transhistorical layerings of creative practices at once essential and inevitable.

When Douglas created the illustrations to accompany Paul Morand's sensationalist short story collection *Black Magic,* he imagined a group of African dancers and musicians in full motion.

DANCE: AMERICAN ART, 1830–1960

The 1934 illustration *Congo* from this series suggests the out-of-time communal moment of sacred dance (fig. 4). Here, figures are proportioned with an exaggerated mass of torsos, thighs, and shoulders. Their majestic heads are adorned with a variety of hairstyles, with many cast back in song. A central figure arches back, acrobatically, as another figure becomes transfixed by a vision of a figure floating across the sky. Notice the witness in the front right foreground, an essential figure who watches the dancers to ensure the physical safety and creative accuracy of the events in process.

Douglas returned to these physical archetypes in the illustration *Dance Magic* (1930), the mural *Evolution of Negro Dance* (1933), and the all-important 1934 series *Idyll of the Deep South*. Among the most famous paintings of dance produced by any artists of the renaissance, this latter series offers pointedly modern rendering of ancestral form. Here dancers are grounded by their connections to the earth, with weighted energy pressing down, insistently, beneath heavily muscled bodies. In *The Negro in An African Setting* (see Mercer essay, fig. 2), Douglas reveals his mythic-fantasy intentions, as he depicts a male and female celebrant dancing together at the center of the image. While twentieth-century African Americans often danced in mixed-gender arrangements, few African ceremonial dances would endorse this sort of pairing. The alignment of hetero-social dance ideologies with mythical modernist African imagery forces the viewer to imagine continuities—and ruptures—of dance styles across geography and social circumstance.

The partnered couple recurs in *Aspects of Negro Life: Idyll of the Deep South* (1934; fig. 5), now cast as ghostly silhouettes in the background of a complex rendering of musical expression, witnessing, and labor. The guiding North Star, beacon for life away from the South, illuminates the center of an outdoor circle of seated musicians. Other figures are depicted in supplication, labor, and celebration. The work offers a temporal mixing of possibilities, its rhythmic layering again suggesting black bodies in motion across time and space.

Douglas's works confirmed the complex diversity of embodied experience that surrounds any survey of black life. Although rarely set in urban landscapes, his crowded, mythical vistas suggested the tumultuous proximities of city work and play. Other artists, including

fig. 5. Aaron Douglas, *Aspects of Negro Life: Idyll of the Deep South,* 1934, oil on canvas. Art and Artifacts Division, Schomburg Center for Research in Black Culture, The New York Public Library, Astor, Lenox and Tilden Foundations

Reginald Marsh, Ellis Wilson, and Archibald Motley, created canvases teeming with the unpredictable variety of social dance and the cacophony of urban nightlife. Remarkably, these canvases share an interest in the detail of relationship always in evidence in crowded social settings fueled by the desire to dance, make merry, and stave off the social degradation that too often awaited outside the ballroom space.

Marsh's exquisite *Savoy Ballroom* (1931; cat. 64) suggests the outlandish extravagance of an imaginary evening at the famous Harlem nightspot. Bright colors, bulbous shapes, and the unleashed thrill of a night out surround a raucous moment barely contained by the painter's craft. Remarkably, Marsh portrays a largely middle-aged, widely diverse collection of African American subjects engaged in various responses to the jazz band barely visible at the back of the room. The scene pulsates with energy and mood, inviting viewers to accompany the characters as they glide, slap hands, clutch in close, twist, or to just lean back, arms akimbo, taking in the scene. Dancing, crowded in on itself, produces relationships both viable and impossible within the tightly spaced group.

Ellis Wilson's *Shore Leave* of a dozen years later depicts a similarly crowded scene, this one populated by young sailors and their dates (cat. 65). Here, the dancers seem more agile and intent in their pursuit of couple time, lower backs released outward as the dancers tilt the pelvis backward to grind with their partners. The military uniforms underscore a familiarity among the men, and the firm press of weight downward, into the ground, executed by everyone in the frame confirms the urgency of the affair. Yes, we all need this dance *now,* the painting tells us, in this brief respite from regimented service in a still-too-often segregated military, to soothe us from the unknowable mystery of tomorrow's call to arms.

Archibald Motley Jr.'s paintings of dancing in nightclubs tilt toward the exotic portrayals that circulated prominently in the early part of the twentieth century. In *Nightlife* (1943; see Mercer essay, fig. 4), an expansive dancing space extends into an ambiguous background, suggesting a party always in motion. The celebrants here convey mysterious, downtrodden aspects of social life, with intrigues and sadnesses unfolding among them. Single patrons nurse drinks at the bar or at small tables; an intent couple two-steps in the central foreground of the scene, seemingly without pleasure. Animated, happier dancing is relegated to the far distance, where exuberant young dancers slow drag and spin. Motley's happiest dancing crowd is slightly out of reach and just at the edge of vision in this mythical night out.

While the Charleston and its affiliated fad dances held sway during the "roaring twenties," no social dance captured the continued imagination of Americans like the Lindy Hop. The dance is actually a loose structure for improvisation, usually grounded by a simple side-to-side, side-to-side, sway-back step. Amid this repeated motion, couples improvise in frequent breakout sections to demonstrate agility, musicality, athleticism, rhythmicity, and an abiding ability to swing. As a dance of volition—it's tagline might simply be, "Let's Go!"—the Lindy Hop confirmed most everything youthful, new, and unprecedented about the striving to shift social circumstances surrounding black life. While Mexican painter Miguel Covarrubias created many idealized and

Cat. 64. Reginald Marsh, *Savoy Ballroom,* 1931

Cat. 65. Ellis Wilson, *Shore Leave*, 1941

glamorous illustrations of Lindy Hoppers throughout the 1920s and 1930s, photographer Marion Post Wolcott's 1939 image captures the dynamic possibilities of this important dance in all its joyous everyday ambulation (fig. 6).

The Lindy arrived full of motion and excitement, and it is no surprise that so many artists worked to capture its energy and fluidity. Charles Alston's undated watercolor (late 1930s; fig. 7) demonstrates a moment of lifted energy by a male dancer, counterbalanced by the downward-directed pull of his partner, her curvilinear bottom and hyperextended calves forming rounded counterpoint to her angular arms and square-shouldered blouse. The man's elongated verticality offers a foil to the woman's shrugging gravity: the moment captured suggests the middle of a physical conversation in full swing. The dancers float in an undefined blank space: as prototypical revelers, they anticipate a future of unlimited physical possibilities.

Only a decade later, celebrated artist William Johnson's "Jitterbugs" series recast the dance in freshly minted, multicolored nostalgia (see cat. 69). The renaming of the Lindy as the Jitterbug corresponded to the broadly accessible version of the dance that was codified and taught to dancers who lacked proximity to African American modes of musicality in motion. Like the Cakewalk before it, the Jitterbug became an international sensation and formed the basis for sock-hop white youth culture in the 1950s and beyond.

fig. 6. Marion Post Wolcott, *Jitterbugging in Negro Juke Joint, Saturday Evening, outside Clarksdale, Mississippi,* 1939, negative. Library of Congress, Farm Security Administration — Office of War Information photograph collection

fig. 7. Charles Alston, *Lindy Hop at the Savoy,* late 1930s, watercolor. Thelma Harris Gallery

THOMAS F. DEFRANTZ

Johnson's jitterbugs arrive in between the most forceful deployment of the Lindy Hop as a marker of cultural hipness during the Harlem Renaissance and the simpler "shag" dancing that became popular after the Second World War. These paintings—Johnson created a series of five Jitterbugs—arrive with great graphic energy, their smiling dancers moving toward embrace, their bodies all angles and eye-popping colors. Johnson emphasizes the hands and feet of his subjects, and these exaggerated appendages are exactly the points of contact that matter most for the Lindy bugs: feet that glide and pat the floor, bouncing and landing off the beat in their circular tapping motions; and hands working hard to grab and release the partner in the drops of weight and inevitable break-away steps that truly define the genre.

The black artists of the Harlem Renaissance were always aware that their work was viewed through the "veil" of double-consciousness that sociologist W. E. B. Du Bois articulated in his famous 1903 collection *The Souls of Black Folk*. Their work stood as documentation of black life, even as it also arrived as creative invention and fantasy—as with dance, which operates as both physical fact and gestural metaphor. In 1926, at the height of the renaissance, Du Bois confirmed the importance of the arts to any understanding of black humanity, proclaiming that "all Art is propaganda and ever must be, despite the wailing of the purists. I stand in utter shamelessness and say that whatever art I have for writing has been used always for propaganda for gaining the right of black folk to love and enjoy."[10] Within the aesthetic structures of black life, dance arrives as an intertwined social, political, and personal event. These dances of the Harlem Renaissance expressed the New Negro ambition to underscore the always-shifting diversity of black life in the first part of the twentieth century. Group creativity and social curiosity are the hallmarks of black dance, and the visual artists included in this survey brought forward these urgent social possibilities in their work.

Notes

1. See Jervis Anderson, *This Was Harlem: A Cultural Portrait, 1900–1950* (New York, 1982); Houston A. Baker, Jr., *Modernism and the Harlem Renaissance* (Chicago, 1987); George Hutchinson, *The Harlem Renaissance in Black and White* (Cambridge, MA, 1995); James Weldon Johnson, *Black Manhattan* (New York, 1930); and David Levering Lewis, *When Harlem Was in Vogue* (New York, 1989), among many other scholars and researchers.

2. Langston Hughes, "The Negro Artist and the Racial Mountain," *The Nation* (June 1926): 692–94.

3. The artists and intellectual architects of the New Negro movement included philosopher and sociologist W. E. B. Du Bois; author Langston Hughes; anthropologist and artist Zora Neale Hurston; diplomat, lawyer, and musician James Weldon Johnson; Harvard-educated philosopher Alain Locke; and politician Walter White. Innumerable artists created landmark works of music, visual art, and literary invention affiliated with the movement.

4. Zora Neale Hurston, "Characteristics of Negro Expression," in *Negro, An Anthology,* ed. Nancy Cunard (London, 1934), 39–46.

5. Few teachers of black students in classical or modern dance can be accounted for during the renaissance era. In Chicago, Katherine Dunham studied ballet with Ludmilla Speranzeva; in New York, African American dancer Edna Guy studied modern dance with Ruth St. Denis. See John Perpener, *African-American Concert Dance: The Harlem Renaissance and Beyond* (Urbana–Champaign, 2005), for a comprehensive assessment of concert dance during the HarlemRenaissance.

6. In October 1933, the Harlem YWCA hosted an event "What Shall the Negro Dance About?" staged by the Workers Dance League and led by Hemsley Winfield. Sculptor Augusta Savage participated in a discussion at the event. In 1937, near the end of the renaissance era, Edna Guy and Allison Burroughs organized a Negro Dance Evening at the 92nd Street YM–YWHA. See Perpener 2005 and Susan Manning, *Modern Dance, Negro Dance: Race in Motion* (Minneapolis, 2006).

7. Alaine Locke, "Enter the New Negro," *Survey Graphic* 6, no. 6 (March 1925): 631–34.

8. See Kyra D. Gaunt, *The Games Black Girls Play: Learning the Ropes from Double-Dutch to Hip-Hop* (New York, 2006), and Sally Banes and John F. Szwed, "From 'Messin' Around' to 'Funky Western Civilization': The Rise and Fall of Dance Instruction Songs," in *Dancing Many Drums: Excavations in African American Dance,* ed. Thomas F. DeFrantz (Madison, WI, 2002), 169–203.

9. Alain Locke once termed dance "the cradle of Negro music"; his profound influence on Douglas inspired the artist to research African forms in order to transform black folk idioms into modernist constructions. See Susan Earle, *Aaron Douglas: African American Modernist* (New Haven, 2007).

10. W. E. B. Du Bois, "Criteria of Negro Art," *The Crisis* 32 (October 1926): 290–97.

The Vicissitudes of African American Artists' Depictions of Dance between 1800 and 1960 | *Valerie J. Mercer*

The Emergence of African American Art and Dance in the Nineteenth Century

The "cakewalk," a folk dance created by enslaved African Americans on Southern plantations in the late nineteenth century, was the first of many African American dances to cross over to a white culture.[1] The dance developed from the "prize walks" held at get-togethers on slave plantations in the South. It combined the forward movement of the body with head held high, and featured exaggerated prancing and strutting, as well as improvised dance steps. The Cakewalk overtly satirized the pretentious behavior of white people at formal dances. On the plantations, it was performed as a competitive dance, sometimes executed with a bucket of water on a dancer's head.[2] The couple judged to be the best performers were rewarded with a cake from their white master. The water carrying, the line-dance format, the competition, and the pantomime all marked the dance as African-derived. In time, the Cakewalk was presented on stage in minstrel shows by white entertainers in blackface who performed comedy routines. In 1890, the first black dancers to bring the Cakewalk to the American stage were Dora Dean and her husband Charles E. Johnson, an attractive couple who performed in elegant clothing, *sans* blackface.[3] In theaters, the Cakewalk was usually performed as a line dance to ragtime, and its influence spread when it was discovered by a broad audience.

While African Americans entered the fine arts professions during the nineteenth century—studying European and European American traditions to excel in painting, sculpture, and the decorative arts—they did not render contemporaneous images of their people performing the Cakewalk or any other dance. On the whole, they avoided depicting African Americans and the experiences of their people, because there was no support for this imagery. The restraints

Cat. 72. Faith Ringgold, *Groovin' High* (detail), 1986

of slavery and legislated oppression of freemen in antebellum America made it impossible for most African Americans to achieve the economic success that would enable them to commission artworks. Thus, those nineteenth-century African American artists who are known to us today became successful with subject matter that dominated American painting of the time: portraiture, still life, landscape, and biblical stories. The support of abolitionists, the end of slavery, as well as the increase in patronage for American art, were factors that contributed to this development.[4]

The U.S. government's continued support of institutional racism prevented African Americans from access to educational opportunities. This made abolitionist support of nineteenth-century African American artists crucial. Some abolitionists were wealthy fine art collectors who made it possible for the artists to study the traditions of painting, sculpture, and the decorative arts by providing them with funds and opportunities to travel abroad to attend art schools, study the work of great artists in museums, and exhibit in Europe. Abolitionists also introduced these artists to European American artists and collectors sympathetic to their plight, and who were willing to expose them to the art of fine arts masters and teach them how to further develop their artistic talents.

The earliest images depicting African Americans dancing were created by nineteenth-century European American fine artists or illustrators interested in documenting diverse scenes of American life in the South. These images usually showed black people dancing for the amusement of whites, as in the ambitious genre painting *Militia Training,* dated 1841 (cat. 18), by James Goodwyn Clonney.[5] At front and center of the scene, which features more than thirty people, an African American male performs the Juba, while to his right another African American male claps and raises his foot to the beat of the fiddler's music. The Juba—also called Jig, Clog, Breakdown, and Hambone—was an improvisational dance that derived from Africa, where it was called Djouba. A sacred dance in Africa and the West Indies, in America it soon became a secular dance and involved stomping, as well as slapping the arms, thighs, and chest when drums were prohibited. The image of the "Negro Boy" dancing and singing had become a useful focal point for many antebellum paintings by white artists to denigrate African Americans by portraying this lively figure as a white male minstrel performer in blackface who could be seen in dance halls and circuses behaving like a buffoon. In contrast to the inclusion of this racial stereotype in paintings and prints at the time, Clonney's dancer is obviously an actual African American male, not a caricature. Clonney intentionally included elements that make this painting recognizable in 1841 as a contemporary American scene, from the patchwork quilt thrown over the beer stand to the prominently displayed American flag and cavorting African Americans in the foreground.[6]

Images of minstrels who were well known white performers in blackface were disseminated far and wide through prints. Such was the case with a nineteenth-century engraving

fig. 1. *Performer Thomas D. Rice as Jim Crow, Caricature of an African American,* n.d., engraving. Library of Congress Prints and Photographs Division, Washington, DC

depicting an image of Thomas Dartmouth ("Daddy") Rice (1808–60), who awkwardly mimics the Juba dance as performed by his character Jim Crow (fig. 1). Rice was the most well known of the blackface performers. He became a wealthy star of the eastern theatrical circuit by playing Jim Crow, whose songs and dances he had appropriated from an elderly African American stable hand in Kentucky. In this engraving, Jim Crow appears as the "happy darkie" racist stereotype, dancing while dressed as a once-prosperous dandy, oblivious to his altered appearance in ragged dirty clothing and worn-out shoes. In the background are jungle animals dressed in city finery similar to that worn by Jim Crow. The whole image aimed to dehumanize African Americans by relating them to animals, and grotesquely distorting their exoticism and contributions to dance to emphasize the racist humor in minstrel performance and justify pro-Southern support of slavery, as well as the exclusion of African Americans from Anglo-American life.[7]

In the post-Reconstruction era, the denigration of African Americans in commercial and fine art, as well as popular culture, intensified. This was due to an ideological backlash that denied the equality of African Americans once they had gained their freedom. Many of these racist caricatures included coons, mammies, pickaninnies, sambos, and blackface minstrels performing African American dances.

Harlem Renaissance, the Savoy Ballroom, and the Great Migration

During the period of the New Negro Movement, more commonly known as the Harlem Renaissance (1919–35), various intellectuals, most prominent among them philosopher Alain L. Locke and sociologist W.E.B. Du Bois, urged African American poets, novelists, visual artists, and musicians to portray the diversity of their people's experiences and educate the masses about their history and culture. Locke and Du Bois, especially, urged visual artists to define the image of their people to counter the proliferation of racist stereotypes in fine and commercial art. Equally important was the adoption of a race-conscious philosophy aimed at cultivating a rebirth of pride in those African Americans who would come to embody the "New Negro" by supporting assertive political activity, demanding the government outlaw lynching, and advocating creative expression in all the arts. They believed that achieving these goals would culminate in a revitalization of their culture for a modern world and build self-confidence in their people. Motivated by the increased migration of African Americans from the rural South to the urban North and Midwest in search of new opportunities after World War I and to escape the heightened threat of lynching, this rebirth fermented in major urban areas of the northern United States, such as New York, Chicago, and Detroit. It emphasized a deliberate break with painful memories of a past as enslaved people in favor of constructing a modern authentic identity that would strengthen them as they moved forward to build a future. Locke and Du Bois encouraged creative people to express their African heritage and African American folk culture, as well as

develop a modern black aesthetic. The concept of the New Negro was thus born and promoted, and it would have a tremendous influence on artists of subsequent generations.

By the 1920s and 1930s, the number of trained African American fine artists began to gradually increase due to the admission of some artists to private art schools in the North and the development of art departments in historically black colleges and universities, most of which were in the South.[8] Patronage, in many instances, was provided by the Harmon Foundation (1925–67), which became known for awarding excellence in the visual arts to African Americans as well as touring exhibitions of their art, and the Julius Rosenwald Foundation (1928–48), which granted fellowships to African American artists to travel in the United States or abroad to further their studies. In addition, there were self-taught, determined artists active in the era who developed careers. Many of these artists influenced by the tenets of the Harlem Renaissance created art that challenged prevalent stereotypes about African Americans, educated the masses about their culture, restored pride in their people, and exemplified a commitment to their profession and objectives that would serve as a model for subsequent generations.

One of the earliest images by an African American artist depicting African Americans dancing is a charming photograph by James VanDerZee (1886–1983) of a group of little girls performing in a dance class (cat. 62). *Untitled (Dancing Girls)* was taken in 1928, well into the Harlem Renaissance. The girls wear top hats and carry canes like adult professional dancers while tapping on the wood floor. Tap dance has roots in Irish step dancing, English clog dancing, and African Juba dance.[9] It first appeared in nineteenth-century minstrel shows. For this photograph, VanDerZee had the girls pose in an interior space with their props, as was typical with most of his subjects, to suggest a feasible narrative for the viewer. VanDerZee, a self-taught photographer, resided in Harlem and spent his lengthy career documenting the lives of the residents from various social and economic backgrounds. His images depicting the New Negro were in contrast to popular racist stereotypes of African Americans and provided valuable information about the most important urban black community during the Harlem Renaissance. VanDerZee became known especially for his images of middle-class African Americans. The subject of prosperous African Americans thriving with dignity during the first half of the twentieth century was unknown to most Americans. In 1969, a broad audience was introduced to this type of imagery when VanDerZee's photographs were included in the controversial but highly attended exhibition *Harlem On My Mind: Cultural Capital of Black America, 1900–1968,* organized by the Metropolitan Museum of Art.[10] This exposure brought him fame and recognition as the chronicler of Harlem life during the first half of the twentieth century. Though young, the little girls represent an aspect of the New Negro identity: they come from a middle-class family that can afford the luxury of dance lessons. The image is a metaphor for the hopeful future of African Americans and their culture.

Rugcutters (1930) by Richmond Barthé (1901–89) is the earliest sculpture by an African American artist to depict an African American couple dancing the Lindy Hop (cat. 66), a popular dance during the 1930s and 1940s that had evolved in Harlem during the 1920s. It was based on a fusion of dances, namely, jazz, tap, the Charleston, and the Breakaway. The Lindy Hop, named

Cat. 66. Richmond Barthé, *Rugcutters,* 1930

after Charles Lindbergh's 1927 transatlantic "hop," was a jazz dance of the swing era that combined solo and partner dancing.[11] *Rugcutters* represents the assertive sensuality that was typically displayed by females performing the dance alone or with a male partner.[12] At the same time, a sense of overwhelming despair seems to hang over the couple, evident in their dramatic embrace that indicates the emotional tensions between the sexes. The Lindy Hop was an improvisational spectacle that took place in Harlem's famous Savoy Ballroom, located at 596 Lenox Avenue, between 140th and 141st Streets, where exhibitionism on the dance floor was provoked by the "hot" music. The title *Rugcutters* indicates that the sculpture was inspired by the then popular phrase "cutting a rug," which referred to the fierce competitive spirit of certain dances, especially the Lindy Hop. About the same year *Rugcutters* was cast in bronze, Barthé was studying modern dance at Martha Graham's studio and frequenting the Savoy Ballroom. Many of his sculpted figures resemble dancers due to the litheness of their limbs and elongation of their bodies, no matter what subject they portray. Throughout his career, Barthé adhered to a traditional naturalist treatment of his figures and subjects that he had adopted as a student at the School of the Art Institute of Chicago in 1924. Still, his early sculptures were often regarded as modern because they represented African Americans, a new subject for art.

Feral Benga (1935; cat. 67) is one of several bronzes by Barthé that synthesizes his interest in dance and African art and culture as a source for "authentic" subject matter, reflecting his pride in his African ancestry.[13] In addition, it exemplifies the appeal of the classical nude male for his art and its dominance for his subject matter. Barthé first saw dancer François Benga perform in 1934 when he was visiting Paris. Benga was originally from Senegal and had made a career in the City of Lights as a chorus dancer for Josephine Baker (cat. 68) and other famous entertainers. The Senegalese dancer became Feral Benga when he performed on the stage, his name alluding to his supposed animal-like sexual prowess. This is just one of the many myths and fantasies his largely white audience held about black people during the 1920s and 1930s, when Negrophilia, the love of black culture as a provocative challenge to bourgeois values, was rampant in Paris and New York as a sign of modernity.[14] Barthé soon executed the small sculpture when he returned to New York. Inspired by Benga in the act of performing dance, it is lifelike and frank in its display of anatomic details; at the same time, its extremely elongated torso and thighs idealize the figure to evoke elegance and lightness. The figure is shown mid-pose as he waves a machete in his right arm, a gesture derived from Haitian folk dances to symbolically cut away evil.[15] A nude male holding a blade in the foreground of Italian artist Antonio Pollaiuolo's much reproduced fifteenth-century engraving *Battle of Naked Men,* in the Metropolitan Museum of Art collection, is believed to have been the model for *Feral Benga*.[16] This source was also the inspiration for Benga's nakedness in the sculpture, although the dancer was not known to have ever danced nude and did not pose for this work. The homoeroticism evoked by Barthé's *Feral Benga* was unprecedented in African American sculpture.

The first visual artist invited to participate in the Harlem Renaissance movement by Locke and Du Bois was Aaron Douglas (1899–1971), regarded by many as the quintessential artist

Cat. 67. Richmond Barthé, *Feral Benga, Senegalese Dancer*, 1935

Cat. 68. Richmond Barthé, *Josephine Baker,* ca. 1951

of the movement because he successfully synthesized African art, Egyptian design, and European modernism. Douglas depicted dance in a mural commissioned for the Harlem branch of the YMCA, an important refuge for artists and writers who moved to the area. Titled *Evolution of Negro Dance,* the mural shows the flat, silhouetted figures of men and women, some of whom wear top or bowler hats. While a few figures overlap, they mainly are arranged in a frieze format that suggests the historic progression of Negro dance, since specific dances are indecipherable in the mural. The men and women dance in profile and seem to be situated in a lush landscape with grass and trees on the left or a night club filled with plants on the right, and in the center, to suggest the rural American South or Africa and the urban centers of the North or Midwest. Douglas suggests the excitement of Harlem nightlife during the period through the mural's warm ocher/greenish tones. The gradated concentric circles radiating out from the center of the elegant composition are an important motif for much of Douglas's art. They might be understood as an aura emanating from the people in the scene that denotes some power or fourth dimension beyond the visible, just as the slanted architecture in many of his works evokes the heady energy of Harlem in the 1920s and the dynamism of urban modernity.[17]

African music, dance, and sculpture are emphasized in *The Negro in an African Setting* (fig. 2), one of Douglas's four murals commissioned by the Public Works of Art Project in 1934 for the New York Public Library's 135th Street branch, now the Schomburg Center for Research in Black Culture. The overall theme of the mural series is *Aspects of Negro Life,* with individual murals focused on the emergence of Black America, beginning with life in Africa and tracing the history of African Americans through slavery, emancipation, and the rebirth of African traditions. A common theme in art during the Harlem Renaissance was a renewed emphasis on continental Africa as the root of African American culture. It was often expressed by Douglas through the inclusion of jungle and tribal scenes rendered in stylized, flat silhouetted forms and abstract geometric shapes to honor African American heritage. Tribal African imagery was also synthesized with modern art, resulting in an innovative genre that connected African heritage with social progress.[18]

European American artist Reginald Marsh (1898–1954) frequented the Savoy during the 1930s and created at least three tempera paintings of people dancing there. He tended to focus on

fig. 2. Aaron Douglas, *Aspects of Negro Life: The Negro in An African Setting*, 1934, oil on canvas. Art and Artifacts Division, Schomburg Center for Research in Black Culture, The New York Public Library, Astor, Lenox and Tilden Foundations

VALERIE J. MERCER

working-class people in New York City as the subjects for his paintings during the 1920s and 1930s. In his upbeat *Savoy Ballroom* (1931; cat. 64), Marsh depicted African Americans dancing the Lindy Hop to the hottest music for a brief respite from their worries. The ballroom was one of the few integrated nightspots in Harlem and was open to people from diverse backgrounds, whether day laborers or successful entrepreneurs. *Savoy Ballroom* is the only Marsh painting in which black people dominate the composition. That the highly animated group dressed stylishly in vibrant colors is being watched and studied by the artist is evident by Marsh's presentation of their skin tones, diverse movements, and physical sizes within a stagelike space. The people are unknown to him, except for the stout man on the right whom Marsh identified as "Shorty," most likely George "Shorty" Snowden, the lead founder of The Lindy Hop, who popularized the dance and frequented the Savoy during the late 1920s and early 1930s.[19] Like many people who came to the Savoy, Marsh was there because of the ballroom's reputation; however, during that era, a favorite pastime of white people was to venture uptown to Harlem to explore African American night life venues for fun and exposure to real or imagined transgressive activities.[20] By the late 1930s, with the onset of the Depression and Harlem's economic decline, whites abandoned this hobby of "slumming."

fig. 3. Archibald Motley Jr., *Saturday Night,* 1935, oil on canvas. Howard University Gallery of Art, Washington, DC

fig. 4. Archibald Motley Jr., *Nightlife,* 1943, oil on canvas. The Art Institute of Chicago, Restricted Gift of Mr. and Mrs. Marshall Field, Jack and Sandra Guthman, Ben W. Heineman, Ruth Horwich, Lewis and Susan Manilow, Beatrice C. Mayer, Charles A. Meyer, John D. Nichols, and Mr. and Mrs. E. B. Smith, Jr.; James W. Alsdorf Memorial Fund; Goodman Endowment, 1992.89

Chicago-based Archibald J. Motley, Jr. (1891–1981) is noted for his colorful paintings representing nightlife in Bronzeville, a section on the South Side of the city populated by African Americans from the 1920s through 1950s, when it was the center for their culture, businesses, and night life. He was the first visual artist to study black nightlife in urban centers,[21] and his paintings depicting this subject are admired for their radical departure from artistic conventions to create stylized images of African American modern life through a contemporary African American perspective. The artist never lived in Bronzeville but was familiar with its nightclubs, and by the 1930s Motley was portraying its busy streets and activities in clubs to portray "a great variety of Negro characters" by emphasizing their diverse skin tones, facial features, and body types.[22] In keeping with this interest, he painted *Saturday Night* (fig. 3), which highlights a vivacious solo female performer dancing in a nightclub patronized by African Americans, who drink while seated at cocktail tables. The female dancer is shown leaning slightly backward, extending her arms to wave her hands and lift one foot off the floor, simulating the movements of someone performing the Lindy Charleston, which contains elements derived from the earlier Juba and Charleston, and anticipates the Lindy Hop. During the 1930s, it was danced to a swing version of jazz. The crowded floor on which she stands is tilted upward toward the picture plane to draw the viewer into the scene, while simultaneously creating the illusion of three-dimensional space.

VALERIE J. MERCER

This device, along with Motley's evocation of artificial light, use of an unnatural reddish color, and the rhythmic syncopation between black and white colors, as well as flat areas with round forms, makes apparent Motley's study of European modernism during his sojourn in Paris between 1929 and 1930, which was funded by a Guggenheim Fellowship. Besides the dancer, the tightly compressed space of the scene includes patrons, waiters precariously balancing trays, musicians in the upper right corner, and a bartender standing behind the bar with a couple of male customers on the other side, one of whom stands with his right arm extended, snapping his fingers to the beat. In *Saturday Night* and other Motley paintings related to dance, such as *Nightlife* (fig. 4), the artist saturates nearly every object and human form with the effects of artificial light, using red violet or teal blue to charge the scene with a heightened energy, equated with the raucous mood of the club and the exuberant spirit of the time.

Motley created a cast of what he called "characters" that are repeated from work to work. In several instances, his stylized characters, which have generalized, blurred, and exaggerated features, seem to be wearing masks that distort their faces into minstrel caricatures. Motley was known for his skills in realistic portraiture, and there is written evidence that he abhorred the popular racist stereotype imagery; however, he likely relied on the viewers' familiarity with visual clichés in order to communicate what he perceived as "authentic" narratives for art that revealed the modern experiences of African Americans.[23] By relocating those visual clichés within contexts he regarded as positive and true, he was attempting to subvert the stereotypes.

Cultural, Social, and Political Changes during the Post-Harlem Renaissance Era Provoked by the Great Depression and the Onslaught of World War II

The earnest creative spirit of the Harlem Renaissance diminished as the Depression impacted world economies from the 1930s through the mid-1940s. African Americans were preoccupied with struggling to survive years of unemployment, poverty, scarcity of food, and housing shortages, regardless of class and level of education. Their problems were exacerbated by racial discrimination and police brutality, often intensified in America during periods of broad economic hardships.[24] Consequently, African Americans were soon becoming more outspoken and active in their efforts to fight social and political injustices. Some were also broadening their knowledge about Africa, European colonialism, and world events.[25]

The Works Progress Administration—established in 1935 and four years later renamed the Work Projects Administration (WPA)—was a program implemented during the Depression as part of President Franklin D. Roosevelt's New Deal that provided jobs for many African Americans.[26] It also made it possible for African American artists to continue to paint and sculpt by employing them for government projects. At the same time, patronage by the Harmon and Julius Rosenwald foundations continued for visual artists. Teaching opportunities at historically

fig. 5. William Johnson, *Jitterbugs (III),* 1941, oil on plywood. Smithsonian American Art Museum, gift of the Harmon Foundation

black colleges and universities with growing art programs also provided employment for them during the 1930s and 1940s.

With the coming of World War II, African Americans were skeptical about fighting for democracy abroad without reaping its benefits at home, yet many ultimately joined military services that were segregated and which relegated them to noncombat duty as servants, laborers, and truck drivers. Urban violence broke out in more than forty cities throughout the United States during the war, especially in 1943, due to a climate of worsened racial discrimination and segregation, and rumors of white civilian and police attacks on blacks. Simultaneously, swing bands incorporated the boogie-woogie beat into their music for young people who wanted to dance the Jitterbug and Lindy Hop to temporarily cope with the onslaught of the war and its attendant problems.

After studying and living abroad for twelve years, artist William H. Johnson (1901–70) in 1938 returned to Harlem and the African American art community there. By that time, he regarded himself as a "primitive," an artistic identity typically asserted in the early twentieth century by European artists who adopted an expressionist approach to making modern art, characterized by their renderings of distorted forms painted with thick applications of vibrant colors to express intense emotion. Johnson now sought to combine these tenets of expressionist art with his interest in black popular culture that included a fascination with folk art. He created four paintings and several prints of couples dancing the Jitterbug (fig. 5), a dance craze that originated in Harlem during the swing era of the 1940s as an extension of the Lindy Hop. One of the prints, *Jitterbugs (II)* (1941; cat. 69), recalls Barthé's *Rugcutters*; however, Johnson's image emphasizes the couple's shared enjoyment in the dance rather than the emotional tensions between the man and woman in Barthé's bronze. Johnson's simplified figures are vibrantly colored flat forms with limbs and body parts characterized by sharp angles. They and their sparse environment in the composition emphasize the image's significance as an iconic symbol of the Jitterbug.

Charles Alston's (1907–77) youthful dancers doing the Lindy Hop at the Savoy Ballroom in an image from the 1930s are very animated (see DeFrantz essay, fig. 7). The technique he used for these works was watercolor with a modern stylized figuration to portray dance partners kicking up their heels, bending their elbows, and waving their hands while moving their bodies to swing music. By the time he painted *Dancers* in 1949 (cat. 70), his paintings and murals with historical and contemporary themes demonstrated his use of either a figurative style, indicative

VALERIE J. MERCER

Cat. 69. William H. Johnson, *Jitterbugs (II)*, ca. 1941

of his absorption of the tenets of social realist art and the Mexican muralist movement, or an abstract mode, inspired by his knowledge of African art and its significant role in the development of modern art.[27] In *Dancers,* Alston combined the influences of African sculpture and analytical cubism to his treatment of the forms to convey their energized movements in response to the rhythm of jazz during the swing era. He was known to be a fan of jazz who frequented the Savoy and often worked while listening to this music in his Harlem studio, a favorite gathering place for artists, writers, photographers, and other creative friends. In the painting, we see heads tilting, knees and backs bending, and arms raised as feet lightly touch the floor. The movement of the dancers is traced by sweeping brushstrokes at the top of the painting. Brushstrokes and a palette knife have been used to apply paint with a fluid consistency to add textural contrasts to the painting's surface and volume to forms constructed and defined by color.[28]

Although the popularity of the Lindy Hop gradually waned in postwar America, a pair of watercolor mural studies for the San Francisco Housing Authority rendered in about 1950 by Sargent Claude Johnson (1888–1967) depicts racially diverse male and female couples performing the dance (cat. 71) in a hall. The lower area of one study shows a trio of crouching musicians playing their instruments while the wood floor above them is filled with dancers whose arms and legs move to the beat of the music. At front and center stage is a dancing African American couple with a transparent, cryptic, abstract form superimposed upon them. The abstract form alters the color of their extended limbs and their apparel. The use of other abstract forms to problematize the reading of space and form is repeated in the lower area showing the musicians. Hovering in the upper left and right corners of the study are masks that reflect Johnson's long-term interest in Indigenous Oceanic and African cultures. These studies by Johnson were never realized as completed murals, likely due to the lingering effects of the 30 percent excise tax levied against "dancing" night clubs in 1944.[29]

The Birth of Bebop, and the Decline in the Creation of Dance Images
Depicting African Americans during the Post-World War II Era, in Favor of
New Subjects related to the Mounting Civil Rights Movement

During the 1940s, swing began to diminish in popularity. Big bands turned into smaller ensembles, quintets, or quartets. Musicians of the younger generation shifted to a heightened focus on improvisation combined with instrumental virtuosity and fast tempo. The result was bebop, an intentionally nondanceable style of music that demanded listening. Synonymous with modern jazz, bebop achieved maturity in the 1960s. African American musicians Charlie "Bird" Parker, who played alto sax, and Dizzy Gillespie, who played trumpet, were the innovators responsible for advancing bebop.

The formalist approach of bebop had its equivalent in the eventual prevalence of abstraction in visual art as African Americans became exposed to a broad range of ideas about art

Cat. 70. Charles Alston, *Dancers*, 1949

Cat. 71. Sargent Claude Johnson, *A Study for a San Francisco Housing Authority Mural #2*, ca. 1950

making through educational opportunities provided by the GI Bill. Many of these artists were also able to further their studies abroad to learn firsthand about European modernism. In subsequent decades, work by African American artists increasingly reflected various approaches and styles prevalent in American art, such as the diverse tendencies toward abstraction, the use of nontraditional materials, the reconsideration of the figure, and the expression of a multitude of interests through choice of subject matter and techniques.[30]

As African Americans gained access to institutions of higher learning, they began to fight against segregation and discrimination in order to have the right to attend any school they desired for which they qualified. Related events in this struggle led to a civil rights movement between 1954 and 1968 that was broad in scope, culminating in legal protection and federal recognition of the rights of African Americans. Iconic images by African American artists depicting African Americans dancing decrease in number as bebop jazz becomes paramount and artistic, social, and political interests take over as subjects for visual art.

The special contribution of Roy DeCarava (1919–2009) to postwar photography was his conscious decision to devote his attention to the beauty and complexities of African American people and culture, presenting them from an artist's sensibility not social record.[31] His subject matter and technique of patiently developing and printing his photographs, sometimes over a period of years, led him to achieve the effects he desired, which included dense shadows and blurs that he regarded as marks of authenticity.[32]

DeCarava grew up in Harlem and eventually attended the Harlem Community Art Center after leaving Cooper Union School of Art in frustration due to his experience of racial prejudice.[33] Artists Charles Alston, Aaron Douglas, and William H. Johnson were some of the instructors teaching there; however, DeCarava credits the social realist artist Charles White, who specialized in creating powerful and respectful images of African Americans, for influencing his commitment toward social responsiveness in his art.[34]

Two photographs made by DeCarava in 1956 depict African Americans engaged in different types of dancing and evoking different moods. Both works are quintessential 1950s DeCarava style, shot in low lighting and printed in a narrow range of gray tones with minimal contrast. The images are mysterious, obscure, and, at the same time, inviting. The ambiance in *Couple Dancing* (1956; Detroit Institute of Arts, no. 2003.79) is intimate and mellow, a quality achieved by the subdued lighting in the room and DeCarava's careful framing of the composition. The dark hollows surrounding the couple seem to absorb and muffle the melodic rhythms in the air, while simultaneously absorbing the light that shines into the interior. Partially hidden in lush, dense shadows, their bodies appear headless, like ancient Greek statues or an abstract sculpture set against a dark ground. Inside the darkened space, forms elucidate, then return to the shadows.[35] The couple is doing the "Slow Drag," which was once part of the Cakewalk, but by the 1950s it was revived to be danced to the blues with a partner. Because a requisite feature of the dance was the closeness of two bodies of the opposite sex, in some African American communities it was understood that the "Slow Drag" was reserved for couples in a romantic relationship.

Cat. 72. Faith Ringgold, *Groovin' High,* 1986

In the same year, DeCarava also photographed *Dancers* (1956; Detroit Institute of Arts, no. F1988.23), featuring two African American males entertaining customers at the Manor Social Club in East Harlem. DeCarava was both disturbed and fascinated by the image of the male dancers wearing broad-shouldered suit jackets with their "processed" hair, displaying expressive hand gestures and exaggerating their stooping postures. He felt it epitomized the reality of African American vaudeville performers of the past who entertained a white audience by demeaning themselves for the sake of survival; yet DeCarava was attracted to the image of the two men, which he also saw as creative and evocative of African American culture and history. Acknowledgment of the duality imbued in the image was painful for the photographer, but he knew it was still a good picture *even* because of that ambiguity. It is possible that the dancers, who were African Americans of a younger generation, thought the racial stereotypes they referenced were no longer a problem for their people.[36]

The image of dance in African American visual art was a favorite subject during the Harlem Renaissance for some African American artists living and working in Northern and Midwestern urban centers. Such colorful and lively depictions of dance by artists were long-overdue expressions in fine art of their hard-won freedom to celebrate and share their history and culture. At the same time, many talented African American artists avoided the subject of African American dance because it reminded them and others of the racist stereotypes embodied by white minstrels in blackface. While this negative imagery diminished over the years, it did not completely disappear. For most African Americans these images still conjure the original intended degradation. Even subsequent artists who were engaged in dance due to family and personal experience, like Romare Bearden and Hughie Lee-Smith, respectively, did not seem to have interest in this type of imagery for their art.[37] Because their formative years as artists were during a period of surging changes in the country, their art did not focus on the subject of dance but directly and indirectly on the cultural, social, and political changes of the time; however, both artists were known to love music and depicted images of musicians in their art. This change in emphasis was due to the strong impact of bebop jazz on American culture in general, and African American culture in particular, which emphasized the musician as artist. Improvisation, innovation, and virtuosity were fundamental to bebop jazz, making this music a source of creative inspiration for visual artists who claimed the same foundation for their work. Similar to the beat generation, bebop continues to have influence on spoken-word artists and hip hop artists' rapping and rhythmic styles. As in its beginning, bebop is associated with the coolness and hipness at the heart of African American culture.

While many people respected the demand of bebop musicians that they listen to the music but not dance, there were likely some jazz fans who could not resist dancing. This is evident in a 1986 story quilt by artist Faith Ringgold titled *Groovin' High* (cat. 72), which pays tribute to bebop jazz composer and trumpeter Dizzy Gillespie. This instrumental composition was regarded as wonderfully radical and strange when it was first introduced in 1945 because it

was so unique. Today it is regarded as a classic of bebop jazz innovation. The story quilt's dynamic imagery depicts stylishly dressed couples as they dance exuberantly. It possibly conveys Ringgold's memories of stories she heard as a young woman from elder residents of Harlem about their experiences dancing in clubs and dance halls of the past. No doubt, there will always be people who cannot resist the challenge of trying to dance to the virtuosic, improvisational musical arrangements of bebop.[38]

The Waning of Interest in Representing Dance in Twenty-First Century African American Art

The respite from dance due to the popularity of bebop jazz in its heyday was brief. Subsequently, new vernacular dances were invented at black church halls, cabaret clubs, house parties, and other familiar social spaces. They were inspired by blues, rock and roll, Motown, funk, disco, and hip hop music, as well as the choreographic performances of musicians and, eventually, the inclusion of professional dancers in MTV videos.

As the twenty-first century unfolds, vernacular dance thrives as an important aspect of African American culture and a constantly changing creative expression; however, rarely does a contemporary African American visual artist demonstrate interest in dance as a viable subject. Instead, since the civil rights era, many of the artists prefer to provoke change by examining in their art ongoing social, political, and economic issues that negatively impact the lives of African Americans. Other topics currently dominating African American art assert the coexistence of individual perspectives on the complexity and diversity of African American identities. For many, the ultimate goal currently being striven for and realized by many of the artists today is their participation on an ever-evolving world stage that respects and appreciates their art as distinctly American.

Notes

1. Barbara Glass, "The Africanization of American Movement," in *When the Spirit Moves: African American Dance in American Art* [exh. cat., National Afro-American Museum and Cultural Center] (Wilberforce, OH, 1999), 22.

2. Ibid., 23.

3. Lynne Fauley Emery, *Black Dance From 1619 to Today*, rev. ed. (Princeton, NJ, 1988), 207–8.

4. Joseph D. Ketner, *The Emergence of the African-American Artist: Robert S. Duncanson, 1821–1872* (Columbia, MO, 1999), 1–10.

5. Sharyn R. Udall, *Dance and American Art: A Long Embrace* (Madison, WI, 2012), 53.

6. Ibid.

7. Ibid., 55–58.

8. Exceptions are historically black colleges and universities (HBCU) located in Washington, DC; Ohio; Kansas; and Pennsylvania.

9. Florence Mills, Josephine Baker, and John Bubbles were a few of the African American tap dancers who were well known stars in staged musicals during the 1920s.

10. Allon Schoener, *Harlem on My Mind: Cultural Capital of Black America, 1900–1968* (New York, 1968).

11. Margaret Rose Vendryes, *Barthé: A Life in Sculpture* (Jackson, MS, 2008), 74–75.

12. Mura Dehn and Herbert Matter, *The Spirit Moves: A History of Black Social Dance on Film, 1900–1986* (New York, 2008), set of 3 DVDs; see Lindy Hop performed, Part I, Jazz Dance From the Turn-of-the-Century, 1900–1950.

13. Vendryes 2008, 64–68.

14. Petrine Archer-Straw, *Negrophilia: Avant-Garde Paris and Black Culture in the 1920s* (New York, 2000).

15. Vendryes 2008, 67.

16. Ibid., 68.

17. Susan Earle, "Harlem, Modernism, and Beyond," in *Aaron Douglas: African American Modernist* [exh. cat., Spencer Museum of Art at the University of Kansas in Lawrence] (New Haven, 2007), 30, image p. 32.

18. Ibid.

19. Carmenita Higgenbotham, "At the Savoy: Reginald Marsh and the Art of Slumming," in *Bulletin of the Detroit Institute of Arts,* vol. 82, nos. 12 (2008): 18.

20. Ibid., 17.

21. Udall 2012, 71.

22. Jontyle Theresa Robinson and Wendy Greenhouse, *The Art of Archibald J. Motley, Jr.* [exh. cat., Chicago Historical Society] (Chicago, 1991), 104.

23. Amy M. Mooney, *Archibald J. Motley, Jr.* (San Francisco, 2004), 88–93.

24. Nell Irvin Painter, *Creating Black Americans: African-American History and Its Meanings, 1619 to the Present* (New York, 2007), 218.

25. Ibid., 211.

26. James Clyde Sellman, "Works Progress Administration," in *Africana: The Encyclopedia of the African and African American Experience,* ed. A. Apiah and H.L. Gates, Jr. (New York, 1999), 20–24.

27. Elsa Honig Fine, *The Afro-American Artist: A Search for Identity* (New York, 1982), 139.

28. http://www.jonathanboos.com/artists/alston-charles-henry (accessed June 1, 2015).

29. Jacqui Malone, *Steppin' on the Blues* (Urbana and Chicago, 1996), 109–10.

30. Valerie J. Mercer, "Diversity of Contemporary African American Art," in *Bulletin of the Detroit Institute of Arts,* vol. 86, nos. 1–4 (2012): 88.

31. Stephanie James, "Extraordinary Shades of Gray: the Photographs of Roy DeCarava," in *Bulletin of the Detroit Institute of Arts,* vol. 80, nos. 1–2 (Detroit, 2006): 58–67.

32. Ibid., 58.

33. Ibid., 59.

34. Ibid., 60.

35. Ibid., 61.

36. Ibid., 60.

37. Romare Bearden's wife, Nanette, was a trained dancer and eventually formed the Nanette Bearden Contemporary Dance Theatre. Hughie Lee-Smith performed with an interracial dance company during the early years of his art career. Neither Bearden nor Lee-Smith produce notable images of dance in their work.

38. Dehn and Matter 2008; see dances performed during Bebop Era, Part 3, Postwar Era.

H. P.: A Lost Dance of the Americas | *Lynn Garafola*

In the history of American ballet, the years from 1917, when the Ballets Russes paid its last visit to the United States, to 1933, when the Ballet Russe de Monte Carlo paid its first and the choreographer George Balanchine landed in New York, are usually viewed as an artistic void. To be sure, scholars have found an occasional bright spot—Americana ballets such as Adolph Bolm's *Krazy Kat* (1922) and Ruth Page's *The Flapper and the Quarterback* (1926); works of high European modernism such as Elizaveta Anderson-Ivantzova's *Les Noces* (1929) and Léonide Massine's *Le Sacre du Printemps* (1930). Still, compared to the research on early American modern dance, the paucity of writing about ballet during these years is striking. In part, this can be explained by the staying power of traditional narratives of American ballet history—above all, the idea that ballet in the United States derives almost wholly from Balanchine. However, the neglect also stems from the fact that many works of these years opened outside New York, were produced by musical organizations, received only a handful of performances, and were choreographed by women.[1] Although all performance is ephemeral, these ballets seem to be unusually so.

This was certainly the case of *H. P. (Horse Power)*, an all-but-forgotten ballet with music by Carlos Chávez (fig. 1), designs by Diego Rivera, and choreography by Catherine Littlefield (fig. 2), which opened in Philadelphia in 1932. *H. P.* shares any number of characteristics with other ballets of this pre-Ballet Russe de Monte Carlo, pre-Balanchine period: the subject matter was American, the composer a modernist, and the choreographer a dancer at an early stage of her choreographic career. Moreover, like these other works it was indebted to the Ballets Russes: like *Parade* (1917), it was set in the contemporary world and conceived by important contemporary artists; like *Petrouchka* (1911) or *Le Tricorne* (1919), it melded nationalism with the exotic; and, like nearly all Ballets Russes productions, treated ballet not as a display of the *danse d'école* but as an art

Cat. 76. Diego Rivera, Set design for Scene IV of the ballet *H. P. (Horsepower)* (detail), 1927 or 1931

fig. 1. Diego Rivera, *Portrait of Carlos Chávez,* 1932, drawing. Image courtesy of the Wiener Music and Art Library, Columbia University

fig. 2. Portrait of Catherine Littlefield, mid-1930s, photograph. New York Public Library

of expressive movement. For artists, musicians, and writers, Ballets Russes works offered a model for transforming popular traditions into the raw material of a high modernist art. Hence, Alejo Carpentier and composer Amadeo Roldan's unrealized *La rebambaramba,* depicting an Afro-Cuban carnival; the choral ballet *Sahdji* (1931), with a libretto by Alain Locke and music by William Grant Still, based on African folk materials; and *Caaporá,* an Argentine "Indigenous" work, also unrealized, with designs by the painter Alfredo González Garaño and a libretto by the writer Ricardo Güiraldes.[2] *H. P.* complicated this trajectory with its dual imagined communities, Americas of the North and the South, Wall Street vs. Tehuantepec, the machine vs. nature, profit vs. people. At the height of the Depression, it was a ballet in which the workers triumphed, and which looked and sounded both modern and expansively American. Here, wrote Chávez in the souvenir program, was the "grand ferment of this, our American continent."[3]

During the 1920s, the Mexican-born Chávez composed several ballets. His earliest efforts dated to the aftermath of the Mexican Revolution and told stories rooted in Aztec folklore. *H. P.,* by contrast, was conceived at a time of heightened musical interest in the machine aesthetic, evident in works such as Arthur Honegger's *Pacific 231* (1923), John Alden Carpenter's *Skyscrapers* (1923–24), and Sergei Prokofiev's *Le Pas d'Acier* (1925–26).[4] Chávez wrote the last tableau first, and a fragment from it, entitled "Dance of Men and Machines," premiered at New York's Aeolian Hall in 1926 at a concert sponsored by the International Composers' Guild. "Machines," he wrote in a program note, "are disciplined energy...a true product of will applied to intelligence and of intelligence applied to will. In other words, they are a human product in which emo-

DANCE: AMERICAN ART, 1830–1960

tion...has welded intelligence and will together." Scored for a small orchestra, the music was intended to conclude a three-part work suggesting "objectively the life of all America."[5]

In 1926 Chávez moved to New York, where he would spend nearly two years, becoming not only an important member of the city's expatriate Mexican community but also an integral part of its modern music one, second only to that of Berlin in the 1920s and a magnet for composers from all over the Americas. Chávez formed close working relationships with two remarkable women—Clare Reis, executive director of the League of Composers, and Minna Lederman, editor of *Modern Music*—both of whom actively promoted his music, and he made friends with influential critics and composers, including Henry Cowell, Paul Rosenfield, Edgard Varèse, and Aaron Copland. He grew especially close to Copland, exchanging letters with him for the next fifty years, programming his music, and inviting him to Mexico to conduct. Both had spent time in Paris in the 1920s, and although this was a formative experience for Copland, it left both convinced that their future as composers lay elsewhere. "I have just returned from Europe," Copland declared in 1931. "All you wrote about music in America awoke a responsive echo in my heart. I am through with Europe, Carlos, and I believe, as you do, that our salvation must come from ourselves and that we must fight the foreign element in America which ignores American music."[6]

Diego Rivera, the era's most prominent Mexican painter, joined the *H. P.* project early on. In 1926, he sent Chávez a "synopsis" of the ballet, with the general lines of its development emerging in conversations between the two friends. Rivera also agreed to design the sets and costumes, although it is unclear how many of the ballet's surviving sketches date to this gestational period.[7] Much to Chávez's disappointment, the concert did not lead to a theatrical production. In 1927 his friend Agustín Lazo wrote him from Paris praising the Ballets Russes production of *Le Pas d'Acier,* while also noting its similarities with *H. P.* "The finale in the factory is perfectly achieved, both in music and in choreography.... What a shame these people have the resources to realize their things so rapidly."[8] Another friend, José Gorostiza, advised him to contact Adolph Bolm, the former Ballets Russes star now settled in the United States, who had met Chávez in Mexico in 1921.[9] But nothing came of this either. In 1928 Chávez returned to Mexico, where he became director of the National Conservatory and principal conductor of the Orquesta Sinfónica Mexicana.

As for Diego Rivera, the sometime Communist party member spent the late 1920s and early 1930s building a lucrative career in the United States, thanks to generous and highly publicized commissions from Rockefeller- and Ford-supported enterprises. Rockefeller money figured heavily in the Museum of Modern Art (MoMA), which gave Rivera a one-man show in 1931 that brought record-breaking crowds to the young museum. The exhibition was huge, with 149 objects, including eight "portable" frescoes commissioned by the museum and painted by the artist in New York. With titles such as *Indian Warrior, Sugar Cane, Liberation of the Peon, Agrarian Leader Zapata,* and *The Uprising,* the majority offered what art historian Leah Dickerman has called a series of Mexican "historical snapshots," a "core set of images" from the artist's reper-

tory.[10] The remaining three were inspired by New York. *Pneumatic Drilling* and *Electric Power* focused on the labor of construction (despite the Depression, the city was in the midst of a building boom), while *Frozen Assets* emphasized the city's social inequities against a background of its newest architectural icons, including Rockefeller Center and the Empire State Building. The show generated reams of publicity, with the art critic Henry McBride proclaiming Rivera "the most talked-about artist on this side of the Atlantic."[11] Even before the show closed, rumors spread that he would receive a much coveted Rockefeller Center commission, and within months he began work on the *Detroit Industry* fresco cycle commissioned by Edsel Ford for the Detroit Institute of Arts.[12] When the artist headed to Philadelphia to work on *H. P.*, he was at the height of his North American fame.

Frances Flynn Paine, the daughter of an American railroad executive who had grown up in Mexico, was a major catalyst for the MoMA show and a key figure in the "Mexican vogue" of the 1920s and 1930s. She received Rockefeller Foundation funding for a touring exhibition of Mexican folk art in 1928 and enjoyed the confidence of Abby Aldrich Rockefeller, serving as her adviser in the purchase of Mexican art.[13] Although Paine's focus was the visual arts, sometime in 1927 she became Chavez's manager, with the express purpose of arranging productions of his ballets.[14] However, nothing came of her efforts until the summer of 1931, when she persuaded Leopold Stokowski to travel to Mexico under the auspices of the Mexican Arts Foundation, another beneficiary of Rockefeller Foundation largesse. Paine introduced the conductor to Chávez, who played some of his music for him and also introduced him to Rivera. Stokowski made tentative plans to stage one of the composer's ballets—it was only after he returned to the United States that he settled on *H. P.*—through a collaboration between the Philadelphia Orchestra, of which he was the principal conductor, and the Philadelphia Grand Opera Company. What appealed to him, Paine told Chávez, was the ballet's "international character" coupled with its exoticism.[15] The day before Rivera's MoMA exhibition opened, Stokowski told Chávez that he hoped to present *H. P.* at the end of March or the beginning of April. The conductor was planning to return to Mexico around February 15 and wondered whether the two of them could travel around the country "among the Indians." Stokowski especially wanted to visit Tehuantepec on the southwest coast, a locale that would ultimately figure in the ballet.[16]

The score, however, was far from complete. Only the first and fourth movements were written, although Chávez had generated ideas for the second and third, both set in the Mexican "south." The second seems to have been especially troubling, and it was not until February 1932, less than two months before the ballet's premiere, that he completed the orchestration.[17] Such delays were hardly uncommon in the Ballets Russes. But with Serge Diaghilev at the helm, the company had a "choreographically minded director" (in critic John Martin's phrase)[18] who understood not only what professionalism in ballet entailed but also how to elicit the best from a team of sometimes inexperienced artists. A trained musician, Diaghilev had no compunction about editing a score or adding stage business to a libretto, asking for changes in casting or the design of a backdrop, or for a scene to be augmented with new dances. Stokowski may have been a

brilliant conductor and propagandist for new music, but his enthusiasm for performance far outweighed his professionalism. So long as he was dealing with experienced choreographers and designers (such as Léonide Massine and Nicholas Roerich in *The Rite of Spring*) he was fine. But in *H. P.* Stokowski was dealing not only with a new score, but also with collaborators who had never produced a ballet, including Catherine Littlefield, who had been dancing all her life. As the *New York Times* dance critic explained,

> each spring, when an important choreographic work is presented by a musical organization, an epidemic of mixed emotions sweeps over the dance world. On the one hand there is the fear that the choreographer has had his hands tied; that the "powers that be" have no inclination to bother about the dancing so long as the music is given a good performance; and that in the public mind another absurd concept of modern dancing will be established. There is precedent for all these fears. On the other hand, the possibility of seeing actual productions of ballets, whether they are new or have been presented for years in Europe, arouses so much interest that against the doubts and misgivings there weighs a substantial amount of genuine gratitude that something is being done.[19]

Little is known about the actual process of collaboration. In January 1932 Littlefield may have gone to Mexico, although the trip is unmentioned in contemporary sources or by her biographer or any of her collaborators, including Stokowski, who made a much publicized trip there the following month to study, so he told the press, the ancient dance and music practices of the country's Indians.[20] In February, a version of the MoMA show, including designs for *H. P.,* opened at the Pennsylvania (now Philadelphia) Museum of Art.[21] In late February, Rivera arrived in Philadelphia, where the scenery was built by A. Jarin Scenic Studios and the costumes executed by Van Horn & Son, the country's oldest theatrical costume firm.[22] Finally, on March 4, Chávez arrived from Mexico. Twenty-seven days remained until the premiere on March 31.

The problems were daunting. Although the ballet had an idea, there was "almost no scenario, as such," "a want of plan," as critics remarked after the premiere.[23] In the souvenir program Chávez explained that he viewed the ballet as a mingling of "diverse characters and regions, North and South, in the grand ferment of this, our American continent." Rivera's vision was even vaguer: "*H. P.* is not an exposition of ideas or propaganda for or against this or that point of view, but the unfolding of plastic and musical incidents whose theme is in accord with the rhythm of our aspirations, interests, and the necessities of our social existence."[24] Stokowski, who believed in detailed libretti (according to one critic, the libretto for his 1931 production of *Le Pas d'Acier* was so complicated "in its argument as to defy centralization of its theme in visual patterns"),[25] now stepped in. The night after Chávez arrived, he and Stokowski met for what the *Public Ledger* called "their first Philadelphia consultation." Several other people were present, including Littlefield, described as "the company's premier [sic] danseuse," and Kathryn

O'Gorman Hammer (identified by her married name, Mrs. William C. Hammer), the Philadelphia Grand Opera Company's general manager (fig. 3).

The anonymous reporter devoted two paragraphs to the work that lay ahead. Although the score "had been long in Stokowski's hands," he wrote,

> creation of the ballet, which aims to give the timbre and tempo of Northern modernity and Southern primitive life, has not yet occurred. That will happen in rehearsals. Contrary to all rules of the conventional ballet, Stokowski and the composer will work it out as they go along.
>
> There is a scenario, but it is not regarded as "stiff." In whipping it into shape, by improvisation after improvisation, they hope to make of its choreographic patterns, its folk-melodic music, its setting and costume design a cross-section of American mood that will show the persistence of pre-Spanish emotional inheritance in its present-day mechanicalized [sic] civilization.[26]

One can only assume that Littlefield was involved in those improvisations and in whipping the scenario into shape, even if her celebrity collaborators acted as though she were invisible.

Choreographers do not spring into the world fully formed. They undergo apprenticeships, assisting more established colleagues, and if they are lucky, they find a mentor who edits their work, sharpens their skills, and sets them tasks of increasing difficulty. In Littlefield's case, the mentor was her mother, Caroline Littlefield, a remarkable woman with advanced musical training who began her theatrical career "walking on" as a ballet extra at the Philadelphia Opera and ended it as the matriarch of Philadelphia ballet. Along the way she learned about training dancers and what constituted good technique, developed a thriving school, and became a dance director. Catherine, her eldest, who danced in several Ziegfeld productions in the early 1920s, received a steady dose of Italian and Russian training, including classes in Paris with the former Maryinsky ballerina Lubov Egorova. As Caroline (or "Mommie," as she was known) spread her wings in Philadelphia, Catherine became her ballerina. She also became her choreographic heir. By the mid-1920s Caroline was working as a "ballet director" for most of the local opera companies, even as she was producing dance numbers for movie "prologs" and a host of local theatrical events. Gradually, she began turning over assignments to Catherine. However, choreographing pageants, musical comedy numbers, or the dances in *Tannhäuser,* her first credited opera-ballet choreography, under a watchful maternal eye was a far cry from choreographing a full-scale modern work, especially a complicated one like *H. P.*[27]

Philip L. Leidy, the secretary and counsel of the Philadelphia Grand Opera Association, who married Catherine in 1933, wrote the program notes for *H. P.* By then, Chávez's original

fig. 3. Frances Flynn Paine, Diego Rivera, Frida Kahlo, and Kathryn O'Gorman Hammer, managing director of the Philadelphia Grand Opera Company, seen in Philadelphia, March 31, 1932, where they are preparing the ballet *Horsepower* at the Metropolitan. Associated Press photo

DANCE: AMERICAN ART, 1830–1960

three scenes had grown to four, with something of a plot imposed upon them. The ballet opened with "Dance of the Man, H. P.," in which "the man, and his mechanical counterpart, H. P., represent the age of machinery. His dance, in rhythmic form, expresses the force of the machinery age which has superseded manual labor of past decades."[28]

The second scene, "A Cargo Ship at Sea," began with a "gymnastic dance of sailors denot[ing] the vigor, activity and physical force of man untrammeled by machinery." As the ship edged south, "the regulated and well-ordered life of the sailors" succumbed to "the warmth and languor of the Tropics." Mermaids invaded the ship, followed by fish (figs. 4–5), whose dancing expressed "all the nonchalance, sensuality and seduction usually associated with the warmer climates. Finally all are swept by the intoxication of the moment and of the dance."

The third scene, "A Ship in the Tropics," opened with "the natives selling their wares and whiling away their time" dancing "their 'Zandunga,'" as "cocoa nuts" (cat. 73) and "sugar-canes" (fig. 6) joined in the "swaying and rhythm of the music": "Other fruits, represented by the 'King Banana' [cat. 74] and pineapples [cat. 75], enter and join in the dance, at the close of which, all move towards the ship as the sailors start loading their cargo of fruit for their trip to the North."

The fourth scene, "The City of Industry," depicted New York (or the "North"), "with its skyscrapers [cat. 76, fig. 7], machinery, and mechanical activities."

> The workers of the world are at their toil,... expressing the Machinery Age by a mechanical and regulated dance. They are sullen and unruly, however, as H. P. urges them on to further efforts. An American Flapper, depicting...the Age of the Automobile, exerts for the moment a restraining influence.... Finally they revolt against the despotism of Machinery, as Capitalism, represented by a large stock ticker, becomes panic-stricken. The workers...open a Safe, representing the wealth of the world, out of which come finally all the Natural Resources of the earth—gold, silver, cotton [cat. 77], iron, etc., and the fruit and produce of the soil. The workers resume their toil as the sun [cat. 78] sets on a resumption of the more normal activities of Man and a return to simpler methods of labor and living.

It's hard to know which is more breathtaking—the racial essentialism, comic-book Marxism, or narrative naiveté.

The night before the premiere more than 300 members of the "musical, art and social worlds" attended the dress rehearsal. The ballet was far from ready. A reporter from the *Philadelphia Record* called it "three and a half rehearsals," since Stokowski, when he "didn't like a scene... made Catherine Littlefield put her dancers through their paces again and again." From the pit came "polite whistles in protest," silenced by Stokowski, who told them, "It's as hard for me as it is for you." He even took off his coat and tie.[29]

The premiere was a major event, filling every seat in the 3,500 capacity Metropolitan Opera House despite heavy rain. Philadelphia society was out in force, and a special Pullman car

fig. 4. Diego Rivera, *Sunfish,* costume design for the ballet *H. P. (Horsepower),* 1927, ink, watercolor, and pencil on paper. The Museum of Modern Art, Gift of Abby Aldrich Rockefeller

fig. 5. Diego Rivera, *Swordfish,* costume design for the ballet *H. P. (Horsepower),* 1927, watercolor and pencil on paper. The Museum of Modern Art, Gift of Abby Aldrich Rockefeller

fig. 6. Diego Rivera, *Sugarcane,* costume design for the ballet *H. P. (Horsepower),* 1927, watercolor on paper. The Museum of Modern Art, Gift of Abby Aldrich Rockefeller

fig. 7. Diego Rivera, *Stock Market (Stage Set — Scene 4)*, set design for the ballet *H. P. (Horsepower),* 1927, watercolor on paper. The Museum of Modern Art, Gift of Abby Aldrich Rockefeller

brought critics and notables from New York—Nelson Rockefeller, Otto Kahn, actress Eva La Gallienne, composer George Antheil, conductor Walter Damrosch, publisher Alfred Knopf, and representing "the modern dance" Doris Humphrey and Charles Weidman. It was a "swell occasion," wrote Robert Reiss in the *Philadelphia Record,* although he felt a "little sorry there were no representatives of the proletariat present," given Diego Rivera's well-known political beliefs.[30] The advance press had been immense, and most reviews registered disappointment. Whether because the plot was too complicated, the music too harsh, the orchestration too heavy, or the action too pantomimic, the "Mexican ballet-symphony" fell short of expectations. Although applause was generous, it lacked real enthusiasm, and many first-nighters rushed to the exits as soon as the curtain fell.[31]

Still, there was praise for Chávez, especially his "southern" music for the third scene, which included a tango, and for the 85 dancers, especially Alexis Dolinoff in the role of H. P. (Photographs of them even appeared in New York newspapers the day after the premiere, a sign of the ballet's importance as news.)[32] Several critics commended the Philadelphia Grand Opera Company for undertaking so expensive and ambitious a production (one called the effort "titanic") in such financially perilous times—and all for a single performance.[33] (In fact, the company

LYNN GARAFOLA

Cat. 73. Diego Rivera, *Cocoa Nut,* costume design for the ballet *H. P. (Horsepower),* 1927

Cat. 74. Diego Rivera, *Banana,* costume design for the ballet *H.P. (Horsepower),* 1927

Cat. 75. Diego Rivera, *Pineapple*, costume design for the ballet *H. P. (Horsepower)*, 1927

Cat. 76. Diego Rivera, Set design for Scene IV of the ballet *H. P. (Horsepower)*, 1927 or 1931

Cat. 77. Diego Rivera, *Tobacco and Cotton*, costume designs for the ballet *H. P. (Horsepower)*, 1927

Cat. 78. Diego Rivera, *Sun,* costume design for the ballet *H. P. (Horsepower)*, 1927 or 1931

Cat. 79. Diego Rivera, *The Man*, costume design for the ballet *H. P. (Horsepower)*, 1927

ended up canceling its 1932–33 season and then quietly died, a victim of the Depression.)³⁴

However, the greatest enthusiasm was for Rivera's contribution. Linton Martin in the *Philadelphia Enquirer* commended the "freshness of fantasy for the eye" and thought that the music was "chiefly auxiliary" to Rivera's costumes. "Fantasy and realism are combined in his dancing fishes and fruits, and most striking is the figure of 'H.P.' himself, chiefly nude, with 'H.P.' tattooed on his bare back, and who has a great time whirling and stamping emphatically" (cat. 79).³⁵ The letters reminded another critic of a football player.³⁶ With his welder's visor, electric coils, and white painted back that looked like a football or work shirt, H.P. was a proletarian of the North. But he was also a man of the South—nut brown, with sculptured jet-black hair. Here was a biracial being who expressed the cultural duality of the ballet's Mexican creators. The *New York Herald Tribune's* Mary Watkins, who found the music "pretentious and empty," attributed "what color and humor…there is" to Rivera's "genius": "His fishes, mermaids, cocoanuts, sugar cane, bananas, cigars and gasoline pumps [fig. 8] provide something quite new and actually distinctive in ballet investiture and retain the qualities of sunlight and intense simplicity which always has been the secret of his success."³⁷

The *Philadelphia Ledger* critic was even more enthusiastic. "It may be said at once," he wrote, "that the most effective features of the performance were the stage settings and the costumes, which, especially in the third section, developed an atmosphere of the tropics not borne out by either the music or the choreography."³⁸ The critic also drew attention to the "extraordinary" lighting effects, especially in Scenes 1 and 4. "In The Dance of the Man 'H.P.,'" he wrote, "a clever shadow effect was used depicting the figure of the dancer enormously enlarged on a light-colored screen at the back of the stage."³⁹ This silhouette effect was almost certainly an idea of Rivera's. In 1926, when Chávez sent the scenario of *H.P.* to his friend Octavio G. Barreda, the poet urged him to confer with Rivera about the use of lighting effects.

> What color here, what colors there, and not leave it to the electricians. For me this is as important as the music itself. I believe that the dynamism of HP can only be achieved with lights and music, much more so than with human movement. Therein truly lies the originality of the matter. The movement of shadows is much more rapid than human movement and much more precise and less sad.⁴⁰

fig. 8. Diego Rivera, *Gas Pump,* costume design for the ballet *H.P. (Horsepower),* 1927, watercolor and pencil on paper. The Museum of Modern Art, Gift of Abby Aldrich Rockefeller

Unsurprisingly, the clearest assessment of the choreography came from the two New York dance critics who attended the premiere—Mary Watkins of the *New York Herald Tribune* and John Martin of the *New York Times*. Watkins was unimpressed. Littlefield, she wrote, "managed to achieve a production totally inoffensive, but equally undistinguished."

> Save for the episode of the sirens, which had points of originality and humor,... Miss Littlefield's chief virtue is that she avoided cluttering her scene, that she was economic and not overambitious for her troupe of none too proficient dancers. The one outstanding performance was that of Alexis Dolinoff,... in whom was observable immediately the trained and seasoned veteran of such companies [as] Diaghilev's and Ida Rubinstein's.[41]

In a follow-up Sunday piece she sounded a much more positive note. "[T]he dance of the Sirens who invade the ship in Scene 2," she wrote,

> is probably the most perfect realization of [Rivera's] claim to have "dance, painting and...scenery...express the music of H. P. in plastic form," and its perfections can be traced to Catherine Littlefield, the choreographer, as well as to the makers of music and setting. In the report of the premiere performance, the paragraph enlarging upon this...episode was unfortunately lost somewhere in a tangle of telegraph wires between here and Philadelphia, and thus it went without the mention which it so supremely merited.[42]

In the *New York Times* John Martin found considerably more to admire, even if he regarded the enterprise as a whole as a missed opportunity. "Indeed, it is possible to feel considerable respect if no great enthusiasm for the choreography, for once again a musician has issued a formidable challenge to a dance composer," he wrote.

> Mr. Chavez has filled his music to the brim with substance. It is endlessly contrapuntal, and in this Miss Littlefield has succeeded admirably in capturing the general musical feeling. She manages to keep as many as three or four groups active at the same time and still maintain a certain unity. It is in the simpler melodic passages that she is less fortunate. When the eye craves a sustained plastic line, it is several times allowed to go unsatisfied. Even here, however, when some of the characters are bunches of bananas, pineapples, coconuts and huge fish in papier-mâché casings, there is not much opportunity to be lyrical without a struggle.[43]

In a later Sunday piece Martin examined the work's missed opportunities.[44] So much was commendable, he lamented, that it was "doubly regrettable" that the production was not "thoroughly distinguished." Chávez, for instance, had originally scored his music for a small orchestra. However, the 1932 score was for a full symphony orchestra, and this easily overpowered the dancers. Martin cited the incongruity of the opening scene, danced by H. P. "in the plenitude of his

Cat. 80. Diego Rivera, *The Siren*, costume design for the ballet *H. P. (Horsepower)*, 1927

Cat. 81. Diego Rivera, *U.S.—Mexico Gold—Silver,* costume design for the ballet *H. P. (Horsepower),* 1927 or 1931

intellect, sentiments and physical powers," a single, slight human figure dancing a solo "while an orchestra of 114 pieces looses intricate mazes of sound." Wisely, Littlefield made no attempt to reproduce those mazes, but sought instead to approximate "their feeling by a spasmodic combination of intense and generally staccato movements, so syncopated and involved that Mr. Dolinoff needed all his rhythmic virtuosity to get through it."

Martin found much to commend in the second scene, although he felt that Littlefield did not consistently develop her material. As an example he cited the sailors' dance, which started well but ended in a "formless exhibition of acrobatics," underscored by a "ragged performance" by the sailors that "made it impossible to tell" whether they were supposed to be dancing in canon or "were merely off beat." Martin liked the moment when the sirens (cat. 80) came spilling over the edge of the ship, "delightfully costumed" and carrying guitars, "a combination," he wrote, "of mermaids and senoritas, with a touch of Waikiki." But Littlefield again failed to develop her "first-rate choreographic theme," and when the libretto called for everyone to be "swept by the frantic pleasures of the rhythm, syncopation and dance," Martin found nothing but confusion, although he admitted that the school of "superhuman" fish who invaded the ship in huge, stiff papier-mâché costumes "present[ed] a problem no dance composer could be expected to cope with."

In Scene 3 Rivera "completely" swamped the choreographer. There were fruits in abundance, all dressed in cumbersome papier-mâché costumes, accompanied by what Martin called "veritable groves of palm trees": "Though in this scene the music presents actual dance themes, orchestrated simply enough to suggest a sustained plastic line, none is forthcoming. The reason is probably that there is not room enough for any dancing of a sustained mass character. A more experienced choreographer than Miss Littlefield might have done a little better, but not much." The fault, in other words, was not Littlefield's or, at least, not Littlefield's alone. Nor was it Rivera's, argued the *Times*' art critic Edward Alden Jewell. Praising the "richness of fancy," color, and "employment of folk traditions," Jewell described the costumes as magically bringing the painted figures of Rivera's murals to three-dimensional life. He continued, without naming Littlefield: "That choreographically these elements were not made use of, were not composed, not permitted to become integral parts of a picture such as Rivera himself would construct—this was not his fault. It lay outside Rivera's allocated province."[45] The composer Marc Blitzstein, reviewing the production in *Modern Music,* was sympathetic to the theatrical problem, although he, too, never mentioned the choreographer by name. He thought the costumes were good "in their way, the way of the mummer's parade."

> [E]normous papier-maché [sic] pineapples, cocoanuts [sic], bananas and palm-trees peopled the stage, the amiable product of a child's profuse imagination. They took up so much room that the logical choreographic plan should have been modelled on the simple *défilé*; instead of which, everybody was made to dance, the Big Fish got in the way of the Grand Pineapple, and the stage was invariably messy and ugly to look at.[46]

LYNN GARAFOLA

This was the scene that Rivera's wife, Frida Kahlo, called a *porquería,* a mess, pointedly noting that this was "not because of the music or decorations but because of the choreography, since there was a crowd of insipid blonds pretending they were Indians from Tehuantepec and when they had to dance the Zandunga they looked as if they had lead instead of blood."[47] Of course, not all the Littlefield dancers were blonde, beginning with Catherine's dark-haired sister Dorothie, who danced the roles of the Siren and the Flapper, and one may assume that at least some of those who weren't enveloped in papier-mâché were brunette and some even wore brown face.[48] It is not impossible that the slap was intended for Catherine, who was very blonde and may well have caught Rivera's notoriously roving eye.

Although none of the critics seems to have remarked on it, the use of the human actor as a piece of moving sculpture has a long history in twentieth-century avant-garde performance—works such as *Victory Over the Sun* (1913), *Parade* (1917), *Les Mariés de la Tour Eiffel* (1921), and *La Création du Monde* (1923) that Rivera and Chávez had to have known about and may even have seen. By contrast, many critics invoked the machine-age tendencies that appeared across the arts in the 1920s but were now widely viewed as passé. ("How tired we have grown of the special little 'machine' esthetic!" exclaimed Blitzstein in his review.)[49] Martin also pointed out that in Scene 4 H. P. returned to the stage "directing workers and machines for all the world like the two time-keepers in the League of Composers' production of 'Pas d'Acier'" only the year before. After that, Martin found the scenario too incoherent to follow even with the aid of the printed synopsis. Linton Martin summarized the ending for Philadelphia readers, "[T]he situation looks desperate until it is solved by having pineapples, bananas, and even a mermaid or two, dance blithely out of a Wall Street safe arm in arm with gold and silver nuggets [cat. 81], meaning a return to the simpler life all around."[50] One wonders what Marx would have made of it.

Although *H. P.* was performed only once, it had lasting consequences for its principal collaborators. For Chávez the production represented a turning point in his U.S. career. The ballet was a long work, his first to be presented with a major symphony orchestra in a large orchestral hall, and the publicity that surrounded it—critical cavils notwithstanding—helped Chávez become "a fixture in U.S. musical life."[51] For Rivera it added to his North American laurels, although his most important commissions—for the Detroit Institute of Arts and Rockefeller Center—lay ahead. After the premiere he made an album of the ballet's costume designs that was purchased by his patron, Abby Aldrich Rockefeller, who loaned twenty-four of them for display in the huge Dance International exhibition of 1937. Later she donated them to the Museum of Modern Art.[52] As for Littlefield, the production marked her transition from an arranger of dances to a serious ballet choreographer. By the late 1930s she had become one of the country's leading ballet figures, a disciplined professional and the director of her own company. *H. P.* brought Littlefield her first taste of national recognition.

H. P. brought to an end the cycle of ballets produced as grand musical events. The economic fallout of the Depression certainly played a part in this. More importantly, the arrival in 1933 of the Ballets Russes company directed by Colonel de Basil, with its extensive repertory

and seasoned dancers, demonstrated a level of professionalism of which the League of Composers and Philadelphia Grand Opera Company could only dream. The dance field itself grew exponentially in the 1930s, as the fledgling modern dance groups of the late 1920s matured into full-dress companies and as new organizations (such as Ballet Theatre and the ensembles affiliated with the School of American Ballet) joined them, all replicating in various ways the production and commissioning functions of the older musical enterprises. Distant echoes of *H. P.* can be heard in the dances of José Limón, who choreographed *Los cuatro soles* (1951) to the music of Chávez's Aztec ballet, and in the scores commissioned by Martha Graham and others from Mexican composers, including Chávez and his protégé Silvestre Revueltas. As for Rivera's workers in revolt, who storm Wall Street and dance cheek by jowl with pineapples and silver nuggets, they figured (albeit in less fanciful dress) in scores of proletarian dances choreographed during the Red Decade.

Notes

1. Suzanne Carbonneau, "Adolph Bolm in America," in *The Ballets Russes and Its World,* ed. Lynn Garafola and Nancy Van Norman Baer (New Haven, 1999), 219–44; Suzanne Carbonneau Levy, "The Russians Are Coming: Russian Dancers in the United States," Ph.D. diss., New York University, 1990, ch. 6; Lawrence Sullivan, "Les Noces: The American Premiere," *Dance Research Journal* 14, nos. 1–2 (1981–82): 3–14; Shelley C. Berg, *"Le Sacre du printemps": Seven Productions from Nijinsky to Martha Graham* (Ann Arbor, MI, 1988), ch. 5. Levy's unpublished dissertation, focusing on Russian dancers who worked in the United States from the 1910s to the early 1930s, is one of the very few studies focusing on ballet during this period, viewing it across genres and especially in tandem with popular culture. Another, albeit more limited in scope, is Dawn Lille Horowitz's "Michel Fokine in America, 1919–1942," Ph.D. diss., New York University, 1982. More recently, Carrie Gaiser Casey in "Ballet's Feminisms: Genealogy and Gender in Twentieth-Century American Ballet," Ph.D. diss., University of California, Berkeley, 2009, has focused on the careers of Anna Pavlova, Albertina Rasch, and Rosina Galli, all active as dancers, choreographers, and company directors in the early twentieth century. Andrea Harris in "Aesthetic Dissidence: Feminist Ballet Historiography and the Boundaries of the Classical," Ph.D. diss., University of Wisconsin–Madison, 2005, offers a feminist critique of received ballet historiography that rests in part on the career of Ruth Page. Page has also been the subject of several recent articles by Joellen Meglin. See, for example, "Choreographing Identities Beyond Boundaries: *La Guiablesse* and Ruth Page's Excursions into World Dance," *Dance Chronicle* 30, no. 3 (2007): 439–69; "Blurring the Boundaries of Genre, Gender, and Geopolitics: Ruth Page and Harald Kreutzberg's Transatlantic Collaboration in the 1930s," *Dance Research Journal,* 41, no. 2 (Winter 2009): 52–75; and "Victory Garden: Ruth Page's Danced Poems in the Time of World War II," *Dance Research* 30, no. 1 (Summer 2012): 22–56.

2. Lester Tomé, "Envisioning a Cuban Ballet: Afrocubanismo, Nationalism and Political Commentary in Alejo Carpentier and Amadeo Roldán's *La rebambaramba* 1928," *Dance Research Journal of Korea* 71, no. 5 (2013): 2–25; Charles Molesworth, "In Search of *Sahdji*: Alain Locke and the Making of an African-American Ballet," *The Berlin Journal,* no. 12 (Spring 2006): 56–59; Leonard Harris and Charles Molesworth, *Alain L. Locke: Biography of a Philosopher* (Chicago, 2008), 251–58; Victoria Phillips Geduld, *"Sahdji, an African Ballet* (1931): Queer Connections and the 'Myth of the Solitary Genius,'" *CORD 2008 Conference Proceedings,* 95–105; Michelle Clayton, "Modernism's Moving Bodies," paper delivered at the Columbia University seminar Studies in Dance, 21 Apr. 2014, 13–17; María Elena Babino, *Ricardo Güiraldes y su vínculo con el arte: Buenos Aires, París, Mallorca, un itinerario estético para un proyecto americanista* (San Martín, 2007), and *Caaporá: Un ballet indígena en la modernidad* (Buenos Aires, 2010). For a overview of ideas about the aesthetic of pre-Hispanic recovery, see Rodrigo Gutiérrez Viñueles, "Recuperación prehispanista en la contemporaneidad: tradición, vanguardia y fortuna crítica," *Revista de Historiografía* 19, no. 10 (2/2013): 88–100.

3. *H. P.* souvenir program, quoted in Christina Taylor Gibson, "The Music of Manuel M. Ponce, Julián Carrillo, and Carlos Chávez in New York, 1925–1932," Ph.D. diss., University of Maryland, College Park, 2008, 190.

4. Gibson 2008, 198. For Chávez's early years in New York, see ch. 5.

5. Program, International Composers' Guild, Aeolian Hall, 28 Nov. 1926, M-CLP (Chavez, Carlos), Music Division, New York Public Library (hereafter MD–NYPL). For the manuscript score signed by the composer and dated 1926, see JON 84–11 no. 97k, MD–NYPL.

6. Letter to Carlos Chávez, 26 Dec. [1931]. JOB 93–4, Correspondence and Scores Belonging to Carlos Chavez, 1907–79, Folder 12, MD–NYPL.

7. Diego Rivera to Carlos Chávez [1926], and accompanying note, *Epistolario selecto de Carlos Chávez,* ed. Gloria Carmona (Mexico City, 1989), 66. See also Octavio G. Barreda to Carlos Chávez, 27 Aug. 1926, ibid., 69. The Museum of Modern Art, which owns the most complete set of Rivera's designs, dates about half to 1927 and identifies the remainder as being made in 1927 or

1931. The images are online at http://www.moma.org/collection/artist.php?artist_id=4942.

8. Agustín Lazo to Carlos Chávez, 10 June 1927, Carmona 1989, 76.

9. José Gorostiza to Carlos Chávez, 4 July [1927], and accompanying note, Carmona 1989, 77–78. In his effort to get *H. P.* and his other ballets produced, Chávez also contacted Irene Lewisohn of the Neighborhood Playhouse in New York City and Eugene Goossens, the conductor of the first English concert performance of *The Rite of Spring* now associated with the Eastman School of Music in Rochester, New York.

10. Leah Dickerman, "Leftist Circuits," in Leah Dickerman and Anna Indych-López, *Diego Rivera: Murals for the Museum of Modern Art* [exh. cat., Museum of Modern Art] (New York, 2011), 28. See pages 31–36 for the New York panels.

11. The show, which opened to the public on December 23 and closed five weeks later, received generous coverage both in the *New York Times* (hereafter *NYT*) and the *New York Herald Tribune* (hereafter *NYHT*). For McBride, see "Diego Rivera Exhibition in New York," *The Sun,* 3 Jan. 1932, AS7.

12. Edward Alden Jewell, "Two Corners Are Turned: Metropolitan's New Director—The Museum of Modern Art—Murals for Radio City," *NYT,* 24 Jan. 1932, X12. Rivera was eventually commissioned to paint *Man at the Crossroads,* the grand mural at 30 Rockefeller Plaza (the RCA Building) that would be chiseled away because of its overt display of political radicalism and because it depicted John D. Rockefeller, Jr., a temperance advocate, swilling cocktails (Dickerman 2011, 40). Some of the Rockefeller Center material was absorbed into the mural series *Portrait of America,* painted by Rivera at the New Workers School, 51 West 14th Street in New York City, founded by the oppositionist Communist leader Jay Lovestone.

13. Dickerman 2011, 21–22. For the various exhibitions of Mexican art in the United States in the 1920s, see Jodi Roberts, "Selected Chronology," in Dickerman and Anna Indych-López 2011, 138–43; for the relationship between Mexican muralism and Americanist modernism, see Edward Lybeer, "Transnational Modernisms: The United States, Mexico, and the Idea of America," Ph.D. diss., University of Pennsylvania, Philadelphia, 2011, 100–121.

14. Gibson 2008, 165–66.

15. Ibid., 180–81. See, also, Oliver Daniel, *Stokowski: A Counterpoint of View* (New York, 1982), 279.

16. Stokowski to Chávez, 24 Nov. 1931, in Carmona 1989, 127.

17. Gibson 2008, 181–82.

18. John Martin, "The Dance: A Handicap Event," *NYT,* 10 Apr. 1932, X11.

19. John Martin, "The Dance: A Mexican Ballet," *NYT,* 27 Mar. 1932, X11.

20. For Littlefield's possible trip to Mexico, see Gibson 2008, 197. Unfortunately, she does not support this with evidence. Nancy Brooks Schmitz's "A Profile of Catherine Littlefield," Ph.D. diss., Temple University, 1986, is the fullest discussion of the choreographer's life and career. For Stokowski's trip, see Gibson 2008, 183.

21. Roberts 2011, 141; Gibson 2008, 183.

22. "Gasoline Pumps to Dance in Stokowski Ballet 'H.P.,'" *NYHT,* 26 Feb. 1932, 11. On his arrival Rivera was photographed with Frances Flynn Paine, his wife Frida Kahlo, and Kathryn O'Gorman Hammer (or Mrs. William C. Hammer, as she was usually referred to), the general manager of the Philadelphia Grand Opera Company, by the Associated Press. See Dickerman and Indych-López 2011, 140. For Van Horn & Son, see Roland W. Van Horn, *Our First Hundred Years: The Story of America's Oldest Theatrical Costume Firm, 1852–1952* (Philadelphia, 1952).

23. Mary Watkins, "Current Events in the Dance World," *NYHT,* 10 Apr. 1932, F9; Paul Rosenfeld, "American Premieres," *The New Republic,* 20 Apr. 1932, 274.

24. Quoted in Gibson 2008, 191.

25. John Martin, "The Dance: Modernism," *NYT,* 26 Apr. 1931, X3. The libretto was by the designer Lee Simonson and the choreography by Edwin Strawbridge, who played one of the efficiency experts. (Yeichi Nimura played the other.) The dancers came from Strawbridge's own dance group as well as the dance

groups of Martha Graham and Elsa Findlay. See Mary F. Watkins, "Annual Spring Production by League of Composers With Philadelphia Orchestra Is Big Dance Event," *NYHT,* 19 Apr. 1931, G10; John Martin, "The Dance: Social Satire," *NYT,* 19 Apr. 1931, 109. Pauline Koner, who danced in the production, wrote in her memoirs that "the scenario was so complicated that I was never quite able to understand it" (*Solitary Song* [Durham, 1989], 50).

26. "Stokowski Opens 'Parley' on Ballet. Chavez, Mexican Composer, Arrives to Work Out Details of 'H.P.' With Conductor," *Public Ledger,* 5 Mar. 1932, JPB 06–15, Philadelphia Grand Opera Records, 1923–32, Box 1, Folder 2, MD–NYPL (hereafter Grand Opera Records).

27. Schmitz, "A Profile of Catherine Littlefield," chs. 2–3; Ann Barzel, "The Littlefields," *Dance Magazine,* May 1945, 10–11. For a list, with credits, of the operas presented in Philadelphia during this period, see "Opera in Philadelphia: Performance Chronology 1925–1949," compiled by Frank Hamilton, 2009, http://hamilton.francocorelli.nl/ph/ph1.pdf. Between 1925 and 1932 Caroline was at various times the dance director of the Philadelphia Civic Opera, Philadelphia La Scala Opera Company, and the Philadelphia Grand Opera Company. The *Tannhäuser* production for which Catherine first received choreographic credit took place at the Philadelphia Grand Opera Company on 16 April 1931. Even apart from Littlefield, a number of women choreographed for Philadelphia's opera companies during the 1920s and early 1930s, including Florence Cowanova, Mary Bernadette Kerns, Anna Duncan, and Louise Le Gai.

28. Philip L. Leidy, "Story of the Opera and Ballet. 'H.P.' By Carlos Chavez and Diego Rivera," playbill, Philadelphia Grand Opera Association, 31 Mar. 1932, *MGZB Programs (Littlefield, Catherine), Jerome Robbins Dance Division, New York Public Library (hereafter JRDD–NYPL). The following quotations are from this program as well.

29. "Stokowski in Shirt Sleeves Whips H.P. Ballet in Shape," *Philadelphia Record,* 31 Mar. 1932, Grand Opera Records, MD–NYPL.

30. Robert Reiss, "'H.P.' Presentation Is Swell Occasion, But Lacks Timely Proletarian Touch," *Philadelphia Record,* 1 Apr. 1932, Grand Opera Records, MD–NYPL. For the theater's seating capacity, see "Chavez Ballet is Whimsy of Machine Age," *The Chicago Daily News,* 31 Mar. 1932, "MGZR Clippings" ("H.P." [Littlefield, C.], JRDD–NYPL.

31. Henry C. Beck, "'H.P.' Makes Premiere Here With a Bang As Sparkplugs Go Into a Song and Dance," *Philadelphia Record,* 1 Apr. 1932, Grand Opera Records, MD–NYPL. See, also, the other reviews in this collection.

32. Martin, "A Handicap Event," 1932. Martin added that this was "without precedent in the five years of the dance revival's greatest intensity. Not even the first production of a ballet in the Library of Congress—and that a ballet commissioned to be written especially for the occasion by Stravinsky—achieved that prominence," a reference to the premiere of *Apollon Musagète* in 1928.

33. L.H.H., "Ballet 'H.P.' Makes Startling Debut in Philadelphia," *Main Line Daily,* 1 Apr. 1932, Grand Opera Records, MD–NYPL.

34. Schmitz, "A Profile of Catherine Littlefield," 55–56; "Opera Suspended in Philadelphia," *NYT,* 2 Oct. 1932, 37.

35. Linton Martin, "'H.P.' New Ballet Fantastic Affair," *The Philadelphia Enquirer,* 1 Apr. 1932, Grand Opera Records, MD–NYPL.

36. "Chokopul's Travels," *Time,* 11 Apr. 1932, 30.

37. Mary Watkins, "Chávez's Ballet, 'H.P.,' Has Debut in Philadelphia," *NYHT,* 1 Apr. 1932, 9.

38. S.L.L., "Ballet 'H.P.' Given World Premiere," *The Philadelphia Ledger,* 1 Apr. 1932, Grand Opera Records, MD–NYPL.

39. Ibid. The anonymous reviewer for *The Christian Science Monitor* made a similar point ("Carlos Chavez's Mexican Ballet," 9 Apr. 1932, 6).

40. Octavio G. Barreda to Carlos Chávez, 27 Aug. 1926, in Carmona 1989, 69.

41. Watkins, "Chávez' Ballet," 1932. Dolinoff danced in the Anna Pavlova and Ida Rubinstein companies and various Paris-based troupes. Littlefield, who met him at Egorova's studio, occasionally took class with him. He was never a member of the Diaghilev company. See Amanda Smith, interview with Alexis Dolinoff, 17 Apr. 1979, *MGZMT 5–670, JRDD–NYPL.

42. Watkins, "Current Events," 1932.

43. John Martin, "Mexican Ballet in World Premiere," *NYT,* 1 Apr. 1932, 16.

44. Martin, "A Handicap Event," 1932.

45. E[dward] A[lden] J[ewell], "Mural Artists A-Tiptoe," *NYT,* 10 Apr. 1932, X10.

46. Marc Blitzstein, "Music and Theatre—1932," *Modern Music,* 9, no. 4 (May–June 1932): 166.

47. Hayden Herrera, *Frida: A Biography of Frida Kahlo* (New York, 1983), 132.

48. This is suggested in Henry C. Beck's review ("'H.P.' Makes Premiere Here"), "The brown-skinned women swirl their 'Zanduga,' the music of which invites participation of pineapples, as well as other fruits, led by a garish King Banana."

49. Blitzstein, "Music and Theatre," 1932, 164.

50. Martin, "'H.P.' New Ballet Fantastic Affair," 1932.

51. Gibson 2008, 175.

52. Diego Rivera, with Gladys March, *My Art, My Life: An Autobiography* (New York, 1960; repr. ed., New York, 1991), 95; "Art Preview Opens Dance Exposition," *NYT,* 29 Nov. 1937, 25; E[dward] A[lden] J[ewell], "Art and the Dance," *NYT,* 3 Dec. 1937, 26; Warren A. M'Neill, "Festival Steals Art Spotlight," *The Sun,* 5 Dec. 1937, 72.

Modern Shenanigans at a Filling Station Designed by Paul Cadmus | *Jane Dini*

On January 6, 1938, in Hartford, Connecticut, Lincoln Kirstein's fledgling dance company Ballet Caravan premiered *Filling Station,* a one-act ballet about the night shift of Mac, a gas-station attendant. Still performed in the repertory of the San Francisco ballet, the thirty-five-minute performance is filled with the antics and general bad behavior of motorists stopping in Mac's gas station to ask for directions, use the restroom, carouse, sober up, and, ultimately, stage a hold up. Mac's visitors seek so much more than fuel for their cars.

The ballet's slice of roadside life was designed by Paul Cadmus. His bold and vibrant scenic design created a cartoonish background for the eclectic choreography of Lew Christensen, who also played the lead role (fig. 1, cat. 82). The choreography interspersed vaudevillian pratfalls with the soaring leaps of classical movement. These motifs were reflected in the ballet's musical score, composed by Virgil Thomson, which evokes the myriad sounds of roadside America, from hymns to honky-tonk.

Filling Station was part of a new genre of Americana ballet that built upon national themes. It began in 1922, when Ballets Russes veteran Adolph Bolm choreographed and played the lead

fig. 1. George Platt Lynes, *Lew Christensen in Filling Station*, 1938, black and white print. The Jerome Robbins Dance Division, The New York Public Library for the Performing Arts, Astor, Lenox and Tilden Foundations.

Cat. 84. Paul Cadmus, Set design for the ballet *Filling Station* (detail), 1937

Cat. 82. George Platt Lynes, *Lew Christensen*, 1938

250

role in George Herriman's *Krazy Kat: A Jazz Pantomime,* with music by John Alden Carpenter for his American company Ballet Intime.[1] Cadmus's gas station was also a madcap world based on the colors and typography of 1930s comic strips. It was Cadmus's framing of the body, however, that was most significant. His costumes for the middle-class patrons are bound up in his vision of Depression-era class and culture. The costume of singular importance, however, were the see-through overalls with bright red trim worn by the central protagonist, Mac, the gas-station attendant (cat. 83). Together, Cadmus and Christensen—designer and dancer—and the photographer George Platt Lynes displayed unbridled delight in the presentation of the athletic male body.

At the time of the ballet's premiere, Cadmus was best known for his WPA painting *The Fleet's In!* (1934; figs. 2–3), depicting a raucous group of sailors on shore leave. "The painting," wrote Secretary of the Navy Claude Swanson, "represents a most disgraceful, sordid, disreputable, drunken brawl, wherein apparently a number of enlisted men are consorting with a party of street walkers and denizens of the red-light district." Naturally, such deliciously salacious reports launched Cadmus's career.[2]

The painting's cast of characters brings to mind a Greek frieze of libidinous gods and goddesses. At the left of the composition, two women, side by side but with little in common, tug at their charges: a small dog and a sailor, respectively. The older woman, with a green pallor, pulls at the dog's leash, which is caught in the skirt ruffle of the younger woman, who, in turn, fails to budge her sailor, who has passed out. He is draped over a police officer, who accepts a cigarette from a man wearing a red tie (1930s code for a gay man).[3] In the center of the composition, a woman in a chartreuse dress flings her arms wide as she decks a man who is trying to get too close. This pose is based on such Renaissance prototypes as Dutch engraver Hendrick Goltzius's *Phaeton* (1588; fig. 4), much in the same way that the image of the cigarette exchange is a play on Michelangelo's *The Creation of Adam* (1512; fig. 5–6).[4]

fig. 2. Paul Cadmus, *The Fleet's In!,* 1934, tempera on canvas. Courtesy of Navy Art Collection, 34-5-A

fig. 3. Detail of *The Fleet's In!*

JANE DINI

Cat. 83. Paul Cadmus, *Mac, the Filling Station Attendant,* costume design for the ballet *Filling Station,* 1937

Cadmus's saucy and sardonic commentary may have shocked top Navy brass but attracted Kirstein, who was looking for artists who could capture quintessential American motifs and gestures. Richard Meyer writes, "Cadmus's work is never a simple borrowing of Renaissance sources. Instead, it fuses Renaissance forms with contemporary satire, creating a pictorial dialogue between classicism and American vernacular culture."[5] In *Filling Station,* Kirstein and Christensen translate this complex, elegant, and ribald movement into dance.

In *The Fleet's In!,* Cadmus's bodies convulse with the complexities of courtship. Their extreme exaggeration as they bend, twist, and throw their arms wide appealed to Kirstein, who had an eye for dramatic performance. Moreover, Cadmus animates the clothing to give the audience a real sense of the flesh and blood beneath; fabrics cling to the skin, ripples of clothing bubble up, and hemlines set off the bulge in a girl's calf. *The Fleet's In!* also appealed to choreographer Jerome Robbins, who based his ballet *Fancy Free* (1944) on the painting. Robbins, however, was careful to hide any homoerotic behavior by engaging all three sailors in a contest to win the affections of women.[6]

Paul Cadmus's set design shows us the opening scene of the ballet (cat. 84). On the left, a red neon sign advertising gas is seen in reverse against the large plate-glass window. The cursive lettering conjures up 1930s cartoon script, such as that of *That's All Folks!* in the closing credits to Warner Bros. Looney Toons. Through the window one spies the dashed outline of a gas pump. This is an old comic technique referring to invisibility or nonexistence. The phantom pump is a graphic device to suggest a dance partner for Mac. That pumps were an extension of the gas-station attendant was stock humor during the 1930s. In a *Saturday Evening Post* cover titled *Fill 'er up* from 1937, the year *Filling Station* was conceived, McCauley Conner illustrates a the serviceman distracted from his pumping by the primping of his female customer. As she applies her lipstick, gas spills from his nozzle.

A less active, more introspective scene between man and anthropomorphic pump is depicted in Edward Hopper's *Gas* from 1940 (fig. 7). In the Cadmus set design, the pump's long,

fig. 4. Hendrick Goltzius, *Phaeton,* from the series *The Four Disgracers,* 1588, engraving. The Metropolitan Museum of Art, Harris Brisbane Dick Fund, 1953

fig. 5. Detail of *The Fleet's In!*

fig. 6. Michelangelo Buonarroti, *The Creation of Adam,* 1512, fresco. Sistine Chapel, Vatican Palace, Vatican State

JANE DINI

Cat. 84. Paul Cadmus, Set design for the ballet *Filling Station,* 1937

looping hose mimics the jaunty arabesque of Mac. In Hooper's image, he depicts three pumps standing at attention—the lit orbs illuminate the winged-horse logo advertising Mobil gas. The glow of the pumps mimics the shine of light cast on the bald head of the attendant. In each scene, the pumps appear as guardians, watchers in the night. This only serves to heighten the isolation of the attendant.

Hopper's image underscores the remote locations of gas stations in the 1930s and their importance along undeveloped tracts of land. As evening falls, the darkness of the forest is heightened by the electric lights that come on across the street. Hooper's serviceman checks on his pumps, perhaps hanging up the nozzle after fueling a car or restocking cans of oil. Hopper's gas station is not unlike *Filling Station,* with constantly changing characters entering and exiting the stage.

Ann Barzel's contemporary video of the original cast performance of *Filling Station* is a rare document of Christensen's choreographic timing and Cadmus's original costumes. In the film, the ballet opens with Mac whiling away the lonely hours of the night listening to the radio and reading a tabloid. He puts down the paper and begins to dance. He moves about the stage with vigorous leaps and turns. His grand jetés, pirouettes, and barrel turns come out of nineteenth-century bravura dancing. Christensen's speedy chaînés, easy gait, and loose upper body with arms held down by his side are similar to the gestures of the contemporary tap dancers like Fred Astaire and Gene Kelly.[7]

Mac's solo is interrupted by The Motorist, who enters the station to ask for directions. Dressed in the garish attire of a comic-strip golfer, he looks a fright in mismatched plaid, sports a ridiculous straw hat, and chomps on a cigar while he dances (fig. 8). Roy and Ray, truck-driver friends of Mac, enter, and as the befuddled motorist departs, the three impress each other, dancing an athletic pas de trois featuring cartwheels and somersaults. The Motorist returns, this time with his family—The Motorist's Wife and The Motorist's Child—who dance like stock characters from vaudeville: the hen-pecked husband, the overbearing wife, and the spoiled little girl.

Kirstein, Cadmus, and Christensen, through story, costume, and gesture, create a comic parade of class in 1930s America. This stinging parody includes the stalwart but sometimes rambunctious working class; the garish, status-hungry, middle class; and the upper class, who dance into the gas station in the form of a debutante and her beau, The Rich Girl and The Rich Boy, returning from a party at a country club. With the addition of the debauched upper class, the hierarchy in the ballet was clearly established. Into this order comes the disruption—The

fig. 7. Edward Hopper, *Gas*, 1940, oil on canvas. The Museum of Modern Art, Mrs. Simon Guggenheim Fund

JANE DINI

fig. 8. George Platt Lynes, Harold Christensen, Eugene Loring, and Paul Magriel in Lew Christensen's *Filling Station,* 1938, photograph. Performing Arts Library, Museum of Performance + Design

fig. 9. George Platt Lynes, Gisella Caccialanza with three male dancers in Christensen's *Filling Station,* ca. 1938, photograph. Performing Arts Library, Museum of Performance + Design

fig. 10 Paul Cadmus, Costume design for the ballet *Filling Station,* 1937, tempera, pencil, and pinned and stapled fabric on paper. Museum of Modern Art, gift of Lincoln Kirstein

Gangster—who finds opportunity late at night in the isolation of the gas station. Just as The Gangster is about to make his get away, The State Trooper arrives, like a sheriff in a cowboy western. The final gag occurs when The Gangster fires his gun and the roadside dancers believe the debutante has been fatally shot (fig. 9). As they carry her off stage, she awakens and waves to the audience, gleefully breaking the fourth wall.

Original costume designs and cast photography reveal Cadmus's working method in creating a satirical study of fashion in America (fig. 10). The Gangster, interestingly, is the one dancer who, from his garb, seems to transcend class. Dressed in a translucent teal blue raincoat, revealing fashionable purple-striped bell-bottomed pants underneath, he seems more hipster than criminal. By all appearances, this bohemian gangster would, according to cultural historian Paul Fussell, fall outside of the strict hierarchical structure of upper-, middle-, and lower-class distinctions and be identified as a "category X." In his *Class: A Guide Through the American Status System,* Fussell states that the "classless class" is made up of academics and artists, including dancers, writers, and painters: "The question of whether to select a black or a beige raincoat never trouble X people, for they don't use raincoats at all: they either

get wet and pay no attention or wait under cover." In this way, The Gangster is aligned with the motley crew of Ballet Caravan, blurring the distinctions of the upper-class, Harvard-educated Kirstein; the middle-class Christensen; and struggling middle-class Cadmus.[8]

The rest of the ballet dancers in *Filling Station* were dressed to emphasize comical differences between classes. For instance, The Motorist who tries to impress Roy and Rob with his golf swing appears constrained in his flashy coat next to the truck drivers in their unbuttoned shirts. Their chests, covered with greasy handprints, identify them as lower-class workers whose bodies, moreover, can be touched. Such contrasts had already been making appearances in Cadmus's paintings, most notably in his satiric observations of suburban life. Originally intended for a post-office mural, *Aspects of Suburban Life* included the 1936 painting *Golf* (fig. 11), depicting paunchy, cigar-smoking geezers surrounding a young, physically fit caddy. The young man's subservient pose and shabby dress telegraph his class. There are indeed, holes in the soles of his shoes, but it is his low-slung trousers that attract the gaze of the viewer and the lecherous men, who seem more interested in the youthful worker in their midst than in selecting the right golf club.

Cadmus's costume confection for The Motorist's Child in *Filling Station* was styled after the bloomers and pin curls made famous by Shirley Temple, a costume that aided the dancer in her playful antics and pratfalls based on the skillful choreography and master of comedic timing Charlie Chaplin (fig. 12). As an archetype, Cadmus's American sprite had early incarnations in such ballets as Jean Cocteau's *Parade,* composed for Serge Diaghilev's Ballets Russes in 1917. For this production, the American Girl, modeled on silent-screen star Mary Pickford, performed her American ragtime dance under the direction of choreographer Léonide Massine. Such borrowings or continuations should make us rethink *Filling Station* as a uniquely American creation, especially when it comes to casting and fashioning the male dancer.

Cadmus employed visual metaphors for framing the male nude in paintings such as *Gilding the Acrobats,* which depicts the transformation of a circus performer's pale flesh into a

fig. 11 Paul Cadmus, *Aspects of Suburban Life: Golf,* 1936, oil and tempera on fiberboard. Smithsonian American Art Museum, transfer from the U.S. Department of State

fig. 12 George Platt Lynes, *The "Motorist's Child"* in the original production of *Christensen's Filling Station,* 1938, photograph. Performing Arts Library, Museum of Performance + Design

JANE DINI

fig. 13 Paul Cadmus, *Gilding the Acrobats,* 1935, tempera and oil on masonite. The Metropolitan Museum of Art, Arthur Hoppock Hearn Fund, 1950

fig. 14 Walt Kuhn, *Top Man,* 1931, oil on canvas. The Huntington Art Collections, San Marino, California

fig. 15 John Steuart Curry, *The Flying Codonas,* 1932, tempera and oil on composition board. Whitney Museum of American Art, New York, Purchase 33.10

golden, shimmering figure under the big top (1935; fig. 13). This act of painting is self-reflexive, standing in for the artist himself, and the coy placement of the seated painter's head stroking on the gilt radiator paint signals the erotic hide-and-seek that heightens the desire of looking. In the 1930s, male circus performers were a popular theme in American art, and their costumes of the trade, leotards and tights, show off their musculature and dexterity, as seen Walt Kuhn's full-length portrait *Top Man* (1931; fig. 14); the title refers to the subject's role in the trapeze routine as the one who catches the bottom man, a daring feat that can be seen in John Steuart Curry's *The Flying Codonas* (1932; fig. 15).

"I had access to rehearsal rooms and performances," Cadmus explained of his association with Kirstein and Ballet Caravan, and its later incarnation the New York City Ballet. A few years after working on *Filling Station,* Cadmus completed two paintings: *Arabesque* (1941; cat. 85) and *Reflection* (1944; cat. 86), based on his visits to the ballet school's practice rooms. "It was a chance to see people," he recalled, "who were as near nude as you could be on the stage—in tights."[9] *Arabesque* takes its title from the perfectly executed pose of the female dancer in the middle ground, but the subject of the work is the muscular articulation of the male physique in the foreground. The dancer's tights afford Cadmus the same detailed scrutiny that Hendrick Goltzius rendered in an engraving of the rear view of the *Farnese Hercules* (1592: fig. 16). The viewer's delight and delectation of the heroic form, both god and dancer, takes place with the meticulous rendering

DANCE: AMERICAN ART, 1830–1960

Cat. 85. Paul Cadmus, *Arabesque,* 1941

Cat. 86. Paul Cadmus, *Reflection*, 1944

fig. 16 Hendrick Goltzius, *Farnese Hercules*, ca. 1592, dated 1617, engraving. The Metropolitan Museum of Art, Gift of Henry Walters 17.37.59

fig. 17 Auguste Bert, *Vaslav Nijinsky in Scheherazade*, ca. 1910, photograph. Roger Pryor Dodge Collection, Jerome Robbins Dance Division, New York Public Library for the Performing Arts, Astor, Lenox and Tilden Foundations

of every muscle. In *Reflection,* Cadmus posed his friends and family as dancers resting after class: his sister Fidelma leans her back against the wall; next to her is the author Donald Windham, with his legs up the wall; and the actor Sandy Campbell lies on the bench in body-hugging green tights. That Cadmus created a modern figure, a dancer in repose whose languor and strength simultaneously conjures up images of a classical Aphrodite and Aquaman (who made his debut in DC Comics in 1941), is testament to an artist who eviscerated hierarchies in his work, collapsing distinctions between high and low art. Cadmus never bought into the artifice of ballet. "I don't think there's anything unrealistic about ballet school. It's a beautiful aspect of life."[10]

Kirstein, however, wanted to create a ballet that featured the nobility of the working man.[11] In the ballet, Mac's dependability and resourcefulness afford his carefree customers safety. His gas station gives safe haven to the uncertainty and wildness of the road, and his playful carousing brings to mind such beloved Hollywood cowboys as Will Rogers. But Kirstein's ballet belies his debt to Russian ballet impresario Serge Diaghilev, whose ballet plots cast the male dancer as central to the libretto, reshaping his very presence on stage. The Ballets Russes productions featured male solos that were daring, vibrant, and physically challenging. These dancers did not play second fiddle to the ballerina.

Kirstein's modern hero clad in Cadmus's see-through overalls with bright red trim reveals the dancer in much the same way that Léon Bakst's costume for Vaslav Nijinsky in

JANE DINI

Scheherazade (1910; fig. 17) revealed the male body as a sensual expression of desire. Adorned with rich bejeweled fabrics, Nijinsky's slave imprisoned in Sultan Shahryar's harem was free to express his own sensuality. "Christensen's costume as Mac," wrote Kirstein, "was cut from transparent plastic, beneath which glowed this brilliant classic dancer's splendid physique."[12] These innovative roles and costumes liberated men from the conventions of the classical idiom and allowed audiences to admire the erotic presentation of their bodies. Together, Cadmus and Christensen, designer and dancer, displayed unbridled delight in the presentation of the athletic male body.

Central to the imagination of many artists, such as Cadmus, dance provided a visual language to express the bonds of community, the allure of the exotic, and the pleasures of the body. Cadmus was inspired by dance to consider how Americans experience time, move together through space, and present themselves to each other. His paintings, in turn, inspired Kirstein to create a dance that reflected American themes. The flashy, cartoony shtick of *Filling Station* should not detract from what has become one of the greatest achievements of modern ballet (a modern ballet that Kirstein, Cadmus, and Christensen continued): the creation of a shared space with the ballerina for the male dance superstar.

Notes

1. For more on the history and development of Americana-themed ballets, see George Amberg, *Ballet in America: The Emergence of an American Art* (New York, 1949). Marcia B. Siegel, *The Shapes of Change: Images of American Dance* (Boston, 1979), esp. the chapter "American Ballet," which chronicles the groundbreaking Americana-themed ballets *Frankie and Johnny* (Ruth Page and Bentley Stone), *Filling Station* (Lew Christensen), *Billy the Kid* (Eugene Loring), *Rodeo* (Agnes de Mille), and *Fancy Free* (Jerome Robbins), 108–37. Also see Suzanne Carboneau, "Adolph Bolm in America," in Lynn Garafola and Nancy Van Norman Baer, *The Ballets Russes and Its World* (New Haven, 1999), 219–44, and Lynn Garafola, ed., *Of, By, and For the People: Dancing on the Left in the 1930s* [Studies in Dance History 5, no. 1] (Spring 1994).

2. For more on Paul Cadmus, his chronology, and his career and critical reception, see Philip Eliasoph, *Paul Cadmus: Yesterday and Today* (Oxford, OH, 1981).

3. George Chauncey, *Gay New York: Gender, Urban Culture, and the Making of the Gay Male World, 1890–1940* (New York, 1994), 3.

4. For interest in Paul Cadmus's admiration for Italian paintings, see Judd Tully and Paul Cadmus, oral history, March 1988, Archives of American Art, Smithsonian Institution, Washington, D.C.

5. Richard Meyer, "Profile: Paul Cadmus," *Art Journal* 57, no. 3 (Fall 1998): 80–84. And for a brilliant account of *The Fleet's In!*, see Richard Meyer, "A Different American Scene: Paul Cadmus and the Satire of Sexuality," in his brilliant and indispensable study *Outlaw Representation: Censorship and Homosexuality in Twentieth-Century American Art* (Boston, 2002), 32–93. Also see Jonathan Weinberg, *Male Desire: The Homoerotic in American Art* (New York, 2004).

6. Deborah Jowitt, *Jerome Robbins: His Life, His Theater, His Dance* (New York, 2004), 74.

7. Ann Barzel shot the footage of *The Filling Station* from the wings of Chicago's Civic Opera House in October 1939. *The Filling Station* video clip, from *Ballet Carovan, 1937–1940*, Ann Barzel Dance Film Archive, The Newberry Library.

8. Although a slightly dated paradigm, no one has been as insightful as Fussell in summing up the pre- and postwar era (the period of *Filling Station*). Paul Fussell, *Class: A Guide Through the American Status System* (1983) (New York, 1992), 181.

9. Tully and Cadmus 1988.

10. Ibid.

11. Lynn Garafola, "Lincoln Kirstein, Modern Dance, and the Left: The Genesis of an American Ballet," in *Dance Research* 23, no. 1 (2005): 25.

12. Lincoln Kirstein, *Paul Cadmus* (New York, 1984), 51.

Immortal Dancers: Joseph Cornell's Pacifism During the Second World War

Analisa Leppanen-Guerra

"Somehow, while looking with curiosity at his neat little boxes filled with this and that, his pretty shells and devious gadgets and the doll enmeshed in silvered twigs, I remembered that there is a war, and after that, try as I might, I couldn't find my way back into Mr. Cornell's world."[1] Thus read Edward Alden Jewell's weary and disenchanted review of Joseph Cornell's work included in the December 1943 exhibition at the Julien Levy Gallery in New York City. Considering that "the doll enmeshed in silvered twigs" was a reference to Cornell's masterpiece *Untitled (Bébé Marie),* the artist must have surely expected a more favorable reception for the unveiling of these assemblages created at the height of his career. He was clearly hurt by this assessment of his work, often referring over the years to the "Jewell affair."[2] As if in calculated response to the review, Cornell immediately created one of the most overtly political works of his oeuvre, *Habitat Group for a Shooting Gallery,* of 1943 (fig. 1). As in a number of his other "Aviary" works, two cockatoos and two parrots are arranged in a shallow vertical box. Numbered markers designate these birds as targets in a shooting gallery, like the games at Coney Island favored by Cornell as a youth. The game, however, quickly turns deadly. While some of the shots leave behind blue and yellow splattered paint, matching the parrots' festive feathers, one of the bullets has pierced the glass and hit the crown of the central cockatoo, bloodying the white bird. He cringes, his crest laid flat against the nape of his neck. The glass shatters, radiating out to the edges of the habitat. French phrases, signage, and architectural motifs dot the background, an obvious reference to the occupation of France by the Nazis in 1940. Cornell identified artists, writers, composers, dancers, and other creative people with birds—individuals whose souls take flight in their creative enterprises. Many of the European artists and writers whom he admired,

fig. 1. Joseph Cornell, *Habitat Group for a Shooting Gallery*, 1943, mixed media. Des Moines Art Center, purchased with funds from the Coffin Fine Arts Trust; Nathan Emory Coffin, 1975.27

such as Marcel Duchamp and André Breton, were displaced during World War II in an effort to escape Nazi aggression. The European theater had, indeed, become a shooting gallery.

Despite Cornell's efforts to foreground the political in his work, Jewell's interpretation of the artist as escapist and out-of-touch with the times has been (inadvertently) perpetuated even up until the present, with much of the scholarship focusing on Cornell's references to other artists, writers, dancers, and celebrities, but rarely to the major event of his time: World War II. While Cornell was enamored with historical figures, he was just as deeply engaged with the political and social changes of his day. As Cornell's contemporary Jean Cocteau wrote in December 1945 as he was filming *Beauty and the Beast,* "However much I may shut myself up in my own unreal and private world, it's impossible for me not to be interested in the Nuremberg trial."[3] Similarly, Cornell created several works in the early 1940s that seem to celebrate the nostalgic aura of the Romantic ballet, and yet, beneath the pink gauze and sequined tulle, lay a sharp critique of the war raging around him.

As a devout Christian Scientist, Cornell adhered to the belief that only spirit has reality, while matter, evil, and illness are unreal and must be corrected by spiritual understanding. Christian Science was founded by Bostonian Mary Baker Eddy in the late nineteenth century after she experienced healing through faith. After suffering headaches, stomach aches, and other nervous ailments for years, Cornell converted to Christian Science in the mid-1920s and remained a loyal follower for the rest of his life. It became the foundation of his artistic practice, a way of charting the fluctuations of his spiritual state. In his journal entries, he noted how a particular theme in his art might indicate a path toward a spiritual "unfolding" or "release." For Cornell, one of the primary subjects that prompted this "release" was dance. Around the same time as he was introduced to Christian Science, Cornell's interest in dance, particularly the Romantic ballet, began to blossom. While Cornell had been enamored with magic and theater since his childhood—in particular, Harry Houdini, the Hippodrome in New York, and Coney Island—his love of dance was sparked by Anna Pavlova's farewell tour in New York City in 1924–25, which he attended no fewer than three times.

Once he was adopted by gallery owner Julien Levy in 1931, Cornell was exposed to the work of a number of European artists who had designed costumes and/or sets for Diaghilev's Ballets Russes, including Max Ernst, Pablo Picasso, Henri Matisse, Juan Gris, Giorgio de Chirico, and Pavel Tchelitchew. In 1933 Levy exhibited the dancer and choreographer Serge Lifar's comprehensive collection of costume and set designs as "25 Years of Russian Ballet," an exhibition that would be foundational to Cornell's dance-inspired works of the 1930s and 1940s. Also through Levy, Cornell formed an important connection with Tchelitchew, a neo-Romantic artist, as well as costume and set designer. His friendship would open many doors for Cornell, including an introduction in 1940 to a principal dancer in the American Ballet, Tamara Toumanova, who would soon become both an infatuation and a muse for his art, as he paired her with earlier legends of the Romantic ballet (cat. 87).

Cat. 87. Joseph Cornell, *A Swan Lake for Tamara Toumanova (Homage to the Romantic Ballet)*, 1946

It is perhaps no coincidence that Cornell's interest in dance was quickening at the very moment when ballet was experiencing a surge of activity and scholarship in America. In 1934 Lincoln Kirstein and Edward Warburg founded the American Ballet, showcasing the choreography of George Balanchine, and after the war founded the Ballet Society (renamed the New York City Ballet in 1948). In Cyril W. Beaumont's *Complete Book of Ballets* and *The Romantic Ballet in Lithographs of the Time,* both published in 1938, Cornell alighted upon a treasure trove of information and source-material relating to the ballet.[4] Many of the souvenir prints reproduced in these books would make their appearance in a number of boxes by Cornell, as well as in the covers he designed in the 1940s for the periodical *Dance Index* (fig. 2). Another major resource for Cornell's work on the Romantic ballet was the Museum of Modern Art's Dance Archives, founded by Kirstein in 1939. Paul Magriel, the first curator of the archives, remembers Cornell as a frequent visitor to the archives from the very start, fondly perusing the photographs, souvenir prints, sheet music covers, and ephemera.[5]

Dance, and in particular the Romantic ballet, was the ideal subject matter in which Cornell could express his Christian Science beliefs. The Romantic ballet—popular in Europe beginning in 1832 with Marie Taglioni's first performance in *La Sylphide* until around 1850 when most of the stars had retired—focused on stories involving mortal men infatuated with otherworldly women, such as ondines, sylphides, and dryads, who could appear only briefly in mortal guise. To create the effect of ethereality, a number of revolutionary changes were made to the costumes and sets of the ballet, including the introduction of the blocked toe shoe so that ballerinas could balance *en pointe,* the wearing of gauzy costumes, and the use of invisible-wire harnesses to enable the dancers to spring into the ocean mist or vanish into the moonlit vista. These immortal beings, unencumbered by the restrictions of the body, perfectly illustrated Mary Baker Eddy's emphasis on the primacy of spirit over matter.

fig. 2. Joseph Cornell, cover of *Dance Index* 6, no. 9 (1947). Courtesy of Dickran Tashjian

In his quest for the absolute, Cornell became so obsessed with these ondines and dryads that he even began to encounter them in his daily life, as when he happened upon a portrait print of the Romantic ballerina Fanny Cerrito at the Fourth Avenue bookstalls in Manhattan in 1940:

> the startling discovery was made that Fanny Cerrito in the full bloom of youth was moving about our metropolis completely unconcerned and unrecognized. Like the capricious Ondine of her favorite ballet she seemed once more to have assumed mortal guise.... In the train of this revelation...the figure of the young

dancer stepped forth as completely contemporaneous as the skyscrapers surrounding her.... In the unfurling of an image was the danseuse set free, the fountain of Ondine unsealed.... It is an eternal youthfulness that she evokes—as new and fresh as the morning.[6]

Cornell would also fantasize seeing her "etherial form" closing the shutters one evening at the Manhattan Storage & Warehouse Building "with ineffable humility and grace," and then again as a conductor "executing a *pas*" before punching his ticket on the train.[7] As an Ondine from the Romantic ballet, Cerrito represented for Cornell the immortality of spirit, briefly adopting mortal form in order to bring a childlike innocence and magic to the dull, workaday world he inhabited. In the September 1945 issue of *Dance Index,* which Cornell guest edited in homage to fellow balletomane Hans Christian Andersen, Cornell included Andersen's account of watching Cerrito dance: "There must be youth, and that I found in Cerrito! It was something incomparably beautiful, it was a swallow flight in the dance, a sport of Psyche."[8] Andersen's account not only corroborates Cornell's association of Cerrito with youthful spirit, but also with the flight of birds. In his art and films, Cornell often equated children, birds, and dancers, as they symbolized, for him, the essence of spirit. In the Fourth Avenue bookstalls incident in which he discovered Cerrito's portrait print, Cornell mused, "In all its etherial grace the fairyland world that was the Romantic Ballet suddenly shattered the oppressive heat like a heavenly bombshell."[9] Writing in 1944 during the height of the war with widespread bombings throughout Europe, Cornell ingeniously reverses metaphors, describing the Romantic ballet as a bombshell sent from heaven to blast through the veil of illusions draped on this world and reveal the realm of immortal spirit. To Cornell, the Romantic ballet was just as powerful as the bombs of war, but it relied on a creative force rather than a destructive one. With its emphasis on weightlessness and ephemerality, Cornell found in the Romantic ballet something profoundly spiritual. Set against the backdrop of World War II, Cornell's work on the ballet can be viewed as his own idiosyncratic, yet entirely ardent, form of pacifist protest.

In *Swiss Shoot-the-Chutes,* 1941 (fig. 3), his only box to feature Romantic ballerina Fanny Elssler, Cornell sent another one of these "heavenly bombshells" to earth. The format is a kind of slot machine in which a ball is inserted in the upper right corner, rolling down a series of ramps while ringing twelve cowbells along the way before exiting through a latch in the lower right corner. A map of Switzerland surrounded by France, Germany, Austria, and Italy is punctuated by a number of circular cutouts either revealing the interior of the box (including a view onto the dreamy gaze of a dark woman—perhaps Elssler's double) or pictures of scenes relating to the Alps: snow-capped mountain peaks, grazing cattle, skiers, and a peasant woman in native dress. The title of the box, *Swiss Shoot-the-Chutes,* is a reference to a popular ride at Coney Island, in which riders would hurtle down a ramp into a lake. The playful title and slot-machine style box belie the serious message beneath. When Cornell created this work in 1941, Switzerland had become an island of neutrality in a sea of Fascist aggression. All its bordering nations—France,

fig. 3. Joseph Cornell, *Swiss Shoot-the-Chutes,* 1941, box construction. Peggy Guggenheim Collection, Venice, Solomon R. Guggenhiem Foundation, New York

fig. 4. Bernard Partridge, "Little Czech-Riding-Hood," *Punch,* 1938. Courtesy of PUNCH Magazine Cartoon Archive

Germany, Austria, and Italy—were under Axis control. The circular cutouts in the box are more than just a novel formal device; Cornell is referring to the pockmarked landscape, heavily bombed by the British Royal Air Force. The skier in the central cutout, as seen from a low viewpoint, becomes a metaphor for one of the bomber planes flying overhead. Perusing the façade, our eye is drawn to the spot of intense scarlet on the right: an image of Little Red Riding Hood encountering the wolf. As Sandra Starr notes in her astute analysis of this work, the map of Germany resembles a wolf with open jaws, and Nazi Germany was often characterized in political cartoons as a predatory wolf (fig. 4).[10] Cornell may be implying that neutral Switzerland, threatened by Fascism on all sides, is like the innocent Little Red Riding Hood—in grave danger of being eaten by the wolf, just like her ailing grandmother. But he also reminds us that both the girl and her grandmother survive the encounter, as they are resurrected from the belly of the beast by a hunter.

Just above this vignette is another messenger of hope. Lightly gliding in from her native Austria is Romantic ballerina Fanny Elssler. She is surrounded by the snow-capped peaks of the Alps and grazing cattle, perhaps a reference to her role in the ballet *Nathalie, or the Swiss Milkmaid* (1831), although the actual portrait print that he used is from her role in *La Gypsy* (1839). Hovering above her ethereal form are the words "Hôtel de l'Ange" (Hotel of the Angels). As an avid

270 DANCE: AMERICAN ART, 1830–1960

Cat. 88. Joseph Cornell, *Crystal Cage Collage (Portrait of Berenice)*, 1943

fig. 5. Joseph Cornell, *The Crystal Cage [Portrait of Berenice].* Published in *View,* ser. 2, no. 4 (January 1943). Joseph Cornell Study Center, Smithsonian American Art Museum

fig. 6. Joseph Cornell, *The Crystal Cage [Portrait of Berenice].* Published in *View,* ser. 2, no. 4 (January 1943). Joseph Cornell Study Center, Smithsonian American Art Museum

dance scholar, Cornell must surely have been aware of the 1940 article by Anatole Chujoy that appeared in *Dance* magazine, "Fanny Elssler: Ballet Bombshell of 1840."[11] In this rebus, Cornell sends heavenly bombshell Fanny Elssler as an angel from the hotel in heaven where all the victims of the war now reside. He declares this angelic bombshell more powerful than any manmade war machine. This is Cornell's wish: that the human power to create—in dance, music, art, and literature—can supplant the power to destroy. He depicts Elssler gliding into neutral Switzerland from her native Austria as a messenger of peace, displacing the Nazi aggressors.

One of Cornell's most complex and extended works also includes a reference to the Romantic ballet as a message of peace during wartime, *The Crystal Cage (Portrait of Berenice).* This work takes two forms: a seven-page "exploration" in text and image published in the January 1943 *Americana Fantastica* issue of the avant-garde periodical *View,* and what Cornell referred to as a "dossier," a valise containing a collection of documents, photographs, and ephemera that Cornell began assembling in 1934, eventually exhibiting the ongoing piece in December 1946 at the Hugo Gallery in New York City (cat. 88). The work centers on the fictional child Berenice, who is both a scientist and visionary inhabiting an observatory made of crystal from which she can chart the movements of the cosmos. During the war, Cornell was concerned that air raids would transform the skies into a space of terror rather than wonder. *The Crystal Cage,* along with other dossiers of the 1940s, such as *Celestial Theater,* was an effort to promote the peaceful practice

DANCE: AMERICAN ART, 1830–1960

of skygazing.[12] In a note from the *Celestial Theater* dossier, he wrote, "Alarmed by the scientific innovations of our age, the approaching commercialization and standardization of man-made paraphernalia of the air, the barbarity of bombings whereby the surface of the earth has almost come to resemble the craters of the moon, in protest against the desecration of the skies was this assemblage drawn in common purpose from the far corners of time and space. To protest."[13] In like measure, Cornell's protégée Berenice reclaims the heavens as a site of serene contemplation and scientific investigation rather than a space controlled by the horrors of war. In the "exploration" in *View* magazine, Cornell includes a picture of an eighteenth-century architectural folly, the Pagode de Chanteloup (fig. 5), which he describes as an "abandoned chinoiserie" that Berenice transplants from France to her home in New England, subsequently transforming it into an observatory and laboratory for her scientific research. On the right side of the previous two-page spread, Cornell reconstructs the multitiered pagoda as a calligram, a visual poem (fig. 6). The words and phrases not only form the building blocks of the tower but also suggest the phenomena that Berenice studies in her observatory (shooting stars, soap bubbles, barometers), as well as the creative geniuses who inspire her (Franz Liszt, Jan Vermeer, Hans Christian Andersen). There are a number of references to her mentors from the Romantic ballet, as well: Marie Taglioni, Carlotta Grisi, Lucille Grahn, and Fanny Elssler.

In fashioning Berenice's tower into a calligram, Cornell was likely inspired by Guillaume Apollinaire, the poet who coined the term and popularized the calligram format in the early twentieth century. Many of his calligrams were written in the trenches while fighting with the French army on the front line during World War I, and so prefigure Cornell's assertion of the creative act (whether found in art, literature, or dance) as a form of resistance and protest against the destruction of war. Some of the elements found in Cornell's collage from *The Crystal Cage* dossier and *View* spread seem directly inspired by one of the poems, "Wonder of War," that Apollinaire penned in the trenches:

> How lovely these flares are that light up the dark
> They climb their own peak and lean down to look
> They are dancing ladies whose glances become eyes arms and hearts…
>
> It's also the daily apotheosis of all my Berenices whose hair has turned to comets' tails
> These dancing girls twice gilded belong to all times and all races
> Swiftly they give birth to children who have just time enough to die
>
> > How lovely all these flares are
> > But it would be finer if there were still more of them
> > If there were millions with a full and relative meaning like letters
> > in a book
> > However it's as lovely as if life itself issued from those who are dying
> > But it would be finer still if there were still more of them
> > And yet I see them as a beauty who offers herself and immediately
> > swoons away….[14]

fig. 7. Joseph Cornell, *The Crystal Cage [Portrait of Berenice]*. Published in *View*, ser. 2, no. 4 (January 1943). Joseph Cornell Study Center, Smithsonian American Art Museum

In *The Crystal Cage* collage (fig. 7), the tower of a castle at lower right is silhouetted against a stream of shooting stars, some ending with the chassé of a ballerina, Carlotta Grisi, performing the role of Giselle. In the scene depicted in the print by John Brandard that Cornell has chosen for his collage, Giselle has died and become a wilis, a female spirit who returns to earth to perform the dance of death.[15] Cornell has transformed Giselle into a set of shooting stars in the night sky or a constellation overlapping with the adjacent Pegasus— perhaps the princess Andromeda, waiting to be rescued by Perseus. Hovering above are the constellations Virgo, Hydra, and Corvus. And just above Virgo, at upper right, is a photograph showing the back of a woman's head with a cascading mane of hair, reminding us that Berenice's namesake is also a constellation: the Coma Berenices, or Berenice's Hair. The constellation, which is adjacent to Virgo in the night sky, refers to the Ancient Egyptian queen who sacrificed her hair in return for her king's success at war. Cornell's reference is intentional, for, as he writes in a note included in the dossier, "origin of name—Berenice—snowdrops melting on thick wavy tresses snowflakes like stars—constellation of Berenice." Cornell also appears to be inspired by a line from Apollinaire's poem: "the daily apotheosis of all my Berenices whose hair has turned to comets' tails" as he depicts his child-protégée Berenice in the form of a dancing constellation shooting against the night sky.

In his poem, Apollinaire spectacularizes the horrors of war, comparing the flares sent out over the battlefield to "lovely" dancing ladies and shooting stars. He attempts to ameliorate the destruction of war by finding life and beauty in the ephemeral fireworks display created by the erupting flares. Working during the Second World War, Cornell attempts a similar feat. In the *Crystal Cage* collage, he enacts a similar scene as that described by Apollinaire: dancing girls, like shooting stars, leap across the night sky, while the Coma Berenices erupt in a fantastic display above the peaks of a European castle. As the child-protégée of the ballerina Carlotta Grisi, Berenice embodies what Apollinaire identifies as the life and beauty that issues even from the monstrosity of war. Cornell sends his child, Berenice, as a messenger of peace. In the collage, as she gazes up to the pyrotechnic dance above the battlefield, she carries in her arm a light-hearted message for the soldiers: a newspaper clipping dated 1940 reads "Rabbit Joins Battalion." In the upper left corner of the collage, we spy Berenice rescuing a duckling in Central Park, while *The New York Times* heading below reads WAR GIVES A BREAK TO . . . BOY. In the top center, Berenice appears in a photograph framed by stars, while a pair of angels blows on trumpets, announcing her presence to all. Always aware of the devastating effects of war, particularly on vulnerable children, Cornell included several photographs in his *Crystal Cage* dossier of children in tattered rags in the streets or playing in the rubble of bombed buildings. Here, he acknowledges the child's gift of resilience and ability to use his or her powers of imagination for positive invention. After all, Berenice is a child-genius—a scientist and seer of the heavens.

DANCE: AMERICAN ART, 1830–1960

In *A Pantry Ballet (for Jacques Offenbach)* (fig. 8), a series of works dating to the summer and winter of 1942, Cornell again invokes the Romantic ballet to promote a pacifist message, but this time using satire to reduce world war to something both ridiculous and obscene. A few versions exist, but in the Nelson-Atkins assemblage, ten red plastic lobsters dressed in tulle tutus and adorned in necklaces dance in a sous-marine theater. As they are affixed with string to both the top and bottom of the box's interior, the corps de ballet wriggle and dance in unison when the box is handled. Cornell calls this a "pantry ballet," since the performance is set in a kitchen: 1930s-style wallpaper decorates the background, while white paper doilies—the kind used for the display of his favored treats, cream puffs—line the upper corners of the scene. Dangling toy cutlery—spoons and forks—completes the kitchen motif. The lobsters serve as the figures uniting the mundane kitchen scene with a more fantastical underwater theater. Etchings of snails, trilobytes, and fish with vacant eyes cluster around the perimeter of the stage, an audience composed of the more primitive cousins to the "civilized" ballerinas onstage.

While the Romantic ballet was a favored theme in Cornell's work, *A Pantry Ballet* series is unique in its use of the color red. Cornell primarily employed deep blue in his art—to the point that critics now refer to this shade as "Cornell blue." *A Pantry Ballet* is dominated by the color red, not only for the corps de ballet—the lobsters—but also in the velvet frame, serving simultaneously as proscenium. The only other work in which he makes substantial use of the color red is *Habitat Group for a Shooting Gallery* (fig. 1), in which the splattered red of the bloodied cockatoo symbolizes the innocent victims of the war. In *A Pantry Ballet,* created in the previous year, the anti-war message is more coded, but still predominant. When Cornell was working on this series during the summer and winter of 1942, the war was escalating: the Nazis completed their takeover of France, spreading into the previously unoccupied zone in the south; Hitler intensified his attack on the Jews with his decision to implement his program of mass extermination called "the Final Solution"; and the battle in the Pacific between the Japanese and Allied forces reached its height, with the United States entry into the war beginning to turn the tide. Cornell's dedication of his box assemblage to Jacques Offenbach is loaded with political significance. Offenbach was a nineteenth-century composer and a German Jew who migrated to Paris as a teenager and gained widespread recognition for his opéras bouffes. Upon the Prussian occupation of France in 1870, there was a surge in anti-German sentiment in Paris, prompting Offenbach to flee into exile. Upon his return, he composed the opéra bouffe *Le Roi Carotte,* caricaturing the Prussians as a

fig. 8. Joseph Cornell, *A Pantry Ballet (for Jacques Offenbach)*, 1942, wood, plastic, paper, and metal. The Nelson-Atkins Museum of Art, gift of the Friends of Art, F77-34

ANALISA LEPPANEN-GUERRA

variety of vegetables (radishes, turnips, and cauliflowers) led by their king, a giant red carrot, who depose the incompetent yet genial King Fridolin XXIV (a thinly veiled reference to Napoleon III) during a banquet. Cornell, who was fond of telescoping time in order to forge connections between different historical moments, likely found in Offenbach's opera a parallel to the Nazi occupation of France in 1940, in which Marshal Pétain signed an armistice with Hitler, allowing Germany to occupy the north and west of France, which, by 1942, spread to include the entire nation.[16] As Sandra Starr notes in her insightful analysis of this work, Cornell may have decided to feature lobsters in his pantry ballet because of their traditional association with cowardice due to their ability to swim backwards when threatened by an enemy, an allusion to the political backsliding of Pétain and his followers. In Cornell's ballet, root vegetables morph into crustaceans, but Cornell clearly states how history repeats itself, and the hunger for power is never satiated.

In his assembling of a corps de ballet of crustaceans, Cornell also invokes the satirical work of nineteenth-century French illustrator J. J. Grandville, whose compositions Cornell greatly admired. In an illustration for his book of 1844, *Un Autre Monde (Another World)*, Grandville depicted a *pas de crabes*, with three crabs

fig. 9. J. J. Grandville, *Pas de Trois*, Illustration from *Un Autre Monde (Another World)*, 1844. The Getty Research Institute, Los Angeles (92-B7023)

en pointe as sylphides of the Romantic ballet (fig. 9). The beetles with anvil heads wielding hammers in the foreground caricatured the restrictive reign of Louis-Philippe, again demonstrating how ballet and its appearance of civilization becomes a delicate veneer for the heavy-handed measures of the presiding government.

In his use of lobster performers, Cornell had more than a few precedents. Hugo Ball, performing his sound poetry *Elefantenkarawane* at the Cabaret Voltaire in Zurich on June 23, 1916, as part of the productions of Zurich Dada, wore a ridiculous cardboard costume including what he referred to as a "witch doctor's hat" and clawlike appendages (fig. 10). Ball, as one of the founders of Zurich Dada, was attempting to resist what he believed to be the offspring of the bourgeois, "civilized" world: the horrors of world war. In his sound poetry, he asserts the prerational, the childlike, and the absurd as the only defense against the corruptions of the age. Cornell not only refers back to Hugo Ball as lobster bishop, but also invokes a shared ancestor for this "Theatre of the Absurd," Lewis Carroll's "Lobster Quadrille." When Alice encounters the Mock Turtle and Gryphon, they teach her the "Lobster Quadrille," danced in two lines along the seashore. This is most likely Carroll's parody of the "Lancers Quadrille," a popular square dance in English ballrooms at the time. The Lobster Quadrille ends by throwing the lobsters out to sea, which may be a reference to the tossing of lances in combat and therefore a kind of coded military reference.[17] Following their performance, Alice is ordered to recite poetry. In her peculiar rendition of "'Tis the voice of the sluggard," she substitutes "lobster" for the usual "sluggard," and remarks how the lobster "turns out his toes" like the first position in ballet. The second stanza refers to a pie shared by an Owl and a Panther, with special emphasis on cutlery: "When

the pie was all finished, the Owl, as a boon, / Was kindly permitted to pocket the spoon: / While the Panther received knife and fork with a growl, / And concluded the banquet by—".... Here, Alice is interrupted, and so never completes the stanza, but one possible ending (as suggested by Martin Gardner) is: "And concluded the banquet by eating the owl."[18]

 Cornell's staging of a lobster ballet in a kitchen setting invokes Carroll's violent and cannibalistic references. Cornell's lobster ballerinas directly recall Tenniel's illustration of a lobster with human feet turned out in first position, prepping at his dressing table for his upcoming performance (fig. 11). And since Cornell's lobsters are red, they are fully cooked and ready to eat, lending the cutlery dangling above them an ominous feel. The trilobites, snails, and fish converging from the wings, rather than fascinated by the performance, could simply be moving in for the feast. We are reminded of Hugo Ball's tirade against the war: "They are trying to make the impossible possible and to pass off the betrayal of man, the exploitation of the body and soul of the people, and all this civilized carnage as a triumph of European intelligence.... They cannot

fig. 10. Hugo Ball performing *Elefantenkarawane,* Cabaret Voltaire, Zurich, Switzerland, June 23, 1916. Swiss National Library

fig. 11. John Tenniel, *The Lobster, with a Hairbrush in Its Claw Standing Before a Dressing Table, with 4 Lines of Verse.* An Illustration from *Alice in Wonderland* by Lewis Carroll, ca. 1865, pen and brown ink. Private collection

ANALISA LEPPANEN-GUERRA

persuade us to enjoy eating the rotten pie of human flesh that they present to us."[19] Cornell's plastic lobsters in tutus and necklaces become a ridiculous parody of that apparently most "civilized" of dances, the ballet. They are "dinner and a show."

Cornell's art of the 1940s was not all fairy dust and light. When the entire world was in upheaval and distress, how could he not be affected? If he showcased the Romantic ballet in his art of the 1940s, it was his way of asserting the power of the spirit to negate the horrors of world war. Since he equated dance with flight, it became a path to the heavens; and the ballerinas, "heavenly bombshells."

Notes

1. Edward Alden Jewell, "Maestro Julien Levy," *The New York Times* (December 12, 1943), section 11, 8.

2. Deborah Solomon, *Utopia Parkway: The Life and Work of Joseph Cornell* (New York, 1997), 156.

3. Jean Cocteau, *Beauty and the Beast: Diary of a Film,* trans. Ronald Duncan (New York, 1972), 102.

4. Cyril W. Beaumont, *Complete Book of Ballets: A Guide to the Principal Ballets of the Nineteenth and Twentieth Centuries* (New York, 1938). Cyril W. Beaumont and Sacheverell Sitwell, *The Romantic Ballet in Lithographs of the Time* (London, 1938).

5. See Sandra Leonard Starr, *Joseph Cornell and the Ballet* (New York, 1983), 12.

6. Joseph Cornell, "Discovery: New York City 1940," diary entry (July 8, 1944), Joseph Cornell Papers.

7. Joseph Cornell, diary entry (July 7, 1944), and "Midsummer Incident 1940," diary entry (1944), Joseph Cornell Papers.

8. Joseph Cornell, *Hans Christian Andersen,* special edition of *Dance Index* 9 (September 1945), 146.

9. Joseph Cornell, "Discovery: New York City 1940," diary entry (July 8, 1944), Joseph Cornell Papers.

10. Starr 1983, 52.

11. Anatole Chujoy, "Fanny Elssler: Ballet Bombshell of 1840," *Dance* (April 1940): 23.

12. For more on Cornell and skygazing, see Kirsten Hoving, *Joseph Cornell and Astronomy: A Case for the Stars* (Princeton and Oxford, 2008), 128.

13. Joseph Cornell, "The Celestial Theater," July 7, 1945. Joseph Cornell Study Center, Smithsonian American Art Museum.

14. Guillaume Apollinaire, *Calligrammes: Poems of Peace and War (1913–1916),* trans. Anne Hyde Greet (Berkeley, 1980), 257.

15. The print by John Brandard was reproduced in Beaumont and Sitwell 1938, no. 2, pl. 22.

16. Sandra Starr, in her brilliant analysis of this work, is the first to point to Offenbach's *Le Roi Carotte* as a possible inspiration for Cornell in his creation of *A Pantry Ballet,* as well as the parallels in the political situations of the time. See Starr, *Joseph Cornell: Art and Metaphysics* (New York, 1982), 33–36, and Starr 1983, 53–54.

17. Martin Gardner, ed. *The Annotated Alice: The Definitive Edition* (New York, 2000), 100–101.

18. Ibid., 107.

19. Hugo Ball, *Flight Out of Time: A Dada Diary by Hugo Ball,* ed. John Elderfield (Berkeley, 1974–96), 67.

Isamu Noguchi and Ruth Page in an Expanding Universe | *Dakin Hart*

Isamu Noguchi (1904–88) and the American dancer-choreographer Ruth Page (1899–1991) met at a concert in Chicago in March 1932. Later she remembered him sitting in front of her wearing "a lost faraway look that was irresistible."[1] Noguchi was in town for an exhibition at the Arts Club of Chicago of ink-wash drawings and sculpture he had made in China and Japan the year before—one stop on an extended road trip with his friend, the eccentric futurist genius Buckminster Fuller.[2] Fresh from "the Orient," and the studio of the Chinese painter Qi Baishi, and already linked with the Romanian modernist sculptor-mystic Constantin Brancusi, whom he had served as a studio assistant in Paris in 1927, Noguchi created a stir with a handful of nudes seemingly designed to liberate motion from form through an abstract application of calligraphic Chinese pictography. Page wasn't the only one taken with the idea of Noguchi's exoticism. In a review of the exhibition, the *Chicago Evening Post*'s Inez Cunningham characterized Noguchi as "an artistic orchid of a strange and fascinating variety, a plant without roots which gets its life from spiritual ether and yet whose strength is self-evident."[3] Noguchi and Page were instantly attracted to each other and more or less immediately began an affair.

Noguchi's interest in dance preceded his infatuation with Page. He had made masks for, and a masklike portrait of, the great Japanese modernist dancer and impresario Michio Ito, his first dance commission. In the late 1920s, his half-sister, Ailes Gilmour, was dancing with Martha Graham, to whom he had been introduced by Ito, and Noguchi and Graham had already become friends. The first idea for a dance performance Noguchi remembered proposing, probably in 1928, he made to Graham and Leon Theremin, the electronic music pioneer. The details are sketchy because Noguchi was remembering events four decades past when he wrote about it and because like many of his most synthetically avant-garde schemes, it went unexecuted.[4]

Cat. 89. Isamu Noguchi, *Miss Expanding Universe*, 1932

Noguchi's concept was apparently for a production that would unify choreography, score, and set in a quite wildly original way that would make the entire production into one large moving musical sculpture. The stage was to be set with a field of Theremins: the first electronic instrument, named after its inventor, which produces sound when the electric field around its vertical and horizontal rods are disturbed.[5] Graham would dance through the field, activating the rods, in effect becoming both part of an instrument and its musician, as well as a mobile part of the set and, of course, the dancer. The set, for its part, in addition to providing a visual and physical environment, would represent a form of musical and choreographic notation, as well as serving as an instrument.

This early foray into synthetic artistic design for dance-theater provides an extraordinarily good window onto the breadth and flexibility of Noguchi's creative instincts and his deep-seated desire to be part of conjuring something uncanny and otherworldly involving the human body in space. Noguchi made an enormous amount of work recognizable as sculpture in his career, but his ideal was not the static, apparent self-possession of an object on a pedestal in a museum. That distinction goes to the biggest dance set around: the earth. At the same time that Noguchi and Page were contriving to launch her into a constellation of literal and figurative spaces (e.g., choreography, sculpture, the universe), Noguchi was hard at work on reframing the mission and soul of sculpture: in interactive, environmental works like *Play Mountain* and *Monument to the Plow*. As he would later say: "If sculpture is the rock, it is also the space between rocks and between the rock and a man, and the communication and contemplation between."[6]

Expanding Universe: *Miss Expanding Universe*

Exhibited in December 1932 at the Reinhardt Gallery in New York, the original plaster *Miss Expanding Universe* (now lost; fig. 1) was not particularly well received. Noguchi's early supporter, the dealer Julien Levy—while recognizing Noguchi's ambition and lauding him for it in a feature for *Creative Art*—nevertheless viewed the three figurative sculptures in the Reinhardt exhibition, including *Miss Expanding Universe,* as "only half-realized, amorphous."[7] The *New York Times* referred to the sculpture as a "strange creation" and the "most debatable" of his abstractions.[8] Time called it "something like a starfish and something like a woman."[9] "A figure such as this may just as well as not be accepted as a symbol of the universe," Richard Jewell wrote in a full review of the show for *The New York Times,* "at any rate until something more satisfying has been produced. The scientists might tell us that no universe ever looked like that. But the scientists don't know everything, and besides, this is an abstraction."[10]

Streamlined, aeronautically-shaped, cast in aluminum and installed hanging from the ceiling, *Miss Expanding Universe* brings to mind not just Fuller's influence (Noguchi had already produced a futuristic bust of Fuller in chrome-plated bronze) but his shameless, oft-repeated origin myth. To explain how he escaped a despair so deep that at one point he contemplated

suicide and came to fully embrace the productive optimism for which he became so famous, Fuller concocted a vision. While standing on the shores of Lake Michigan, he said, considering whether to drown himself, a glowing figure appeared in the sky and, levitating him in "a sparkling sphere of light," explained that he belonged to the universe, and charged him with that most American of ambitions: making himself useful. "... You do not belong to you. You belong to Universe... you may assume that you are fulfilling your role if you apply yourself to converting your experiences to the highest advantage of others."[11] *Miss Expanding Universe* (cat. 89) personifies this apocryphal guardian angel: the spirit of a limitless, streamlined future of cosmic significance. Decades later when Fuller settled on a favorite analogy for explaining Noguchi's importance as an artist-designer, it is no surprise that he chose the airplane, both of them, as he put it, being means by which the planet was knit into a single world.[12]

The sculpture is also a progressive, highly intellectualized, futurist Eve to the Adam of Noguchi's more conventional sculpture *Glad Day,* itself a reification of Fuller's concept of a universal man (fig. 2). Whether Noguchi began *Miss Expanding Universe* before meeting Page and then came to associate it with her, or began it after meeting her, two things are clear: it makes as much sense as an abstract soul mate for *Glad Day* as she did for him, and by the time he finished the piece and Fuller named it, all three of them identified Page as *Miss Expanding Universe* and the sculpture with her. If one were seeking first words for *Miss Expanding Universe* (fig. 1), Noguchi, Page, and Fuller's collaborative Galatea, to speak upon coming to life, in the form of Page in the *Sack Dress,* one could hardly do better than Fuller's brilliant, oft-repeated personal mission statement: "I seem to be a verb."[13]

The sobriquet *Miss Expanding Universe* derives from a lecture Sir Arthur Eddington gave

fig. 1. F.S. Lincoln, Isamu Noguchi's *Miss Expanding Universe,* 1932, photograph. Reproduced with the permission of the Special Collections Library, the Pennsylvania State University Libraries

fig. 2. Berenice Abbot, *Noguchi with Glad Day,* ca. 1930. The Noguchi Museum, New York. Berenice Abbott/Masters/Getty Images

DAKIN HART

fig. 3. F.S. Lincoln, Isamu Noguchi, and Ruth Page, *Page in Noguchi's First Sack Dress*, 1932. photograph. Reproduced with the permission of the Special Collections Library, the Pennsylvania State University Libraries

fig. 4. Isamu Noguchi and Ruth Page, *Page in Noguchi's Second Sack Dress*, 1932. The Noguchi Museum

in Cambridge, Massachusetts, in September 1932, as well as on American radio, and published the following year as the book *The Expanding Universe*. The Carl Sagan's *Cosmos* or Stephen Hawking's *A Brief History of Time* of its day, the book is a sophisticated explanation, for a lay audience, of the nature and implications of Edwin Hubble's proof of the French physicist Georges Lemaître's postulation that the universe is not only not fixed but rapidly expanding. Caught up, as they were, in the wider contemporary mania for creatively misunderstanding Einstein's theory of relativity, it is no wonder that *Miss Expanding Universe* would become a leitmotif of Noguchi, Fuller, and Page's relationship.[14] Fuller would later describe all of history in two paradigmatic eras, spanned by the age of the airplane: Newton's, which he characterizes as static and at rest, and Einstein's, defined by a "constantly accelerating complex of relative transformations."[15] *Miss Expanding Universe* is, of course, an iconic example of the latter.

Though it fits squarely in the tradition of biomorphic abstraction, looking not unlike a streamlined amoeba, the sculpture is based on a woman in a dress. Probably sometime in the summer of 1932, either shortly before, after, or most likely while he was working on *Miss Expanding Universe,* Noguchi designed a sack dress for Page (fig. 3). The dress exists only in photographs and has been long confused in the limited literature with a second, yet quite different sack dress (fig. 4), a version of which still exists.[16]

In comparing the two dresses with *Miss Expanding Universe,* the correlation between the sculpture and the first dress becomes inescapable (cat. 89, fig. 3). They share the same nipped-in waist and the complete encapsulation of the hands and feet. The logical conclusion is that *Miss Expanding Universe* is a portrait of Page in the first dress, or vice versa. That is the only way that the sculpture makes sense as an object for which Page could have posed, as both artists always

DANCE: AMERICAN ART, 1830–1960

said she had. But without more information, whether that dress was an effort to turn Page into a living, breathing, mobile *Miss Expanding Universe* or the sculpture was simply intended to immortalize Page in the dress will likely remain irresolvable. In either case, Noguchi's feelings could hardly have been more clear (fig. 5).[17]

It is worth clearly distinguishing between the two dress concepts.[18] The first, while it made for good posing, was difficult for Page to move in, and it is unlikely that she ever performed in it. It was more an act of living sculpture than a dance costume. The second dress, a true sack, was an open volume without internal structure or definition; it cinched at the ankles, wrist, and neck, leaving Page's hands and feet free. Where the first dress gave Page a fixed shape very like *Miss Expanding Universe,* in the second she could create, as she put it in a program note for *Figure in Space No. 2,* "different sculptural ideas"—it turned her from a fixed object into a potentially formally inexhaustible volume.[19]

A number of the "sculptural ideas" Page explored in the second dress are captured in photographs, as well as four ink-wash drawings (owned by the Page Center for the Arts) that Noguchi likely made for her on a visit to Chicago in 1934 (fig. 6). One version of the drawing, which is etched on Page's gravestone, is particularly interesting in that it shows the dress pushed to an abstract, aerodynamic extreme that recalls Brancusi's *Birds in Space*. Page appears caught halfway through the process of morphing into an "age of flight" hood ornament, of being transformed from a point into a vector (by the implied addition of speed and direction).[20]

The second dress, with Page spread eagle and seemingly in full-flight, assuming a pose not unlike that of *Glad Day,* is also the subject of a provocative watercolor likely made by Page's

fig. 5. F.S. Lincoln, *Isamu Noguchi with His Plaster Model of Miss Expanding Universe,* 1932. Reproduced with the permission of the Special Collections Library, the Pennsylvania State University Libraries.

fig. 6. Isamu Noguchi, *Ruth Page in Noguchi's Second Sack Dress,* 1934. Ruth Page Foundation

DAKIN HART

285

fig. 7. Attributed to Andre Delfau, *Ruth Page in Noguchi's Second Sack Dress,* ca. 1970s, watercolor. Page Center for the Arts

fig. 8. Unidentified news clipping, ca. 1932–33. The Archives of the Noguchi Museum, New York

longtime collaborator and eventual second husband, Andre Delfau (fig. 7). The painting is the best single depiction of the dress if for no other reason than that it reminds us to remember it in a brilliant, royal, early evening blue.

An undated and unaccredited, but clearly contemporaneous, newspaper clipping in the archives of The Noguchi Museum (fig. 8), which Page must have sent Noguchi at the time, describes the creation of the second dress: "Miss Page, as she is known professionally, asked him to make a costume for her. After some study, Noguchi created the sack. It was then up to her to think of a dance to go with it." The implication, given the accompanying cartoon, which clearly shows the second dress, is that Page's decision to choreograph the dance that became *Expanding Universe* followed the creation of the second version of the dress.

The idea for a sack dress was not a wholesale invention. As Robert Tracy has noted, Martha Graham, in her long woolens period, had worn an all-encompassing, tubelike purple sack dress in *Lamentation* of 1930 (figs. 9–10).[21] Noguchi's half-sister, Ailes, who served as a live model for the development of at least one of Noguchi's sack dresses, was dancing in Graham's company at the time.[22] The conception and intent of Noguchi's second dress, however, turn Graham's inside out.[23] Where *Lamentation* dramatizes an internal struggle with a universe of grief

DANCE: AMERICAN ART, 1830–1960

conducted within the confines of the self, Page's dance *Expanding Universe* is an extroversion of human aspiration on a cosmic scale. Much later, in a 1979 interview, Noguchi recalled: "Martha Graham used to say that in dancing she never opens her hand *out,* she closes it *in,* and this retains the energy. It doesn't flow out indiscriminately, it flows back into her."[24] Whereas the indiscriminate release of energy into the universe is exactly what Noguchi and Page were after.

Page took the dance she created with the second dress—titled *Expanding Universe,* at Noguchi's suggestion—on tour in fall 1932.[25] Before she set out, Noguchi ended a letter expressing his pleasure at learning that she would be "attempting my dances" with this postscript: "In the meantime dear heart work hard, dance beautiful dances. I shower you with 1000000000000 kisses." That's at least a trillion. It's impossible to know exactly how many because the line of zeroes trails off into a receding infinity of little swirls—a playful illustration of how integral the notion of galactic space was to their relationship.[26]

The difference between *Miss Expanding Universe* and Page's dance in the second dress is the difference between a cosmos composed of tidy, fixed concentric spheres (the ancient Ptolemaic model) and the big, amorphous, rapidly expanding, post-Hubble void we now accept as fact. The first dress and the sculpture are emblematic of an expanding universe in the same way that the winged figure on the hood of a Packard or the vapor trail in the early United Airlines logo symbolized motion without being independently capable of it. The genius of the second dress, and the choreographed body in concert with which it was conceived, is that it brings the reality of an organic, pulsing, amoebalike expansion of space to life—in other words,

fig. 9. Herta Moselsio, *Martha Graham performing Lamenation,* No. 9, ca. 1930, gelatin silver print. Library of Congress

fig. 10. Herta Moselsio, *Martha Graham performing Lamenation,* No. 4, ca. 1930, gelatin silver print. Library of Congress

DAKIN HART

it turns their collaborative noun into a verb, their inside joke into a mission. In the first dress Page was a vessel theoretically capable of moving through space; in the second she became a kinetic metaphor, somewhere between dance and sculpture (a place Noguchi would come to see as sacred), for a revised mental model of the universe itself.

Following that thread, an undated single-page scenario for *Expanding Universe,* in Page's handwriting, summarizes the progressive, pseudo-scientific, Fullerian fog in which their collaboration subsisted: "Ex-Uni is based upon non-Euclidian-cosmic-relativity Einsteinean geometry; the 4th dimensional tension dance must superceed [sic] and in all ways be opposite to the theory that the world is flat. / relations + properties of solids, surfaces, lines + angles—the theory of space or of figures in space."[27] Both tension, as a structural principle, and an overused, under-explained idea of the fourth dimension were Fullerian tropes. In a photograph of plaster models Noguchi made while serving as Fuller's sculptural amanuensis, in helping him prototype the Dymaxion Car, they look more than a little bit like shooting stars—each one engraved with the two letter abbreviation "4D" (fig. 11), for fourth dimension—streaking through a wormhole in space-time and into the future.

fig. 11. F.S. Lincoln, Isamu Noguchi, and Buckminster Fuller, *Plaster Prototypes for Fuller's Dymaxion Car,* ca. 1932. photograph. Reproduced with the permission of the Special Collections Library, the Pennsylvania State University Libraries

On October 30, 1932, from a Western Union office in Fargo, North Dakota, Page sent Noguchi a telegram, care of Fuller: "OUR UNIVERSAL CHILD SOMEWHAT STARTLED THE NATIVE IOWANS LAST NIGHT BUT THEY LIKED IT STOP [...] HAPPY OVER OUR EXPANSION= RUTH." By the time Page's 1933 tour with the brilliant Harold Kreutzberg began, her and Noguchi's "universal child" seems to have been supplanted by a pair of related dances, *Figure in Space No. 1* and *Figure in Space No. 2*. In program notes compiled in 1933 and 1934, presumably for that tour, Page described both dances:

> "Figure in Space" is danced entirely inside a jersey sack designed for Miss Page by the Japanese-American sculptor, Isamu Noguchi, son of the poet, Yone Noguchi. To those who are plastically-minded the dance will seem to be a series of startling poses—new inventions in design and ever-remindful of Twentieth Century sculpture in its most abstract and fourth-dimensional imagery. To those who are philosophically-minded the dance will seem to be the continuous struggle of mankind, through calmness and strife, to expand into new ideas and new forms ending in the complete mystery which is the universe. But for this dance each must make his own interpretation [...]
>
> "Figure in Space No. 2" is also danced entirely inside of a jersey sack—using different forms and different sculptural ideas but reaching always towards the same infinity of space and form.[28]

The same undated newspaper clipping Page sent Noguchi (fig. 8) notes *Expanding Universe* was to be performed against a dark background with "flickering" lights.

In terms of its importance in the history of dance, what we can say for certain about Noguchi and Page's capacious collaboration is that it is impossible to know how one of the most significant multidisciplinary partnerships of modernism, Noguchi and Graham's, would have developed without it. In his autobiography Noguchi uses highly cosmically charged language to explain the years from 1932, when he was with Page, to 1935, when Graham's *Frontier,* with Noguchi's first set for her, premiered (fig. 12). Within a span of scarcely three pages, Noguchi communicates a galaxy's worth of ambition and desire: "My thoughts were born in despair, seeking stars in the night. In this frame of mind I designed a *Musical Weather Vane*"[29]; "If [Benjamin] Franklin and his kite recalled my childhood enthusiasm, it was also the sky of aspirations where the kite flies seeking its lightning"[30]; "My model [for *Monument to the Plow,* dedicated to Franklin and Thomas Jefferson] indicated my wish to belong to America, to its vast horizons of earth"[31]; "Through the use of rope [for the set for Martha Graham's *Frontier*] I was able to create within the void of the stage a vastness of the frontier."[32] With that simple parabola, both ends invisible off stage, Noguchi also linked the idea of the frontier to the limitlessness of the universe—fixing the dancer to a specific spot on stage on earth while reminding us that even when she is not in motion, the planet is vast and hurtling through space.

The rhetorical transit in the autobiography, meanwhile, from outer space to the immensity of the American west, tracks a direct arc from Page to Graham: head in the clouds to feet on the ground, romantic love to platonic collaboration, dance as an abstraction to abstraction in the service of dance. From Noguchi's point of view, the exchange was one limitless expanse, the literal one of the expanding universe, for another, the figurative boundlessness of the American dream.

fig. 12. Barbara Morgan, *Martha Graham, "Frontier,"* 1935, gelatin silver print. Collection of the Haggerty Museum of Art, Marquette University, gift of Mr. and Mrs. John Ogden

DAKIN HART

Notes

This essay was adapted and expanded from an exhibition brochure written for *Space Choreographed: Noguchi and Ruth Page* (September 24, 2013–January 26, 2014).

1. John Martin, *Ruth Page: An Intimate Biography* (New York, 1977), 80. In later interviews, Page would sometimes say she had always known Noguchi, or that she had met him through the sculptor Alexander Calder.

2. Page had nearly as much in common with Fuller as she did with Noguchi. Her brother-in-law Howard Fisher was an up-and-coming architect whose firm, General Houses, Inc., was one of a handful of companies developing a modular, prefabricated house of tomorrow, a prototype of which Page and Fisher occupied in Hubbard Woods, Illinois. ("HOUSING: Prefabrications," *Time,* March 27, 1933.) At the same time, Fuller was extrapolating ideas from his *Dymaxion House* for hyper-modernizing American life, such as designs for modular kitchens and bathrooms, and the three-wheeled Dymaxion Car (1933), the shape of which Noguchi helped model.

3. Inez Cunninghamm, "Noguchi as Master of Long Scroll," *Chicago Evening Post,* March 8, 1932.

4. Isamu Noguchi, *Isamu Noguchi: A Sculptor's World* (New York, 1968; reprint ed., 2004), 21. For more detail see Neil Printz, "'A Nearer Function than that of the Eye': Noguchi, Graham, and the Physicality of the Dance," in *Noguchi and Graham: Selected Work for Dance* [exh. cat., The Isamu Noguchi Foundation and Garden Museum] (New York, 2004), 48.

5. The Theremin, the direct ancestor of the synthesizer, was an instant sensation when it appeared in 1920; it appeared to many to be a form of magic—an instrument that didn't need to be touched to be played.

6. Isamu Noguchi, "Meaning in Modern Sculpture," *Art News* 48 (March 1949): 55.

7. Julien Levy, "Isamu Noguchi," *Creative Art* (January 1933): 35.

8. "Art Roster: New Exhibitions," *New York Times,* December 18, 1932, 10.

9. "Sport: Third Noguchi," *Time,* October 10, 1932.

10. Richard Jewell, "Art in Review: Noguchi's Abstract Sculpture at Reinhardt Gallery Is Puzzling but Indicative of His Brilliance," *The New York Times,* December 17, 1932, 20.

11. Lloyd Steven Sieden, *Buckminster Fuller's Universe: His Life and Work* (New York, 1989), 88.

12. R. Buckminster Fuller, "Isamu Noguchi," *The Palette* (Winter 1960): 2–4.

13. Dore Ashton, *Noguchi: East and West* (Berkeley, CA, 1992), 18.

14. In 1928, more than three years before she met Noguchi and Fuller, Page choreographed a piece called *Through Space* (to music by Ferruccio Busoni and danced in a Greek chiton) based on a Native American allegory of spiritual development in which the Thunderbird character wheels chaotically through space until, calmed by the benign influence of Rainbow, he learns to soar. The scenario is explained in the program for performances at the Imperial Theatre in Tokyo, October 25, 1928 (The Noguchi Museum). This would have been more or less the same time Noguchi was working on his idea for a performance for Graham and Theremin.

15. Fuller 1960, 2.

16. A version of Noguchi's second sack dress is in the collection of the Chicago History Museum.

17. Page later choreographed *Pygmalion* as an opera ballet.

18. In an annotation on a copy of a love letter from Noguchi to Page (originals in the New York Public Library, annotated copies in the Noguchi Museum), Martin notes that there were three dresses, one covering the feet and hands and two leaving them free.

19. Various program notes, undated, D–16–P18, Ruth Page Collection, Jerome Robins Dance Division, The New York Public Library for the Performing Arts.

20. There is a great synchronicity between the many "flying lady," greyhound, Pegasus, griffin, jaguar, gazelle, zephyr, and Mercury hood ornaments featured on Rolls Royces, Fords, Chryslers, Packards, Cadillacs, Auburns, and others, starting in the 1910s all the way up through

the 1950s and *Miss Expanding Universe*. This is typical of Noguchi. Many of his most distinctive forms and concepts were imported from design and industry into the "fine" art of sculpture.

21. Robert Tracy, *Spaces of the Mind: Isamu Noguchi's Dance Designs* (New York, 2000), 22. Particularly early in her career, Graham was famous for making (and remaking and remaking) her own costumes, including the tube dress.

22. In an undated love letter to Page that included a couple of small sketches, Noguchi describes how "When Ailes was trying out postures for me she evolved some really beautiful ones." This letter is reproduced in Amy Wolf, *On Becoming an Artist: Isamu Noguchi and His Contemporaries, 1922–1960* (New York, 2010), 52.

23. Katherine Crockett, a recent soloist for the Martha Graham Dance Company, is well known for her performances of *Lamentation*. Of wearing that dress, she has said, "You begin to feel that the tube is your flesh, and that you're trying to get out of it as relief from your pain. That effort creates internal tension. It's almost as if you are in a womb." Valerie Gladstone, "When the Costume Comes First: Dancers and Choreographers on Working with Wearable Art," *Dance Magazine* 83, no. 10 (October 2009). See http://www.dancemagazine.com/issues/October-2009/When-the-Costume-Comes-First (accessed April 23, 2015).

24. "Artists in Their Own Words: Isamu Noguchi by Paul Cummings," in Diane Apostolos-Cappadona and Bruce Altshuler, eds., *Isamu Noguchi: Essays and Conversations* (New York, 1994), 143.

25. Noguchi makes the suggestion in an undated letter on letterhead from Structural Study Associates, one of Buckminster Fuller's organizations. New York Public Library for the Performing Arts, D–16–32C2.

26. This letter is held in the Ruth Page Collection in the Jerome Robbins Dance Division, The New York Public Library for the Performing Arts. It is reproduced in Wolf 2010, 52. Anyone who remembers how ruthlessly Carl Sagan was lampooned in the 1980s for the phrase "billions and billions of stars" will catch the significance of Noguchi's use of what is often known as an "astronomically large" number.

27. Ruth Page, statement about *Expanding Universe*, Jerome Robbins Dance Division, The New York Public Library for the Performing Arts, D–16–M28. Reproduced in Wolf 2010, 51.

28. Various program notes, undated, D–16–P18, Ruth Page Collection, Jerome Robins Dance Division, The New York Public Library for the Performing Arts.

29. Noguchi 1968, 21.

30. Ibid., 21–22.

31. Ibid., 22.

32. Ibid., 23.

Checklist

Charles Alston
American, 1907–77
Dancers, 1949
Oil on canvas; 29½ × 39¾ in. (74.9 × 101 cm)
Private collection
Cat. 70

Richmond Barthé
American, 1901–89

Rugcutters, 1930
Bronze; 17 × 12 × 7 in
(43.18 × 30.48 × 17.78 cm)
Moorland–Spingarn Research Center,
Howard University, Washington, DC
Cat. 66

Feral Benga, Senegalese Dancer, 1935
Bronze; 19 × 7½ × 4½ in. (48.3 × 19 × 11.4 cm)
Collection of The Newark Museum, Gift of
Mr. and Mrs. Charles W. Engelhard by
exchange, 1989, 89.125
Cat. 67

Josephine Baker, ca. 1951
Bronze; 14 × 6 × 12 in.
(35.6 × 15.24 × 30.48 cm)
Private collection
Cat. 68

William Holbrook Beard
American, 1824–1900
The Bear Dance, ca. 1870
Oil on linen; 41 × 62 in. (104.1 × 157.5 cm)
Courtesy of The New-York Historical Society,
Gift of Enoch G. Megrue, 1942.108
Cat. 6

Cecilia Beaux
American, 1855–1942
Dorothea and Francesca, 1898
Oil on canvas; 80⅛ × 46 in. (203.5 × 116.8 cm)
The Art Institute of Chicago, A. A. Munger
Collection, 1921.109
Cat. 2

Thomas Hart Benton
American, 1889–1975
Burlesque, ca. 1930
Tempera with oil glazes on canvas, mounted
on pressboard; 18 3/16 × 25⅛ in.
(46.2 × 63.82 cm)
Los Angeles County Museum of Art, Gift of
Mr. and Mrs. Ira Gershwin, M80.104
Cat. 54

George Caleb Bingham
American, 1811–79
The Jolly Flatboatmen, 1846
Oil on canvas; 38⅛ × 48½ in.
(96.8 × 123.2 cm)
National Gallery of Art, Washington, Patrons'
Permanent Fund, 2015.18.1
Cat. 11

Ralph Albert Blakelock
American, 1847–1919
The Vision of Life / The Ghost Dance, 1895–97
Oil on canvas; 21⅛ × 39⅜ in. (53.7 × 100 cm)
The Art Institute of Chicago, Charles H. and
Mary F. S. Worcester Collection, 1947.55
Cat. 21

Robert Frederick Blum
American, 1857–1903
Study for "Moods to Music," 1893–95
Oil on canvas; 40 × 80⅜ in. (101.6 × 204.2 cm)
Cincinnati Art Museum, Gift of Henrietta
Haller, 1905.145
Cat. 31

John George Brown
American, 1831–1913
The Sidewalk Dance, 1894
Oil on canvas; 40¼ × 60 in. (102.2 × 152.4 cm)
Manoogian Collection
Cat. 28

Paul Cadmus
American, 1904–99

Mac, the Filling Station Attendant, costume
design for the ballet *Filling Station,* 1937
Gouache, pencil, and watercolor on paper;
11 × 6⅞ in. (27.9 × 17.5 cm)
Museum of Modern Art, Gift of Lincoln
Kirstein, 506.1941.4
Cat. 83

Set design for the ballet *Filling Station,* 1937
cut-and-pasted paper, gouache, and pencil
on paper
8 × 10⅞ in. (20.3 × 27.6 cm)
Museum of Modern Art, Gift of Lincoln
Kirstein, 506.1941.8
Cat. 84

Arabesque, 1941
Egg tempera; 7 × 7 in. (17.8 × 17.8 cm)
Evansville Museum of Arts, History and
Science, Evansville, IN, Bequest of William
A. Gumberts
Cat. 85

Reflection, 1944
Egg tempera on pressed wood panel;
16¾ × 19 in. (42.6 × 48.3 cm)
Yale University Art Gallery, Bequest of
Donald Windham in memory of Sandy M.
Campbell, 2011.56.1
Cat. 86

Mary Cassatt
American, 1844–1926
Bacchante, 1872
Oil on canvas; 24 × 19 15/16 in. (61 × 50.6 cm)
Courtesy of the Pennsylvania Academy of the
Fine Arts, Gift of John Frederick Lewis,
1932.13.1
Cat. 27

George Catlin
American, 1796–1872
Bull Dance, Mandan O-kee-pa Ceremony, 1832
Oil on canvas; 23¼ × 28 (59.0 × 71.1 cm)
Smithsonian American Art Museum,
Gift of Mrs. Joseph Harrison, Jr., 1985.66.505
Cat. 20

William Merritt Chase
American, 1849–1916
Carmencita, 1890
Oil on canvas; 69⅞ × 40⅞ in.
(177.5 × 103.8 cm)
The Metropolitan Museum of Art, Gift of
Sir William Van Horne, 1906, 06.969
Cat. 46

James Goodwyn Clonney
American, 1812–67

Study for "Militia Training": Boy Dancing,
ca. 1839
Pen and black ink with brush and gray wash
on paper; 8 5/16 × 6⅛ in. (21.1 × 15.6 cm)
Museum of Fine Arts, Boston, Gift of Maxim
Karolik for the M. and M. Karolik Collection
of American Watercolors and Drawings,
1800–1875, 62.215
Cat. 10

*Study for "Militia Training": Boy Singing and
Dancing,* ca. 1839
Wash on paper; 7⅝ × 5 9/16 in. (19.3 × 14.2 cm)
Museum of Fine Arts, Boston, Gift of Maxim
Karolik for the M. and M. Karolik Collection
of American Watercolors and Drawings,
1800–1875, 62.216
Cat. 19

Militia Training, 1841
Oil on canvas; 28 × 40 in. (71.1 × 101.6 cm)
Courtesy of the Pennsylvania Academy of the
Fine Arts, Bequest of Henry C. Carey (The
Carey Collection), 1879.8.1
Cat. 18

Dolores Purdy Corcoran
Native American, Caddo Nation of Oklahoma,
born 1952
*Caddo Women Taking Repatriation of Ghost Dance
Pole into Their Own Hands,* 2007
Color pencils and india ink on antique paper;
20½ × 16 in. (52.1 × 40.6 cm)
Kansas Historical Society, 2007.28.
p. 81

Caddo-lac Dancers, 2014
Watercolor; 10½ × 16 in. (26.7 × 40.6 cm)
Private collection
Cat. 24

Joseph Cornell
American, 1903–72
Crystal Cage Collage (Portrait of Berenice), 1943
Valise containing documents; 15⅝ × 19 3/16 ×
4 5/16 in. (40 × 48.7 × 11 cm)
Richard L. Feigen Gallery & Co.
Cat. 88

*A Swan Lake for Tamara Toumanova (Homage to
the Romantic Ballet),* 1946
Box construction: painted wood, glass pane,
Photostats on wood, blue glass, mirrors,
painted paperboard, feathers, velvet, and
rhinestones; 9½ × 13 × 4 in.
(24.1 × 33 × 10.2 cm)
The Menil Collection, Houston
Cat. 87
[Detroit only]

Arthur Bowen Davies
American, 1862–1928
Dances, 1914/15
Oil on canvas; 84 × 138 in (213.4 × 350.5 cm)
Detroit Institute of Arts, Gift of Ralph
Harman Booth, 27.158
Cat. 36

Aaron Douglas
American, 1899–1979
Dance, ca. 1930
Gouache; 15 × 12¼ in. (38.1 × 31.1 cm)
Private collection
Cat. 63

Thomas Eakins
American, 1844–1916

*Study for "Negro Boy Dancing":
The Banjo Player,* 1877
Oil on canvas on cardboard
19½ × 14 15/16 in. (49.5 × 37.9 cm)
National Gallery of Art, Washington,
Collection of Mr. and Mrs. Paul Mellon,
1985.64.16
Cat. 14

CHECKLIST 293

Study for "Negro Boy Dancing": The Boy, 1877
Oil on canvas; 21 × 9 ⅛ in. (53.3 × 23.2 cm)
National Gallery of Art, Washington,
Collection of Mr. and Mrs. Paul Mellon,
1985.64.15
Cat. 13

Abastenia St. Leger Eberle
American, 1878–1942
Girls Dancing, 1907
Bronze; 13 ½ × 7 ¼ × 7 ⁵⁄₁₆ in.
(34.3 × 18.4 × 19.3 cm)
National Gallery of Art, Washington,
Corcoran Collection
(Gift of the artist)
Cat. 3

Harry Fonseca
Native American, 1946–2006
Shuffle Off to Buffalo #V, 1983
Acrylic and mixed media on canvas; 60 × 48 in.
(152.4 × 121.92 cm)
Denver Art Collection: William Sr. and
Dorothy Harmsen Collection, 2005.63
Cat. 5

Robert Henri
American, 1865–1929

Salome Dancer, 1909
Oil on canvas; 77 ¼ × 36 ¹⁵⁄₁₆ in.
196.2 × 93.8 cm)
Mead Art Museum, Amherst College,
Museum Purchase, 1973.6
Cat. 45

Ruth St. Denis in the Peacock Dance, 1919
Oil on canvas; 85 × 49 in. (215.9 × 124.5 cm)
Courtesy of the Pennsylvania Academy of the
Fine Arts, Gift of the Sameric Corporation in
memory of Eric Shapiro, 1976.1
Cat. 7

Malvina Hoffman
American, 1887–1966

Russian Dancers, 1911
Bronze; overall: 10 in. (25.4 cm)
Detroit Institute of Arts, Gift of George G.
Booth, 19.53
Cat. 41

Bacchanalia, 1914
Bronze; 11 ¾ × 8 ¾ × 8 in. (30 × 22.2 × 20.3 cm)
Santa Barbara Museum of Art, Gift of Mrs.
George M. Newell, 1946.5.2
Cat. 42

Anna Pavlova, 1924
Wax and pigments; 15 ⅞ in. (40.3 cm)
Detroit Institute of Arts, Gift of John S.
Thatcher, 46.344
Cat. 43
[not in exhibition]

Winslow Homer
American, 1836–1910

A Summer Night, 1890
Oil on canvas; 30 ³⁄₁₆ × 40 in. (76.7 × 101.6 cm)
Musée d'Orsay, Paris, 1977 427
Cat. 29
[Detroit only]

A Summer Night—Dancing By Moonlight, 1890
Oil on canvas; 28 ¾ × 35 × 2 ½ in.
(73 × 89 × 6.4 cm)
Dr. and Mrs. John E. Larkin
Cat. 30
[Denver and Bentonville only]

Edward Hopper
American, 1882–1967
Girlie Show, 1941
Oil on canvas; 32 × 38 in. (81.28 × 96.52 cm)
The Museum of Fine Arts, Houston,
Collection of Fayez Sarofim
Cat. 55

Oscar Howe
Native American, Yanktonai Sioux, 1915–83
Ghost Dance, 1960
Watercolor on paper; 28 × 33 ¾ in.
(71.12 × 85.73 cm)
Heard Museum Collection, Phoenix, Arizona
Cat. 23

George Hurrell
American, 1904–92
Bill "Bojangles" Robinson, 1935
Gelatin silver print on paper; sheet: 9 × 6 ¼ in.
(22.8 × 15.9 cm)
National Portrait Gallery, Smithsonian
Institution, NPG.89.193
[not illustrated]

Jasper Johns
American, born 1930
Costumes for "Rainforest," 1968
Slashed and distressed v-neck long sleeve shirts,
long sleeve leotards, footless tights; various
sizes
Collection Walker Art Center, Minneapolis,
Merce Cunningham Dance Company
Collection, Gift of Jay F. Ecklund, the Barnett
and Annalee Newman Foundation, Agnes
Gund, Russell Cowles and Josine Peters, the
Hayes Fund of HRK Foundation, Dorothy
Lichtenstein, MAHADH Fund of HRK
Foundation, Goodale Family Foundation,
Marion Stroud Swingle, David Teiger,
Kathleen Fluegel, Barbara G. Pine, and the
T. B. Walker Acquisition Fund, 2011
[not illustrated]

Eastman Johnson
American, 1824–1906
Negro Life at the South, 1859
Oil on linen; 37 × 46 in. (94 × 116.8 cm)
Courtesy of The New-York Historical Society,
The Robert L. Stuart Collection, S-225
Cat. 17

Sargent Claude Johnson
American, 1888–1967
A Study for a San Francisco Housing Authority Mural #2, ca. 1950
Mixed media on paper; 11 × 8 in.
(27.94 × 20.32 cm)
The Melvin Holmes Collection of African American Art
Cat. 71

William H. Johnson
American, 1901–70
Jitterbugs (II), ca. 1941
Oil on paperboard; 24 × 15 3/8 in. (61 × 39.1 cm)
Smithsonian American Art Museum, Gift of the Harmon Foundation, 1967.59.611
Cat. 69

Franz Kline
American, 1910–62
Large Clown (Nijinsky as Petrouchka), ca. 1948
Oil on canvas; 33 1/8 × 28 1/8 in. (84.1 × 71.4 cm)
Wadsworth Atheneum Museum of Art, Hartford, CT. Gift of Miriam Orr in Memory of her late husband, Israel David Orr, and through the courtesy of her daughter, Sulamith L. Orr, 2001.24.1
Cat. 58

Walt Kuhn
American, 1877–1949
Plumes, 1931
Oil on canvas; 40 × 30 in. (101.6 × 76.2 cm)
The Phillips Collection, Washington, DC, Acquired 1932, 1096
Cat. 52

George Luks
American, 1867–1933

The Spielers, 1905
Oil on canvas; 36 1/16 × 26 1/4 in.
(91.6 × 66.68 cm)
Addison Gallery of American Art, Phillips Academy, Andover, Massachusetts, gift of anonymous donor, 1931.9
Cat. 1

Pavlova's First Appearance in New York, ca. 1910
Oil on canvas; 22 1/4 × 26 1/4 × 2 1/2 in.
(56.5 × 66.7 × 6.4 cm)
Munson–Williams–Proctor Arts Institute, Utica, New York, Museum Purchase, 58.296
Cat. 40

George Platt Lynes
American, 1907–55
Lew Christensen, 1938
Black and white print; 9 1/4 × 7 1/4 in.
(23.5 × 18.5 cm)
The Jerome Robbins Dance Division, The New York Public Library for the Performing Arts, Astor, Lenox and Tilden Foundations
Cat. 82

Jenne Magafan
American, 1916–52
Cowboy Dance (mural study, Anson, Texas Post Office), 1941
Oil on fiberboard; 23 7/8 × 30 3/4 in.
(60.5 × 78.1 cm)
Smithsonian American Art Museum, Transfer from the Internal Revenue Service through the General Services Administration, 1962.8.46
Cat. 8

Paul Manship
American, 1885–1966
Dancer and Gazelles, 1916
Bronze; 32 × 33 × 10 in. (81.3 × 83.8 × 25.4 cm)
Detroit Institute of Arts, Gift of George G. Booth, 19.43
Cat. 34

Marisol
American, born 1930
Portrait of Martha Graham, 1977
Oil and pencil on wood and plaster; 53 × 25 1/2 × 32 1/2 in. (134.6 × 64.8 × 82.6 cm)
Crystal Bridges Museum of American Art, Bentonville, Arkansas.
[not illustrated; Bentonville only]

Reginald Marsh
American, 1898–1954
Savoy Ballroom, 1931
Tempera on Masonite; 24 × 48 in.
(61 × 121.9 cm)
Detroit Institute of Arts, Gift of Lillian Henkel Haass, 48.11
Cat. 64
[Detroit only]

Arthur F. Mathews
American, 1860–1945
Youth, ca. 1917
Oil on canvas; 39 × 50 in. (99.1 × 127 cm)
Collection of the Oakland Museum of California, Gift of Concours d'Antiques, the Art Guild, A66.196.24
Cat. 35

Jan Matulka
American, 1890–1972
Indian Dancers, ca. 1917–18
Oil on canvas; 26 × 16 in. (66 × 40.6 cm)
Collection of Jan T. and Marica Vilcek, Promised gift to the Vilcek Foundation
Cat. 57

Christian Friedrich Mayr
American, 1803–51
Kitchen Ball at White Sulpher Springs, Virginia, 1838
Oil on canvas; 24 × 29 1/2 in. (61 × 74.9 cm)
North Carolina Museum of Art, Purchased with funds from the State of North Carolina, 52.9.23
Cat. 16

William Sidney Mount
American, 1807–68

Rustic Dance After a Sleigh Ride, 1830
Oil on canvas; 22 1/8 × 27 1/8 in. (56.2 × 68.9 cm)
Museum of Fine Arts, Boston, Bequest of Martha C. Karolik for the M. and M. Karolik Collection of American Paintings, 1815–1865, 48.458
Cat. 15

Dance of the Haymakers, 1845
Oil on canvas mounted on wood; 24 × 29¾ in. (70 × 75.6 cm)
The Long Island Museum of American Art, History & Carriages. Gift of Mr. and Mrs. Ward Melville, 1950
Cat. 12

Frank Myers
American, 1899–1956
The Charleston, 1926
Oil on canvas; 32 × 36 in. (81.3 × 91.4 cm)
The Irvine Museum
Cat. 39

Alice Neel
American, 1900–1984
Ballet Dancer, 1950
Oil on canvas; 20⅛ × 42⅛ in. (51.1 × 107 cm)
Hall Collection
Cat. 60

Isamu Noguchi
American, 1904–88

Miss Expanding Universe, 1932
Aluminum; 40⅞ × 34⅞ × 9 in. (103.9 × 88.6 × 15.2 cm)
Lent by the Toledo Museum of Art, museum purchase, 1948.12
Cat. 89

Cave of the Heart: Serpent and Spider Dress, 1946
Brass wire and bronze; serpent: 15 × 39½ × 44 in. (38.1 × 100.3 × 111.8 cm), dress: 81 × 81½ × 16 in. (205.7 × 207 × 40.6 cm)
The Isamu Noguchi Foundation and Garden Museum, New York
Cat. 9

Werner Philipp
American, 1897–1982
Portrait of Katherine Dunham, 1943
Oil on canvas; 54¾ × 45⅛ × 2 in. (139.1 × 114.6 × 5 cm)
Courtesy of the Missouri History Museum, St. Louis, 2008.34.1
Cat. 61

John Pratt
Canadian, 1911–86
Two Piece Cotton Patchwork Dress, ca. 1946
Cotton, wool, velvet, silk; bust: 28 in., waist: 26 in.
Missouri History Museum, St. Louis, 1991.77.361
[not illustrated]

Anne Estelle Rice
American, 1879–1959
The Egyptian Dancers (Two Egyptian Dancers), 1910
Oil on canvas; 57 × 73 in. (144.8 × 185.4 cm)
Brooklyn Museum, Dick S. Ramsay Fund, 2007.51
Cat. 37

Faith Ringgold
American, born 1930
Groovin' High, 1986
Acrylic on canvas, paint, dye, fabric, sequins, and beads; 56 × 92 × 2¾ in. (142.2 × 233.7 × 7 cm)
Spelman College, Atlanta. Gift of Barbara B. and Ronald David Balser, 1996.1
Cat. 72

Diego Rivera
Mexican, 1886–1957

Banana, costume design for the ballet *H.P. (Horsepower),* 1927
Watercolor, pencil, and colored pencil on paper; 14½ × 10¼ in. (36.8 × 26 cm)
Museum of Modern Art, Gift of Abby Aldrich Rockefeller, 505.1941.10
Cat. 74

Cocoa Nut, costume design for the ballet *H.P. (Horsepower),* 1927
Watercolor and pencil on paper; 13⅞ × 9¾ in. (35.2 × 24.8 cm)
Museum of Modern Art, Gift of Abby Aldrich Rockefeller, 505.1941.8
Cat. 73

The Man, costume design for the ballet *H. P. (Horsepower),* 1927
Ink, watercolor, and pencil on paper; 20⅞ × 29⅜ in. (53 × 74.6 cm)
Museum of Modern Art, Gift of Abby Aldrich Rockefeller, 505.1941.1
Cat. 79

Pineapple, costume design for the ballet *H. P. (Horsepower),* 1927
Watercolor, pencil, and colored pencil on paper; 14½ × 9¾ in. (36.8 × 24.8 cm)
Museum of Modern Art, Gift of Abby Aldrich Rockefeller, 505.1941.13
Cat. 75

Set design for Scene IV of the ballet *H. P. (Horsepower),* 1927 or 1931
Watercolor and pencil on paper; 12⅛ × 18⅝ in. (30.8 × 47.3 cm)
Museum of Modern Art, Gift of Abby Aldrich Rockefeller, 505.1941.22
Cat. 76

The Siren, costume design for the ballet *H. P. (Horsepower),* 1927
Watercolor and pencil on paper; 13⅞ × 9½ in. (35.2 × 24.1 cm)
Museum of Modern Art, Gift of Abby Aldrich Rockefeller, 505.1941.7
Cat. 80

Sun, costume design for the ballet *H. P. (Horsepower),* 1927 or 1931
Watercolor on paper; 5⅜ × 3⅞ in. (13.7 × 9.8 cm)
Museum of Modern Art, Gift of Abby Aldrich Rockefeller, 505.1941.17
Cat. 78

Tobacco and Cotton, costume designs for the ballet *H. P. (Horsepower),* 1927
Watercolor and pencil on paper; 16⅝ × 12½ in. (42.2 × 31.8 cm)
Museum of Modern Art, Gift of Abby Aldrich Rockefeller, 505.1941.16
Cat. 77

U.S.—Mexico Gold—Silver, costume design for the ballet *H. P. (Horsepower),* 1927 or 1931
Watercolor and pencil on paper; 16 3/8 × 12 1/4 in. (41.6 × 31.1 cm)
Museum of Modern Art, Gift of Abby Aldrich Rockefeller, 505.1941.14
Cat. 81

John Singer Sargent
American, 1856–1925

Capri Girl on a Rooftop, 1878
Oil on canvas; 20 × 25 in. (50.8 × 63.5 cm)
Crystal Bridges Museum of American Art, Bentonville, Arkansas
Cat. 26

La Carmencita, 1890
Oil on canvas; 91 5/8 × 55 7/8 in. (232 × 142 cm)
Musée d'Orsay, Paris, RF746
Cat. 44
[Detroit and Denver only]

Gertrude Vanderbilt Whitney, ca. 1913
Charcoal and graphite pencil on paper; 24 5/8 × 19 5/8 in. (62.5 × 49.8 cm)
Whitney Museum of American Art, New York, Gift of Flora Miller Biddle, Pamela T. LeBoutillier, Whitney Tower, and Leverett S. Miller, 92.22
Cat. 47

Joseph Henry Sharp
American, 1859–1953
The Harvest Dance, 1893–94
Oil on canvas; 27 11/16 × 48 5/8 in. (70.3 × 123.5 cm)
Cincinnati Art Museum, Museum Purchase, 1894.10
Cat. 22

Everett Shinn
American, 1876–1953

A French Music Hall, 1906
Oil on canvas; 24 × 29 1/2 in. (61 × 74.9 cm)
Crystal Bridges Museum of American Art, Bentonville, Arkansas
Cat. 50
[Bentonville only]

Dancer in White Before the Footlights, 1910
Oil on canvas; 35 × 39 in. (88.9 × 99.1 cm)
Collection of The Butler Institute of American Art, Youngstown, Ohio. Museum Purchase 1957, 957-O-128
Cat. 51

The Green Ballet, 1943
Oil on canvas; 19 3/4 × 30 in. (50.2 × 76.2 cm)
Westmoreland Museum of American Art, Gift of the William A. Coulter Fund
Cat. 49

John Sloan
American, 1871–1951
Isadora Duncan, 1911
Oil on canvas; 32 1/4 × 26 1/4 in (81.92 × 66.68 cm)
Milwaukee Art Museum, Gift of Mr. and Mrs. Donald B. Abert, M1969.27
Cat. 25

David Smith
American, 1906–65
Terpsichore and Euterpe, 1947
Bronze; 32 1/2 × 45 × 12 1/2 in. (82.5 × 114.3 × 31.7 cm)
Harvard Art Museums / Fogg Museum, Gift of Lois Orswell, 1994.17
Cat. 56

Raphael Soyer
American, 1899–1987
Dancing Lesson, 1926
Oil on canvas
24 × 20 in. (61 × 50.8 cm)
The Jewish Musuem, New York, Gift of the Renee and Chaim Gross Foundation, 2008–225
Cat. 4

Edward Steichen
American, 1879–1973
Fred Astaire, 1927
Gelatin silver print; image: 9 1/2 × 7 5/8 in. (24.2 × 19.3 cm), sheet: 9 15/16 × 7 15/16 in. (25.2 × 20.2 cm)
National Portrait Gallery, Smithsonian Institution; acquired in memory of Agnes and Eugene Meyer through the generosity of Katharine Graham and the New York Community Trust, The Island Fund, NPG.2001.15
Cat. 53

Florine Stettheimer
American, 1871–1944
Music, ca. 1920
Oil on canvas; 69 × 50 1/2 in. (175.3 × 127 cm)
Rose Art Museum, Brandeis University, MA; Gift of Joseph Solomon, New York
Cat. 48

James VanDerZee
American, 1886–1983
Untitled (Dancing Girls), 1928
Gelatin silver print; 8 × 10 in. (20.5 × 25.4 cm)
Spencer Museum of Art, The University of Kansas, Museum purchase: Peter T. Bohan Art Acquisition Fund, 2007.0036
Cat. 62

Bessie Potter Vonnoh
American, 1872–1955

The Dance, 1897
Bronze; 12 × 11 1/2 × 5 3/4 in. (30.5 × 29.2 × 14.6 cm)
Collection of The Newark Musuem, Gift of Joseph S. Isidor, 1914
Cat. 33

The Scarf, 1908
Bronze; 13 1/2 × 5 1/2 × 6 1/2 in. (34.29 × 13.97 × 16.51 cm)
Museum of Fine Arts, Boston, Anonymous gift in memory of John G. Pierce, Sr. RES.65.62
Cat. 32

Stanislaus Julian Walery
Polish, born England, 1863–1935
Josephine Baker, 1926
Gelatin silver print; image: 8 ¾ × 6 ⅜ in. (22.2 × 16.2 cm), sheet: 9 ⅛ × 7 1/16 in. (23.2 × 17.9 cm)
National Portrait Gallery, Smithsonian Institution, NPG.95.105
Cat. 59

Andy Warhol
American, 1928–1987

Dance Diagram [2] [Fox Trot: "The Double Twinkle-Man"], 1962
Casein and graphite on linen; 71 ½ × 51 ¾ in. (181.6 × 131.4 cm).
The Andy Warhol Museum, Pittsburgh; Founding Collection, Contribution, 1998.1.11
[not illustrated; Detroit only]

Silver Clouds, 1966
Helium-filled metalized plastic film; 36 × 51 in. (91.4 × 129.5 cm)
The Andy Warhol Museum, Pittsburgh
[not illustrated; Detroit and Denver only]

Max Weber
American, 1881–1961
Russian Ballet, 1916
Oil on canvas; 30 × 36 in. (76.2 × 91.4 cm)
Brooklyn Museum, Bequest of Edith and Milton Lowenthal, 1992.11.29
Cat. 38

Ellis Wilson
American, 1899–1977
Shore Leave, 1941
Oil on composite board; 16 × 20 in. (40.6 × 50.8 cm)
Courtesy of the Amistad Research Center, New Orleans, LA
Cat. 65

Selected Bibliography

Banes, Sally. *Dancing Women: Female Bodies on Stage*. London, 1998.

Cassidy, Donna. *Painting the Musical City: Jazz and Cultural Identity in American Art, 1910–1940*. Washington, DC, 1997.

Corn, Wanda M. *The Great American Thing: Modern Art and National Identity, 1915–1935*. Berkeley, 1999.

Crunden, Robert Morse. *Body and Soul: The Making of American Modernism*. New York, 2000.

DeFrantz, Thomas. *Dancing Many Drums: Excavations in African American Dance*. Madison, WI, 2002.

Desmond, Jane. *Dancing Desires: Choreographing Sexualities On and Off the Stage*. Madison, WI, 2001.

Dixon Gottschild, Brenda. *The Black Dancing Body: A Geography from Coon to Cool*. New York, 2003.

Duncan, Isadora. *My Life*. New York, 1927.

Flitch, J. E. Crawford. *Modern Dancing and Dancers*. London, 1912.

Foulkes, Julia L. *Modern Bodies: Dance and American Modernism from Martha Graham to Alvin Ailey*. Chapel Hill, NC, 2002.

Franko, Mark. *Dancing Modernism/Performing Politics*. Bloomington, IN, 1995.

Garafola, Lynn. *Diaghilev's Ballets Russes*. New York, 1989.

———. *Legacies of Twentieth-Century Dance*. Middletown, CT, 2005.

Graham, Martha. *Blood Memory: An Autobiography*. New York, 1992.

Hill, Constance Valis. *Tap Dancing America: A Cultural History*. New York, 2010.

Johns, Elizabeth. *American Genre Painting: The Politics of Everyday Life*. New Haven, CT, 1991.

Jowitt, Deborah. *Time and the Dancing Image*. New York, 1988.

Kirschke, Amy Helene. *Aaron Douglas: Art, Race, and the Harlem Renaissance*. Jackson, MS, 1995.

Kirstein, Lincoln. *Dance: A Short History of Classic Theatrical Dancing*. Brooklyn, 1969.

Lears, T. J. Jackson. *No Place of Grace: Antimodernism and the Transformation of American Culture, 1880–1920*. New York, 1981.

Lepannen-Guerra, Analisa Pauline. *Children's Stories and "Child-Time" in the Works of Joseph Cornell and the Transatlantic Avant-Garde*. Burlington, VT, 2011.

Manning, Susan. *Modern Dance, Negro Dance: Race in Motion*. Minneapolis, 2006.

Murphy, Jacqueline. *The People Have Never Stopped Dancing: Native American Modern Dance Histories*. Minneapolis, 2007.

Needham, Maureen. *I See America Dancing: Selected Readings, 1685–2000*. Urbana, IL, 2002.

Udall, Sharyn Rohlfsen. *Dance and American Art: A Long Embrace*. Madison, 2012.

Index

Note: Page numbers in italic type indicate illustrations. Titles are given only for catalogued works.

Abbot, Berenice, *283*
Allan, Maud, 119, 121
Alston, Charles, 193, *193*, 209, 211, 214; *Dancers* (cat. 70), 209, 211, *212*
Altman, Robert, *110*, 111
Astaire, Fred, 164, 255
Awa Tsireh (Alfonso Roybal), *73*

Baker, Josephine, 181, *182*, 202
Bakst, Léon, 119, 136, *137*, 156, 261
Balanchine, George, 221, 268
Ball, Hugo, 276, *277*, 278
Barthé, Richmond, 202; *Feral Benga* (cat. 67), 202, *203*; *Josephine Baker* (cat. 68), *204*; *Rugcutters* (cat. 66), 181, 200, *201*, 202
Baryshnikov, Mikhail, 149
Beard, William Holbrook, *The Bear Dance* (cat. 6), 16, *19*
Bearden, Romare, 216, 219n37
Beaux, Cecilia, *Dorothea and Francesca* (cat. 2), 13, *14*
Benga, François "Feral," 202
Benton, Thomas Hart, *Burlesque* (cat. 54), 164, *167*
Bert, Auguste, *261*
Bingham, George Caleb, 13; *The Jolly Flatboatmen* (cat. 11), 26, 32, *34*, *50* (detail), 51, 56–57, 59, 60, 89–90
Blakelock, Ralph Albert, *The Vision of Life / The Ghost Dance* (cat. 21), 68, *69*, 76

Blum, Robert Frederick, 102; *Study for "Moods to Music"* (cat. 31), 102, *103*, 104
Bolm, Adolph, 160, 221, 223, 249
Bone Shirt, Walter, *68*, 70
Brown, E., Jr., 53, *53*, 55
Brown, James, 36, *36*
Brown, John George, *The Sidewalk Dance* (cat. 28), 95, *96*

Cadmus, Paul, 25, 249–262, *251*, *253*, *256*, *257*, *258*; *Arabesque* (cat. 85), 258, *259*; *Mac, the Filling Station Attendant* (cat. 83), 251, *252*; *Reflection* (cat. 86), 258, *260*, 261; set design for *Filling Station* (cat. 84), *248* (detail), 253, *254*, 255
Cassatt, Mary, *Bacchante* (cat. 27), 93, *94*
Catlin, George, 83n5; *Bull Dance, Mandan O-kee-pa Ceremony* (cat. 20), 66, *67*
Cerrito, Fanny, 269
Chase, William Merritt, 156; *Carmencita* (cat. 46), 156, *157*
Christensen, Lew, 25, 249, *249*, *250*, 251, 255, 257, 262
Clay, Edward William, 55, *55*
Clonney, James Goodwyn: *Militia Training* (cat. 18), 45, *47*, 56, 198; *Study for "Militia Training": Boy Dancing* (cat. 10), *28*, 30, 45; *Study for "Militia Training": Boy Singing and Dancing* (cat. 19), 45, *48*
Corcoran, Dolores Purdy, *64*, 80–81, *80*, *81*; *Caddo-lac Dancers* (cat. 24), 79, 80
Cornell, Joseph, 25, 265–278, *264*, *268*, *270*, *272*, *274*, *275*; *Crystal Cage Collage (Portrait of Berenice)* (cat. 88), 271, 272–274; *A Swan Lake for Tamara Toumanova (Homage to the Romantic Ballet)* (cat. 87), *267*
Couse, Eanger Irving, 72, 74–76, *75*
Curry, John Steuart, 258, *258*

Davies, Arthur B., 21, 115, 117, 118, 121, 123, 126; *Dances* (cat. 36), 115, *116*, 126–128
Daystar / Rosalie Jones, 81
Dean, Dora, 197
DeCarava, Roy, 214, 216
Delfau, Andre, 285–286, *286*
Delsarte, François, 104, 118–119
Demuth, Charles, 129, *129*
Dewing, Thomas, 99, 102, 115, *117*, 118–120
Diaghilev, Serge, 23, 135, 136, 149, 156, 224, 257, 261, 266
Dolinoff, Alexis, 229, 238, 246n41
Douglas, Aaron, 23, 185, 188–189, *188*, *189*, 195n9, 202, 205, *205*, 214; *Dance* (cat. 63), 185, *187*
Dreier, Katherine, 122, 129, 131, *131*
Duchamp, Marcel, 128–129, *129*, 266
Duncan, Isadora, 21, 87, 102, 104, *104*, 113n23, 117–121, 123, 126, 129, 131, 139, 143
Dunham, Katherine, 181, 185, 195n5
Durand, Asher B., 90, *90*

Eakins, Thomas, 37–38, *38*, 118; *Study for "Negro Boy Dancing": The Banjo Player* (cat. 12), 37, *40*; *Study for "Negro Boy Dancing": The Boy* (cat. 13), 37, *39*
Eberle, Abastenia St. Leger, *Girls Dancing* (cat. 3), 13, *15*
Elssler, Fanny, 53, 55, 60, 91, *91*, 150n3,

300

269–270, 272, 273
Emmett, Dan, 42

Ferrara, Rosina, 93
Fokine, Mikhail, 120, 136, 156, 160
Fonseca, Harry, *Shuffle Off to Buffalo #V* (cat. 5), 16, *18*
Fuller, Buckminster, 281–284, 288, *288*
Fuller, Loïe, 122, 123, 139

Genthe, Arnold, 104, *104*, 139, 143, *143*
Gibson, Charles Dana, 99, *102*
Graham, Martha, 25, 26, 70, *70*, 72, 131, 169, 202, 243, 281–282, 286–287, *287*, 289, *289*
Grandville, J. J., 276, *276*
Grisi, Carlotta, 273, *274*

Halsman, Philippe, 25, *26*
Hayden, Palmer, 188
Henri, Robert, 121, 141, 143; *Ruth St. Denis in the Peacock Dance* (cat. 7), *20*, 21; *Salome Dancer* (cat. 45), *155*, 156
Hoffman, Malvina, *134*, 143, 147, *147*; *Anna Pavlova* (cat. 43), 147, *148*; *Bacchanalia* (cat. 42), 143, *145*, 146; *Russian Dancers* (cat. 41), 143, *144*
Homer, Winslow, 45–46, *46*, 95, 97, *97*, 98, 118; *A Summer Night* (cat. 29), *87* (detail), 97–99, *100*; *A Summer Night—Dancing by Moonlight* (cat. 30), 98, *101*
Hopper, Edward, 253, 255, *255*; *Girlie Show* (cat. 55), 164, *168*
Howe, Oscar, 16, 78; *The Ghost Dance* (cat. 23), 76, *77*, 78

Ito, Michio, 281

Johnson, Charles E., 197
Johnson, Eastman, 38, *42*; *Negro Life at the South* (cat. 17), 42, *44*, 51, 57
Johnson, Emily, 81
Johnson, Sargent Claude, *A Study for a San Francisco Housing Authority Mural #2* (cat. 71), 211, *213*
Johnson, William H., 23, 193–194, 209, *209*, 214; *Jitterbugs (II)* (cat. 69), 209, *210*

Kelly, Gene, 57, 255
King, Louise Howland, 115, 117, *117*, 120
Kirkland, Forrest, 65, *65*
Kirstein, Lincoln, 25, 249, 253, 255, 257, 258, 261–262, 268
Kline, Franz, 169, 173, *173*; *Large Clown (Nijinsky as Petrouchka)* (cat. 58), *172*, 173
Krimmel, John Lewis, 11, *12*, 52, *52*, 56
Kuhn, Walt, 126, 258, *258*; *Plumes* (cat. 52), *152* (detail), 164, *165*

Lane, William Henry, 37, *37*
Langsdorff, Georg Heinrich von, 105, *105*
Lee-Smith, Hughie, 216, 219n37
Limón, José, 243
Lincoln, F. S., *283*, 284–285, *284*, *285*, 288
Littlefield, Catherine, 23, 221, *222*, 225–227, 238, 241–242
Lowe, "Uncle" Jim, 37
Luks, George, 141, 143, *180*; *Pavlova's First Appearance in New York* (cat. 40), *142*, 143; *The Spielers* (cat. 1), *10*, 13, 95
Lynes, George Platt, 249, 251, 256, 257; *Lew Christensen* (cat. 82), *250*

MacDonald-Wright, Stanton, 122, *122*
Magafan, Jenne, *Cowboy Dance (mural study, Anson, Texas Post Office)* (cat. 8), 22, *23*
Magee, John L., 59–60, *60*, 63n17
Manet, Edouard, 156, *156*
Man Ray, 127–129, *127*
Mansfield, Portia, 110
Manship, Paul, *Dancer with Gazelles* (cat. 34), 105, *108*
Marsh, Reginald, 190, 205–206; *Savoy Ballroom* (cat. 64), 190, *191*, 205–206
Massine, Léonide, 221, 225, 257
Mathews, Arthur, 110; *Youth* (cat. 35), 105, *109*, 110, 120
Matulka, Jan, *Indian Dancers* (cat. 57), 169, *171*
Mayr, Christian Friedrich, *Kitchen Ball at White Sulphur Springs, Virginia* (cat. 16), 42, *43*, 56
McLenan, John, 29–31, *31*
Montez, Lola (Eliza Oliver), 59–61
Mordkin, Mikhail, 135, 136, 139
Moreno, Carmen Dauset, 153
Morgan, Barbara, *289*

Moselsio, Herta, *287*
Motley, Archibald, Jr., 190, 206, 207–209, *207*
Mount, William Sidney, 13, 31–32, *31*, 33, *46*, 46, 49, 51; *Dance of the Haymakers* (cat. 12), 33, *35*, 46, 51, 56–57, 59, 60; *Rustic Dance After a Sleigh Ride* (cat. 15), 38, *41*, 42, 53, 56
Muybridge, Eadweard, 97, *98*
Myers, Frank, *The Charleston* (cat. 39), *130*

Nadelman, Elie, 129, *129*
Nahl, Charles Christian, 90–91, *91*
Neel, Alice, *Ballet Dancer* (cat. 60), 181, *183*
Nichols, Francis, 52, 54
Nijinsky, Vaslav, 119, 123, 135, *135*, 160, *160*, 261–262, *261*
Noguchi, Isamu, 25–26, 281–289, *283*, *284*, *285*, 289; *Cave of the Heart: Serpent and Spider Dress* (cat. 9), *24*, 26; *Miss Expanding Universe* (cat. 89), 26, *280*, 283–285, 290n20
Novikov, Laurent, 139
Nureyev, Rudolf, 149

O'Keeffe, Georgia, 70, 72
Oqwa Pi (Abel Sanchez), *73*, 74–76, *74*
Overton, Aida Reed, 180

Page, Ruth, 28, 221, 281–289, *284*, 290n14
Parrish, Maxfield, Jr., *179*
Partridge, Bernard, 270, *270*
Pavlova, Anna, 21, 23, 129, 135–149, *135*, *138*, *140*, *143*, 266
Philipp, Werner, *Portrait of Katherine Dunham* (cat. 61), *184*, 185
Primus, Pearl, 181

Quah Ah (Tonita Peña), 72–74

Rice, Anne Estelle, 123; *The Egyptian Dancers* (cat. 37), 123, *124*
Rice, Thomas Dartmouth "Daddy," 33, 36, 42, *198*, 199
Ringgold, Faith: *Groovin' High* (cat. 72), *196* (detail), 215, 216–217
Rivera, Diego, 222, 223–224, 226, 227, 228, 229, 237, *237*, 245n12; *Banana* (cat. 74), 227, *231*; *Cocoa Nut* (cat. 73), 227, *230*; *H.P. (Horsepower)* (ballet), 23, 25, 221–243; *H.P.*

INDEX 301

Rivera, Diego (*cont.*), *The Man* (cat. 79), *236*, 237; *Pineapple* (cat. 75), 227, *232*; *The Siren* (cat. 80), *239*; *Sun* (cat. 78), 227, *235*; *Tobacco and Cotton* (cat. 77), 227, *234*; *U.S.–Mexico Gold–Silver* (cat. 81), *240*, 242

Robbins, Jerome, 253

Rodin, Auguste, 143

Rubinstein, Ida, 123

Russell, Morgan, 122, *122*

Sargent, John Singer, 93, *93*, 110, *110*; *Capri Girl on a Rooftop* (cat. 26), *92*, 93, 95; *La Carmencita* (cat. 44), 155, *154*, 156; *Gertrude Vanderbilt Whitney* (cat. 47), *158*

Sarony, Napoleon, 53, *53*

Schloss, Jacob, 104, *104*

Sharp, Joseph Henry, *The Harvest Dance* (cat. 22), *71*, 72

Shawn, Ted, *70*, 72, 119, 120, 122, 129, 131

Shinn, Everett, 160, 163; *Dancer in White Before the Footlights* (cat. 51), 160, *163*; *A French Music Hall* (cat. 50), 160, *162*; *The Green Ballet* (cat. 49), 160, *161*

Simas, Rosie, 81

Sloan, John, 87, *89*, 104, 121; *Isadora Duncan* (cat. 25), 87, *89*

Smith, David, 169, *169*; *Terpsichore and Euterpe* (cat. 56), 169, *170*

Smith, George Washington, 60

Snowden, George "Shorty," 206

Soyer, Raphael, *Dancing Lesson* (cat. 4), 16, *17*

St. Denis, Ruth, 21, 104, 118–120, 123, 131, 139, 195n5

Stebbins, Genevieve, 104, 118–119

Steichen, Edward, *Fred Astaire* (cat. 53), 164, *166*

Stettheimer, Florine, *Music* (cat. 48), *159*, 160

Taglioni, Marie, 268, 273

Tallchief, Maria, 156

Tchelitchew, Pavel, 268

Tenniel, John, 277–269, *277*

Thorpe, Thomas Bang, 53, 56

Toumanova, Tamara, 268

VanDerZee, James, 200; *Untitled (Dancing Girls)* (cat. 62), *176* (detail), 185, *186*, 200

Vonnoh, Bessie Potter: *The Dance* (cat. 33), 105, *107*; *The Scarf* (cat. 32), 105, *106*

Walery, Stanislaus Julian, *Josephine Baker* (cat. 59), *182*

Walker, George, 180

Walkowitz, Abraham, 104, *104*, 121

Weber, Max, *Russian Ballet* (cat. 38), *114* (detail), 123, *125*, 126

Williams, Egbert Austin, 180

Wilson, Ellis, 190; *Shore Leave* (cat. 65), *191*, 192

Wolcott, Marion Post, 193, *193*

Woodville, Richard Caton, 51

Acknowledgments

Dance: American Art, 1830–1960, is dedicated to my contributing authors, without whom there would be no comprehensive, thoughtful, and lively study. Chief among them is the incomparable Lynn Garafola, who consulted on this project from its inception. The brilliant dance historians Thomas F. DeFrantz, Constance Valis Hill, and Jacqueline Shea Murphy brought insights that were fresh and necessary. Innovative art historians Analisa Leppanen-Guerra, Dakin Hart, Bruce Robertson, Sharyn Udall, and my former DIA curatorial colleagues Kenneth John Myers and Valerie J. Mercer waltzed into a whole new discipline bringing their expertise and their inspired research. It was an honor to have you all participate.

A bow to Graham W. J. Beal, former director of the DIA, who was always supportive of my ideas and art history research, and a flamenco stamping of the feet to Salvador Salort-Pons, current director, for carrying this project forward. More gratitude than you could ever imagine to Robert T. Stark, former director of human resources, who supported my leave of absence under the FMLA to write my essays from my mother's house, where I spent the last six months of her life. Patty McClaran's joyous spirit is everywhere in this catalogue. Thank you, too, to Amy Hamilton Foley, director of exhibitions, who aided in my decampment, and her chorus line of exhibition assistants, including Linda Johnson, Andrea Potti, and the indispensable Kimberly Long, who spent hours securing images and photo rights. Maria Ketcham, director of the research library and archives, was an enormous help, assisting me and my loyal curatorial interns Nicole Corrigan, Emilie Murphy, Jessie Lipkowitz, Mallory Jamett, Amanda Walencewicz, and Garrett Swanson, as well as the superb curatorial assistants Megan Reddicks, Virginia Reynolds, and Anna Stein. I am very grateful to Eric Wheeler, manager of photography, for illuminating these pages, and Patricia Inglis for the gorgeous design. A tip of the tiara to the extraordinary professionalism of Susan Higman Larsen, director of publishing and collections information, who brought her enormous talent and gifts as an editor to this catalogue.

I began my research on American dancers at the Huntington Library, San Marino, thanks to an Ernestine Richter Avery Fellowship. For further exhibition development, an ADAA Foundation Curatorial Award and support from the Association of Art Museum Curators was critical, as was that of the DIA's Associates of the American Wing. I share with the entire museum community our honor in the awards from the National Endowment for the Arts and the generous implementation grant from the National Endowment for the Humanities, for both of which I am grateful.

My profound debt remains to the private collectors and public institutions who loaned to the exhibition and its tour, and my curatorial colleagues far and wide who offered enthusiasm and encouragement. In addition to those at the DIA, I was supported by the staff of the Metropolitan Museum of Art, especially Randall Griffey, associate curator, modern and contemporary art, and Sylvia Yount, Lawrence A. Fleischman curator in charge of the American Wing.

Before I leave the stage, a grateful flower toss up to the balcony for my beloved Peter and Skip. My final bow, and book, are for the two of you.

JANE DINI

Photo Credits

Unless otherwise noted, all images are courtesy of the owners.

©Berenice Abbott/Masters/Getty Images: Hart essay, fig. 2. ©Estate of Charles Alston, c/o Corrine Jennings: Cat. 70; DeFrantz essay, fig. 7. ©Robert Altman Photography: Dini essay, "Dancing Out-of-Doors," fig. 17. ©Jon F. Anderson, Estate of Paul Cadmus/Licensed by VAGA, New York, NY: Cats. 83, 84, 85, 86; Dini essay, "Modern Shenanigans," figs. 2–3, 5, 10–11, 13. ©The Art Institute of Chicago: Cats. 2, 21; Hill essay, fig. 3; Mercer essay, fig. 4. ©2016 Banco de México Diego Rivera Frida Kahlo Museums Trust, Mexico, D.F./Artists Rights Society (ARS), New York: Cats. 73–81; Garafola essay, figs. 1, 4–8. ©2016 Barnes Foundation: Robertson essay, fig. 8. ©T.H. Benton and R.P. Benton Testamentary Trusts/UMB Bank Trustee/Licensed by VAGA, New York, NY: Cat. 54. ©Valerie Gerrard Brown and Mara Motley, M.D., courtesy of Chicago History Museum: Mercer essay, figs. 3, 4. ©The Cleveland Museum of Art: Hill essay, fig. 9. ©Dolores Purdy Corcoran: Cat. 24; Shea Murphy essay, figs. 12–14. ©The Joseph and Robert Cornell Memorial Foundation/Licensed by VAGA, New York, NY: Cats. 87–88; Leppanen-Guerra essay, figs. 1–3, 5–8. ©John Steuart Curry, courtesy of Kiechel Fine Art, Lincoln, NE: Dini essay, "Modern Shenanigans," 15. ©2016 Delaware Art Museum/Artist Rights Society (ARS), New York: Defrantz essay, fig. 2. Heirs of Aaron Douglas/Licensed by VAGA, New York, NY: Cat. 63; DeFrantz essay, figs. 3–5; Mercer essay, fig. 2. ©Succession Marcel Duchamp/ADAGP, Paris/Artists Rights Society (ARS), New York, 2016: Robertson essay, fig. 7. P. Richard Eells: Cat. 25. ©Fonseca Trust: Cat. 5. ©Oscar Howe Family: Cat. 23. ©Courtesy of the Huntington Art Collections: Dini essay, "Modern Shenanigans," 14. ©Jean-Pierre Joyce: Robertson essay, fig. 4. ©2016 The Franz Kline Estate/Artists Rights Society (ARS), New York: Cat. 58; Dini essay, "Dancer as Muse," fig. 4. Erich Lessing/Art Resource, NY: Dini essay, "Modern Shenanigans," fig. 6. Hervé Lewandowski, ©RMN-Grand Palais/Art Resource, NY: Cat. 29. ©F.S. Lincoln: Hart essay, figs. 1, 3, 5, 11. ©Estate of George Platt Lynes: Cat. 82; Dini essay, "Modern Shenanigans," figs. 1, 8–9, 12. ©Estate of Jenne Magafan: Cat. 8. ©2016 Estate of Reginald Marsh/Art Students League, New York/Artists Rights Society (ARS), New York: Cat. 64. Michael McKelvey: Robertson essay, fig. 2. Melville McLean: Leppanen-Guerra essay, fig. 8. ©The Metropolitan Museum of Art/Art Resource, NY: Cat. 46, Hill essay, fig. 6; Myers essay, fig. 2; Dini essay, "Modern Shenanigans," figs. 4, 16. ©Barbara Morgan, The Barbara Morgan Archive: Hart essay, fig. 12. ©Museum Associates/LACMA. Licensed by Art Resource, NY: Cat. 54. ©2016 Museum of Fine Arts, Boston: Cats. 10, 15, 19, 32; Dini essay, "Dancing Out-of-Doors," figs. 6, 16. ©The Museum of Modern Art/Licensed by SCALA/Art Resource, NY: Robertson essay, fig. 6; Dini essay, "Modern Shenanigans," figs. 7, 10. ©The Estate of Alice Neel, Courtesy David Zwirner, New York/London: Cat. 60. ©New-York Historical Society: Cats. 6, 17. ©2016 The Isamu Noguchi Foundation and Garden Museum, New York/Artists Rights Society (ARS), New York: Cat. 9, 89; Hart essay, figs. 4, 8. ©Estate of Milton Oleaga: Shea Murphy essay, fig. 4. Lillian and Derek Ostergard: Cats. 41, 43; Udall essay, fig. 7; ©1970 Ruth Page Foundation: Hart essay, fig. 6. ©Lydia Parrish, courtesy of the University of Georgia Press: DeFrantz essay, fig. 1. ©Philadelphia Museum of Art: Robertson essay, fig. 7. Kenvi Phillips: Cat. 66. Dwight Primiano: Cat. 50. ©Man Ray Trust/Artists Rights Society (ARS), NY/ADAGP, Paris 2016: Robertson essay, fig. 6. ©Anne Estelle Rice: Cat. 37. ©Faith Ringgold, 1986: Cat. 72. ©The Estate of David Smith/Licensed by VAGA, New York, NY. Imaging Department ©President and Fellows of Harvard College: Cat. 56; Dini essay, "Dancer as Muse," fig. 3. Smithsonian American Art Museum, Washington, DC/Art Resource, NY: Dini essay, "Modern Shenanigans," fig. 11. ©Estate of Raphael Soyer, Courtesy of Forum Gallery, New York. Photo by Richard Goodbody, Inc.: Cat. 4. ©The Estate of Edward Steichen/Artist Rights Society (ARS), New York: Cat. 53. Tim Thayer Photography: Cat. 28. V&A Images, London/Art Resource, NY: Dini essay, "Dancing Out-of-Doors," fig. 10. ©2016 Courtesy of Peyton Wright Gallery: Robertson essay, fig. 5.